Alan Walker

About the Author

PAT SHIPMAN is the author of seven previous books, including *The Man Who Found the Missing Link* and *Taking Wing*, which won the Phi Beta Kappa Prize for science and was a finalist for the Los Angeles Times Book Award and named a *New York Times* Notable Book for 1998. Her numerous awards and honors include the 1996 Rhone-Poulenc Prize for *The Wisdom of the Bones* (written with Alan Walker). Her other highly respected books include *The Evolution of Racism*, *Neanderthals* (written with Erik Trinkaus), *The Human Skeleton* (written with Alan Walker and David Bichell), and *Life History of a Fossil*. She is an adjunct professor of anthropology at Pennsylvania State University and lives in State College, Pennsylvania.

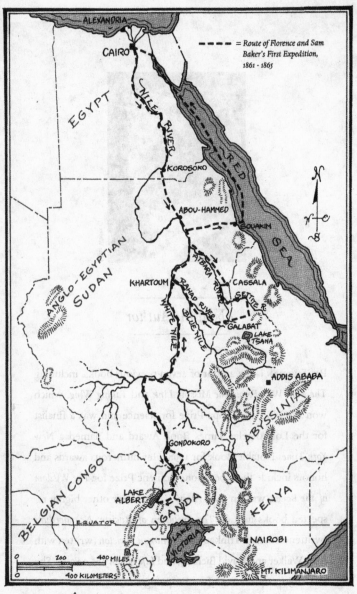

= Route of Florence and Sam Baker's First Expedition, 1861 - 1865

ALEXANDRIA

CAIRO

EGYPT

NILE RIVER

KOROSOKO

ABOU-HAMMED

SOUAKIN

RED SEA

N

W · E

S

ATBARA RIVER

KHARTOUM

CASSALA

RAHAD RIVER

SETTE R.

ANGLO-EGYPTIAN SUDAN

WHITE NILE

BLUE NILE

GALABAT

LAKE TSANA

ADDIS ABABA

ABYSSINIA

GONDOKORO

BELGIAN CONGO

LAKE ALBERT

UGANDA

EQUATOR

LAKE VICTORIA

KENYA

NAIROBI

MT. KILIMANJARO

200 400 MILES
0
0 400 KILOMETERS

Florence AND Sam Baker's
FIRST EXPEDITION

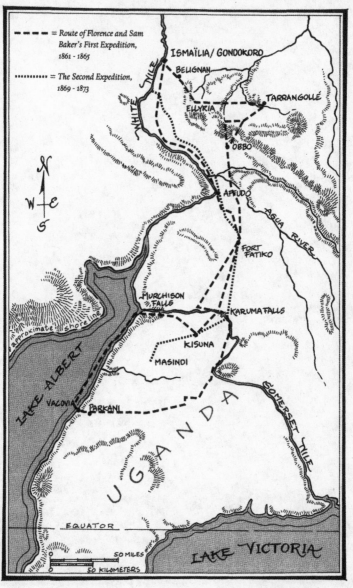

ISMAÏLIA / GONDOKORO

BELIGNAN

TARRANGOLLÉ

ELLYRIA

OBBO

WHITE NILE

AFFUDO

ASUA RIVER

FORT FATIKO

MURCHISON FALLS

KARUMA FALLS

approximate shoreline

KISUNA

MASINDI

LAKE ALBERT

VACOVIA

PARKANI

U G A N D A

SOMERSET NILE

EQUATOR

50 MILES

50 KILOMETERS

LAKE VICTORIA

N
W E
S

Florence AND Sam Baker's
SECOND EXPEDITION

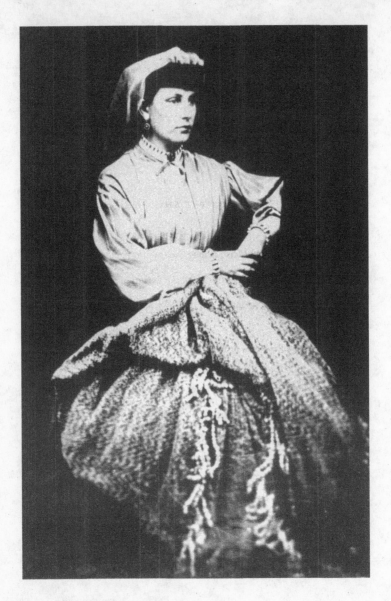

*Florence in Paris (1865). This earliest known
photograph of Florence shows her beauty,
self-confidence, and exotic air.*

to the
HEART
of the
NILE

Lady Florence Baker
and the *Exploration* of
Central Africa

PAT SHIPMAN

HARPER

NEW YORK • LONDON • TORONTO • SYDNEY

For the Baker family, past and present,
who have inspired me with their indomitable courage
and open-hearted generosity

HARPER

A hardcover edition of this book was published in 2004 by William Morrow, an imprint of HarperCollins Publishers.

TO THE HEART OF THE NILE. Copyright © 2004 by Pat Shipman. All rights reserved. Printed in the United States of America. No part of this book may be used or reproduced in any manner whatsoever without written permission except in the case of brief quotations embodied in critical articles and reviews. For information address HarperCollins Publishers Inc., 10 East 53rd Street, New York, NY 10022.

HarperCollins books may be purchased for educational, business, or sales promotional use. For information please write: Special Markets Department, HarperCollins Publishers Inc., 10 East 53rd Street, New York, NY 10022.

FIRST PERENNIAL EDITION PUBLISHED 2005.

Book design by Shubhani Sarkar

Interior maps by Jeff Mathison

B10 -2-25-15

The Library of Congress has catalogued the hardcover as follows:

Shipman, Pat.
 To the heart of the Nile : Lady Florence Baker and the exploration of central Africa / Pat Shipman.—1st ed.
 p. cm.
 Includes bibliographical references (p.) and index.
 ISBN 0-06-050555-9
 1. Baker, Florence, Lady. 2. Baker, Samuel White, Sir, 1821–1893. 3. Nile River—Discovery and exploration. 4. Africa, Central—Discovery and exploration. 5. Explorers—Nile River—Biography. 6. Women explorers—Nile River—Biography. 7. Explorers—Africa, Central—Biography. 8. Women explorers—Africa, Central—Biography. I. Title.

DT117.B14S55 2004
916.76'1041'092—dc21
[B]
 2003054137

ISBN 0-06-050557-5 (pbk.)

13 14 15 NMSG/QW 10 9 8 7 6 5 4

ACKNOWLEDGMENTS

This book would not have been possible without the generosity and cooperation of the Baker family, to whom I express my deep gratitude, although I know they may not always agree with my interpretations.

Of many willing and helpful archivists I contacted, Sarah Strong of the Royal Geographical Society and Jane Hogan of the Sudan Collection at Durham University stood out for going above and beyond the call of duty. So did Eric Novotny and the indefatigable interlibrary-loan staff of Penn State University. Johanna and Joszef Geml read and translated much information from Hungarian for me; Alex Miron and Andreea Trasca translated from the Romanian, rewrote a letter into Romanian, and placed a phone call to the Colegium Bethlen Gábor for me, which resulted in a very useful response from Gyorgy Dionisie, the librarian, pertaining to the Szász family. Donna Chen of the Family History Center in State College, Pennsylvania, assisted me in obtaining additional information about the Szász family. Zsuzsa Berend, of UCLA, and Cornell Fleishman, of the University of Chicago, patiently answered questions about

Hungary and the Ottoman Empire in my quest to understand Florence's past. My niece, Karen Walker, offered temporary housing and lasting advice at a few critical moments, as did my brother-in-law Gerald Walker and his wife, Ida In't Veldt. Anjali Singh and Ian Maxted offered small but crucial bits of information. Janet Padiak at University College, London, went on an unfortunately fruitless search for a record of Florence's first passport for me at the Public Record Office. Ayhan Irfanoglu kindly obtained for me a usable scan of the image that appears on page 6 in this book. My friends Barbara Kennedy and Cheryl Glenn offered moral support and editorial advice. I thank my editors, Jennifer Brehl of HarperCollins and Sally Gaminara of Transworld, for gentle, helpful editing.

Last but never least, I wish to thank my husband, Alan Walker, with whom I spent years of my life (albeit a few months at a time) in Africa and with whom I learned to love Africa and Africans. Together we discovered the joys of Sam and Florence Baker, many years ago. He has never doubted I could write Florence's story and I am grateful for that and so much more.

CONTENTS

Acknowledgments ix

Author's Note xiii

Timeline xv

1. I Am Not a Slave 1

2. Shots, Knives, Yells, Corpses, and Fire 18

3. Like a Hawk After a Mouse 37

4. A Girl from the Harem 48

5. So Absurd an Errand 69

6. Heart of a Lion 88

7. Sitt, I Be Your Boy 105

8. A Perfect Hell 125

9. Are the Men Willing to March? 144

10. A Gorilla in London 162

11. Tock-tock-tock 179

12. The Water Cabbages Are Moving 189

13. My Legs Are But Useless Things 200

14. Life So Uncertain Here 214

15. A Courageous Lady 233

16. Supreme and Absolute Power 247

17. My Lady and I Shall Proceed Alone 275

18. Not a Gentleman in the Whole of Africa 295

19. The Legendary Reputation for Amazonian Qualities 318

20. That Disgraceful Outrage 335

21. You Promised You Would Never Return Without Me 343

22. How Can I Live? 360

23. March 11, 1916 373

Notes 377

Bibliography 405

A Note on Archives 411

Illustration Credits 413

Index 417

AUTHOR'S NOTE

Florence's early life is scantily documented; she has always been a lady of mystery. Although I have had some success in tracing records of her natal family, I have derived many of the details about her early life from Baker family legends or I have deduced them from extensive research into the Hungarian Revolution and the Ottoman slave trade. Rather than using cumbersome constructions such as "she might have said . . ." or "he must have wondered," I have attributed thoughts and words to Florence and the people in her life that are in keeping with their characters and recorded words. Any queries or concerns about the source of quotations, facts, opinions, and speculations can be resolved by consulting the endnotes.

For those who believe the best biographies contain nothing but documented facts, I beg to disagree. "All biography is ultimately fiction," as Bernard Malamud has said. As Florence's biographer, I consider it my job to portray the deeper truth of her character and a more insightful perspective on her significance than can possibly be conveyed by mere facts. Filling in the gaps—what I prefer to think of

as putting forward informed hypotheses—is both necessary and appropriate.

I have followed nineteenth-century usage of terms such as "black," "white," "Negro," and "native" and have quoted some remarks and opinions that may strike the reader as blatantly racist. This is not an expression of my personal views after many years of working in Africa; it is an attempt to portray accurately the attitudes of the imperial, Victorian age.

In direct quotations, I have tried to make the spelling of African names consistent, although the original documents are inconsistent. Because some of the place names cannot be identified with extant places, I have generally followed nineteenth-century spellings such as Florence used. I have occasionally altered punctuation for clarity. In the endnotes I have given modern equivalents, in pounds sterling and U.S. dollars, of all sums mentioned in the text. As some of these are quite impressive, I urge readers to consult the endnotes regularly.

TIMELINE

~1845	Barbara Maria Szász (the future Florence Barbara Maria Szász Baker) is born in Transylvania.
1848	Uprisings all over Europe protest the old monarchies and autocratic empires.
MARCH–MAY 1848	Hungary unites with Transylvania to declare its independence from Austria.
JANUARY 8, 1849	Nagy-Enyed is burned and destroyed by Vlach soldiers; Barbara and her nursemaid flee to join her father Mathias Szász, who is in the rebel Transylvanian army.
AUGUST 12–22, 1849	The Hungarian Revolution fails; Louis Kossuth abdicates; General Görgei surrenders to the Russians; thousands of Hungarian refugees flee to Viddin in the Ottoman Empire.
SEPTEMBER 11, 1849	Mathias Szász and nine other officers in the refugee camp draft a letter vowing their allegiance to Kossuth and the revolution and refusing Austrian amnesty.
SEPTEMBER–OCTOBER 1849	About 500 of the refugees convert to Islam and join the Ottoman army; Mathias Szász was probably among them.

C. NOVEMBER 1849	Barbara is taken for training in the harem; she is re-named Florenz.
DECEMBER 29, 1855	Henrietta Baker, first wife of Sam Baker, dies of typhus.
1856	Richard Burton and John Speke set out to discover the source of the Nile.
LATE JANUARY 1859	Florenz is sold at an elite white slave auction in Viddin; the pasha of Viddin is the high bidder, but she leaves with Sam Baker and becomes "Florence."
FEBRUARY 1859– JUNE 1860	Florence and Sam in central Europe.
MAY 9, 1859	Speke returns to England announcing the discovery of the source of the Nile, a lake he named the Victoria N'yanza.
MAY 21–23, 1859	Burton returns to England, disputes Speke's claims, and receives the Victoria medal from the Royal Geographical Society.
APRIL 27, 1860	Speke and James Grant leave for Africa to confirm Speke's claim.
MARCH 1861	Florence and Sam arrive in Cairo to begin exploring the Nile tributaries of Abyssinia.
JUNE 11, 1862	Florence and Sam reach Khartoum.
DECEMBER 2, 1862	Sam writes his will, leaving considerable money to Florence.
DECEMBER 18, 1862	Florence, Sam, and their men leave Khartoum by boat.
FEBRUARY 2, 1863	Florence and Sam reach Gondokoro, a slaver's station and the rendezvous point for Speke and Grant.
FEBRUARY 15, 1863	Speke and Grant arrive at Gondokoro; they suggest that Sam explore the Luta N'zigé, another lake that may be a secondary source of the Nile.
FEBRUARY 26, 1863	Speke and Grant leave for Khartoum.
MARCH 27, 1863	Florence, Sam, and their men begin the march toward the Luta N'zigé.
FEBRUARY 9, 1864	Florence and Sam meet with Kamrasi, the king of Bunyoro.

MARCH 14, 1864	Florence and Sam discover the Luta N'zigé and re-name it Lake Albert.
APRIL 5, 1864	Florence and Sam discover the Murchison Falls, where the Somerset Nile drains into Lake Albert.
APRIL 14– NOVEMBER 17, 1864	Florence and Sam are trapped in Bunyoro without adequate food, medicine, or porters.
SEPTEMBER 18, 1864	John Speke dies in England under peculiar circumstances.
MARCH 13, 1865	Florence and Sam return to Gondokoro.
APRIL 16, 1865	Sam makes another will, leaving additional monies to Florence.
MAY 5, 1865	Florence and Sam arrive back at Khartoum.
SEPTEMBER 1865	Sam's brother James meets Sam and Florence in Paris.
OCTOBER 14, 1865	Florence and Sam arrive at Dover, England.
NOVEMBER 4, 1865	Florence and Sam marry in St. James's Church by special license.
NOVEMBER 13, 1865	Sam addresses the Royal Geographical Society and introduces Florence.
JULY 1866	Sam's book *The Albert N'yanza* is published.
AUGUST 15, 1866	Sam's knighthood is announced.
FEBRUARY 1867	Queen Victoria refuses to receive Florence.
OCTOBER 1868	Florence and Sam meet the Prince and Princess of Wales; the prince asks Sam to arrange a trip to Egypt for them.
FEBRUARY 1869	The royal party visits Egypt; the khedive offers Sam the position of governor-general of Equatoria.
APRIL 1, 1869	Sam's appointment as governor-general or pasha of Equatoria begins; he is charged with eradicating the slave trade on the White Nile.
FEBRUARY 8, 1870	Florence, Sam, Julian, and 650 soldiers leave Khartoum.
SEPTEMBER 21, 1870	Defeated temporarily by the sudd, Florence and Sam return to Khartoum.
APRIL 14, 1871	The expedition arrives at Gondokoro and sets up the station known as Ismailïa.

APRIL 25, 1872	Florence, Sam, Julian, and 212 soldiers reach Masindi, the capital of Bunyoro.
JUNE 8, 1872	The Banyoro attack the expedition in the battle of Masindi.
JUNE 14, 1872	The expedition flees Masindi, fighting their way through fierce ambush.
MARCH 1873	Rumors of the death of the Bakers reach England.
APRIL 1, 1873	Sam's appointment as pasha terminates.
JUNE 29, 1873	Sam telegraphs the Prince of Wales triumphantly from Khartoum.
DECEMBER 8, 1873	Sam addresses the Royal Geographical Society.
FEBRUARY 6, 1874	General Charles Gordon arrives in Khartoum to take over as Pasha; he serves until 1878.
AUTUMN 1874	Sam publishes *Ismailïa*.
NOVEMBER 1874	The Bakers move to Sandford Orleigh in Devon.
1881	In the Sudan, Mahommed Ahmed ibn Abdullah declares himself to be the Mahdi, an awaited Islamic leader.
NOVEMBER 5, 1883	The Mahdi's growing army massacres British general William Hicks and his native troops.
JANUARY 12, 1884	Gordon visits Sandford Orleigh to persuade Sam to go to the Sudan to relieve the British garrisons.
JANUARY 18, 1884	Gordon leaves for Khartoum.
MARCH 10, 1884	The siege of Khartoum begins.
JANUARY 26, 1885	Khartoum falls; Gordon is killed.
DECEMBER 30, 1893	Sam Baker dies.
1895	Robin Baily, Sam's grandnephew, visits Sandford Orleigh and begins his friendship with Florence.
1909	Robin Baily joins the Sudan Political Service.
MARCH 11, 1916	Florence Baker dies.

to the
HEART
of the
NILE

1

I AM NOT A SLAVE

*T*he nubile girls would be sold in January 1859. It was the wish of the matriarch of the Finjanjian family, Finjanjian Hanim. She was one of Viddin's top licensed dealers in white slaves and prided herself on her merchandise. Finjanjian Hanim had an uncanny ability to spot a promising girl at a very early age, train her for the harem, and then sell her at puberty for a top price.

Admittedly, Viddin was not the site of a major trade in white slaves, even within the Ottoman Empire in Europe. Men who were sent to Viddin as pasha, or governor, were being punished for some misdeed. The *hanim* had not the stature of the members of the Slave Traders Guild in Constantinople or Cairo, who might manage to place a girl in the Imperial Harem. Viddin had no equivalent of the incredible Topkapi Palace with its extensive harem. However, Finjanjian Hanim had succeeded in producing some girls of excellent quality who had gone into large and prestigious harems, enhancing the wealth and social standing of the Finjanjian family. They had climbed far from the days when they were simple porcelain sellers, the trade that gave them their family name.

January was the usual time for selling the most attractive girls, and the *hanim* now had a girl of exceptional quality to sell: Florenz. A young blond beauty, Florenz had been raised and trained most carefully for ten years. She took lessons in mathematics, reading and writing, geography, music, and all the womanly arts alongside the *hanim*'s own granddaughters in the harem. Finjanjian Hanim had taken great care to see that Florenz retained her knowledge of Hungarian and German, the languages of her natal family, as well as learning Arabic, the lingua franca of the harem. Knowing European languages was a highly prized accomplishment in girls these days. Watching the girl with a critical eye in the *hamman,* the baths, the *hanim* was sure Florenz had reached puberty and the height of her attractiveness. It was time for her to put on the veil in public.

Another year might put a fuller bosom and a more womanly shape on the girl, but Finjanjian Hanim had another reason for deciding to sell Florenz now. A new immigration law had been passed in Constantinople, which offered highly favorable terms to those who would immigrate to the Ottoman Empire. As long as the immigrants pledged their loyalty to the empire, they would even be permitted to practice their own religions freely. Finjanjian Hanim feared that this opportunity would tempt a flood of immigrants from Circassia and Georgia, where ethnic Russians were harassing the natives and trying to drive them out.

As concubines, Circassian and Georgian girls were always much sought after because of their fair coloring and beauty. Sometimes they were kidnapped for the harem trade, abducted in raids, or taken as trophies of war. Circassian or Georgian girls were also sold by their parents, which carried no dishonor. A life in the harem was much easier and more luxurious than the ceaseless work that awaited girls as the wives of poor farmers. And if such families came into the province in numbers, what better way was there for them to raise cash for a new start than to offer a fair daughter to a slave trader? The market in white slave girls could be ruined by an influx of Circassians and Georgians; better to sell Florenz now than wait.

She notified the other members of the Slave Traders Guild first of all, in case they wanted to enter girls of their own into the sale. A number of girls of lesser quality would fatten the audience and make Florenz look better by comparison. Discreet notices were placed in the newspapers in Constantinople, Sofia, Viddin, and Vienna. Brochures were sent to poten-

tial buyers, and gossip carried the news farther into Europe. Finjanjian Hanim fantasized happily about the possible attendees and the money she would make.

As the mother of the master of the household, Finjanjian Hanim ruled over the *haremlik*, the secluded part of the house where all the women and children lived in cloistered isolation. Her title in the harem was Sultana Validé, and she was esteemed more highly than anyone else, even the master's first wife. A favorite Turkish proverb said "A man has but one mother but might have many wives." She decided who would be sold and when. She decided who lived where in the *haremlik* and who got an extra supplement to her *paşmalik,* or "slipper money." Now she thought that Florenz should be allowed the great privilege of new and expensive clothes for the auction.

Florenz did not know why she was being so favored, but some of the other girls of the harem were given clothes too. Her friend, the *Sultana Validé*'s granddaughter, had been given beautiful new garments only a few weeks earlier before she received a visit from a *goruçu,* one of the older women who acted as marriage brokers. Florenz wondered if she too would soon receive a visit from a *goruçu.* She did not much like the idea, but she had to marry, she supposed, and that was how it was done. Her only hope was that the husband the Finjanjians found for her would be a kind and lovable man. The Sultana Validé, a woman of some perception, never mentioned the upcoming sale to Florenz, thinking the girl might make trouble.

As soon as the date of the sale was announced, the kitchen slaves began working extra hours, preparing pastries and other delicacies, squeezing fruits for juice and sherbet concoctions. The finest coffee sets were taken out of storage and cleaned meticulously, the supply of delicately embroidered silk napkins refreshed. Silver utensils were polished to a high shine. Musicians practiced frantically, as they would be stationed discreetly in the main reception room of the *selamlik,* the public area of the household where men might go, to fill the room with music.

Everything and everyone was washed and beautified. All of the girls took especial care with their hair and dress on the great day. The Sultana Validé had suggested to Florenz that she might select pale, delicate colors for her new clothing—perhaps shades of light blue and lavender—but

The Abduction (1875). Pretty Circassian and Georgian girls were kidnapped or sometimes sold into slavery by their parents, usually well before puberty.

Florenz had different ideas. With the help of the *ikbal*, the master's favorite concubine, Florenz selected a gorgeous costume in rich blues and greens, with bright yellow patterns to set off her hair, and new yellow boots that fitted tightly about her dainty ankles.

The main reception room was readied to receive the distinguished visitors. Its walls, covered in subtle blue and green tile work, were washed, and the gilt work on the intricately decorated and arched ceiling was touched up. The chandeliers were polished until they glittered. The low divans were re-covered, some European chairs taken out of storage and brushed or reupholstered, and carpets cleaned and arranged. At the back of the

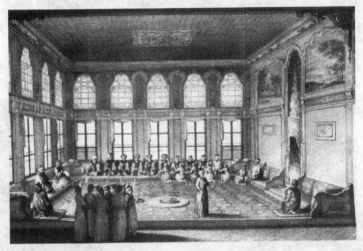

Selamlik (Hall Reserved for Males). The selamlik *was the public reception area of a wealthy Ottoman household, where white slave auctions would be held.*

room was a newly constructed latticework screen, lined with thin fabric. The screen enclosed an area where the girls would wait until they were called out to be exhibited. The scribe prepared bottles of fresh ink and a new book in which to mark down the winning bids and record the tax payments; he prepared receipts to be filled out for those who had acquired a new slave girl. The accountant would receive the monies from the buyers and validate the bill of sale. The black eunuch Ali was given the responsibility of guarding the girls against intruders throughout the

proceedings. He would also ensure that each girl was handed over to the correct buyer only after he had paid his money and obtained the proper papers.

Although Finjanjian Hanim's son, Finjanjian Effendi, allowed his seal to be used on the receipts, his role was primarily ceremonial: greeting the visitors, allocating them seats according to status and wealth, making sure everyone had refreshments. Finjanjian Hanim was much in evidence too, to make sure everyone knew who should receive the credit for the fine girls who were up for auction. She was gorgeously attired in a fine, gauzy, white *gomlek*, or chemise, left open at the throat and then buttoned below down to her knees. With the *gomlek* she wore full trousers, *shalwar*, that were made of the finest silk with a green-and-blue pattern. Pearls, gold thread, and lace were sewn onto the *shalwar*, and around her waist she wore a thick, folded girdle, a *kuşak*, with an intricate design in bright yellow, red, and blue. Over the top she wore a long sleeveless gown, or *anteri*, of blue-and-gold brocade that fitted closely at the back. It was fastened across the bosom with a gorgeous, jeweled brooch and fell open to trail on the ground when she walked. Ropes of pearls surrounded her wrinkled throat, and numerous pairs of gold bangles decorated her plump arms. Her dark, oiled hair was elaborately braided and coiled and decorated with ornaments that were shaped like flowers; they were made of sparkling gems that trembled on fine gold stems.

A male slave trader had been hired to describe each girl as she was presented and to recognize the bids. In premium sales, girls were presented singly and fully clothed in their finest gowns. Virgins, unlike ordinary slave girls, or *cariyes*, were never exhibited naked and could not be fondled or intimately examined by potential buyers. Certificates of virginity signed by a midwife were provided for each girl because an untouched status constituted a large part of the girl's value.

As the potential buyers filed into the reception room, the girls tittered nervously, peeking through the screen to evaluate the men. There was an avid and unceasing appraisal of the attire, physical characteristics, and apparent personality of the buyers. These men would control their fates, their future lives. They might be kind or cruel, handsome or ugly, generous or stingy: these attributes mattered a great deal. Besides, these were

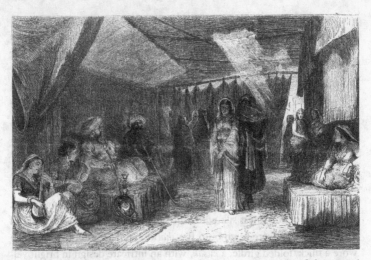

In the Private Sale Room—Connoisseurs Viewing the "Property" (1875). This is a rare Victorian depiction of the sale of a white slave girl. A girl like Florence might command a price equivalent to $48,000 (about £ 21,000) in 2001 currency and would not be sold in a shabby tent.

the first men outside of their natal families and the master that most of them had ever seen.

It was not until the bidding began on the first girl, Fatima, that Florenz finally understood what was going on. She was horrified.

When she had first arrived in the harem, Ali had been assigned to be her *lala*. For ten years now he had been her protector, her nursemaid, her guardian, and the emotional mainstay of her life in the harem. He loved her devotedly. He had never before been appointed a *lala*. Of course, he had no children and no wife of his own. He had not even any good friends. The harem was a closed world full of schemes and intrigues, and someone was always maneuvering for status or money or favor. A high-ranking eunuch like Ali must keep himself aloof from others, lest a confidence be used against him. He was accustomed to dealing with people who connived and conspired for their own selfish ends.

Florenz could not have been more different. As she grew up, she was like an innocent flower blossoming in the sun. She never seemed to consider improving her position; in fact, she seemed oddly immune to jealousy. She had a gift for joy and laughter. For the first time

The Guard of the Harem (1859). Black eunuchs were used to guard the harem; they sometimes served as lalas, caretakers of small children. Painting by Jean-Léon Gérôme.

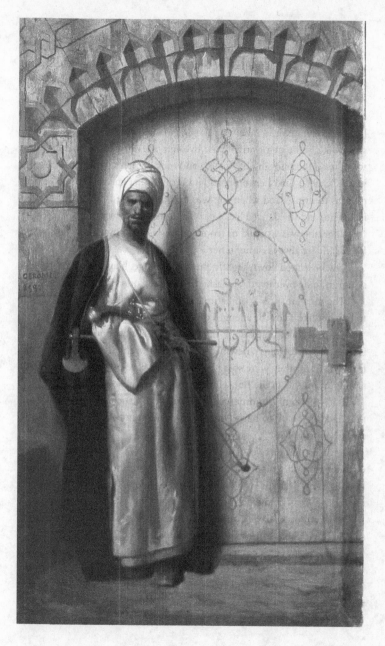

in many, many years—since his own childhood—Ali had someone to love. When Florenz missed her family, he put his arms around her and told her stories from Africa, ones that his own mother had told him when he was small. When she asked yearningly why her father didn't come for her, he comforted her gently, "I don't know, little blossom. I am sure he loves you and would come if he could." She was too young to realize that, even if her father came for her, he would have no idea where to find her. When she awoke in the night, frightened by memories of flames and blood, Ali was always there to sing her a song and rock her back to sleep. When she was sick, he bathed her forehead and brought her special foods to eat or potions to drink. And when she was bored, he played tunes for her on a little flute and she danced like a gazelle in the long grass of the garden.

When she was worried or troubled, as she was now, she always called for Ali and he always came to her immediately.

Now he leaned down slightly, putting his large, black face close to hers so as not to be overheard, and asked, "Yes, little one? What is it?"

"The men are *bidding* on Fatima," she said accusingly. "They are going to buy her like a cow or a length of cloth!"

"Yes, my child, that is so," Ali replied soothingly. "She is a slave and it is time for her to go to a new harem. You have seen girls come and go before; you knew they were sold. Of course, we have never before had such an important sale in the household during your time."

"But"—Florenz stammered, hardly able to articulate the realization that had just come to her—"but that was *them,* not *me.* Are we *all* to be sold, then? All of us?"

"Perhaps one or two of the girls will not sell," Ali conceded. "Some of them are rather plain and lack graces. But you," he continued proudly, looking at his dear charge, "you will surely sell for a fine price. You will be the central jewel of the entire auction."

"But *I* am not a slave! I am not like the other girls!" Florenz protested so vehemently that some of the others shushed her. The audience did not want to hear angry voices from behind the screen.

Putting his large hand upon her cheek in a caress, Ali told his beloved Florenz the fact that she had apparently never comprehended. "My jewel, my shining star, you *are* a slave, as I am. You have been a slave since you

came here, since you first came to Ali. Do you remember? You were so small and so afraid then, even of me. But you have been raised with great care by the Sultana Validé, side by side with her own granddaughters, so you can be taken into a great household and live in comfort. Today you will probably bring one of the highest prices ever recorded in Viddin, and you will go in glory to your new home. I cannot come with you," he added sadly, "not unless you persuade your new master to buy your ugly old *lala*, with his black skin and his scarred cheeks. When you are the *ikbal* and the master is dizzy with your charms, you can beg him and perhaps I can come to look after you once again."

Florenz was dumb with outrage and shock. She had been so young when she came to the harem that she never understood herself to be a slave. She had been treated very much like the Sultana Validé's own granddaughters; she did everything they did and slept alongside them. In a vague, unconsidered way, she had supposed herself to be a sort of adopted child. All these years, had everyone else known she was only a slave to be bought and sold? Why hadn't anyone told her? In her fury and embarrassment, she looked at Ali for explanation and comfort and he discerned her problem.

He was astonished. "Did you not know, my Florenz? Did you not see you were a slave—not just any slave, but the best of the girls in training?" She shook her head violently, *no,* and he put his long arms around her and held her. "Oh, my child, my child," he murmured. "I thought you understood our ways, I thought you knew." She wept bitter tears that spotted his vibrant yellow chemise like raindrops.

When it was time for Florenz to go out, Ali wiped her face tenderly with his brilliant red sash and tucked a stray piece of hair into her elaborate braided coiffure. "I am very proud of you," he told her. "You are my own girl, the most beautiful one of all. Remember what you have been taught, and fetch a good price!"

Following the other girls, Florenz was indeed outstanding. Her hair was pale and silky, her long braids set off by tiny pearls; her vibrant clothes caught the eye; and her fine features and graceful carriage caused murmurs of appreciation throughout the audience of potential buyers. Here was a very fine girl of the best quality. As the slave trader extolled

her virtues and accomplishments—"a certified virgin from Hungary who speaks not one, but two European languages, an excellent dancer and horsewoman"—Florenz's rage came to the fore. She would not be treated like a cow at auction. She would stand there and turn and exhibit herself—she had no choice—but she would not be demure. *She would not be a slave.* Her chin came up, her cheeks reddened becomingly, and she turned her blue eyes, burning with anger, directly on the audience. Her eyes raked the assortment of middle-aged Turks and Bulgarians whose clothes and manner reeked of wealth and privilege. She despised them.

Her gaze settled on one man, an oddity in that crowd. He was a square-shouldered, fair-skinned European with curly reddish brown hair,

large sideburns, and a moustache. He wore a wool tweed suit that, judging from the way it fitted his barrel chest and powerful arms, had been tailor-made for him. His companion, sitting in the next armchair, was a slender man of dark complexion who wore elegant silk robes and a satin turban, ornamented with a large stone and a plume. He was bedecked with more ropes of pearls than even the Sultana Validé. They made a peculiar pair, the burly European and the young maharajah, for such was the latter's title, and they were out of place among the men from the Ottoman Empire.

Sam Baker (1857). When their boat rammed an ice floe on the Danube, Sam and the Maharajah Duleep Singh pulled ashore at Viddin in the winter of 1859–1860.

As Florenz focused on the face of the European, his blue eyes met hers. Something extraordinary passed between them, a flash of sympathy and attraction that jolted girl and man alike with its intensity. He knew exactly what she was feeling, and she saw unmistakably that he did. She was very, very angry—indignant, even—and her bold defiance of the situation was clear.

His stare fixed on the girl, Sam Baker raised his hand to bid. He hardly knew what he was doing. He had certainly not intended to bid for a slave girl. Like nearly all Englishmen, he was morally opposed to slavery. This auction was meant only to distract his companion for a few hours and to keep him from proposing marriage to yet another unsuitable girl. The younger man in the turban was Maharajah Duleep Singh, a dispossessed Indian prince of romantic disposition. There had already been reports in the newspapers from Frankfurt and Vienna—reports that were unfortunately picked up and reprinted by three different London daily newspapers—that the maharajah had recently become affianced. Keeping him out of awkward entanglements on this trip had proved more difficult than Sam had expected.

None of his chaperonal responsibilities occupied Sam's mind now. He thought only of the angry and beautiful girl on the slave block. His bid was promptly countered by one from a well-dressed servant. Murmurs went through the crowd: the servant was an agent of the pasha of Viddin himself. Everyone else but Sam dropped out of the bidding, nervous at the prospect of displeasing such a powerful man. Sam did not know and Florenz did not care who was bidding against him. The price rose and rose. Soon the pasha's man was offering seventy thousand *kurus*—about eight hundred pounds—for Florenz. Sam consulted quickly with his companion, who nodded once; then Sam made a stunning counteroffer. The crowd waited quietly to see what the pasha's man would do. He increased the bid again. Sam looked to Duleep Singh, who carelessly shook his head in refusal. He was bored and would lend Sam no more money that day; he wanted to leave. The last bid stood. Florenz was sold to the pasha of Viddin.

The audience erupted in applause and conversation. What an event it had been! That blond girl had brought an unprecedented price. How satisfied Finjanjian Effendi and Finjanjian Hanim must be! Who was that foreigner who bid against the pasha's own emissary? Someone had heard him talking and thought he was English, but the man with him clearly wasn't.

The men arose from their seats and slowly moved toward the door, gossiping all the while about various girls. That plump and nicely rounded

dancer—didn't she look passionate? What about the one with the very dark, luxuriant hair, who was said to make superb coffee? Another was taken with the musician who sang so sweetly, even if she looked a bit old. Those who had bought girls surged toward the scribe and the accountant in a disorderly mob, some smugly pleased and others suddenly doubtful. A few greedily took a last sweetmeat or pastry before heading for the street or to the coffeehouse, where the auction would be the favorite topic of discussion for weeks.

Finjanjian Effendi intercepted the pasha's emissary, inviting him to enjoy more coffee and sweets while they waited for the crowd to clear. The pasha had graced the sale by sending his man, who had honored their family with his splendid last bid.

Sam got to his feet as soon as the auction was declared over and nudged the maharajah. "We need to leave promptly," he declared. "Don't dawdle."

Duleep Singh smiled a little to himself, thinking that his English friend was embarrassed at having bid for a girl and even more embarrassed at having been outbid. He wondered at Sam's indiscretion. However lovely she might be, *that* one, to Duleep Singh's eye, was bound to be a handful. Sam was lucky he had not succeeded in his rash impulse. Though the maharajah had greatly admired several of the girls, he knew he could never take them back to England without incurring the wrath of Queen Victoria. He was something of a pet in her court. She had granted him princely sta-

The Maharajah Duleep Singh (1854). Sam's companion on the hunting trip, Maharajah Duleep Singh, was a ladies' man and a keen sportsman who did not care for the primitive conditions under which Sam traveled.

tus when his hereditary kingdom and its Koh-I-Noor diamond had been seized by the Raj during his childhood. The queen provided his generous allowance too. He dared not risk her terrible disapproval for a mere sexual adventure. There were girls enough who were willing: servants, ladies' maids, even some of the upper classes who found a Sikh prince an exotic and exciting admirer.

Ah, well, Duleep Singh thought to himself, *Sam in his overly vigorous way probably has another adventure planned for this afternoon.* He only hoped it did not involve standing up to his knees in a cold and muddy swamp shooting at ducks. He had had altogether too much sport arranged in a primitive and uncomfortable manner for his taste on this trip. Sam's willingness to rough it had surprised him considerably. Taking a boat down the Danube to go hunting had sounded very exciting in the drawing room of a great house in Scotland, where Sam first proposed the trip. But when Duleep Singh saw the crudely modified boat that would transport them downstream—it was the sort normally used to carry corn—he was dismayed. How could they live for days in such a vessel? The reality was if anything worse than he feared. What was the fun of shooting if you got cold and miserable in the process? Where were the warm fires, sumptuous meals, and sparkling conversations at dinner? What was the point of traveling under Spartan conditions with only three servants?

"Duleep Singh," Sam interrupted sternly, "stop wool-gathering! We must go at once. Please collect our coats and go out into the street and hail an *araba* for us. Make sure it is a closed carriage. I'll be along directly. I have something to do first."

Once Singh was safely headed toward the door, Sam pushed his way brusquely through the crowd to Ali. He remarked quietly to the eunuch, "I require your services."

"Yes, Effendi." Ali bowed slightly. "What is it I might do for Effendi?"

"That girl," Sam tried to explain. "That blond girl, the last one."

"Yes, Effendi, that is my own charge," Ali responded, his eyes shining with pride. "That is Florenz. She was the best, don't you think? The most beautiful?"

Sam leaned close and stuffed a wad of currency into Ali's sash. "I would like you to bring that girl to me around the back of the house," he said in an undertone. "This is a delicate matter."

Ali did not even glance at the money, but he could feel it made a very substantial lump. He knew Sam had bid earnestly and high against the pasha's man. He had also seen a look pass between him and Florenz that suggested a powerful attraction there. If he assisted in Florenz's abduction and anyone learned of it, Ali would be beheaded. Still, it might be worth the risk. Florenz was gone, in any case, and Ali could enrich himself greatly by helping this man, if he was very careful.

Keeping his voice low and his manner disinterested, in case anyone was watching, Ali told Sam to wait at the gate on the south side of the compound.

Sam moved away immediately and left the room without looking back. Ali walked toward the scribe, catching his attention with a hand gesture. He said he needed to relieve himself. In the meantime, would the scribe and accountant keep an eye out for any buyer who might try to take a girl without paying?

Ali exited through the door that led to the area behind the screen, where the girls were chattering in twos and threes. He grasped Florenz gently by the hand. "You must go into the corridor, little one," he said urgently. Then he looked around the room as if searching for another girl who was needed out front. Florenz complied and Ali left the room after her, locking the door behind him. He led her through the *selamlik*, pausing to throw a man's cloak over her shoulders and place a fez on her head to conceal her hair. It was hardly an effective disguise. Florenz asked no questions. They climbed out a large arched window into the back garden, near the kitchen.

"I cannot send you to the pasha," he said, begging for understanding as they approached the back gate. "He is a wicked man, selfish and cruel, and you would hate him. You are going with the Englishman, the one who bid against him."

Florenz could not imagine how Ali knew she was so drawn to that Englishman, but she trusted her *lala* completely. He had never failed her, never deceived her, and she loved him. "Ali, please be careful," she whispered urgently.

"Ah, my little star"—Ali grinned and showed the gap where the four incisors in his lower jaw had been removed—"I am too canny for that.

They will never know it was me." He pushed the gate open and handed her up into the darkened carriage. "Barakallah," he whispered; "may Allah bless you."

"Jazakallahu khayran," Florenz replied; "may Allah reward your kind deed."

They will never know it was me." He pushed the gate open and handed her up into the darkened carriage. "Barakallahu," he whispered, "may Good bless you."

Jazakallahu Khyaran," Florenz replied, "may Allah reward your kind deed.

2

SHOTS, KNIVES, YELLS,
CORPSES, AND FIRE

 uten Tag, Fräulein," Sam greeted her in German, their
only common language, and invited her to sit down:
"Setzen Sie sich bitte hin." He gestured to the crudely up-
holstered bench on the opposite wall of the carriage. Then
he introduced himself and his companion: "Mein Name ist
Samuel Baker; hier ist Maharajah Duleep Singh."

"Guten Tag, mein Herren," she answered politely, and
then gave her name. "Ich heiße Florenz." She did not give
a surname, as there was some confusion in her mind. Was
she Florenz Barbara Maria Szász now? Or simply Barbara
Maria Szász, the person she had been born? She had been
Florenz for nearly ten years. All that time, she thought of
the Finjanjians as her adopted family. Now she supposed
they had paid money for her, when she had thought they
were simply being kind. Was she Florenz Finjanjian? Did a
slave take the surname of the family that owned her?

Florenz sat down gracefully as the *araba* began to move
over the rough streets. She was very apprehensive, for she
did not know what was expected of her and she hadn't been

in such close company with men since her earliest childhood. Now that she realized she had taken an irrevocable and possibly fatal step, her hands were shaking. She clasped them together in her lap to steady them and appear calmer. With wide, anxious eyes she looked at Sam, the man who now controlled her fate. *He owns me,* she reminded herself nervously. His kind demeanor and the deep, fundamental decency in his face reassured her a bit. Still, the whole world had changed in the last few hours, and she did not know what lay ahead. "May I ask where we are going?" she asked, feigning calm curiosity.

"Ja," chimed in Duleep Singh, irritated and a little anxious. His German was very rudimentary, and he thought if they carried on their conversation in German much longer, it would be tedious. "Where are we going, Sam? What are we going to do with this girl? You know it was the pasha who outbid you; he will surely send men after us. I have no desire to experience an Ottoman jail!" He sounded put out at Sam's recklessness.

"I shall leave you off at the hotel," Sam said, planning their course of action. "Have the servants pack our bags and meet me at the docks, as quickly as possible. Our boat will not yet be repaired, so we'll leave it here. I'll find someone to take us across the Danube."

"What are we going to do with this girl, this Florenz?" repeated Singh in English. To him, one of Sam's most irritating habits as a traveling companion was his tendency to do things hurriedly. Sam just did not understand the charm of a leisurely pace. "They will spot us immediately," Singh predicted, "a Sikh and an English gentleman fleeing with a harem girl. We cannot possibly go unnoticed."

"Yes," agreed Sam in English. Switching back to German, he added, "We shall have to get her some other clothes." He had no idea how to accomplish such a thing.

"I know a woman in the bazaar who sells European clothing," Florenz offered. "You could send the driver in to get what I will need."

"Excellent!" Sam cried, rubbing his hands together. "We shall dress you plainly for traveling and disguise you as one of the servants. No one will remember whether we had three or four. Capital idea, Florence!"

He had already adopted the English pronunciation of her name, even when he spoke to her in German, and that is how she was known from

then onward. *I am Florence now,* she thought to herself with a certain relief. *Barbara was before, when I was little; Florenz was in Viddin, in the haremlik. Now I am Florence.*

"Just leave me at the hotel," pleaded the maharajah a trifle wistfully. "Perhaps I can get some luncheon before we begin our journey."

"Eat if you must," Sam cautioned sternly, "but we will be leaving on a boat in two hours, no less. You must be there on time, with the servants and the luggage, or I shall leave you behind. Every minute we delay here puts us in greater danger."

In two hours the maharajah, the servants, Sam, and Florence were reunited at the docks. The ferryman appeared and the manservants struggled to get the mass of luggage onto the ship. The ferryman noticed the pretty maidservant, a slender girl in a plain, serviceable dress, with her hair put up primly and concealed by a demure hat.

They set out across the broad Danube River, and the bitter wind struck them like a blow as soon as they left the shelter of the shoreline. When they arrived in Calafat, they were shown into a customs office in a small, dirty room. A Turkish official in an ill-fitting uniform lounged on a divan with upholstery so old its original color was no longer discernible.

"You," ordered Singh with an imperious wave of his hand to the three servants and Florence, "wait outside with the luggage. It is too crowded in here." They dutifully left to stand in the cold street with the luggage. Florenz was agog with all the new sights and smells. She tried to remember to keep her mouth closed and stand with some dignity, as if she had always traveled like this, but she had hardly ever been out of the *haremlik* in Viddin and there was so much to see.

The customs officer did not speak any language that Sam and Singh would admit to knowing. In response to a gesture from the Turk, the two men sat down on the carpet. Then he clapped his hands and a servant appeared carrying a tray with thick coffee in tiny porcelain cups, which they sipped politely. It was too sweet, and gritty with grounds. They reciprocated by offering the Turk some cigarettes, a courtesy that they had often found useful. The official helped himself to half a dozen and promptly lit one. For some minutes he smoked and they sipped, the silence broken only by the sound of the wind howling off the river into the chilly, damp room.

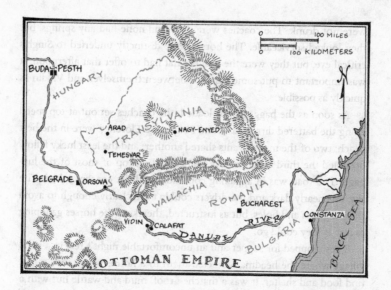

Finally the Turk put his hand out, palm up, and waited. Adopting his most aristocratic air, Sam handed him a sheaf of papers. They included passports for the men and a British gun license,

Central Europe (ca. 1850). Florence left her home in Nagy-Enyed, Transylvania, during the Hungarian Revolution and followed the army to Temesvar; after the defeat, she went to a refugee camp in Viddin in the Ottoman Empire. With Sam and the Maharajah Duleep Singh, Florence fled from Viddin to Calafat and on to Bucharest.

which he hoped would be mistaken for Florence's passport. It bore an official-looking seal and lots of elegant writing that Sam hoped the official could not read. When the Turk glanced at the papers, holding them upside down, Sam suppressed a smile. When the man extended his hand again, Duleep Singh understood this as a tacit request for baksheesh, a gratuity. Gracefully, he handed over a few more cigarettes and a handful of piastres. The Turk set these carefully aside and then clapped his hands again. A harried clerk entered and scribbled illegible initials on each passport. Then the travelers left, breathing a sigh of relief.

Sam paid the boatman while the maharajah began negotiating for some coaches and swift horses. He managed to find three drivers, three coaches that were little more than crude, covered wagons, and twenty-four fast horses. The most attractive feature of the drivers was that they

were not drunk. The coaches were dirty and none had any springs, but they looked serviceable. The horses were distinctly underfed to Singh's critical eye, but they were the best Calafat had to offer that afternoon. It was important to put some distance between themselves and Viddin as quickly as possible.

As soon as the baggage was loaded, the coaches set out at top speed along the battered dirt roads. Sam, Singh, and Florence were in the best coach; two of the manservants shared another; and the least lucky fellow occupied the third coach, where he perched on top of most of the luggage. The road was in appalling condition, and the coaches jolted. The sky was nearly dark and the drivers couldn't see clearly enough to avoid the deep ruts and holes, but as instructed, they kept the horses galloping as fast as they could go.

They stopped for supper and an uncomfortable night's rest in a rural village where the headman directed them to a house where they might find food and shelter. It was a thatched-roof, mud-and-wattle hut with a mangy dog asleep on the front step. Still, there was a warm fire within and the widow who owned it welcomed them. She soon served up large bowls of hot, fragrant stew and chunks of rustic bread with a bottle of crude Wallachian red wine. The next difficulty came over sleeping arrangements. There were only two rooms in the house, one with two large beds in it, the other being the kitchen–cum–reception room. Sam, Singh, and the three manservants took the room with the beds. The proprietress placed two benches covered with featherbeds and quilts near the fire, indicating that she and Florence would rest there.

Walking into the Vlach house was a strange experience for Florence. The building and the woman who lived there seemed very familiar. It was something about the whitewashed walls, the brightly embroidered apron, the linen cap, and the fire in the open grate. Fragmentary memories of her early childhood and a brief refuge in a Transylvanian farmhouse surfaced. She had been frightened and exhausted when she walked into that house, and the people took her in and fed her and let her sleep. This was after some terrible event, some horror that she could not yet recall. Florence lay quietly by the fire, listening to the vigorous snoring of her hostess. In the flickering light, in that moment before sleep, she remembered

more. She had been there, in that farmhouse, with her nanny, her *dadus*, and they had escaped from a place that was burning like hellfire. A nightmarish vision of death lurked at the edge of her consciousness. Someone had died on that night of fire, someone close to her. The next morning, over breakfast, she was haunted by these pieces of her past that she could not assemble into a whole.

Sam sensed her distress. The day before had been a lark, an adventure, and they had quite enjoyed it. But now Florence was silent and worried and Singh was irritable from the fleas that had bitten him in the night. Sam tried to cheer them up by chatting over breakfast, but the maharajah kept losing the thread of the conversation. He did not like being left out.

"I think today," he announced a little petulantly, "that I shall ride in the second coach by myself. I might perhaps doze if that is possible. Besides, I do not feel like conversation in German this morning. I shall simply admire the scenery." His decision meant that the three manservants had to squeeze in on top of the luggage in the third coach, but they did not complain. Complaining was for maharajahs, not servants.

The road was as poor as ever, full of ditches that jarred their spines and icy patches that threatened to turn the coaches over. The horses staggered up hills, barely able to pull their loads, then careened wildly downhill. For the next few days the coaches stopped only at small and miserable villages. They ate what they could get, and the food was usually plentiful if not always tasty or varied. They slept at night in flea-ridden beds, on the floor on piles of dirty straw, or on benches covered with featherbeds. Florence was always separated from the men by virtue of her sex, for even in the wilds of Wallachia a maiden girl was not thrown into a room full of men to sleep.

As the hours and then days passed, Florence and Sam found they did not mind—in fact, barely noticed—the discomfort. Most of the time Singh traveled in miserable isolation in a separate coach while Florence and Sam talked and got to know each other. Sam regaled Florence with tales of his hunting trips, his time at the tea plantation in Ceylon with his brother, and his rambunctious boyhood. She was fascinated. "Oh, I wish I might see an elephant," she said wistfully, her blue eyes shining. "Ali used to talk to me of elephants, and the ivory trade, along the Nile."

"Pardon my curiosity," Sam interjected, "but who is Ali?" He couldn't imagine to whom this girl had spoken who knew about African elephants.

"Oh, Ali was my *lala*," she explained. Seeing his puzzled look, she said, "You don't know what a *lala* is, do you? When a small child comes to live in the harem, one of the African eunuchs is assigned to be a sort of nursemaid or guardian. Usually, it is only boys who are given *lalas*, but I had one too and his name was Ali."

Sam looked at her incredulously. It was disconcerting that she knew the word *eunuch,* much less that she knew one. She had had a eunuch as her nursemaid? In the harem? *Astonishing girl,* he thought. *Astonishing.*

Florence continued, "You saw Ali at the auction. He was the tall black man, the Dinka, who guarded all of us who were up for sale. He was kinder to me than anyone. He used to call me 'little star.' " She got a soft look on her face.

"Yes, I saw him," Sam responded, thinking for a moment of the very real danger they were still in if the pasha caught them. Sam returned to the previous subject. "The elephants of Ceylon aren't the same as those from Africa, you know. I'd certainly like to try my hand at hunting the African ones. The Asian ones are said to be a little smaller, but they are excellent sport. If your aim is good, you can drop them with a single shot to the forehead."

"Yes," Florence agreed enthusiastically, "hunting elephants would be most interesting. When I couldn't sleep, Ali used to tell me about the elephants he had seen when he was a little boy, before the slave traders stole him. What magnificent beasts they must be! He said they were as big as a house with feet as large as serving trays. The best shot, you say, is a shot to the forehead, yes? Does it kill them instantly even when they are charging?"

"Yes, exactly," affirmed Sam. "You hit them just here." He pointed to his own forehead, just above the eyes. "That was the shot my brother John and I perfected in Ceylon. Now, of course you have to be quite a marksman to make the shot correctly, and a good stalker. If you fire from too far away, or with an insufficient powder charge, the bullet simply cannot penetrate the braincase. Many hunters lose their nerve and fire too soon, instead of waiting. You have to get awfully close. One time in Ceylon," he

remembered happily, "my brother Valentine and I went on a three-week hunting trip with Lord Wharncliffe and Eddie Palliser. Between us, we accounted for fifty elephants! Ah, that was a time."

Sam was a wonderful raconteur, and his stories made Florence marvel and laugh. All he had done and seen seemed so heroic to her, so wonderful and free. Her fears and shyness started to recede as she spent more and more time with Sam and he continued to act like anything but her master. "Do you think," she asked one day, as if it were her heart's only desire, "that you could teach me to shoot and hunt?"

Sam was surprised by the question; not many ladies in his experience were keen hunters. Then again, *no* other ladies in his acquaintance had been sold at white-slave auctions. He was nonetheless surprised at this extraordinary creature, so full of life and so eager to try anything new. "Yes," he said thoughtfully, "I think I could. You can ride well?"

"When I was a child," she answered—she was only fourteen or fifteen years old, but by Ottoman standards she was a woman and that is how she thought of herself—"I could handle a pretty difficult stallion. Of course, nobody would ever let me go off onto open ground by myself, but I ride well. I like horses."

Sam nodded, though he had not the least understanding of the rigid restrictions that had been placed on Florence's freedom during her harem childhood. "And have you a good eye?" he asked.

"I think so," she replied, "but I don't know. I've never had a chance to find out."

"Well, let's find out now," Sam suggested merrily. He set his hat upside down on the seat behind him and banished her to the farthest corner of the coach. He wrapped some coins in his handkerchief and passed the bundle to her. "Now," he said, "let's see if you can throw that into the hat, Florence." Since that task proved no problem, Sam began devising more and more difficult games to test her vision and coordination. He felt like a boy again. They had little to work with, so some of his inventions were preposterous. Most of his targets toppled over like a child's set of blocks when the coach hit yet another bump in the road and gave them cause for laughter. Sam had promised they would go riding as soon as possible, and when she was good enough, he would teach her how to shoot and hunt.

Later that day Florence began telling him about life with her "adopted

family"—she did not know what else to call the Finjanjians. Her owners? At first he thought she was saying "Finnian," the Irish name.

"No," she explained, "it's an Armenian name, Fin-YAN-ee-an, with *j*'s pronounced like *i*'s or *y*'s. I lived in the *haremlik* with Finjanjian Effendi's daughters."

The shock on Sam's face was indescribable. Finjanjian Effendi, the civilized and cosmopolitan man he had met at the auction, put *his own daughters* into the harem? What kind of a monster was he? He could not help but ask, as delicately as possible.

Florence was greatly amused to find out that Sam suffered from a complete and total misapprehension about the very nature of harems. He thought harems were brothels full of prostitutes where girls and women were subjected to debauchery.

"What an idea!" Florence teased him. He was surprised but found he did not mind her amusement at his expense. "Do you think all the women in the Ottoman Empire are concubines and do nothing but make love all day long? The *haremlik* is the sheltered place in the house, the safe place where all the women and children live away from the outside world—and that includes men." She told him of the varied roles women played in a big harem: some were aged grandmothers, some were the children of the household, and some were specialists such as accountants, seamstresses, laundresses, bath attendants, or cooks. Some talented girls were trained as dancers or musicians. "Only a few girls are concubines," she explained, "who draw the attention of the master when he visits. And other than the master, the only men in the harem are eunuchs like Ali—and they are not really men."

Sam was embarrassed again by the use of the term *eunuch* and her experience with them. How could she be so worldly and seem so innocent?

"We were completely sheltered from the world," she went on. "I was never allowed to go anywhere outside of the *haremlik* without Ali. It was so frustrating never to have a moment of freedom! And there was never a moment of privacy, when someone else might not see what you were doing or overhear what you were saying. But I knew that any girl who went out alone would be considered unmaidenly and immoral; she would have no value, no respect after that. She would be ruined. The auction was the first time I saw a man other than Finjanjian Effendi, except of

course, when I was a small child, and we lived with the army," she ended nostalgically.

"You had never seen another man?" Sam asked in astonishment. "Not since you entered the harem?" Despite her matter-of-fact description, he kept picturing the harem as a place seething with sexuality and eroticism.

"Of course not," Florence replied indignantly. "The Sultana Validé—that's what we called Finjanjian Hanim—would have punished me most severely if I had looked at a man. She made sure we all heard the story of the man who tossed a love message through the window for one of the girls in the pasha's harem. She was sewn into a bag with stones and drowned in the river; he was beheaded. No, we never saw men in the *haremlik*." She tried desperately to hide her feelings, but her inexperience meant she found it unnerving to be alone with a man, much less one like Sam, whom she found attractive. She continued, "How could a girl remain cloistered and virginal"—Sam blushed at her choice of word, for it was something no English girl would have said—"if she could talk and flirt with men all day long?"

"But isn't that the point of the harem?" Sam asked incredulously. "I mean, why are there harems if not for men to . . . to . . ." he searched for the right words. "To indulge their baser instincts?"

"The master," Florence replied a little shyly, "did visit his wife and his *ikbal*, the favorite, in their private apartments. A man needs an heir, a son to inherit his wealth and name. But no other men were allowed to enter the *haremlik*, ever."

"But what about other girls? Doesn't a man with a harem have lots of girls? You know, that business with the handkerchief?" Sam asked, intrigued.

"Handkerchief? Oh, you mean that old story that the master drops his handkerchief in front of any girl he desires?" Sam nodded. "Perhaps that is done in some harems, maybe in Constantinople, but I never saw such a thing when I was growing up. The master took a concubine, the *ikbal*, in addition to his wife because she had only female children, poor thing," Florence elaborated. "He never went around dropping handkerchiefs in front of anyone else."

Sam fell silent and contemplated this new information. If what she said was true, harems were nothing like his titillating imaginings. A man might

have a wife and a few concubines in his harem, but it seemed that there were many women and female children in the harem who were nothing of the sort, who were simply part of the household. He believed Florence was telling the truth; she seemed so frank and honest. And she had lived in a harem, whereas he had never even been in one. But then, if she was right, the popular image of a harem was very far from the truth.

He struggled to understand. Growing up in the harem must be rather like . . . like . . . He searched his mind for an apt comparison and one came to him. *Growing up in a harem was rather like attending a convent school.* It seemed a bizarre comparison. Yet in the harem, girls were kept safely away from boys and men and the wicked world. The Sultana Validé in charge of the girls was sort of like a mother superior, he supposed. She sounded strict and kept a close eye on the girls' morals. How extraordinary! No wonder this high-spirited creature had longed to escape. And no wonder she was so naïve, so untouched. He realized, to his surprise, that he found this oddly reassuring. She was more attractive to him now than if she had been experienced and seductive. He tried to forget that she was his slave, his possession to do with as he wished. That truth made him extremely uncomfortable.

He returned to a remark she had made earlier. "What did you mean, that you lived with the army?"

"When I was a very little girl, before the harem," Florence explained, "my father was in the army. His name was Mathias Szász, and he worked for a general. I was so proud of my papa! He went off to war and my mother and my brothers and I stayed at home, in my grandfather's house in Nagy-Enyed. He was a professor. We were happy there."

But then something happened, something terrible of which she had only confused and frightened memories. She tried to put those memories into words. "It was the middle of the night, in winter, and some rough men came to the house. They were Vlach peasants, not Magyars like us. They were angry and carried scythes and shovels, picks and hay forks. I was frightened, so I hid. I was only three or four years old, I think. I remember shots, knives, yells, corpses, and fire. There was a lot of blood," Florence's eyes filled with tears and her voice trembled as she struggled to remember and then to forget the night of burning and killing. "I think they killed Mama and the boys, my older brothers.

"And then everything was burning, like Hell, and we were running. I was with my *dadus*, my nanny," she explained, "and we ran and walked for days. We were so cold and hungry. *Dadus* said we couldn't stop at farmhouses of strangers, so we kept walking, except for once or twice when someone was kind to us and invited us in for a meal and a rest. Finally we found Papa and the Transylvanian army. The general said we could stay with the army because we had no place else to go."

It was a terrible story of a child caught in a vicious war. Sam knew a good deal about the Hungarian Revolution, for it had been covered extensively in the British newspapers, and even when Sam was in Ceylon, those newspapers eventually made their way to him. The Hungarians, united with the Transylvanians, had tried to establish a certain independence within the Austrian Empire; they had asked for their own Diet, for the ability to collect their own taxes, and for the right to speak their own language, form their own army, and manage their own defense. At first Emperor Ferdinand had agreed, and Louis Kossuth, the brilliant orator and statesman, had set up a government. Then Ferdinand revoked their freedoms and a bloody, hatred-filled war had ensued. He asked which general Florence referred to.

"It was General Bem," she answered. "He was a nice man with a bald head and silver hair and lots of medals. He used to sing to me and give me pony rides on his horse sometimes. Papa and all the soldiers loved him."

Sam was astonished. Bem was a Polish officer, a military genius who had led the Transylvanian army to great victories. Eventually in the tragic, closing days of the revolution, Bem had commanded all the rebel forces. He was one of those gifted leaders who inspired tremendous loyalty and courage from his men, perhaps through simple touches like playing with the little daughter of his adjutant. Sam paused before asking her what happened afterward, after the Hungarian generals surrendered to the Russians.

Florence's recollections were charged with emotion, but she tried to reply matter-of-factly: "We walked to Orsova. My *dadus* was with us, I called her Mama by then, and all the soldiers and the general. It took a long time, many days, and it was August; the road was very hot and dusty. Everyone was very discouraged about the surrender. Papa was wounded at Temesvar."

Orsova was an outpost of the Austrian Empire on the Danube about 120 miles from Temesvar, where Bem's last battle was lost. It must have been, indeed, a long, hot walk for a small frightened child and her wounded father. But the Austrians were bent on punishing the leaders of the revolution and the officers in the revolutionary army, so the soldiers had to flee. On reaching Orsova, the remnants of the army boarded boats to go downstream and cross into the Ottoman Empire at Viddin; it was their only chance of escaping retribution. Louis Kossuth, his cabinet, and even General Artur Görgei, the first general to surrender to the Russians, arrived well before Bem and his men.

Florence began to remember details. "The camp in Viddin was on the plain next to the Danube River," she said. "When we got there, I thought it was nice, but the weather soon turned very cold and damp and there wasn't much food. We lived in a tent that leaked and smelled horrible, like mildew. There seemed to be almost one Turkish guard for every refugee. I used to try to work out who was *my* soldier, the one who watched me."

Sam didn't know what to say; he had no idea what sort of life this girl could have led in a refugee camp in the Ottoman Empire. He kept silent and listened.

"Soon the camp was awful: muddy and filthy and vile. There were no latrines and the water was bad. There wasn't enough medicine or even clean bandages for the wounded. People were dying all around us. Mama and I were afraid that Papa would die too, from his wound. Every morning and every evening two old wooden wagons creaked through the camp, pulled by pairs of oxen, to collect the bodies. The oxen were lovely, with big brown eyes and wet noses, but the carts terrified me. I think they burned the dead someplace to keep down the typhoid and cholera; I could see smoke every day. The soldiers kept dying anyway and the wagons kept coming." Florence shuddered a little as she remembered the gruesome sights she had seen.

While the refugees waited and starved and died, there had been an international problem, nearly a war, over their fate. The Austrians and Russians demanded that the refugees be returned to them for punishment, under the terms of the Belgrade Treaty of 1739 between the sultan of the Ottoman Empire and the Austrian emperor. The treaty declared that they would not give asylum "to evil-doers, or to discontented and rebellious

subjects, but each of the contending parties shall be compelled to punish people of this description, as also robbers and brigands, even when subjects of the other party."

When the fleeing Hungarian rebels threw themselves upon the mercy of the sultan, they created a quandary. One the most fundamental tenets of Islam was to offer asylum to those who sought it, so the sultan and his government—known as the Sublime Porte or the Porte—were honor-bound to accept and protect the Hungarian refugees according to religious law. But by treaty, the Porte could not allow the rebels, and most especially their leaders, to live freely in Viddin, a mere boat ride away from the borders of the Austrian Empire.

Once in the Ottoman Empire, the refugees posed a serious problem within days of their arrival at Viddin. The Austrians and Russians demanded their extradition. The sultan refused. Almost immediately, the British and the French governments—allies of the Porte—expressed the opinion that the refugees were political prisoners, not evildoers or brigands. Being a practical man as well as a Moslem, the sultan appreciated this outspoken support, which made his moral decision more defensible.

Before long, new options were offered to the refugees. The Austrians offered amnesty to the junior officers and enlisted men, if they agreed to join the Austrian army as privates and renounce their rebellion. Senior officers, high government officials, and those who had defected from the Austrian army to join the rebels found their names on a list of those especially wanted by the Russians and Austrians for punishment. Louis Kossuth, the other Hungarian ministers, and the Polish generals, like Bem, were singled out, for the Russian czar feared the Polish leaders would foment revolution in his empire. Death awaited those on the extradition list, without doubt. Demands for extradition and refusals continued, tensions grew, and the French and British considered the fact that their alliance with Turkey might draw them into an international war.

Florence had been much too young to know about these political ructions, but she did remember that her father and several of his friends had written a letter to Louis Kossuth, who was the effective leader of the refugees. On September 11, 1849, they asserted their conviction that Hungary was entitled to self-rule and that Kossuth was their only lawful and duly elected leader. With brave words, they spoke of their hope that liberty

could not be suppressed for long and that Hungary would rise again. As for the deprivations of the refugee camp, they would accept them as "voluntarily subjected to" and thus tolerable. They wrote:

> So long as our homeland is ruled by despots against whose domination we fought, the mere idea of returning to our native country would be a denial of our deepest sense of right and wrong. . . . We cannot undertake amnesty; even if it should become promised and really happens, it can be understood only as the pardoning of crime and we have committed no crime.

It was a brave statement from men in a desperate circumstance. Though many officers of the Fifty-fifth, Eighty-eighth, and Twenty-seventh Battalions added their names to this noble missive, still more hesitated to do so. As winter approached and disease and malnutrition ravaged the camp, amnesty seemed a more attractive alternative than waiting for death, which accounted for nearly five hundred men by the time the camp closed.

Finally Sam asked Florence what had become of her father. Her pretty face twisted up and she held her handkerchief to her mouth, fighting back tears as she stared out the window silently for a while. Sam thought guiltily that he had been overly inquisitive. "I'm sorry I asked," he said quietly. "I shouldn't have distressed you."

When she regained her composure, Florence said simply, "I don't know what happened to my father."

On September 18, 1849, the sultan had sent an envoy, Ekrem Effendi, to meet with the Hungarian leaders and present them with an extraordinary offer. Anyone who converted to Islam would be given a military position in the Turkish army equivalent to his former rank. As a new citizen of the Ottoman Empire, such a man would be completely protected from extradition. If all those on the extradition list converted, the problem would be neatly solved.

General Bem was among the first to accept the offer and convert, for he hated the Russians and Austrians and wanted to continue to fight. "Rather the Russians than the Austrians," Bem reasoned. "Rather Mohammedanism than the Russians!" Even before the option was presented to the

lower-ranking men, Bem and fifteen other senior officers confirmed their decision to accept the offer to convert.

Kossuth took a completely opposite view; he was deeply offended by the offer, which he felt suggested they were all mercenaries. In the camp, Kossuth made an impassioned speech to try to prevent the junior officers and the common soldiers from following their generals in conversion. He also wrote a long letter to Lord Palmerston, prime minister of England, expressing his indignation at this offer and begging for Britain's intervention.

<div style="text-align: right;">VIDDIN (TURKEY), SEPT. 20</div>

[A] fresh letter from his Majesty the Czar arrived in Constantinople, and its consequence was the suggestion sent to us by an express messenger of the Turkish Government, that the Poles and Hungarians, and I in particular myself, Count Casimir Batthyanyi, Minister of Foreign Affairs of Hungary under my government, and the Generals Meszaros and Perzcel (all here), would be surrendered unless we chose to abjure the faith of our forefathers in the religion of Christ, and become Musselmans. And thus five thousand Christians are placed in the terrible alternative either of facing the scaffold, or of purchasing their lives by abandoning their faith. So low is already fallen the once mighty Turkey, that she can devise no other means to answer or evade the demands of Russia.

Words fail me to qualify these astonishing suggestions, such as never have been made yet to the fallen chief of a generous nation, and could hardly have been expected in the nineteenth century.

My answer does not admit of hesitation. Between death and shame the choice can be neither dubious nor difficult. . . . I am prepared to die. . . .

Time presses—our doom may in a few days be sealed.

Nearly five hundred soldiers followed Bem's lead and took Muslim names. Mathias was probably among them, as he had already abjured amnesty. Trouble broke out in the camp, since Kossuth and many other Hungarians thought conversion was disgraceful and the converts thought accepting amnesty was cowardly. On October 13, 1849, approximately 3,360 men formally accepted amnesty and returned to Austria with Gen-

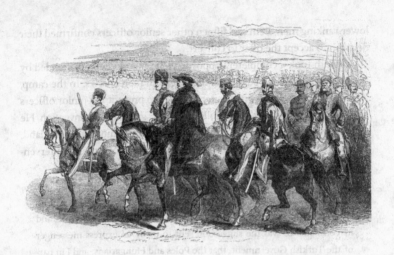

Hungarian Refugees Marching Toward Shumla (1849). By November 1849, the 1,250 refugees still in the camp at Viddin were moved to Shumla; Florence stayed in Viddin and her father was never heard of again.

eral Hauslab. The remaining 1,250, including Kossuth and many other leaders, stayed in the camp until November, when they moved to Shumla, farther from the Austrian border. Eventually, they were released and Kossuth sought asylum in the United States.

The converts were given Muslim names and were sent away briefly to be placed in the Turkish army, Florence told Sam. "Mama and I waited for him in the camp. One day Mama disappeared. She didn't come back from collecting our food ration. I couldn't find her anywhere. Then the bundle woman came for me and took me to the Finjanjians."

"What's a bundle woman?" Sam inquired.

"She was an Armenian woman who used to come into the camp, to sell food and pots and blankets and things that everyone needed," Florence replied. "She carried them in a cloth bundle. We had nothing in that camp, not even a pile of straw to sleep on or a chair. Mostly the bundle woman sold fine cloth and trinkets to the harem ladies in town, but there was a whole camp full of people who needed everything." Then, with a sudden flash of memory, she remembered more. "She used to wear this vivid green cloak and a *yashmak*, the gauzy two-part veil, for respectability, even though she was a Christian. She had the loveliest crimson boots

too; I always used to want ones like hers. Once she gave me a yellow silk handkerchief, just to be kind. It was the only beautiful thing in the refugee camp."

"But how did you get to the Finjanjians?"

"After Mama disappeared, the bundle woman found me crying in the tent. I was hungry and scared. I thought when Papa came back, if he ever came back, he'd be angry with me for losing my *dadus*. He had been gone a long time and maybe he was dead. Nobody told me. The bundle woman took me home with her and said she could find a nice family to look after me. That was when I met Finjanjian Hanim. Her house was so splendid, and there was so much food! I felt so lucky to go to such a magical place after the camp. Finjanjian Hanim thought I should have a new name, so she called me Florenz, which means "flower" in Armenian. I was Barbara Maria before that, Barbara Maria Szász."

The lonely child dreamed that her father was going to come for her any day. She waited for him for years and years, making up stories to explain why he hadn't come yet. "I never forgot my true name or my papa's name. Finally I grew old enough to realize that Papa was never coming for me; he was dead or couldn't find me anyway. I never saw that I was a slave until the day of the auction," she confessed. "I told myself that the Finjanjians had adopted me. I guess that was just another fairy tale, like my papa coming to get me." The tears flowed easily down her pale cheeks, and she turned her face away from Sam out of modesty. Her rage had turned to despair at being betrayed and abandoned.

"You poor child," Sam murmured sympathetically. He patted her hand gently and dropped the subject of her strange early life. There were many gaps in her story, but she had been very young; of course she could not remember every detail. But even the barest outline of her life told Sam that this seemingly delicate girl had lived through more than any other woman he had ever known. She had been robbed of her loved ones and uprooted, and somehow she had come out self-sufficient and smart and strong. She was remarkable—and remarkably beautiful.

Florence stared at the scenery for a long time. At first they passed through a hilly, forested area, and all she could see were thick, dark trees and rocks. Then they came to a more open region, with fields where crops had been grown, and bare orchards. Sometimes they passed through

villages—a small church, perhaps ten or twenty scattered houses. On the outskirts of these small towns were a few farmhouses, stuccoed and whitewashed, with thatched roofs and dogs that barked at strange vehicles going past. She knew that inside those houses there would be a large room with a wide fireplace for cooking and heat, tin bowls and utensils propped up on shelves around the walls, and a hand-painted chest, or *ladahk,* that had been the mother's dowry. Through the small windows, from time to time she glimpsed a family sitting together at a well-scrubbed kitchen table. She imagined they were eating soup and bread, or maybe sausage. The girls would be pretty with dark braids and embroidered aprons, the young men handsome and vain, the parents worn down from a life on the land. She knew the family she had been born into and the house she lived in as a tiny child weren't like this—her family had been educated people, not farmers; still, these houses and families seemed so warm and familiar that seeing them made her homesick for a life she could barely remember.

3

LIKE A HAWK AFTER A MOUSE

The next day Duleep Singh again chose to ride in the second coach, so Sam and Florence had another day alone to talk. Sam questioned Florence more about the harem, a topic that did not upset her as much as asking about her family. She told him proudly that she had received an excellent education, side by side with the granddaughters of the Sultana Validé.

The girls learned to recite verses of the Koran by heart, as well as geography, arithmetic, reading and writing, fine needlework, calligraphy, and pastry making. They had lessons in dancing, singing, and playing the lute; horseback riding; drawing and painting—all the accomplishments of a well-brought-up young lady in Ottoman society. Sam thought the curriculum sounded a little like his own haphazard education, with the exception that he had engaged in many more athletic pursuits and knew nothing of the Koran. He had mastered no musical instruments, but he had a large, resonant, baritone voice; he was a graceful dancer and an excellent horseman.

Florence also told him that they were instructed in the "womanly arts," a concept Sam found fascinating. Think-

ing of an odalisque's legendary seductive wiles, he hardly dared ask what those were. "What exactly are the 'womanly arts'?" he finally blurted out.

"An accomplished woman of the Ottoman Empire knows many things: how to dress hair, for example, and how to make coffee. A girl's future can be decided on her ability to make an excellent cup of coffee and serve it with her eyes suitably downcast when the *goruçu*—the match-maker—comes calling. Then there are the arts of choosing the right clothes, moving gracefully, removing body hair, and decorating the hands with henna."

"Are there more?" Sam asked.

"There was one art," Florence admitted, "at which I was a very poor student: deportment. I was constantly scolded for my outspoken manner. I am very curious, and if I want to know something, I can't help asking. I could never remember to keep my hands still and my eyes down. Once the Sultana Validé accused me of looking around the room like a hawk after a mouse." Florence laughed at the memory. "And biddable. How the Sultana Validé tried to teach me to be biddable! She used to say, 'A woman has only to please. Your job is to make a man happy. He does not want to know what you think! A man does not want you to think at all, only to be pleasing and beautiful and feminine. Then he will reward you with jewels and beautiful clothes, with slaves and affection, and you will reward him with a big, healthy boy-child.' She used to tell me terrible stories of girls who turned into viragoes and were sold into ghastly conditions to get rid of them." After thinking for a moment, Florence grinned impishly at Sam and added, "Yes, I was a hopeless failure at deportment."

Sam grinned back. He had never liked incurious, passive people him-self—and he had certainly never been described as one. A woman should be womanly, gentle, and caring, but he greatly preferred women with a spark to them to the overgenteel, passive type.

As the days passed and the discomforts of their humble mode of travel accumulated, Duleep Singh grew less and less cheerful. When he rode with Sam and Florence, he was often sullenly silent; when he chose to ride alone, he was bored and complaining when they stopped. Florence and Sam enjoyed the trip a great deal more, not because their conditions were better but because they were involved in the intoxicating business of

getting to know each other. The two of them talked for hours during the five days it took to reach Bucharest, a cosmopolitan city where traveling Europeans could be more anonymous. They could not be sure that the pasha was not still following them and trying to reclaim his "property."

There were no fancy hotels on the road, only crude inns or rural farmhouses where guests were accepted. They had no facilities for washing properly, and Florence had only one set of clothes, yet Sam noticed that she looked well groomed every day. *The womanly arts,* he thought. Despite the painful recollections that were coming back to her, Florence was enjoying her adventure and so was Sam. He realized he was falling in love, and he did not know what he could do about it. She was a slave, a girl from the harem, and he was an English gentleman, a widower, and a father. He was even—he laughed at the absurdity of it all—the one supposed to keep Duleep Singh out of woman trouble.

Over the next days, Florence began to question Sam about his life story, which seemed as exotic to her as hers seemed to him.

He was born the first son of a prosperous commercial family in Enfield, Middlesex, on June 8, 1821. The family fortune was considerable. It was originally based on the ownership of extensive sugar plantations in Jamaica and Mauritius, which showed large profits that Sam's father wisely invested in ships, railroads, and banks. Sam had three brothers—John, Valentine, and James—and three sisters—Ellen, Anne, and Mary, nicknamed Minnie. As a young man, Sam had fallen in love with Henrietta Martin, the daughter of the rector who lived on the next property. His favorite brother, John, had fallen in love with Henrietta's sister, Eliza, and the four had a double wedding in 1843. Then they all went out to the family plantation in Mauritius and then later to Ceylon, where the Baker families started a British settlement in the highlands. They called it Newera Eliya. At first it was a disaster; the livestock died and the crops failed to grow or caught strange diseases.

In time, Newera Eliya attracted about a dozen emigrants with useful trades, among them an Irish nanny, a bailiff, a blacksmith, a coachman, and their families. Experiments and experience began to yield good results. They farmed, made beer, raised livestock, and started a school, a church, and a reading room. While the settlement grew, so did the Baker families. After having two sons and a daughter who died young, Henrietta

bore daughters: Edith, Agnes, and Constance. Her sister Eliza had two sons, Julian and Arthur, and a daughter, Mary.

Despite the new prosperity of the settlement, Sam and Henrietta decided to go home after eight years in Ceylon. Their children needed schooling, Henrietta's health was poor—she had borne six children in twelve years and was pregnant again—and Sam's usually robust constitution was starting to give way. Back in England, Sam recovered his strength quickly but Henrietta did not. After the tropics, she found the cold, damp climate very trying and alien. She was badly weakened by the birth of yet another daughter, Ethel. Henrietta died of typhus on December 29, 1855. At thirty-four, Sam was suddenly a widower with four young daughters and no profession.

"I can't tell you how dreadful I felt after her death," Sam told Florence. "I felt it was my fault she died, and the children abroad. If only I hadn't put them in such danger! But opportunities in England felt too small, too limited for me. I wasn't cut out for the church or for the military, as my brothers Valentine and James were. And without Henrietta, I felt . . . rootless." Florence nodded sympathetically; she had been rootless most of her life.

"I left the girls with Henrietta's youngest sister, Charlotte, and then they went to my sister Min. I couldn't take care of them, not without Henrietta. They needed a mother to bring them up—a woman's touch, you know. I couldn't think of remarrying right away, though many widowers do so to provide mothers for their children. The girls were much better off with Min, who loves them as if they were her own, than with a stepmother whom I did not love."

Sam, like many a Victorian father, loved his children and was proud of them but did not expect to participate intimately in their

Min Baker (1857). Sam's unmarried sister Mary, nicknamed Min, became a surrogate mother to Sam's four daughters after their mother's death.

care until they were nearly grown. In Ceylon there had been native nurse-maids—amahs—who looked after the girls under their mother's supervision. If Henrietta had lived, a comparable arrangement would doubtless have been made in England.

"I could not face England without a *home*—I was *alone* in lodgings in *London*. It was terrible, perfectly miserable. So I began to travel. I visited James and Valentine; they were in the Crimea with the cavalry. Valentine is a born cavalry officer—stylish, a brilliant horseman, a clever strategist. You should see him ride! In his home regiment, the Tenth Hussars, they call him 'the Man on the White Horse' after his favorite mount. He was with the Twelfth Lancers in the Crimea. He makes it all look so easy, but I could see it wasn't for me. I'm not cut out for a job where someone else gives the orders and I obey.

Valentine Baker (1857). This daguerreotype of Sam's brother Valentine, a famous cavalry officer, was taken when he returned from fighting in the Crimea with the Twelfth Lancers.

"For a while I had no plans for the future, no heart for anything. I simply wandered about and trusted to fate. 'Anything for a constant change' was my motto." Sam smiled ruefully, remembering his aimlessness and depression. Florence kept silent; she simply listened with an intent and sympathetic expression.

"Then I toyed with the idea of joining Dr. Livingstone's expedition to Africa. I sent inquiries to Roderick Murchison, president of the Royal Geographical Society, through my friend Wharncliffe. I felt I had a lot to offer: my strength and hunting skills; my experience in organizing work gangs of natives; and my practical knowledge of living in the wild. Do you know what they said?" He looked keenly at Florence here, showing his indignation and pain. "I was refused on the grounds that no one who 'lacked a useful occupation' would be permitted to join the expedition."

"How cruel," Florence murmured. She could see how bitterly disappointed he had been by this thoughtless criticism.

"Perhaps it was a good thing after all," Sam conceded. "I understand Livingstone is a dour old soul, and he probably isn't much fun as a traveling companion. Last winter I met the maharajah on a shooting weekend on the Scottish estate of my friend the Duke of Atholl. Duleep Singh is an excellent shot, you know, and we got along well. That weekend I received a bit of acclaim," he confessed with a mild blush, "for stalking a stag on foot with dogs and taking it down with a knife—a trick I learned in Ceylon that seemed to impress the maharajah greatly. I suppose I was flattered, and I had heard that the Logins, the maharajah's guardians, wanted him out of England for a while. So I suggested he come with me on a hunting expedition to central Europe this winter. I planned to tour the Balkans, going after bear in Transylvania and wild boar in Serbia, with stops in Frankfurt, Berlin, Vienna, and Buda-Pesth. Duleep Singh was keen to go."

Florence's eyes grew wide at the thought of all of the places and things they had seen. "I should love to travel like that," she said. "Geography was my favorite subject in the harem. Once I understood what maps were, I wanted to study more and more of them. They let me spend a few afternoons with an old man in Viddin who was a scholar in cartography. He showed me these wonderful maps, with beautiful calligraphy. Some of them were very old and precious. And he showed me how the information on maps about rivers and seas, mountains and plains, cities and settlements could determine trading routes, what crops could be planted or what minerals mined, and the outcome of battles."

"Which maps did you like best?" Sam inquired.

"I suppose my favorites were the ones of all the places my friends in the harem came from: Circassia, Georgia, Abyssinia, and the Sudan. Sometimes people would talk about their homes when they were melancholy, and I loved seeing the different places. When the Sultana Validé said I couldn't go to the cartographer anymore, I was so disappointed."

"Why did she say that?" Sam asked. "What could be harmful about looking at maps? You weren't alone with the cartographer, were you?"

"Oh, no, Ali was there, just like my shadow, as always. No, when I asked the Sultana Validé why I couldn't study geography anymore, she simply recited a proverb: 'Women have long hair and short intelligence.'

I guess I wanted to know too much." She sighed. After a pause, she asked Sam to tell her more about the hunting trip.

"I didn't realize when we set out that Singh was far more interested in dancing with society ladies in the European capitals than in hunting or viewing the scenery. The maharajah," he confided, "is always getting into scrapes with the ladies. I have never seen such a Romeo. I have to apologize to our hosts because his ideas of propriety are so different from ours! He may be a maharajah, but he is no gentleman. No wonder the Logins have had such a time with him. As his guardians, they might have warned me, you know. But what can one do? Still, he's a jolly good shot, I'll say that for him, and a keen falconer. Not much for roughing it, though. These Oriental types just don't have the constitution for it; they are too used to their comforts." He and Florence shared a laugh, thinking of Duleep Singh's nonstop grumbling about the coaches and roads and inns of Wallachia.

"But how did you get to Viddin?" Florence wanted to know.

"When we got to Pesth," Sam explained, "we hired a covered boat, sixty or seventy feet long. She was quite comfortably fitted out, I thought, and we had a crew to row as we descended the Danube. Everyone prophesied all kinds of miseries and dangers, as it was merely a modified corn boat. Of course, it was cold on the river, but we had three good stoves onboard, lots of wood and champagne, two casks of splendid beer and wine. With the maharajah's three English servants—he won't travel with fewer, can you imagine?—and the fowls, turkeys, ducks, and other waterfowl we shot, we were rather jolly. No, what I said is not quite right"—he corrected himself scrupulously—"I was jolly enough, but the maharajah was rather glum. I suppose he expected a much higher standard of accommodation than that. But it was a hunting trip, after all, and you don't expect luxury in the wilds. I wrote to my sister Min that the maharajah was of too soft a texture for the successful pursuit of large game in midwinter in a wild country, and I think that is fair."

Florence, who had never been on a hunting trip, did not know what one expected. She had certainly traveled under trying conditions, though, and she never felt that complaining made anything better.

"As for the rest of my story," Sam resumed, "you already know it. We holed our boat on an ice floe on the Danube and had to limp into Viddin

for repairs. The pasha received us in his palace—he is fond of receiving foreign visitors—and that entertained the maharajah for an afternoon. But there is not much to do in Viddin that suits his tastes. So"—he smiled at her warmly, and she at him—"we went to that auction to amuse the maharajah."

Florence and Sam were unreasonably happy exchanging stories, singing songs, and reciting their favorite poems to each other as the crude coaches bumped their way through the icy landscape to Bucharest. When they stopped for meals or rest and tried to draw Singh into their merriment and conversation—in German—he was sour and grumpy.

"How do you talk me into these dreadful excursions, Sam?" the maharajah asked, only half in jest. "Is it not enough that you nearly froze me to death on the Danube?"

"Come, come, old chap," Sam answered good-humoredly. "Didn't you like that bit where we shot like a rocket through the rapids at the Iron Gates?"

"Like it?" the maharajah bantered back. "As a boar enjoys the sight of the bullet that will end its life! I thought we would drown. I must say, striking that ice floe near Viddin was a bit uncalled-for too. Couldn't you have steered around it?"

"Now, how was I to know there would be such a large ice floe on the Danube in January?" Sam replied a trifle defensively, for he prided himself on his ability in handling boats. "Anyone might have hit it. And a corn boat does not maneuver very well, as I discovered."

"Yes," Singh conceded, smiling despite himself. "But the boat itself was a nightmare, a leaking tub with no heat. And these coaches! They are as far from roadworthy as that boat was from riverworthy. We might move faster if we dragged the boat along these roads." He smiled again to show his good humor had not entirely vanished. "I fear after this bumpy journey it shall be some days before I can waltz again, you know."

"The road does rather jar the backbone into the cushions, doesn't it?" Sam agreed cheerfully.

"Think of the poor ladies with whom I shall dance next week in Constantinople," the maharajah added, "or those in Italy, when I meet up with Dr. and Lady Login once again. My back will be sore and my legs stiff. I

shall step all over their toes and soil their dancing slippers. Alas, alas, a tragedy!"

After the death of his father, the great warrior king of the Punjab, Ranjit Singh, Duleep had been raised by the Logins at the request of Queen Victoria. Everyone was very pleased when, as a boy, he decided to convert to Christianity and abandon his Sikh faith. It was perhaps part of the reason that Queen Victoria had dealt with him so generously. But now the maharajah was a young man, and he wanted to marry. He was insistent that he would marry none but a Christian girl and an aristocrat. He openly aspired to a well-bred English bride and had spurned a possible match to Victoria Gouramma, the daughter of the ex-rajah of Coorg. In Queen Victoria's mind, Singh could not possibly marry an Englishwoman. Though he had been properly raised and was most amiable, he was still a black man in her eyes. The queen's emissaries and the Logins were scouring the world for a suitable match. They hoped to find a light-skinned girl from one of the princely states of India, one who would be willing to convert to Christianity and who would be pretty enough to overcome the maharajah's objections. Singh hoped that when he rejoined the Logins they would tell him of several possible matches. At the very least, there would be gay parties with music and dancing and pretty women. (In fact, the process of finding Singh a bride took several years. In 1864 he married Bamba Müller, a half-German, half-Abyssinian Christian girl from Cairo.)

His eagerness to get on with all this made him doubly irritable throughout the long journey. By the time the threesome reached Bucharest, the maharajah was anxious to leave on the first train with an available first-class compartment. Florence and Sam seemed impervious to what the maharajah regarded as basic requirements: decent food, good drink, and comfortable hotels. Singh and Sam parted company less amicably than Sam had hoped. Unfairly, Lady Login described the trip in her diary as "rather a fiasco" in which the maharajah was poorly supervised by "an old habitué of Eastern cities."

Florence and Sam were wholly absorbed in each other. They were an unlikely match, the girl from the harem and the middle-aged widower, and yet a match they were. They were both born adventurers, seeking worthy challenges and freedom from petty regulations. Each held to a

The Hotel Manuk in Bucharest (1860). Florence and Sam may have stayed in this old caravansary in Bucharest. The crude wagons in the courtyard are probably the sort of vehicle in which they traveled from Calafat to Bucharest.

code of morality that ran strong and deep. They shared too a sense of fun and playfulness, an almost childish appreciation of life.

Florence was in an entirely new situation. Since early childhood she had been told her only future was to be a strictly guarded appendage to some man. Then Sam came into her life and everything changed. Though strictly speaking he had kidnapped her, he treated her as neither possession nor slave. It was exhilarating. So too was the compelling attractiveness of this burly, solid man. She could not explain what drew her, and did not try: it was his kindness, his character, and something else she did not put a name too.

Sometimes she was frozen with a flash of fear that he would betray and abandon her as so many people had done in her brief life. Caution and cynicism warned her to be wary, yet her instincts were all to the contrary. Ali had must have trusted Sam too, she thought, for he had taken an impossibly foolish gamble to send her off with him. As she came to know Sam, she trusted him more and more. He was a man who was never cruel or deceitful, who expected fair play from others and dispensed fairness automatically. He was, in many ways, an overgrown English schoolboy with a keen sense of honor, duty, and right—and like a boy, he loved a good prank. But he was far stronger, morally and physically, than any boy. She

could not help falling in love with him. He offered all she had ever wanted: the freedom to be herself and still be loved. He made her feel like the most desirable woman in the world.

Sam saw in Florence an uncommon spirit and a captivating resilience. She was utterly unlike his late wife, or any other woman he had ever met. Florence was eager to see new places and try new things, rejoicing in their novelty. She did not cling to a small, familiar, circumscribed world. Her hunger for experience and freedom mirrored his own needs; her clear sense of right and wrong echoed his own deeply held values. And she was gloriously, radiantly beautiful.

Duleep Singh departed for Italy, and Florence and Sam were left alone in Bucharest.

4

A GIRL FROM THE HAREM

*I*n Bucharest the first order of the day was to buy Florence some suitable clothing. Sam took great pleasure in escorting her to an expensive dressmaker. He ordered for her a wardrobe of evening gowns, pretty day dresses, and practical sets of blouses, jackets, and skirts for traveling. Then he took her to a jeweler's, where he bought her a garnet-and-pearl necklace set in gold, with a matching bracelet and a pair of delicate, dangling earrings such as any well-born, respectable lady might wear. Florence was amazed by his openhearted generosity. Having heard stories in the harem of generous masters who showered their *ikbals* with clothing and jewels in exchange for a night of love, she was almost disappointed that he never seemed to expect favors in return for his gifts. In truth, he was too shy and too proper. He might have bought a slave girl—the mere thought made him terribly uncomfortable and he preferred to think of it as an accident—but he would never press his attentions on an unwilling partner.

That evening, a hotel maid helped Florence put her golden hair up in a fashionable European style and don her new finery. When she came down the central staircase of

the hotel, Sam thought he would burst with pride. This elegant young creature was surely the most beautiful, exotic, and amusing woman in the city. They attracted considerable attention, the big-shouldered, distinguished-looking man with the stunning, young blond woman. Florence was unaware of admiring glances other than Sam's. He was, then and ever after, the only man who mattered to her. He was just as clearly in love with her as she with him. They drank and ate and laughed their way through the night.

The physical attraction between Sam and Florence was powerful. When he held her in his arms to dance, she sometimes looked about the room expecting people to be scandalized. His nearness left her breathless and her skin became exquisitely sensitive. Even the touch of his hand on hers, through their gloves, filled her with a passionate longing.

One late evening, when Sam saw Florence to the door of her hotel room, she noticed that his handkerchief was awry in the breast pocket of his dinner jacket.

"You must be careful," she told him tenderly, while she removed and refolded the linen square. Putting it back into his pocket, gently, slowly, felt like an act of great intimacy. "You seem to be in danger of dropping your handkerchief."

"So I am," he answered in the softest of voices. He put his hand up to clasp her lovely, small hand and hold it to his breast. Then, deliberately, he removed the handkerchief from his pocket and dropped it at her feet. She looked into his blue eyes for a long moment and then bent gracefully to pick it up. She put it to her nose to inhale the clean smell of starch and ironing and manliness.

"You shall have to retrieve it, I think," Florence murmured over her shoulder as she went into her room.

❧

FLORENCE AND SAM WERE BLISSFULLY HAPPY in Bucharest, though Sam described the city to Min as "a mass of filth, the streets everywhere are five inches deep in black mud" and complained of "fleas as big as bantam cocks and bugs as large as turbots." The rustic nature of Bucharest did not bother Sam and Florence in the least; it was far more civilized than Viddin or the remote villages of Wallachia. In any case, they lived in

a world of their own. Sam invented a tender nickname for her, Flooey, and called her by it most of the time.

One of the few Englishmen whose acquaintance they sought was Robert Colquhoun, the longtime British consul to Bucharest. Colquhoun shared many English friends with Sam, and it was common courtesy to call on him. It seemed especially urgent when Sam heard rumors that there might be a new British consul appointed in Constanza. Though Constanza was a small and insignificant fishing village on the Black Sea, a railway was being built to link it with Cernovoda on the Danube. High-speed rail access to the Danube might transform Constanza into a port of some importance, requiring a consul. It would be a minor consulate but an honorable position, suitable for a man of Sam's stature. The consul-ship would provide a perfect excuse to keep Sam and Florence in central Europe, well away from the awkward questions sure to be posed if they returned to London. Sam asked Colquhoun for his advice: would there be a consulship? How best might he secure it? Unfortunately, Colquhoun thought the chance of a consulship in Constanza was very slight.

Sam wrote optimistically to his sister Min that he was applying for the managing directorship of the firm that was building the new railway as well as for the consulship. He apologized that this would keep him from home for some time, perhaps a few years, during which she would need to continue looking after his daughters. Though the consulship never came about, the position with the railway did. On March 11 Sam wrote his eldest daughter, Edith, telling her that he had accepted a position as the manag-ing director of the new railway. "I had a great struggle with myself as to whether I should accept my present appointment; for, of course, it will detain me for some time out here and away from you all. But I felt sure that, though away, you would not forget me; and as man was not made to be idle . . ."

He did not add the biblical injunction that man was not made to live alone either, though Florence was much on his mind. He didn't know how to tell his fourteen-year-old daughter, Edith, that he had fallen pas-sionately in love again, with a girl close to her own age. He wrote again to Min but mentioned nothing about Florence and only asked her to send out his china and silver. He wrote to Wharncliffe, his old hunting partner and great friend, to explain his new job, but Sam didn't know how to tell

Wharncliffe of his new love either. The Baker family and his friends were pleased that Sam seemed at last to have settled down to something. What they did not know was that he had settled down to live with a Hungarian girl from a harem who was less than half his age.

Before he and Florence left Bucharest, Sam begged a tremendous favor of Colquhoun. As consul, he had the power to issue British passports. Florence badly needed a passport. She had no papers and the trick with the gun license could not be counted on to work very often. The state of Hungary to which she belonged by birthright no longer existed, and the Austrian Empire would never issue her a passport, because her father was considered a traitor. The Ottoman Empire, where she had lived for ten years, had never noticed Florence's presence or accepted her as a citizen. She was a beautiful young woman, and traveling without papers would leave her endangered and vulnerable.

Colquhoun knew that Florence was neither British by birth nor British by marriage. Indeed, even if Florence and Sam decided to marry, there were some difficulties to be overcome. Florence had been baptized a Catholic, and Sam was staunchly Church of England. Mixed marriages were actively discouraged if not flatly prohibited in most European countries. A mixed marriage performed in Romania was unlikely to be accepted as legal in England. As a representative of the British government, Colquhoun knew that other Hungarian refugees had been given English passports on political grounds. Florence was a charming young woman in great need of political asylum. Sam gave Colquhoun his word of honor as a gentleman that he would take full responsibility for Florence—no more than he had already promised Florence in private. Colquhoun relented and granted her a British passport in the name of Florence Barbara Maria Finnian.

Colquhoun's kindness resolved a major problem in the couple's life together. Later that day Sam whispered to her tenderly, "This means I need never leave you, Flooey."

"Nor I you, Sam," Florence answered him gently. "You are my world, my life now. No one can separate us."

She did not know the right words to tell Sam how she felt about him. His love had melted the cold and hurt and frightened places in her heart. With Sam, she felt utterly free and yet utterly bound. She was reminded

The Captive Zebra (1621). This Persian miniature, painted by Mansur, shows a wild zebra tethered by a fragile red silk halter. Like the zebra, Florence chose a gentle, voluntary confinement based on affection.

of an exquisite Persian miniature she had seen once, of a beautiful wild zebra wearing a delicate red silk halter.

Florence and Sam moved into the rather grim and empty director's house in Constanza like a pair of newlyweds. To have a place that was theirs and theirs alone seemed a wonderful adventure, though the house was small, run-down, and shabby. Florence transformed it into a comfortable home with local carpets and furniture. Sam's china and silver, which had arrived from England, lent an elegant air to their dining table, which stood near the window in one of the two rooms. The location of the house was its best feature, for it was close to the teeming Black Sea marshes where hunting and fishing were excellent. Sam could always manage time away from the office, and Florence enjoyed their excursions as much as he did.

Florence very much wanted to go riding with Sam every day, but there was a special problem. Sam had ordered a riding habit for Florence in Bucharest. She was completely astounded when it arrived. "Sam, look at

this!" she exclaimed after she had unwrapped the garments. "What fools those dressmakers are! How do they think anyone can ride in this?" She laughed and held up the long skirt in ridicule.

"What do you mean?" replied Sam, puzzled. "It seems a perfectly ordinary ladies' riding habit to me—and I think the color of the jacket suits you."

"Oh, Sam," Florence teased him, "could *you* ride in a garment like this?"

"Well, of course not, my dear. I couldn't get my, um, limb over the saddle," Sam answered, using the Victorian euphemism for "leg." He couldn't help smiling at the absurdity of his muscled and masculine figure garbed in a ladies' riding habit.

"Exactly so," Florence agreed, "and neither could I." The two looked at each other, incredulous.

"Do you mean," Sam said slowly, "that you were taught to ride like a man, astride a horse?"

"Not like a man," she replied, "but certainly astride. That is how all Turkish ladies ride. How could you possibly ride a galloping horse if both legs were on one side? You couldn't jump over a wall or a ditch like that, surely. Don't English ladies ride that way?"

"No, my flower, that would be most . . . indecorous. Ladies wear skirts, like this one, on top of a sort of divided skirt or pantaloon. They have a special sidesaddle so they can keep both limbs together on the left of the horse. There is a large leather hook high up on the saddle that goes under your right limb." He perched on the arm of a sofa and tried to twist his body into the appropriate position to demonstrate the arrangement of the legs on a sidesaddle. "Now, the other goes into the stirrup . . . and then, your crop . . . oh, I admit, I don't know quite *how* it works." He lost his balance and fell onto the sofa cushions, laughing at himself while Florence dissolved into giggles at his contortions.

"I," announced Florence playfully, putting one leg over each side of the sofa's arm, "shall ride astride, in a normal saddle, so that I can balance properly." She grinned at Sam, and after a moment's thought Sam grinned back.

"I see," Sam commented, trying to regain a straight face. He reck-

oned he understood what was in her mind, and the plan seemed good to him. "You know, Flooey, I think it must be time for me to buy riding breeches for my nephew. He must be coming to visit shortly. He likes to ride."

"Exactly!" Florence cried, delighted. "I am sure your nephew will be here in a few days and he will want to ride with you."

Florence's dressing in a young man's clothes became their secret joke. She was slender and not terribly buxom; with her hair up under a hat, she could pass for a youth as long as no one looked very closely.

Sam thought it most exciting and fun, and Florence's trousers were becoming as well as practical. He did not know another woman who would have worn them. Certainly his first wife, the parson's daughter, would have been horribly embarrassed to have the outline of her limbs so visible. Sam had always admired Henrietta's natural modesty, but she was never his companion the way that Florence was. Florence was someone rather like himself, prepared to abandon silly rules and customs if they were not sensible, who did not worry too much about what other people thought. In any case, almost all the English in Constanza were navvies and laborers who worked on the railroad. They didn't know Sam's family or friends at home, and they weren't likely to go riding through the wild marshes and plains where they would recognize Florence.

Sam's four principal assistants in Constanza—Jack, George, Robert, and Henry Barkley, the sons of a Norfolk vicar—were another matter. Initially they welcomed the new director, "Mr. Baker, the great elephant shooter" from Ceylon. However, they disapproved of Florence, and Henry's wife did not believe Florence was *Mrs.* Baker, though she had been introduced as such. It was not the *difference* in age between Sam and Florence that bothered Mrs. Barkley, for many wealthy widowers married much younger women. What looked suspicious to her was Florence's age itself: about fifteen. While marriage to a young girl was perfectly legal—the age of consent in England was twelve years old—no one of Sam's social position would think of marrying a girl before she came out in society, at seventeen. To put it succinctly, Florence was too foreign, too young, and far too beautiful. The Barkleys ostracized the couple as much as possible.

When Sam wasn't working in the office or going hunting, he was writing vivid and clever travel essays for an English country magazine called *The Field*, about life in Wallachia and Ceylon. In one of them, he told of hunting in a swampy marsh and finding that the black sticky mud had seized his boots: "Accordingly," he wrote, "they were extracted and slung over the shoulders of my Wallachian lad, both he and I voting boots an encumbrance." Behind this charming anecdote of the happy, barefoot hunters lay a private joke: the "Wallachian lad" was Florence herself, clad in the fictive nephew's clothes.

Florence loved having the security of a home, and most of all, she enjoyed living with the man she loved. Sam treated her with a sweet concern she had rarely known. It was the common practice in England for a husband and wife to address each other as Mr. and Mrs., but they never used such formality. He was Sam and she was Flooey. The only concession to propriety was that Sam called her "Florence" in public.

They were jolted out of their contented state by news from home, in the form of a bundle of English newspapers, which arrived in the late summer of 1859, several weeks after being sent. African exploration and the source of the mighty Nile River were topics being urgently debated in learned societies. Was there a great inland lake in the heart of Africa, on some undiscovered massive plateau? Did the Nile spring, instead, from a series of interconnected lakes? Or was there an enormous set of

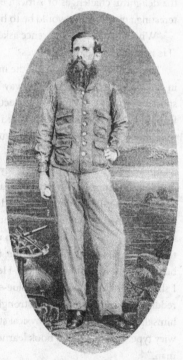

John Hanning Speke (1863). Speke returned from Africa in May 1859 to announce that he had found the source of the Nile, the Victoria N'yanza.

mountains gracing central Africa, from which the rainfall poured into the Nile? In 1856 Richard Burton and John Hanning Speke had set out to resolve this great scientific mystery by marching from Zanzibar on the east coast across into central Africa. Now, in 1859, Speke had returned and announced that they had accomplished their aim.

"Fancy that!" Sam exclaimed, reading a newspaper article about it. "Old Speke's found the source of the Nile! He and Burton found Lake Tanganyika all right, as they planned, but Speke says he has discovered a larger lake; he calls it the Victoria N'yanza. He describes it as an enormous body of water, an inland sea almost, and the true source of the Nile. Oh, I'd love to see it!" Sam got a faraway look on his face as he contemplated the delightful challenges of African exploration—and all the new and interesting animals there would be to hunt on that continent.

"Who is this Speke?" Florence asked, looking up from her needlework. "He is an old friend of yours, yes?"

"Jack Speke, he's a captain in the Indian army," Sam replied. "I met him in Aden a few years ago on my way back from the Crimea. He's a great sportsman with a wonderful collection of heads and skins of animals from India. On his leave, he surveyed parts of Tibet no one else had been to and added some rare specimens to his collection. We had some long talks about hunting in Asia."

Speke had joined the Indian army at seventeen, fought the Sikhs, and distinguished himself. A rather stiff, almost priggish man at times, he had taken well to military life, but he had never warmed to the native men he led and learned only the bare minimum of Hindustani necessary to command them. Still, Sam thought him a "splendid fellow" and commented to Florence, "He looks a bit like me, in fact. I hadn't thought of it before, but we might almost be brothers. He's a few inches taller, nearly six feet I should think, fair-haired and blue-eyed, and his beard comes in rather reddish, like mine. He's not as strongly built as I am"—Sam rightly prided himself on his exceptional physical strength and barrel chest—"for he's a wiry type. Not much of a book learner, Jack Speke, but a grand outdoorsman."

"And Burton," Florence inquired, "who is he?"

"Captain Richard Burton of the Bombay army of the East India Company; he was the leader of the expedition. Now, he's a different sort alto-

gether, an intellectual and a writer—a bit of an odd duck too, you might say. He's one of a kind. It was Burton who entered Mecca and Medina disguised as an Arab."

Florence drew in a sharp breath. To Muslims, Mecca was sacred. Every Muslim had a sacred obligation to make a pilgrimage—a hajj—to Mecca at least once in his lifetime, and Medina was the second-most holy city in the world. Neither Mecca nor Medina was the sort of place where a white unbeliever would be welcomed or even tolerated. Such a person was very likely to be put to death for defiling a holy place. Burton must be a master of disguise and a scholar of both Islam and Arabic if he had pulled off such a deception.

Seeing her amazement, Sam continued, "Burton has an extraordinary ability to blend in, to become someone else. They say he has passed as an Afghan, a Hindu, a Gypsy, and a whirling dervish. He has mastered a dozen different languages at least. Not many Englishmen could do the things Burton has, and fewer would have tried. I admire him for his courage and insatiable curiosity. Speke told me they used to call Burton the 'White Nigger' or 'that Devil Burton' in the East India Company army. Not Speke; he'd be a total failure in disguise. They couldn't be more different in temperament. Don't suppose Speke has written any books on linguistics or ethnography in his life; he probably hasn't read any either."

He told Florence that it was Burton who first approached the Royal Geographical Society—the RGS—about an expedition to find the source of the Nile, after he was already acclaimed for his explorations in Arabia. Burton was the leader, and Speke was the surveyor of the expedition.

"It sounds as if they'd make a good team, your Burton and Speke," Florence commented. "Burton could study the languages and the customs of the people; he could negotiate for food and collect information. Speke could do the surveying and measuring and make a collection of the skins and heads of African animals to go with his Asian ones."

The association between Burton and Speke had begun disastrously. On a brief expedition to Somalia with two other Englishmen, Stroyan and Herne, they had been attacked by tribesmen outside of Berbera in the middle of the night. Burton took a spear through his face that knocked out four teeth, broke his palate, and left a large and sinister scar. Speke was

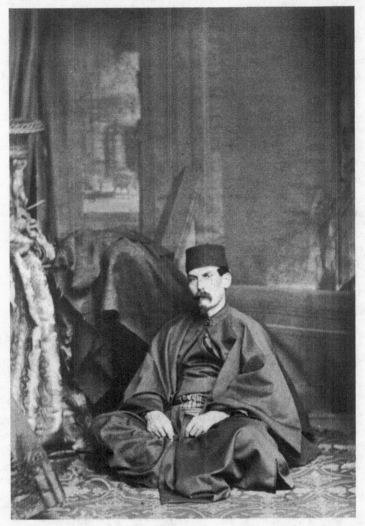

speared in eleven places. The other white men in their party were hacked to pieces. In the middle of the fighting, Burton cried out to Speke, "Don't step back or they'll think we are retreating!" Speke felt he had been accused of cowardice and never forgave Burton for it; he was angry too at the way Burton edited his diary of the Somali trip for publication. Why they embarked on another journey of African exploration together was not clear; some suggested Burton invited Speke along because Speke had lost so much money—about five hundred pounds—in the Somali debacle. The persistent illnesses, hardships, and mental strain of the second voyage brought Speke's resentments, jealousies, and suspicions of Burton to the fore.

"I see here," Sam said, pointing to his newspaper, "that Speke came back in May and announced their success, leaving Burton behind in Aden, recovering from exhaustion and illness. Odd. You wouldn't think a gentleman would do that, would you? Burton was the leader of the expedition, and he ought to speak for them both." It didn't sound right to Sam, the subordinate officer taking all the glory and leaving the leader behind in poor health.

Burton would maintain for the rest of his life that Speke's last words to him before leaving for England were, "Good-bye old fellow; you may be quite sure I shall not go up to the Royal Geographical Society until you come to the fore and we appear together. Make your mind quite easy about that." Burton saw Speke's actions as a deliberate betrayal and never forgave him.

"Yes, it does seem strange," said Florence thoughtfully, examining her stitches closely. "There must be something very wrong between them. Is he a very ambitious man, this Speke?"

"Well, he's a proud man, that's for sure, even a little prickly if anyone implies anything against him. Rather quick to take offense, now I think of it, and yes, I'd call him ambitious. It says here that Speke went off on his own to discover the Victoria N'yanza on July 20 in '58 while Burton remained in camp too sick to walk. When Speke returned to camp, he and Burton made their way back to Zanzibar and took a ship to Aden. The English doctor

Richard Burton (1853). Burton was the first infidel to make a pilgrimage to Mecca disguised as an Arab (shown here). Though Burton led their African expedition, Speke received most of the credit for discovering the source of the Nile.

there advised them both to stay put and recuperate before undertaking the ocean voyage home, but Speke rushed back to meet with Sir Roderick Murchison of the RGS."

"When did Speke get home?" Florence questioned. "And when did Burton come?"

Sam consulted the newspaper. "Speke went to see Murchison on May 9, 1859. Once he heard Speke's news, Murchison apparently declared, 'Speke, we must send you there again!' and directed him to address the membership immediately. I'll have to look through some other papers to see when Burton arrived."

Sam checked through the pile of newly arrived newspapers from London and announced, "Ah, here it is. Burton didn't get home for almost another fortnight. The RGS gave him its Founder's medal on May 23, two days later. Still, he must have been jolly annoyed to find Speke had already lectured on their findings and was busily planning his own return expedition."

"So Captain Burton came home to find his surveyor had received all the accolades and praise?" Florence asked shrewdly. She stabbed her needle firmly into the cloth. "He must have been very angry with Speke. Surely they had some understanding about who would announce and publish their findings, yes?"

"I don't know," Sam admitted. "You would have thought so. Anyway, Speke is going back to the Victoria N'yanza to prove his claim that the Nile issues from that great lake. Speke never saw the river's exit for himself; he only had the natives' word for it." He shook his head in disapproval. "Careless, that; he should've gone himself and checked. In this later newspaper account, it seems that Burton doesn't believe Speke's claim and implies he was misled by the natives and by bad translators. Speke had to address his headman in Hindustani, though neither of them was fluent. Then the headman translated the message into Arabic and spoke to the locals. Then everything would have to be translated back again. Can you imagine how cumbersome that would be? A poor way to get information, if you ask me."

He stopped and gazed up at Florence, a dreamy look on his face. "Now if I were going to search for the source of the Nile, I'd take some time to learn Arabic first. I believe it is the lingua franca along most of the Nile

because of the Arab traders. I wouldn't want to trust some native drago-man for everything."

"That is wise," Florence commented, smiling impishly as she set aside her needlework for a moment. "Arabic isn't a difficult language; it wouldn't take you so very long to learn it, *inshallah*."

Sam suddenly looked at her keenly. "What's that you say?" he asked, thinking he had not heard her correctly.

"*Inshallah*," Florence repeated. "It is a very common expression in Arabic; it means 'God willing.' "

"Do you mean to say you speak Arabic?" asked Sam, astonished. He had never known another woman who so often surprised him. What a marvel she was!

"Yes, of course. I learned it in Viddin, when I was a little girl," Florence replied matter-of-factly. "Circassian always seemed harder to me." She laughed at the expression on Sam's face. "Oh, Sam, you know I was taught to read and write Arabic in the *haremlik* when I was a little girl. How else could I study the Koran? And what claim to an education would I have if I could not even read the Koran? Arabic was the one language almost everyone spoke in the harem. And Ali, my *lala*, taught me a little bit of Dinka, the language of his people. Shall I teach you?"

"If we knew Arabic," Sam spoke as his thoughts raced ahead, "it would be very easy for us to go up the Nile and trace the river from Cairo. Then we would know for sure that the great river we were following was indeed the Nile when we reached its source. No one could suggest we had gotten confused by another river."

"I don't see why someone hasn't done that before," Florence remarked practically. "What is the point of starting overland from the coast and then hoping that the river you come across is the Nile? Why not know it's the Nile? Surely river travel is less dangerous and more comfortable than marching across country in an unknown territory anyway."

She remembered how, as a happy child in the cartographer's library in Viddin, she had stared at the vast blank spaces on the map of Africa. The Mediterranean end of the Nile was always there, drawn in much detail, but its source in central Africa was clouded in speculation. There were so many regions with no details, no towns, no mountains, no rivers or lakes

marked on them at all. It would be a marvelous thing to find the source of the Nile with Sam by her side.

Sam's brain was working like some vast industrial machine, thought pushing thought, one idea turning another round and round, faster and faster. "It would not be easy, I expect," he said slowly. "The Nile runs the wrong way, toward the Mediterranean, not south toward the source. Naturally so. And of course the source is higher in elevation; it'd have to be. That's why there are cataracts on the Nile, eight if I remember correctly, so we'd have to stop and portage the boats over them or something."

"Would that be so very difficult?" Florence wondered aloud. "I mean, we'd have to hire lots of porters and boatmen anyway, wouldn't we? So maybe they could carry the boats around the cataracts, if the boats were not very large . . . I wonder how many boats we'd need and how many men."

Suddenly, Florence and Sam grinned at each other; they had started to plan an adventure. The romantic fantasy of going to Africa someday had been transmogrified into an almost-reality. Though most genteelly raised ladies would have been terrified to go to darkest Africa, Florence was not. She knew the languages and had lived among Africans in Viddin for years. For his part, Sam had always wanted to see Africa and its legendary big game: elephants, buffalo, lions, rhinoceroses, and giraffes. From his plantation days, Sam knew how to command large numbers of natives and live in wild countries. He liked traveling by boat too. On a boat you could have your comforts and not rely on making camp or being welcomed at whatever village was near. If there was trouble, you could just sail away.

Over the next six months, Florence and Sam followed the news from London eagerly while they elaborated their own plans. Burton and Speke fell to quarreling in print unbecomingly. In a letter to *The Times* on October 8, 1859, Burton presented his views of central African geography, making Speke look a fool for announcing the discovery of a vast lake without adequate geographical observations to back up his claims. Foolish or not, it was Speke, the good chap, the likeable fellow, who seemed to command the Royal Geographical Society's sympathies.

Burton had also fallen out badly with the British consul at Zanzibar, Colonel Rigby. Rigby was an old rival of Burton's and an old friend of Speke's. He accused Burton of failing to settle his debts before leaving Africa, a most ungentlemanly act. Burton argued that the native porters had failed to fulfill

their duties and so were owed no monies at all, past the clothing and food with which they had been supplied on the journey. Burton also pointed out that, if there were a valid debt, Speke was liable for part of it. No one knew the real truth of the matter, except possibly Speke, and he wisely said nothing. The Royal Geographical Society wanted nothing to do with a man involved in a scandal, and Burton seemed to attract scandal.

Speke concentrated on organizing a new expedition. At their committee meeting on June 20, 1859, the RGS had agreed to give Speke half the funding for another African expedition, whereas Burton's request was denied. Burton was tainted despite his towering intellectual accomplishments. People thought him too likely to "go native"; perhaps he was not quite a gentleman.

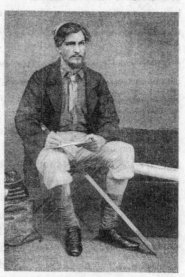

Looking for a trustworthy companion, Speke enlisted Captain James Augustus Grant, a fellow officer in the Indian army. Speke arranged with Rigby to set up caches of supplies and trading goods in the interior to await his and Grant's arrival, so they would not have to carry so much from the coast. They planned to march inland from Zanzibar and to go as directly as possible to Lake Victoria. They would then proceed up the shore of the lake until they verified that the Nile issued from

James A. Grant (1863). Speke's companion on his second trip to Africa, James Grant, is shown here in the clothes he wore in Africa.

its northern end. To return, they would march further northward along the Nile until they reached Gondokoro, the most southerly navigable point of the White Nile. From there they could sail to Khartoum, Cairo, Aden, and home. The strict injunction of the Royal Geographical Society, in return for its funding, was that Speke's expedition must endeavor to reach Gondokoro by December 1861.

This specific charge was linked to Speke's final provision for safety. He

and Burton had been exhausted, ill, and perilously close to death in the closing months of their expedition. This time he set up a rescue mission in advance, relying upon John Petherick, the newly appointed British consul at Khartoum. Petherick was to meet Speke and Grant on their way home and to provide them with "succor." Using twelve hundred pounds raised by private subscription through the Royal Geographical Society, Petherick was specifically charged to bring boats, supplies, clothing, medicines, firearms, and other essential items to Gondokoro. Petherick agreed to wait at Gondokoro for seven months, from November 1861 until June 1862, allowing several months on either side of the targeted arrival in December 1861. Because Petherick's salary as a consul was meager, he supplemented it by trading in ivory. He specifically obtained permission from the RGS to collect ivory while he waited for Speke and Grant, in order to offset the cost of the rescue. Confident that they had planned for every eventuality, Speke and Grant set sail from Portsmouth on April 27, 1860, arriving in Zanzibar on August 17.

Even before Speke and Grant set out, Florence and Sam had decided that they too must go to Africa. They would start at the other end of the Nile, at Cairo, and travel southward, hoping to meet Speke and Grant en route. The railroad was nearing completion and Sam had less and less work to do, so he visited London briefly in May 1860 to sign off on his contract with the railroad. Sam sought advice from men in London who had useful contacts or experience in Africa, including Admiral Murray and William Oswell Cotton. By June, Sam was back in Constanza, a free man again. When the railroad was opened in October with great fanfare, the former managing director and his wife were conspicuously absent.

That autumn they planned their trip in earnest. One of the key questions was who should come along on the expedition. Sam dashed off a letter to Burton, asking if he might care to come up the Nile with him. "What a tremendous help Burton would be," Sam said wistfully on finishing the letter. "But I suppose it is too much to expect him to come along as my subordinate, never mind helping us to rescue Speke."

"It doesn't matter." Florence stood over him and rested her cheek on the top of his head. "If he does not like to come, we shall go together, like always." And so they did.

In November Sam wrote to Murchison asking for copies of Royal Geographical Society maps of Africa and then again to request support for his planned expedition. His stated aim was to explore the White Nile as far south as he could: "what point that will be I know not." He asked too for the loan of a thermometer and scientific instruments for determining altitude and geographical position.

With exquisite self-righteousness, the RGS refused Sam the loan of instruments. "Mr. Baker," an anonymous official wrote dryly on his letter of request, "is not an FRGS [Fellow of the Royal Geographical Society] and declined to become one when asked. This is not the first time that the council has furnished him at his request with instruments." The previous request is unrecorded but may have been related to his time in Ceylon.

Undiscouraged by this refusal, Baker sent a new proposal asking for permission to accompany Petherick in his mission to rescue Speke and Grant. Of course, Sam made no mention of Florence's existence; no one in England would have sanctioned a young woman's participation in such an expedition. He received a set of instructions from the RGS that was remarkably demanding, considering that they offered Sam's expedition neither funds nor equipment. Though the society "fully appreciate the value of the services which it may be in Mr. Baker's power to tender" to Petherick's mission, they instructed him to follow a different route. They suggested he might make his objective the exploration of the Sobat, an important tributary to the White Nile "which had not yet been ascended" and thus

to set to rest the much vexed geographical question, whether the Gibbe, Gojeb and other rivers rising in the high country of Kaffa and its neighborhood are affluents of the Nile, or are rivers of the East Coast. Success in this endeavor would be attended with the most interesting results, both in a commercial and geographical point of view, as Mr. Baker would now find himself in the Galla country which is as yet totally unexplored. . . .

The object of Mr. Petherick's own expedition being in a great measure special, it seems expedient that a separate route should be followed by Mr. Baker, more especially as there is still some chance of his being accompanied by Captain Burton.

A Meeting with Captain Speke and his companion might be one of the objects of the journey, though inasmuch as the route suggested for Mr. Baker lies to the Eastward of Captain Speke's probable track, & the likelihood of such a meeting is not great, it should be considered subservient to the Geographical interest of the Expedition.

This letter constituted grudging approval of the expedition, if not material assistance.

Sam was happy with the response from the RGS and immediately began to correspond with Petherick, who was in London and courting his future wife, Katherine. Sam asked for advice on his expedition, which he painted as largely an elephant-hunting trip.

Sam began to order items he and Florence would need on their expedition, including a selection of firearms, some custom-made to his design; bullets and gunpowder; a large assortment of tools; a medical chest complete with quinine and opium; custom saddles; a selection of sewing and cooking utensils; and a portable bath. Sam arranged for money to be available to him through the Bank of Egypt in Alexandria—an important issue, since his expedition was self-funded.

While they awaited the arrival of these items, like children anticipating Christmas, Sam and Florence went on an extended hunting trip to Lake Sapanga in the mountains. They were many miles from civilization, and it was, in their view, a perfect place to celebrate the second anniversary of the fateful auction in Viddin. It was part honeymoon, part trial expedition, and they had a marvelous time. They hunted and rode, stayed in countrified and somewhat crude accommodations, and enjoyed themselves enormously.

Sam took the occasion to write the necessary letters of explanation to his family and friends. To his brother John, he wrote frankly of his plans and goals:

I intend to be in Alexandria in the first week of March, I am going to Khartoum, and from thence, God only knows where, in search of the sources of the Nile. I shall very likely meet Speke, who is working up that way from Zanzibar. . . . You know that Africa has always been in my head.

To his old friend and hunting companion, Wharncliffe, Sam wrote:

> I cannot tell you with what pleasure I am looking forward to this journey
> (up the Nile). It will be new ground; and the diversity of animals, with
> the chance of discovering a new species, will be a source of additional
> interest.

To Min, the faithful sister who was raising his children, Sam wrote a more
romantic version of his quest:

> A wandering spirit is in my marrow which forbids rest. The time may
> come when I shall delight in cities, but at present I abhor them. . . . My
> magnetic needle directs me to Central Africa.

What Sam did not do, could not do, was explain about Florence. He was
not ashamed of her, he assured Florence, nor had he any intention of
parting with her. He simply could not see how to explain her place in his
life to his family and thought it might best be done in person, when they
could meet her.

Florence tried to understand his reticence, but she found it hurtful.
What was there about her that needed to be hidden? Yes, she and Sam had
begun an intimate relationship without benefit of marriage, but she knew
enough of the world by now to realize this was not uncommon. First
babies often arrived unusually rapidly after marriage and were accepted
without demur, even in the highest circles. She thought he was being
overly cautious, but she reminded herself that she had seen in the harem
how ruthless a closed society could be to one who did not meet its rigid
expectations. She wanted to believe Sam's discretion was wise rather than
cowardly. Still, his reluctance to acknowledge her raised some uncomfort-
able doubts in her mind.

From an English perspective, the situation was transparently clear.
Sam, as a gentleman, must marry a lady; Florence, to be a lady, could not
be a girl from the harem. It mattered not at all that she had been a virgin
at the time of her sale or that she was in the slave trade only because of
the perfidy of others. It was irrelevant that Florence had never been "in

the harem" according to the English view of a harem as a pleasure palace of immoral sensuality and lust. However far the truth lay from that false stereotype, if Florence's history became known, she would be labeled a prostitute. She would be ruined in the eyes of society, and Sam would be irrevocably tainted for continuing to associate with her.

Florence and Sam decided that, until they could come up with a scheme for concealing her past and legitimizing her role, they would ignore the issue. In Africa they could be free.

5

SO ABSURD AN ERRAND

*F*lorence and Sam arrived in Cairo in March 1861. Egypt was swelteringly hot, dusty, and chaotic, but they had much to arrange for their journey and the capital city was a good place to do it. One of their first duties was to call on the British consul general, none other than the same Robert Colquhoun who had been transferred from Bucharest.

It was a pleasant reunion, but when he and Sam were alone, Colquhoun scolded Sam fiercely for not yet making an honest woman of Florence. Colquhoun thought it downright irresponsible to take Florence on an expedition up the Nile. Traveling in central Europe with a mistress, or *chère amie* in the euphemism of the age, was one thing; placing her in extreme danger by leading her into unknown Africa was both irresponsible and caddish. If Sam cared for Florence, Colquhoun argued, then he should order her to go home to England and live with his sisters while he carried out his explorations. The heart of Africa was no place for a young woman, Colquhoun reiterated, scowling.

Sam smiled a little at Colquhoun's reprimand, for Florence was not the sort of woman one ordered about. Then he recalled himself and set his face into a more somber

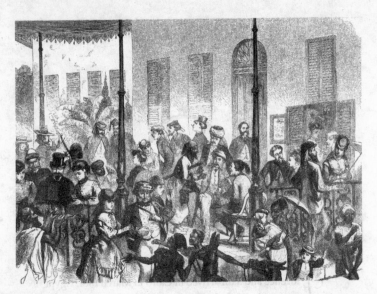
Shepheard's Hotel in Cairo (1870). Shepheard's was the fashionable hotel in which well-to-do English travelers like Florence and Sam stayed.

frame. "I see your point of view, Colquhoun," he agreed heartily, "I really do. I have begged Florence to spend the time awaiting my return in England, with my sisters and daughters."

"Glad to hear it," Colquhoun muttered approvingly. "She's a sensible woman."

"She is indeed," conceded Sam, "but she would not go, no matter what I said." He elaborated, as much for Colquhoun's benefit as for his own. "Florence is determined that her duty is to be by my side, as my helpmeet and comfort. I implored her to remain in safety, in vain. I painted the difficulties and perils still blacker than I supposed they really would be, but she is resolved, with woman's constancy and devotion, to share all dangers and to follow me through each rough footstep of the wild life before me. 'None but death shall part us,' she vowed. What could I do?"

Florence had indeed been adamant that she would go with him and would not go to England. "I'd rather return to the iron rule of the Sultana Validé in Viddin," she insisted passionately, "than face years of life with Min without you." Sam could understand her feelings. To live in England

as a woman of uncertain status would be painful; to face alone the spinster sister who cared for Sam's children would be a misery. Besides, he did not want to be parted from her for a week, much less some years, and he was pleased she felt the same way.

Colquhoun, not knowing this part of the story, merely grunted and said he supposed Sam could not send Florence to England without her consent. "You must regularize her situation, though, Baker, you really must," he urged. "She has no protection in the case of your death. What do you suppose would happen to a lone white woman in the middle of black Africa? Even if she got back to civilization, what would she live on? What rights would she have? You must honor your pledge and insure her well-being." Sam assured Colquhoun he would.

The first year, he and Florence planned to explore the Sobat and other rivers of Abyssinia as the RGS had suggested. They would improve their (especially his) fluency in Arabic, become accustomed to the explorer's life, and study the character and habits of the people they encountered. After that interlude, the source of the Nile and the rescue of Speke and Grant lay ahead of them. Sam later wrote:

> I had not the presumption to publish my intention, as the sources of the Nile had hitherto defied all explorers, but I had inwardly determined to accomplish this difficult task or to die in the attempt. From my youth I had been inured to hardships and endurance in wild sports in tropical climates, and when I gazed upon the map of Africa I had a wild hope, mingled with humility, that, even as the insignificant worm bores through the hardest oak, I might by perseverance reach the heart of Africa.

They set sail from Cairo on April 15 at 6 A.M. with "a spanking breeze" in a Nile *diahbiah*, a small steamer with a triangular lateen sail and a minimal crew. There was something serenely timeless about gliding up the Nile, past camels and palm trees and sand. The *fellahin* dressed in their traditional robes worked the fertile floodplains beside the Nile as they had for a thousand years. Everything looked flat, yellow-brown below and stark blue above, and sailing was very pleasant. When the wind dropped, the temperature was still and hot. At night the cabin was insufferably airless,

so Florence and Sam took to sleeping on the deck. The days fell into a sort of regular rhythm of sailing at daybreak, making occasional stops to see ancient Egyptian ruins, reprovision at market towns, or shoot some game; then they would stop at night to eat and rest.

Sam wanted to test out the rifles and pistols and find which performed best for which sort of task. Florence found she much preferred the beautiful little Fletcher rifle, as it was lighter and smaller than the others and had not such a powerful recoil. She soon became proficient with the Fletcher and was a good shot, though Sam was of course better. Sam preferred the larger-bore guns that packed a bigger wallop.

He had one custom-made rifle of which he was especially fond. "The Baby," as he nicknamed it, fired an explosive shell weighing half a pound and a charge of twelve drams of powder. He used it for the first time on a six-foot-ten-inch-long crocodile asleep on a sandbank of the Nile. After maneuvering the boat to within 120 yards of the beast, Sam fired and struck his target on the snout just in front of the eyes. The crocodile's head was thrown up by the blast, while the recoil hurled Sam across the boat, dislodging the gun from his hands. Sam was a little disconcerted—he had never before been knocked down by a rifle's recoil—but the shot was thoroughly effective and the crocodile was dead. The delighted crew rushed to retrieve the carcass so they might eat it.

Crocodile stew was one of the crew's favorite meals, though Sam and Florence found upon their first encounter with this dish that it was not to their liking. "Of all the rank stinking flesh I ever saw," Sam complained as he tried to chew the rubbery meat, "crocodile stands first. The flavor is between that of musky fish and the perspiration of a dirty person." He could hardly choke the dreadful stuff down, even when he cut the meat into small pieces.

"I watched the cook prepare it," Florence told him with distaste. "When he stirred the big pot, the crocodile's hand rose above the water and then disappeared again. It looked so human it made me shudder." She tasted the broth, which had great globules of grease floating on the surface, hoping it might be preferable to the meat. A single swallow of the foul, rotten-fish flavor was enough. "I do not think this cooking is very nice," she pronounced decidedly, putting down her spoon. They ate flatbread and agreed to skip crocodile stew from then on.

The Upper Nile offered endless opportunities for learning, about each other, about Africa, and about the boat. On this part of the journey,

Landing a Crocodile at Gondokoro (1874). Crocodiles made clearing the sudd a dangerous proposition, but the men were very fond of crocodile stew.

Florence and Sam were alone with only a few servants and workers. Sam recounted later:

> My impedimenta were not numerous. I had a *firman* from the Viceroy, a cook, and a dragoman. The *firman* was an order to all Egyptian officials for assistance; the cook was dirty and incapable; and the interpreter was nearly ignorant of English, though a professed polyglot.

Mahomet, the dragoman, usually worked as an interpreter on luxury boats that plied the Upper Nile carrying tourists to the ancient ruins. His prepared speeches about pyramids, temples, and Ancient Egyptian rulers were most of what he knew of English, and they were of little use. His severely limited vocabulary meant that his "translations" frequently bore only a faint relation to their intended meaning. Mahomet's lack of skill as a dragoman provided incentive for Florence and Sam to study Arabic devotedly every day. Though Florence spoke colloquial Arabic fluently, they knew that Sam would often have to speak for both of them. Arab men felt it beneath their dignity to converse or negotiate with women.

They observed the ways of the people who lived along the Nile a little,

marking the changes as they passed from one tribal group to another. On the Upper Nile there was a heavy Arab influence in culture and looks; the farther south they went, the more purely African the natives seemed. These racial and ethnic differences among tribes were all-important to the natives themselves. One group of natives would claim that other tribes downstream or across the mountains were disgusting naked savages because they had different marriage customs, or strange eating habits, or wore their scanty clothing differently. Treatment of the hair with oil or mud and the construction of elaborate braids, curls, or complex arrangements that were almost architectural were also of tremendous significance to the natives, indicating not only tribal affinity but also social status.

Natives frequently pestered Florence or Sam for baksheesh, whether a service had been performed or not. The art of giving a little, or refusing without insult, was one the travelers needed to perfect. From the natives' perspective, begging for money was not demeaning, since the ways of the dispensers of coins were so arbitrary. Who could tell what a white man wanted or would reward? Since they all seemed to be rich, it was always better to ask, in hopes of success.

There were also, of course, remarkable differences in what was considered normal behavior. On May 2 Sam wrote:

> Down one of the worst rapids about a dozen naked fellows shot like so many fish, some nearly swimming while others rode a kind of river horse in the shape of a log of light wood which they bestride like an ordinary nag, their weight sinking the log only so deep that the man was waist high above the water. This is their ordinary way of crossing the river. After their performance the stark naked party ran up to us to ask for *baksheesh*. I could not help thinking how much young ladies must gain by a journey up the Nile which affords such opportunities for the study of human nature. All the children are naked in these parts. The girls of eleven years are wearing nothing but a light fringe of black string about six inches long about their waist.

Though he was too English to confess it, the experience provided Sam himself a rare opportunity for the study of "human nature." In Victorian society a glimpse of a well-turned ankle or a handsome set of

feminine shoulders was enough to set a man's heart pounding. As Florence had almost no experience with naked males of any age, she found it an education to travel among these unclothed and unashamed people. She and Sam were confronted on an hourly basis with physical nakedness; muscles, breasts, buttocks, and genitals were exposed for all to see. The difference in the mores of the people among whom they traveled isolated them. They were a society of two.

After twenty-six days of sailing, they reached the town of Korosoko, where they disembarked and sent their boat back to Cairo. From here they would cross the desert by camel to rejoin the Nile, rather than sail up the Nile in a wide loop that would take them miles out of their way. Planning to go by camel and obtaining suitable mounts proved to be widely different tasks.

On May 12 Sam started bargaining with the sheik of the bedouins for camels. Florence primed Sam with the phrases to use, the sort of playacting that was effective, and the almost ritual turns that negotiations often took. As she had expected, the sheik's opening price was outrageous; Sam told him so and immediately offered a much lower price. To explain his refusal, Sam cast aspersions on the quality of the camels, a matter about which he knew nothing but pretended to: they were scrawny, not muscled enough, and that one had a mean eye and would doubtless be difficult to handle. In response, the sheik sang their praises: no, by Allah, they were the best of camels, each one strong with comfortable gaits. Back and forth it went: this one didn't look as if it could carry a heavy load, with that sore on its back; ah, but *this* one was very large and could carry extra weight without difficulty; *that* one looked a little lame and would surely not hold up for the journey; not at all, everyone knew that these camels were very healthy and strong. Eventually the sheik pretended that Sam's insistence on paying a more realistic price was a personal insult and stalked off with his head held high.

"Now what are we going to do?" Sam turned to Florence, worried and discouraged. "No one else has enough camels for our needs, and we will have to negotiate separately with several dealers. It will be a nightmare!"

Florence was not dismayed at all. "His leaving is just what we wanted," Florence explained exultantly. "Now he has been rude to you, treated you as if you knew nothing about camels or the prevailing prices. This is excel-

lent! He has walked away from the discussion and refused us assistance, a serious mistake. Send him a very formal message, with many flowery greetings. Say also that you regret you will have to report to the viceroy that his *firman* is of no use whatsoever, save to raise the price of camels twenty percent over the normal price."

It was a clever strategy, and before long Sam and Florence had hired sixteen camels to carry themselves, their cook and dragoman, a guide, some camel drivers, and a voluminous pile of luggage and supplies to Berber. They set off on May 16. The camels were indeed hardy and strong and well able to function in the intense heat, which at times exceeded 137 degrees Fahrenheit in the sun. The humans had a much harder time than the camels. The desert wind, known as the *simoom,* seemed to suck the moisture right out of their bodies as if they were exposed to a blast from a furnace. Sam had brought 108 gallons of water from Korosoko in *girbas,* goatskin water bags, plus two large barrels of water. *Girbas* did not hold much but had the useful property of permitting a small amount of evaporation, which meant the water stayed cool enough to be pleasant to drink. However, in the burning, dry heat of the *simoom,* a poorly made *girba* could lose too much precious water to evaporation. Sam soon realized that those sewn with leather thongs were more watertight—because the thongs swelled when wetted—than those on which thread had been employed, of which he had far too many.

There was only one source of water on the way to Berber, an extinct crater that collected salt and acrid water in its bowl. Known as Moorāhd, or "bitter well," its distance from Korosoko at the one end and from Abou Hammed at the other had taken many lives. The surrounding desert was barren and nearly lifeless. For miles there was nothing but an endless stretch of blazing hot sand under a merciless blue sky. They breathed sand, ate sand, drank sand, slept on sand, and dreamed of sand.

The desolate landscape surrounding Moorāhd was littered with the dried remains of camels that had perished before reaching the well. There were so many carcasses that the crows and vultures could not keep up with eating the flesh; the bodies were desiccated in place, without disturbance. Once their camels died, had the humans on those caravans survived? It was not likely. The killing dryness was no respecter of people. In the distance Florence and Sam could see hills, but they offered no comfort.

They were treeless, sterile granite or dark volcanic rock. The desert was a dead zone, a dangerous terrain that forgave no mistakes in navigation or provisioning.

The Desert Journey (1867). Florence and Sam rode camels from Korosoko to Berber across the barren desert, where the simoom felt like a furnace blast and any miscalculation in water supplies would spell death.

At night temperatures fell to a blissfully cool 78 degrees Fahrenheit and the camel men shivered in their robes as the expedition moved along. After the *simoom* ceased its howling, the desert turned still and beautiful. Moonlight transformed rock formations into weird and unearthly shapes, sand dunes into imaginary seas. They encountered no signs of life or civilization at all. As much as possible, they traveled at night and during the cooler hours of the morning, resting during the balance of the day. Sometimes the only meager shade was that cast by the camels themselves. Long before they reached Moorāhd, Sam was enervated and Florence was ill from heatstroke and dehydration. Florence felt obliged to wear women's clothes, as they were still in a region sometimes visited by European travelers. She perspired uncomfortably in her high-necked, long-sleeved blouse and long, heavy skirt, even though the moisture evaporated quickly into the arid air. She could not drink enough to replenish her body, and stopping to regain her strength was impossible. They had to push on as quickly as possible toward the well. In the desert water was life. A day of rest meant a day's extra water consumption and a day's delay in reaching the next water source. A day could kill.

Groaning and gurgling in complaint, the camels padded on, their shifting loads and bells making a constant tinkling sound. The camel drivers began to run worryingly short of water. Sam had warned them to bring plenty, but perhaps they did not believe the trip was as long as it was—or perhaps they had counted on being able to steal water from Sam's supply. On the first night a *girba* full of water had disappeared. Every night thereafter, Sam made sure that he or Mahomet guarded the water supplies diligently and no more was stolen.

After forty-six hours and forty-five minutes of forced march over several days, the caravan reached the valley of the water hole, Moorāhd. It was the worst place they had been yet. The air was even hotter than in the rest of the desert because the high, dark rock formations on either side of the valley radiated heat like an oven. When the camels came within smelling distance of the water hole, the camel men lost control of them. The animals ran frantically for the water, collapsing onto their knees and drinking their fill as fast as possible. The camel men, the cook, and the dragoman followed suit, running and flinging themselves down at the edge of the acrid water next to the camels. For some reason, the Arab guide who had led them all there held back and waited.

Florence and Sam celebrated their arrival at the water hole with a large drink of water from their precious supplies. They then retreated into the privacy of their tent to share a modest "bath," which consisted of about two quarts of water that they sponged onto their bodies from a basin. They were so dehydrated that it felt as if they could absorb water directly through their skin. This was the only place since Korosoko where there was enough water to wash; feeling wet and clean was luxurious. When their bath was finished, Sam carried the basin outside and told Mahomet to throw the dirty, soapy water away. Before Mahomet could comply, the guide snatched the basin out of his hands and drank it down greedily. "El hambd el Allah!" he cried: "Thank God." He preferred used bathwater to the salty fluid available from the water hole.

Florence and Sam were elated and amused. "We have gotten this far, Flooey," Sam exulted. "This is our first triumph. Many have died before reaching Moorāhd, but our prudence and good planning has seen us through."

"Yes," agreed Florence with a grin, "but I tell you, Sam, I think I am done."

"Done?" asked Sam, alarmed. He thought she was misusing the British expression "done for," meaning "finished" or "dead."

"See, I have a nice brown crust," she answered, rolling back her sleeve and tapping the skin of her arm, which had burned through her blouse. "I am a good loaf of bread in the oven." They had a hearty laugh together and settled down to sleep, fully contented with each other and their accomplishment.

After six hours' rest, the water bags were refilled, the camels were loaded up again, and the expedition set off on the last leg of their trek to Abou Hammed. They rarely spied signs of life, just a few gazelles and the odd, stunted acacia tree here and there. Sam counted an average of eight dead camels per mile on this stretch of the journey, with the carcasses concentrated in the spots where the going was worst. Two days before the caravan reached Abou Hammed, the camels were again parched and the men's provisions and water were exhausted. Taking pity on them, Florence prevailed upon Sam to open and share out their "sacred stock" of water from the barrels. The expedition arrived, exhausted but alive, at Abou Hammed at about four-thirty on the morning of May 23. They had marched upward of thirteen hours a day for ninety-two hours over a total of seven days, Sam noted. He reckoned that loaded camels walked two and a half miles per hour, making the total distance 230 miles. Abou Hammed was almost two thirds of the way to Berber.

They rested in Abou Hammed for two days. While they were there, one of the Arabs clumsily broke the thermometer. Florence and Sam could no longer keep track of the daily temperature. What was worse, they would not be able to calculate altitude without a thermometer, so it had to be replaced as soon as possible. There were, of course, no thermometers to be had in Abou Hammed.

They set off again early on the third morning. The heat was just as fearful and the *simoom* as inexorable as before. After a few days Florence was so ill that the expedition stopped for half a day on May 27 to allow her to recover. Sam found some gazelles to shoot, and the fresh meat helped revive Florence. The dryness attacked everything. The leather covers of

the gun cases shrank so badly that they had to be cut open to extract the guns. The ivory knife handles split, and wooden items of any sort warped and twisted as they gave up their last vestiges of moisture. Florence's face felt like crinkled parchment paper. Her eyes were as gritty as the bottom of a dried-up pond. After marching another 143 miles, the tired travelers reached Berber, a large town along the Nile.

Civilization, for so did Berber appear to Sam and Florence, was relative. The town had dusty, unpaved streets and simple, flat-roofed houses made of mud brick. Yet Berber also boasted well-watered gardens of fruits, vegetables, and flowers, date and palm groves full of singing doves, and citrus trees that provided welcome shade to rest in. Berber was an object lesson in the vast power of water to transform the desert into a charming, habitable oasis. The town reminded Florence of the elaborate gardens in the courtyards of some of the *haremliks* she had visited.

The local governor resided in Berber, guarded by about fifteen hundred soldiers who also enforced the law and kept the peace. Florence and Sam sent their *firman* to the governor with the dragoman as soon as they arrived, for this was their most important social and political obligation. The ex-governor, Halleem Effendi, gave Florence and Sam permission to camp in his luxuriant, fruit-filled garden, which was so green it seemed a paradise to them after the endless yellow sand.

Late that afternoon the governor, ex-governor, and an entourage of officers called upon Florence and Sam in the garden to inquire as to the purpose of their journey. The *simoom* still blew so strongly that Sam and Florence had to receive their visitors lying down. Fortunately, the dignitaries were not offended, since reclining on carpets and pillows was a habitual posture among the Turkish.

Upon hearing that Florence and Sam hoped to discover the source of the Nile, the visitors were astonished. "The head of the Nile?" they exclaimed. "Impossible!"

"Do they know where it is?" the governor asked the dragoman, who answered his master and mistress did not know where the Nile began but proposed to discover the place. The men shook their heads in disbelief. They drank their coffee politely and smoked in silence until their host, Halleem Effendi, offered this sage advice:

Don't go upon so absurd an errand; nobody knows anything about the Nile, neither will any one discover its source. We do not even know the source of the Atbara; how should we know the source of the great Nile? A great portion of the Atbara flows through the Pasha of Egypt's dominions; the *firman* in your possession with his signature will ensure you respect, so long as you remain within his territory; but if you cross his frontier, you will be in the hands of savages. The White Nile is the country of the Negroes; wild, ferocious races, who have neither knowledge of God nor respect for the Pasha and you must travel with a powerful armed force; the climate is deadly; how could you penetrate such a region to search for what is useless even if you should attain it? But how would it be possible for a lady, young and delicate, to endure what would kill the strongest man? Travel along the Atbara river into the Taka country, there is much to be seen that is unexplored; but give up the mad scheme of the Nile source.

It was an apt analysis of their situation. Anyone but Florence and Sam would have heeded it and revised their plans. But Florence and Sam had already accomplished the impossible. She had been kidnapped into slavery and escaped it; he had stolen a girl from the harem, in complete defiance of his society's norms, and fallen in love with her. They had already crossed the dreadful desert from Korosoko to Berber, an endeavor that had killed many Arabs familiar with the region. What was it to Florence and Sam to attempt one more impossibility? Even though they were both already suffering from attacks of fever that might have dissuaded the less courageous, they were determined to investigate the Atbara River and then attempt the White Nile. Their heavy baggage—twenty-eight individual pieces—was unloaded and sent ahead to Khartoum by boat so that they could travel more lightly.

Halleem Effendi's tranquil garden was an excellent place to rest and recuperate. On another evening, a request came for Florence from Halleem Effendi's harem: could they please call upon the English lady (for so they took her to be) the next day? Sam obligingly quitted the tent for the shady date-palm grove while Florence received the delegation of ladies.

Like a flock of parrots, they arrived in a flutter of brilliant yellow, magenta, scarlet, blue, and green robes, accompanied by several eunuchs and

attendants. Their dress vividly recalled to Florence her own harem days. How interesting and enjoyable it would have been for her then to have a chance to visit with an English lady! What an amusement it would have been to see her different style of clothing and jewelry, to see her temporary abode and find out how she lived!

Since she spoke some Turkish and more Arabic, Florence was able to talk with the ladies quite well. The style of compliment and the gentle verbal skirmishing of the harem came back to her immediately. She learned each woman's family and history, admired the luxuriant hair of one and the jewels of another, and gave them a few small gifts from England as favors. The women were delighted with their gifts and even more pleased with the chance to examine all of Florence's wardrobe and possessions. Her elegant gowns from Bucharest caused much exclamation, but the ladies thought her pearl and garnet jewelry a little plain, Florence surmised. For the week after the harem visit, the camp was deluged with fruits and vegetables, flowers for Florence, and visitors for Sam. The husbands, brothers, fathers, and miscellaneous relatives of the harem ladies appreciated the courtesy their women had been shown, and wished also to see the unusual items these Europeans carried.

Despite the pleasantness of their locale, Florence and Sam noticed that the *simoom* was worsening. Swirling dust settled out of the wind and coated everything. The ugly yellow haze in the air did nothing to lessen the intensity of the sun. Florence and Sam both began to suffer from "a peculiar fever," which Sam was at pains to describe in detail in his journal:

JUNE 8 SUNDAY. It begins by a feeling of extreme lassitude, pain in the limbs, inclination to lie down, thirst, loss of appetite (no headache). A burning sensation suddenly commences, pulse weak 125 to the minute, great difficulty of respiration and airing of chest, *total* prostration of strength and vomiting. Treatment: 1½ grain emetic tartar to assist vomiting. Allow stomach to rest after vomiting ceases for an hour; then give half a pint of mulled claret and opium with ginger. This produces a profuse sweat and the pulse falls. . . . Then give two grains quinine, 5 drops of Sulphuric acid, 10 drops camphorated salts. The sweat induces sleep and upon wakening, the fit is passed away. Give 6 grains of quinine and 5 drops of S. acid and give 2 grains of quinine every 4 hours for 2 days.

While waiting to recover his strength, Sam summarily fired their dirty cook. He hired another, who was recommended to him. When Halleem Effendi recognized the new cook as a "notorious thief," he ordered the man who had suggested the new cook to be given two hundred blows with a whip for lying.

On June 10 Florence and Sam left Berber with yet another cook but no diminution in the frequency of the peculiar fever and other ailments. They had a new group of porters and attendants too. Only the dragoman Mahomet stayed on, and he was firmly convinced that his employers had taken leave of their senses to travel in such a supremely uncomfortable style. As a sort of passive protest, Mahomet became intermittently "deaf" after they left Berber, unable to hear awkward requests from Sam or Florence. When not conveniently deaf, Mahomet was unbearably irascible and miserable; he was nearly useless, but they felt obliged to keep him until they were certain of their command of local Arabic.

Florence and Sam traveled the next leg of their journey on donkeys, which walked more rapidly than camels, Sam carefully observed, but which had a greater need for both water and forage. The camels were so Spartan in their need for forage that they might feast happily on vegetation as succulent as "a green umbrella and a *Times* newspaper," he noted.

The heat was dreadful. With Florence's ability as a seamstress and Sam's experience in living rough, they had soon perfected comfortable garments. Sam wrote in his journal:

> I dress in brown flannel shirt, arms bare to elbows, belt and pouches, loose light brown gingham trousers and leech gaiters—pith cap covered with light brown stuff . . . a useful and invisible dress. Of course the arms suffer at first from the sun but they soon become as hard and brown as hazel.

With only a few modifications, Florence wore the same outfit. Her trousers were a little looser, her long overshirt covered her arms, and her hat was broad-brimmed to protect the skin of her face. Her garments were as practical as Sam's and much cooler than a dress or blouse and skirt. They gave her a welcome freedom of movement.

Living in tents was fairly comfortable, as they were easily shifted to catch what shade there was as the sun moved across the sky. Because of

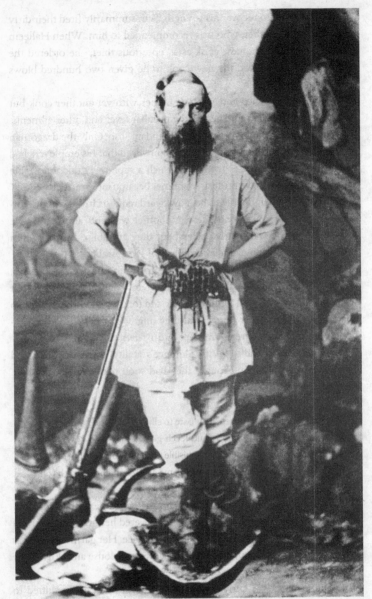

the lack of water, the region had few trees, only a number of "wretched bushes dignified by the name tree here," Sam recorded in disgust. Florence and Sam suffered from intermittent attacks of malaria compounded by heatstroke and dehydration. The prophylactic use of quinine to prevent malaria was unknown at the time, and the doses used once malaria was contracted were insufficient to effect a cure.

At last, day by day, the weather grew cooler and more humid as the rainy season approached. A cool breeze from the south became a regular and welcome companion replacing the *simoom*. Sometimes they could see fluffy clouds in the sky, but these, heartbreakingly, seemed to evaporate before loosing any moisture. The red cuckoo cried a three-note song over and over, maddeningly: *it will rain, it will rain*. A few days out of Berber, they reached the junction of the Atbara and the White Nile. At this time of year, the White Nile was a broad sand river. There were only occasional pools of standing water, and those were thick with wriggling fish, crocodiles, turtles, and hippopotami. The gazelles, hyenas, birds, and wild asses all crowded into the same few water holes in dry season, as did the flocks of goats and sheep kept by the local Arabs. At least the Atbara had enough underground water to support a gallery forest alive with birds and thick stands of dome palms with distinctive fan-shaped leaves. The palm fruit was bright orange and looked as if it had been polished by a diligent housemaid. The local Arabs prized the palm fruit, which they pounded into a powder from which they made a porridge that Florence and Sam pronounced delicious. It tasted a little like gingerbread. Corn and sorghum were cultivated locally and ground into a flour called *dhurra*, which was the other local staple and the main ingredient of an unleavened bread.

Because water could always be obtained by digging in the sand river, the expedition was now freed from the tedious necessity of carrying enormous supplies of water as they made their way along the Atbara. The largest remaining pool they came upon was nearly a mile in length and lay some 160 miles from the junction of the Atbara and the Nile. Here Sam was able to fulfill a fond wish to hunt hippo. It

Sam the Hunter (1865). Florence made practical garments for Sam to wear in the field and copied them for herself. This photograph is a studio image taken in England.

was part public service, for a hippo had been raiding the carefully tended melon patches and had killed a man.

Stalking along the riverbank in search of his prey, Sam was alerted by a loud snort followed by a deep, repetitive grunting like very low-pitched laughter—"huh-huh-huh-huh-huh"—behind him. He had passed his quarry unknowingly, while it was underwater. He turned and walked a half mile back, watching the surface of the water carefully for ripples. Finally he came upon a group of six hippos standing in shoulder-deep water. His first shot, with the Ceylon No. 10 double rifle, caused a terrific commotion that Sam described later:

At the report of the rifle, five heads sank and disappeared like stones, but the sixth hippo leaped half out of the water, and, falling backwards, commenced a series of violent struggles: now upon his back; then upon one side, with all four legs frantically paddling, and raising a cloud of spray and foam; then waltzing round and round with its huge jaws wide open, raising a swell in the hitherto calm surface of the water.

A few more shots with the No. 10 and the Fletcher double rifle No. 24 completed the kill. Sam left the first hippo and followed the five others downstream, where he soon dispatched a second hippo.

Three hundred Arabs came running wildly, knives out, to haul the carcasses from the water and butcher them. Two hippos: what treasures! Sam gave his permission for the carnage to begin, and a veritable slaughterhouse sprang into being. In moments people were covered in blood and fat. Men stood knee-deep in hippo intestines and fought aggressively over the choicest bits. Women participated too, hacking off great slabs of fatty meat for their families. Sam returned to camp, his guide carrying two choice hippo steaks, which were grilled for breakfast for Florence and Sam. When they returned to the scene of the kills later, every scrap of the hippos was gone. Uneaten portions of meat were cut into strips and dried for future consumption; hides would be tanned to make *girbas*; bones were pounded into splinters to remove the marrow, a special delicacy, and any remaining morsels put into pots for soup. Sam was welcomed as a hero by the Arabs for supplying them with so much food.

On the night of June 23 the rainy season arrived with a vengeance.

There were no clouds in the sky, no flashes of lightning or thunder, no drops of rain. It began with nothing but an ominous rumbling that came out of the darkness. Some of the Arabs awoke and recognized the sound. "El Bahr! El Bahr!" "The river! The river!" they shouted, awakening their own camp and the expedition's. Everyone and everything had to be removed from the riverbed to the safety of the banks. In minutes a massive wall of water came charging down the riverbed like a locomotive. In the morning Florence and Sam found a silver sheet of water where the night before there had been smooth, dry sand. Within days, the barren desert blossomed with leaves and flowers and fruits, and animals and birds gave birth. Huge flocks of migratory storks and other birds appeared as if newly created.

"That is it, Florence," Sam said, his voice choked with emotion, as he gestured to the life-giving water that had appeared seemingly out of nowhere. "That is the key to everything. The rains are pouring in Abyssinia! *These are the sources of the Nile.*"

6

HEART OF A LION

*A*nother six days' marching brought Florence and Sam to Gozerajup, about 220 miles from the junction of the Atbara with the Nile. The village was inhabited by Bishareen Arabs, the largest Arab tribe of Nubia.

Gozerajup was appalling. Its inhabitants suffered from a complete ignorance of or a disregard for sanitary habits. Human waste and garbage contaminated the river that the people drank and washed in, yet the village never moved. No one dug proper latrines. No one even bothered to gather drinking water upstream of the village.

"The river is as thick as pea soup," Sam wrote in his journal, "and not only undrinkable but unwashable. . . . All water and likewise milk should be boiled in this country before it is drunk—fever lies in both." Why did people choose to live like this? They could not imagine.

Florence and Sam did not want to drink water out of the river at Gozerajup. They preferred to drink milk, which seemed surprisingly scarce despite the large number of cows in the area. When they sent their Turkish soldiers to buy milk, they were offered an inventive and seemingly endless set of excuses as to why there was none. Florence

and Sam began to suspect that the villagers simply disliked the soldiers and refused to oblige them. After a few days the Turks lost patience and beat villagers with a hippo-hide whip known as a *coorbatch*, freely, cruelly, and randomly. After that, milk became miraculously available. One of the Turkish soldiers solemnly informed Sam and Florence that they knew nothing of the Arab character or how to manage such people. It was ridiculous to pay good money to "Arab dogs" when casual brutality worked better. Violence was a primary medium of communication along the river.

The expedition left the banks of the Atbara to head east toward Cassala, a principal town of the Sudan second in importance only to Khartoum. The amount of animal and bird life had increased extraordinarily simply because the rains had begun. They passed great herds of wild asses or gazelle and admired endless flocks of pigeon, guinea fowl, and migratory birds. Leaves seemed to burst out minutes after a tree or bush had been seen to be barren. Cassala lay on the river Gash in the country of the Hadendowa Arab tribes and was a major trading center for gum arabic, senna, ivory, hides, beeswax, and black slaves.

Florence noticed that most of the slaves in Cassala were from the Galla tribe, as had been some of the slaves in Viddin. Using Arabic and what little Galla she knew, she asked about their lives. Like Circassians, Galla were commonly sold into slavery by their parents when they were children. Her own confused memories of losing her parents and being sold into the harem were too painful for her to hear such stories calmly. How could anyone do such a thing to an innocent child? Here children were literally possessions of their father, not people; they could be seized to pay debts, for example. She could not shake her disgust at this principle.

She was learning too that although the slave trade along the Nile fed both the Ottoman Empire and the countries of Africa, local conditions of enslavement were very different from Ottoman ones. In Africa, none of the slave children were trained or educated; there were no wealthy households comparable to those in the Ottoman Empire. Slaves in Africa were drudges, unpaid servants of the lowest order. They were worked, beaten, fed when convenient, and starved when not. They were or were not sexually exploited, according to their owners' whims. And slaves in Africa were never manumitted except by death, unlike those in the Ottoman Empire.

In Gozerajup there was a sweet-faced young girl, three or four years old, who followed Florence about in fascination. Florence reciprocated with such kindness and interest that one day the child's mother asked her to come to the girl's big ceremony. She said it was a time of great danger to the child, so no man could approach, but Florence would be safe. She followed the woman to an isolated hut crowded with other women. The air was close and smoky. Some sort of herb was being burned and wafted around, masking the odor of unwashed female bodies. Florence was urged to go into the center of the hut, as an important visitor. There she witnessed a scene of such deep and unexpected horror that she did not know what to do.

The hut was dark after the bright sun outside, but in a few moments Florence's eyes adjusted to the light. The little girl sat naked and proud in the middle of a ring of women. At the direction of her mother, the girl lay down on her back. Her mother knelt, placing her knees on either side of the girl's head. She massaged the girl's shoulders with some sort of ointment. Other female relatives knelt to massage her arms and hands, legs and feet. Then an old woman took out a shining knife and the massaging hands turned to restraints. The old woman started to cut between the child's legs and the girl shrieked with pain. She struggled to move or get away, but the hands of her loved ones kept her still. She cried out over and over again, begging for help, as the knife sliced and sliced again. When the old woman was satisfied, she asked the child's mother to inspect her work. The mother looked closely and nodded. Then the old woman sprinkled some powdered myrrh onto the wounds and pinned the two bleeding surfaces together with acacia thorns. She bound the child's big toes to each other to keep the child in position for the next two weeks. She would stay, alone and hurt, in the dark hut, while her wounds healed into a single great scar that left only a tiny hole for urination.

Florence watched in horror as the ritual unfolded, unable to leave and unable to turn away. The blood and the girl's obvious pain disgusted her; the mother's role frightened her. When she could stand no more, she rose and left the hut, saying that she felt faint. She stood in the air and the light, breathing slowly with her eyes tightly shut, trying to blot the gruesome vision from her mind. One of the older, unmarried girls brought her a drink of water, telling Florence it was a great day for the child.

"Is it done to everyone?" Florence asked in a trembling voice.

"Oh, yes," the girl replied proudly. "All the tribes from Cassala to Berber circumcise their women; we are very clean people."

"*All* the women?"

"Of course! No man would marry a dirty woman who had not been properly circumcised. Besides, an uncircumcised wife could take many lovers without his knowing."

Badly shaken, Florence made her way back to her tent. She felt like screaming and vomiting, wanted to burn down the village with everyone in it. How could anyone condone such mutilation? How could a mother perpetuate it upon her daughter at such a tender age? How could she listen to her child's cries and do nothing? She had no answers for the world's savagery. Later Sam found her in the tent, sobbing and shaking in outrage. He was aghast at what she told him. For science's sake, he recorded a description of the ceremony in his journal, but he had trouble finding suitably unemotional words:

The operation upon the females to secure their chastity is performed from the age of two years to five—the parts being scarified or rather the edges being shaved off with a razor, the knees and the big toes are tied together and the child lying in this position for about fourteen days, everything heals together like a natural wound. Thus an orifice no larger than a quill is left for the demands of Nature and there is no more semblance of actual sex than upon a marble statue.

When the marriage night arrives and the bridegroom is prepared to visit his wife, the women operate upon her by inserting a probe in the small orifice and pushing it upward in a direction toward the surface, the point of the instrument is soon felt near the skin. The probe acting as a guide, an incision is made with a razor from the entrance to the place defined by the point; but the aperture is not so large as originally intended by Nature. The husband is then admitted.

When the time of accouchement [childbirth] arrives it is necessary to enlarge the opening. The woman is thus delivered: A heap of clean sand is made, and kneeling upon this supported by other women she grasps a rope suspended from the roof and strains upon this. Stretching her knees as wide apart as possible and thus holding on the rope, her friends continually pass

their hand with considerable force down her sides and back, while another woman inserting the tube as formerly, enlarging the aperture to the greatest extent with a razor, and the infant at length enters his life turning a somersault upon the heap of sand. The mother being then attended to according to civilized custom is again forced to submit to a recumbent posture for about fourteen days, the knees and toes being bound together as formerly that the parts may again unite. A piece of wood is inserted to ensure an aperture of the size desired, and this is strapped around her to certain it in its place until all is properly healed. Thus do these beastly savages mutilate themselves not only to ensure chastity before marriage, but to increase their lustful desires afterward [by ensuring that the vaginal opening stays tight].

Florence was ill for some days afterward. She had nightmares and awoke feverish and sweating.

Florence slowly realized that her childhood was not so very different from that of this poor Galla child. In the harem Florence's potential sexuality had been confined and restrained at every turn. Like all females, she was veiled, sequestered, guarded, and controlled, kept from the sight of strange men. In Ottoman society, passing the family name, honor, and possessions from father to son was of paramount concern. An uncontrolled woman might take a lover and so make the paternity of the heir uncertain. Such a woman posed to the social order the most serious danger that could be imagined. The Galla enforced chastity more brutally, that was the main difference. Both practices met the same needs. So, Florence suddenly saw, were the rigid social prescriptions that ruled the conduct of women in Europe.

Florence had never thought about why societies were organized as they were—had never seen a pattern of organization. The customs that no one ever questioned had enormous power. *Men must have a tremendous fear of women to treat them so,* she thought. In her own life, the most pertinent issue was not whether Sam would marry her when they returned to civilization but whether she would marry him—and how she would live if she did not. As his mistress, she inhabited an ambiguous and difficult social position, but at least she existed as an individual. If they married, her legal and social existence would be subsumed in his. Her property, her children, her money, her physical self, would all legally belong to Sam. She

would no longer exist. If she were to live as she liked, as she needed to, Sam must agree not to engulf her.

To marry or not was a moot point, as the opportunity did not present itself in Cassala. She could decide later.

Sam's negotiations for fresh camels to carry them further met with little success, as the Arabs flatly declined to hire their animals out. The Turkish soldiers solved the problem once again by seizing as many camels as were needed, plus their owners to act as camel drivers. Additional men were needed, and Mahomet the dragoman begged Florence and Sam to hire a "near relation" of his, named Achmet. Everywhere they went, an endless parade of putative close relatives had pestered Mahomet for money, loans, or favors. It was the African way. Achmet was probably a lazy rogue or a thief; he certainly spoke no English and knew no useful trade. Sam agreed to take Achmet on trial but sternly warned Mahomet that he would be held personally responsible for his relation's good behavior.

A corporal from one of the Nubian regiments would be joining their expedition at the insistence of the governor of Cassala, who chose for the job a very tall, very black man named El Baggar, "The Cow," for his prowess in hunting the oryx, known locally as the cow of the desert. El Baggar would replace the odious Turkish soldiers, who were returning to Berber.

Finally, Sam hired two "wild young Arabs" who were about eighteen and twenty years old. One of them, Bacheet, proved "incapable of being tamed and domesticated." He was a source of much amusement. Mahomet was delighted to have an inferior to boss around. Bacheet learned that Florence and Sam, for some inexplicable reason, did not care for flies or other insects in their food or drink. His first appointed task was to waft the insects away and to remove them if they persisted in committing suicide by foodstuff. One morning Bacheet made a most interesting mistake in carrying out his responsibilities; Sam could not resist describing the incident in his journal:

> Bacheet, being caught wild had never seen a chamber pot. . . . At breakfast, observing a fly drowning in its contents under the bed, he carefully wiped a salt spoon which he took from the table, and thinking that the *drink* would be spoiled by the fly, *he took him out!*

Bacheet then carefully wiped the spoon on the tablecloth and returned it to its place next to the salt dish, satisfied he had done his duty. Florence and Sam laughed uproariously.

The rainy season had begun in earnest, so the expedition was frequently deluged. When they arrived back at the banks of the Atbara, the once dry river was full of water that ran dark with fertile silt. They wanted to spend the winter months in the village of Sofi on the other side of the river. There was a rude ferry to transport people, but animals were expected to swim across, supported by inflated *girbas* to get through the deepest parts. As camels are not fond of swimming, the camel men anticipated a prolonged ordeal of shouting, beating, pulling, and pushing the beasts into the water. Rather than facing it, the camel men and their charges absconded in the night.

El Baggar was dispatched to find more animals. When he returned, he announced that he had managed to obtain some baggage camels and even some *hygeen*, special riding camels prized for their comfortable gaits. Florence and Sam soon found that "comfortable" was a term defined differently by those who had grown up on camelback and those familiar with horses. El Baggar saddled up the easiest, smoothest *hygeen*, intended for Florence, to demonstrate its exceptional abilities. Sam wrote:

> I never saw such an exhibition! "Warranted to ride, of easy action, and fit for a lady!" This had been the character received with the rampant brute, who now, with head and tail erect, went tearing around the circle, screaming and roaring like a wild beast, throwing his fore-legs forward, and stepping at least three feet high in his trot. . . . A disjointed-looking black figure was sometimes on the back of this *easy*-going camel, sometimes a foot high in the air; arms, head, legs, hand appeared like a confused mass of dislocations; the woolly hair of this unearthly individual, that had been most carefully trained in long stiff narrow curls . . . alternately started upright *en masse*, as though under the influence of electricity, and then fell as suddenly upon his shoulders. . . . This object, so thoroughly disguised by rapidity of movement, was El Baggar; happy, delighted El Baggar!

As he was jarred up and down, El Baggar assured them that this was a lovely, flat-gaited camel most suitable for a lady. The others, he admitted, were a

little rougher. Trying to keep a straight face, Florence said she preferred another beast, a steady baggage camel that promised to be easier to stay on.

She later found that her camel was a stubborn creature given to dashing uncontrollably ahead to steal a mouthful of green leaves whenever possible. Listening to his rider's wishes was not among his accomplishments. Sam's camel made a specialty of bolting through thornbushes, which had the desirable (from the camel's point of view) effect of dislodging the luggage tied upon its back and redistributing items in all directions. When the thornbushes didn't succeed in dislodging Sam as well, the thorns shredded his clothing and skin, leaving him bleeding and nearly naked. The bad habits, irritable temperaments, and jerky, endless rocking motion of the camels made Florence and Sam long for a well-trained pair of horses.

Some weeks later, when they were finally loaned a pair of genuine *hygeens* by another sheik whom they met along the route, Florence and Sam discovered how pleasant travel on camelback might be. These elegant creatures were pure white, with swift, smooth-striding gaits that left the baggage camels far behind. A servant followed them closely, carrying a carpet for them to lounge upon, supplies for brewing coffee, and cold roast fowl and biscuits to be served for a casual repast. By the time the baggage camels finally labored into camp, the servant had already set up some of the tents and started to cook a meal. *Hygeens* were a distinctly superior mode of transport.

The torrential rainstorms grew more frequent as they moved southward. The dry rivers filled to the brim, and everyone and everything began to look glossy and fat. At night the thunder made sleep impossible and the rain fell like a waterfall unimpeded through the canvas of the tents, soaking Florence and Sam in their beds. In the morning the landscape was a sodden mud pit. The camels, so well adapted for the desert, could hardly walk. Their larg e, flat feet sank deep into the mire and came up bearing large clumps of mud. With each step, their feet became heavier and heavier. Their movements worked the mud into a filthy, slippery soup. Finally, the camels could walk no further and stood until a camel man cleaned their feet. Then the process began again. Some of the baby camels traveling with Arab caravans were so small they could not keep up even on dry terrain, so they traveled slung in nets suspended from their mothers' backs.

At Sofi, Florence and Sam were pleased to meet a German, Florian Mouche, who had been based there for years. Sam had heard of Mouche's prowess as a hunter and was eager to learn as much as he could from him about the country, the tribes, and the animals. He was by trade a stone-mason and had left his homeland to come to Africa with the Austrian mission, to convert the heathens. After a time, he found the work distasteful and he and a fellow German who was a carpenter took off to make their living as commercial hunters. They supported themselves by making and selling *coorbatchs* and performing odd building jobs.

Florence and Sam made their camp about three hundred yards from the Atbara, choosing a shady spot where the grass had been cropped by goats, so snakes or scorpions would not go unnoticed. Sam had the men dig drains around their camp to keep it from flooding and bought a large empty hut, which was rapidly dismantled and reerected in their camp. It was a "mansion"—their first home in Africa—and Sam described it play-fully as if he were an estate agent touting a property. The ownership of this mansion included

> the right of shooting throughout the parishes of Abyssinia and Sudan, plentifully stocked with elephants, lions, rhinoceroses, giraffes, buffaloes, hippopotami, leopards, and a great variety of antelopes; while the right of fishing extended throughout the Atbara and neighboring rivers, that were well stocked with fish, ranging from five to a hundred and fifty pounds; also with turtles and crocodiles.
>
> The mansion comprised entrance-hall, dining-room, drawing-room, lady's boudoir, library, breakfast-room, bed-room and dressing-room (with the great advantage of their combination in one circular room about fourteen feet in diameter).

At the back they had two huts that served as the kitchen and "servants' hall." Between the huts Florence had walks cut, which were filled with white sand. She spent some days collecting beautiful, multicolored agates and fossil wood to edge the paths. She chose scenic spots and had the men set a few large, flat rocks at each so one could sit and admire the view. Florence also collected wild plants, vegetables, and flowers and planted them in a small garden by the house. The flowers attracted brilliantly

colored sunbirds, tiny fast-flying creatures that sucked nectar from the blossoms. The gourd vines soon climbed up to the roof, where they made a leafy bower reminiscent of a rosebush on a Cotswold cottage.

"Sam," she remarked one day, after much thought, "I think it would be good if we had a table and chairs in the garden. We could dine outdoors or sit and watch the sunset. We could put them just there," she said, pointing, "yes?"

Sam agreed and set about constructing a rustic table from bamboo and two matching chairs. He was pleased by the feminine touches of comfort and beauty that Florence brought to their camp. Besides, he loved a building project of any sort.

Florence carefully lined the inside of the hut with canvas, to keep the insects and snakes that inhabited the thatch out of the living space. Canvas was a most practical wall covering in a house without shelves or cupboards. Maps, sewing notions, guns, instruments, and fishing rods were suspended in baskets or nets attached to the canvas to keep them away from the ants and termites that ate everything. Soon the camp was cozy, neat, and functional. In the late afternoons the couple sat admiring the lovely view from their garden in peace and contentment.

The rainy season soon washed their comfort away. Horseflies, tsetse flies, mosquitoes, and every sort of stinging or biting insect now hatched in the millions. Insects transformed coffee into a wriggling soup before a cupful could be drunk, no matter how hard Bacheet tried to keep them away. People and animals alike were covered in welts and sores from biting flies. Ox peckers and egrets stood on the animals' backs and picked away at the sores, removing lice but also enlarging the wounds. The donkeys were so tormented that they refused to graze in the open, preferring to stand in dense smoke clouds produced by burning green sticks and grass.

Fever struck hard. Sam doctored the German, Mouche, and the men when he was not tending to Florence. She suffered from a terrible attack of gastric fever that kept her miserable in bed for nine days. An outbreak of boils—disgusting, pus-filled skin eruptions—infected almost everyone in the camp. Sam knew no cure, so he improvised one based on a remedy he had used to cure dogs of the mange at home. He mixed gunpowder and sulfur together, adding water and fat to make an ointment, which he rubbed into the skin. This noxious mess made Africans appear shiny black

and white men look like they were wearing blackface, but it seemed to work.

The Arabs, Sam learned, were woefully ignorant of medicine and preferred to trust in magic to heal their ills. Relics of religious men, mementoes of a trip to Mecca, ink used to write the verses of the Koran, and talismans of all kinds were considered effective medicines by the Faky, a self-proclaimed holy man who was the local healer. He prescribed drinking a quart of hot fat to relieve fever or to cure syphilis. The Faky also believed that failing sexual powers could be renewed by eating crocodile, which Sam supposed accounted for the immense popularity of crocodile stew.

Sam undertook project after project. He made new shoes for himself and Florence out of the hides of animals he had shot and tanned. He also decided they should have a canoe for crossing the river whenever they wanted. For days he labored to carve one out of a solid log, but the result was so heavy it promptly sank. His next attempt was to make a raft out of bamboo. It floated but was unstable and very difficult to steer. Bored by inactivity, Sam stared longingly at the opposite bank of the Atbara, which was tantalizingly alive with game—elephants, giraffes, and gazelles—that he had no way to reach.

To Sam's immense delight, he encountered some Hamran Arabs, a tribe noted for hunting elephant and other big game with swords. Even though Sam was skilled at hunting, bringing down an elephant with a sword seemed well-nigh impossible to him. He was happy to go hunting with the *aggageers*, the sword-hunters, who carried only unornamented hide shields and swords. Sam inspected the swords carefully. With the hilt, they averaged about three feet six inches long, and they were kept sharp enough to shave the hairs off a man's arm. The ones used for elephant hunting were bound with cord from the hilt to about nine inches down the blade. This enabled the elephant hunter to wield the sword with his left hand, while he placed his right on the corded area to enhance the accuracy and force of a blow.

Elephant hunters worked in twos or threes with fast horses. One man, the decoy, would induce the elephant to chase him and then allow it to come right up on his horse's tail. While the elephant was distracted by the decoy, the others galloped up from behind. The first pursuer jumped off

his horse and severed the elephant's Achilles tendon with a single blow of his sword. The second pursuer held the bridle of the first horse, assisting the first man in remounting rapidly. Then the decoy circled back and provoked the elephant until it charged again, a movement that would dislocate its injured foot. The final blow, delivered by one of the pursuers, severed the elephant's other Achilles tendon. Thus immobilized by its two terrible wounds, the elephant bled to death. Sam was overcome with admiration for this carefully choreographed demonstration of hunting skill and declared himself a mere amateur compared with the *aggageers*. He hunted with them many times, returning with meat for the larder and skins to be tanned and used.

With familiarity he began to learn a great deal about Arab culture, some of it troubling. In disgust, Sam wrote in his journal on August 19:

Nothing can exceed the abject savagedom of the women of this country; taken as children at the age of 10 years by libidinous men as wives nominally, but as slaves in fact. [Women] have none of the feelings which give them their charm in other lands. . . . Real love is unknown; a forced chastity is by a surgical operation rendered necessary until marriage, and as marriage may take place at the early age of ten or twelve years, the necessity of such an operation sufficiently attests the brutality of the men and the utter savagery of the females. Thus, none of those emotions which the word love explains are in any way felt by the savages; they eagerly desire medicines to promote desire and they keep a certain number of wives as circumstance permits, generally three or four.

Sam's criticism was no hypocrisy. Though he had begun living with Florence when she was only in her midteens, and though he had kidnapped her in a manner of speaking, there was a crucial distinction: Florence's choice.

It was only occasionally, as she cuddled an adorable African baby, that Florence was sad she had not yet borne Sam a child. Sam had fathered seven children with his first wife; were he and Florence to have none of their own? A man needed an heir. It was a phrase uttered over and over again in her childhood in the harem, when the master's first wife—who bore only girls—was supplanted by an *ikbal* who, it was fervently hoped,

would at last bear him a son. Though Henrietta had borne two sons, Charles Martin Baker and John Lindsay Sloan Baker, the first had died in Mauritius and the second in Ceylon. A baby girl, Jane Baker, died at sea off the Maldive Islands. Now there were only the four Baker daughters, Edith, Agnes, Constance, and Ethel. Florence thought it would be her greatest gift to Sam, her greatest point of security, if only she could bear him a son.

She considered why she had not yet conceived. In the dry season, they were on the march, which was physically demanding. She grew strong but thin then, perhaps too thin to carry a child. Yet she could hardly take to her bed, as ladies in Europe who suffered from miscarriages sometimes did. In the rainy season, food was more abundant but so were the pestering, horrible insects. She was more often ill with fever or other complaints. Neither the rainy nor the dry season could be avoided or changed. But Florence had plenty of hope and youth, and they might effect a cure for her infertility in time.

She and Sam were weary of Sofi and wanted to move on; the Germans Mouche and his carpenter friend decided to come with them. Although they had heard endless tales of the ferocity of the Basé who inhabited the other side of the river, the numerous elephants were too tempting for Sam to resist. He calculated the number of his guns and men and felt they could put up a formidable resistance if attacked. He decided to cross the river once again now that the rainy season was coming to an end.

On September 12 and 13, observed by a horde of helpers and bystanders, Sam and Florence set out to move themselves, their belongings, and their men. Sam's wobbly raft was abandoned in favor of an *angarep,* or bedstead, with eight inflated *girbas* attached to the sides to keep it afloat, rather after the manner of swimming camels across. On top of the *angarep* Sam lashed their large metal sponge bath, which served as the receptacle for people, tents, guns and ammunition, provisions, and any other necessaries that needed to be kept dry. He reckoned the boat could support 190 pounds without difficulty. It was an extraordinary contraption that caused much comment and inquiry among the natives.

Because the improvised boat lacked steering, Sam employed a team of hippopotamus hunters to act like tugboats, guiding the craft backward and forward across the river at his command. So great was their volume

of luggage that many transits of the river were required; the human tug-boats tired and had to be replaced several times. Sam considered it a great triumph when the only load that got wet was some corn.

Mahomet posed a greater difficulty. The saucy dragoman was a coward, and he feared losing his life by drowning in this peculiar boat. The boats he knew and trusted were Nile steamers, and this outlandish creation was nothing like them. After endless procrastination, Mahomet climbed reluctantly into the sponge bath, clutching a parcel of his clothing and leaving Achmet to guard his other personal possessions until the final trip. When he arrived trembling and pale on the opposite shore, Mahomet turned to look back at Sofi. Neither Achmet nor his belongings were any-where in sight. Mahomet screamed, waved frantically, and pleaded for help in capturing him, but no one would do his bidding. Mahomet dared not risk the crossing a second time and turned away from the river, a mis-erable and disappointed man.

In the new camp, Sam fished and hunted a great deal, discovering some delicious types of fish in the river. For hunting, Florence made him some tough gaiters of gazelle skin. They pulled on over the feet and tied both above and below the knee, thus protecting his lower legs from the sharply barbed grasses and thornbushes of the region. Many of the men fell seriously ill with fever in the new camp, and some died.

Sam began to worry again about Florence's position. Suppose he died of fever? On September 23 he composed a formal letter to John Petherick, the British consul at Khartoum, dictating instructions for Florence's care and finances in case of his death. He gave the letter to Florence before leaving on a prolonged hunting trip. After reading the letter, she carefully folded it up, and kissed Sam good-bye. She kept the letter with her at all times for months to come.

The hunting party marched toward the Settite River, where game abounded, but only a few gazelles fell to Sam's rifle that day. At night they slept rough. The smoke of the fires gave some protection, but the firelight also attracted insects. Hundreds of beetles became entangled in Sam's beard and then crawled inside his clothes. When he crushed them, they emitted a pungent, nasty odor. It was a crestfallen and odoriferous hunting party that returned to camp the next day empty-handed.

Florence awaited Sam's arrival with clean clothes, a fresh bath, and a

hot curry-and-rice meal, which he enjoyed greatly. Neither of them had been worried that Florence would be in danger left alone in a camp full of men. She was a formidable lady—a *sitt*—and not even the uneducated ruffians on this expedition would dare impose upon her. Aside from her moral dignity, Florence was fully capable of protecting herself with a gun.

They left on August 17, 1861, to go farther down the Settite River. Mouche was very weak; he had had fever for months. Unfortunately, he purchased a rogue of a horse thinking to make traveling easier. His disagreements with the animal began when he attempted to mount it from the wrong side, a practice to which the horse took great exception. The horse soon had the upper hand and deposited Mouche on the ground at will. At last, the German prudently decided he would rather walk than trust his life to the balky beast any further. He slowly became a more irritable and more difficult companion; he and his carpenter friend spent hours muttering together and expressing their dissatisfaction in German. Florence understood every word, of course, though she and Sam sometimes conversed in English now. Neither Florence nor Sam was sorry when the two Germans quitted the expedition shortly after Christmas.

In October, more rain fell and more men fell ill. Everything began to rot, mold, and mildew: clothes, canvas, leather, even the pages of books. Sam scribbled irritably in his diary: "The curse of Africa is the want of water. It really is a trying country. In the rainy season this part is lovely—one vast carpet of green grass and dark shrubs—but the mud! Oh the mud! No one can understand it, no animal can travel through it." They were trapped, unable to travel at all. Everyone was intermittently ill, even Sam. The rains dispersed the game animals but attracted birds in extraordinary numbers: buzzards, hawks, ducks, storks of several varieties. The tinkerbird gave its maddening call of "*tink-tink-tink*" all day long.

Sam bought three new horses, a bay he named Tetel, or "hartebeest," and two grays he called Aggahr, after the sword hunters, and Gazelle. Florence and Sam also made the acquaintance of Sheik Achmet of Wat el Négur. As had happened before, the sheik's wives called on Florence and inspected her possessions with wonder. They admired her soft hands, which had never ground corn or done hard labor. They thought her the *ikbal*, or favorite, in Sam's harem, though the want of beautifying henna patterns on Florence's hands struck them as odd.

In private the sheik asked Sam to explain the domestic arrangements common in England. Sam painted his culture in such glowing colors that the sheik was convinced England was a charming paradise, full of gloriously attractive women.

"How," the sheik asked with a sigh, "could you possibly come away from all your beautiful wives? True, you have brought one with you: she is, of course, the youngest and most lovely; perhaps those you have left at home are the *old ones*!" He looked at Sam inquisitively.

Sam explained that a man was allowed but one wife in England. The sheik and the Arab men in his retinue were tremendously indignant and disbelieving. "Why," the sheik exclaimed, "the fact is simply *impossible*! How *can* a man be contented with one wife? It is ridiculous, absurd! What is he to do when she becomes old? When she is young, if very lovely, perhaps, he might be satisfied with her, but even the young must someday grow old, and the beauty must fade. The man does not fade like the woman; therefore, as he remains the same for many years, but she changes in a few years, Nature has arranged that the man shall have young wives to replace the old; does not the Prophet allow it?" He suspected Sam was lying to him.

"Look at yourself," the sheik invited Sam. "Your wife is young, but in ten years she will not be the same as now; will you not then let her have a nice house all to herself, when she grows old, while you take a fresh young wife?"

Sam's assertion that Englishwomen never grew old and only improved with years—were in fact better loved with time—failed to convince his listeners. "You men are selfish," Sam accused them. "You expect from the woman that which you will not give in return, 'constancy and love'; if your wife demanded a multiplicity of husbands, would it not be impossible to love her? How can she love you if you insist upon other wives?"

The sheik would have none of this. "Ah!" he answered, shaking his head in mystification, "our women are different to yours, they would not love anybody; look at your wife, she has traveled with you far away from her own country, and her heart is stronger than a man's; she is afraid of nothing, because you are with her; but our women prefer to be far away from their husbands, and are only happy when they have nothing whatever to do. You don't understand our women, they are ignorant creatures, and

when their youth is past are good for nothing but to work." Sam and the sheik parted amicably, agreeing that perhaps it was right that different customs pertained among different peoples.

As Sam walked back to the tent that night, his head was full of the subjects they had discussed. *Perhaps,* Sam thought, *he is right and I do not understand Arab women. This sheik surely understands Flooey, though. I have heard no more apt description of her: heart stronger than a man's and afraid of nothing.*

As he drew near, he saw his beloved Flooey, sitting and sewing by lamplight as she waited for him. Her long shining hair was down, flowing like a river over her lovely shoulders. He held his arms out to her and called her name softly. She looked up, smiled, and immediately set aside her work to go to him.

No, thought Sam, *the sheik was mistaken. This is no heart stronger than a man's. My Flooey has the heart of a lion.*

7

SITT, I BE YOUR BOY

*T*hey traveled and hunted along the Settite River in a fertile area thick with elephants, buffalo, and lions. They heard lions so often that Sam decided to make a *zareeba,* or thorn-break, to keep them out. The *zareeba* was dense and high and surrounded both the camp and the area where the riding camels, donkeys, and horses were kept at night. Every night lions roared and prowled and tested the thorn-break, terrifying the men. Florence was unnerved, for the lions were separated from her only by the wall of the *zareeba.* She wondered if it was strong enough and high enough to keep the lions out. Sam checked its strength carefully every day.

Mahomet was more anxious than anyone else, especially after Bacheet helpfully filled his head with tales of horrible deaths by lion. "What for master and the missus come to this bad country?" he pestered Florence and Sam nervously. "That's one bad kind will eat the missus in the night! Perhaps he could come and eat Mahomet!" He regretted the day he had signed on with these European lunatics, but he could see no way to get home except carry on with the expedition.

Others, who had hired on in Katariff, felt no such enforced loyalty. As the expedition traveled further, the men grew more and more reluctant to stay. One of the few loyal men, a brave and excellent Tokroori hunter named Jali, broke his thigh during an elephant chase. The seriousness of the accident threw a pall over the entire camp. Sam set the bone and splinted it as best he could, using techniques he had perfected in mending the broken stock of a rifle, but Jali was in terrible pain. After four days Sam arranged for him to be carried on an *angarep*, or wooden bedstead, back to his family. In six weeks he was well and eager to rejoin the expedition, but Sam thought the risk of reinjury too great.

After Jali's accident, all those of his tribe—about a third of the men—resolved to desert together. They offered Sam transparent excuses involving sudden sickness and binding promises to make a pilgrimage to Mecca. Sam saw that his authority was in danger of being undermined and confronted the men, asking who was sick and who wished to make a pilgrimage. Only Abderachman, a huge individual nicknamed "El Jamoos," or "the Buffalo," publicly claimed to want to go to Mecca. Many more feigned illness and Sam insisted they swallow large doses of tartar of emetic before leaving. The rest wanted openly to desert, and Sam told them:

Now, my good fellows, there shall be no misunderstanding between us, and I will explain to you how the case stands. You engaged yourselves to me for the whole journey, and you received an advance of wages to provide for your families during your absence. You have lately filled yourselves with meat, and you have become lazy; you have been frightened by the footprints of the Basé; thus you wish to leave the country. To save yourselves from imaginary danger, you would forsake my wife and myself, and leave us to a fate which you yourselves would avoid. This is your gratitude for kindness; this is the return for my confidence, when without hesitation I advanced you the money. Go! Return to Katariff to your families! I know that all the excuses you have made are false. Those who declare themselves to be sick, *inshallah* (please God), shall be sick. You will all be welcomed upon your arrival at Katariff. In the letter I have written to the Governor, inclosing your names, I have requested him to give each man upon his appearance *five hundred lashes with the* coorbatch, *for desertion;* and to imprison him until my return.

Only Abderachman, who had spoken often of going to Mecca on pilgrimage, was freed from his contract with Sam's blessings. He gratefully planted a wet kiss on Sam's cheek and moved toward Florence. Sam hastily instructed him to kiss Florence's hand instead. As Abderachman and the others set out, the tartar emetic began to work and the so-called invalids soon became real invalids. This fulfillment of Sam's prophecy led most of the would-be deserters to return.

More and more, Florence and Sam saw that they would survive in Africa only by boldness and moral strength. They needed porters, guides, and soldiers—without them, Florence and Sam were only two in all of Africa—and yet those they hired had no binding commitment to the expedition. Men were held, or lost, by the perceived courage and intelligence of their leaders. A moment of weakness, a hesitant decision, and the natives would desert to a man.

The year 1862 started uneventfully. Before long, some of the local Arabs adopted an unpleasant ploy of leaving the work of hunting to Sam while claiming a portion of the meat he brought in. Horses fell lame and the Arabs promised replacements, but they never came. Sam railed against their perfidy and disloyalty.

One of the most satisfying days came when Sam managed to kill a magnificent male lion. It was probably the one that had been regularly serenading the camp for many nights, trying to penetrate the *zareeba* and steal the meat that was drying on branches around the fire. Sam determinedly spent the day searching for spoor. In a small glade surrounded by thick jungle, he suddenly came upon a large, dark-maned lion with no fear of humans. Sam's first shot hit the animal's spine and paralyzed its back legs. With enormous strength, the lion dragged itself with its forelegs into a dense stand of bush. Sam followed. Even partially paralyzed, the lion was full of fight. It roared and tried to kill Sam with its forepaws, but Sam's second shot was killing. He called to the men to bring Tetel over. The horse flared his nostrils and rolled his eyes but courageously allowed Sam to load the still-warm carcass of the lion onto his back.

In camp, Sam removed the lion from Tetel's back and laid it at Florence's feet in tribute. "I shall make you a necklace from its claws," Sam promised her, "so you will always be protected from the attacks of wild

animals." She wore the necklace with pride, making matching bracelets as he killed more lions.

Sometime later, Sam's eyes became inflamed, whether from an infection or some substance he might have gotten in his eyes, he did not know. He did know they were unbearably sensitive to strong sunlight and there was no place that was truly dark at midday. The best Florence could do was keep him in the stifling tent where the canvas filtered the light, and even that pained his eyes. Florence made an eyeshade and bathed his eyes regularly with cool, clean water. Sam was a poor patient, and immobility and discomfort made him irritable. He hated feeling weak and preferred vigorous activity to rest at any time.

Sam was not the only invalid in camp. The slave woman, Barraké, ate too much wild fruit and developed severe dysentery. She was so weak she could not grind the *dhurra* or make bread for days. The men disdained this woman's work and complained bitterly at having to do it. Their complaints grew even louder when Barraké's dysentery turned to fever, prolonging her inability to work. After more than a month, Barraké died on February 18.

Mahomet was nearly useless as a translator, especially now that Florence and Sam had a much better command of Arabic. Sam tried teaching Mahomet other tasks, but he was a clumsy and careless man. One day Mahomet badly damaged an antelope skull he had been asked to clean with especial care, and then denied his responsibility for the breakage. Irritated beyond endurance by the combination of carelessness and lying, Sam gave Mahomet a whack across the shoulders and scolded him severely. Humiliated, Mahomet ran away later that night. Sam circled the entry in black in his journal.

Florence and Sam were in low spirits too. The deprivation and the constant threat of betrayal or mutiny taxed their minds, while the nearly constant illnesses undermined their bodily health. Though they toasted the birthday of Sam's father on April 9 with coffee, the only drink they had left, Sam was homesick and sad all day.

Two days later Sam was recovered enough to go out hunting with some of the *aggageer*s. When they did not return by late afternoon, Florence became worried. If they had killed a large animal and stayed to butcher it before coming home, Sam would have sent a man to tell her

of the delay. There was no word at all. She ordered dinner to be prepared while she paced the camp, stopping at every high point to scan the landscape for a sign of them. About dark, Sam's horse Aggahr cantered into camp in a lather. His skin and his saddle were scraped and scratched, his rider gone. *What had happened to Sam?* Florence was frantic with fear.

Once darkness fell, Florence could wait in camp no longer. She ordered the men to build the fire up and to keep it flaming so it could be seen from a long distance. She posted sentries in all directions to watch for the hunting party. After eating hastily, she took the little Fletcher rifle and gathered a few men, armed with lances and swords, to set out to find Sam. The moonlight was feeble and searching in the dark would be difficult, but she could not sit passively in camp while Sam might be hurt. At intervals, she stopped to fire a shot into the sky, listening desperately for a reply. The shots echoed in the dark night, and no answer came. She and the men scanned the darkened landscape around them repeatedly, but they could see no fires. It felt as if there were no other humans alive on earth.

Sam can't be dead, she thought frantically, adding illogically: *if he is dead, I can't leave his body for the hyenas. And he can't be dead, not my Sam, not larger-than-life Sam. I have to find him.* She had lost much in her life, but nothing had ever been as important to her as Sam.

At 9 P.M., three hours after she had set out, Florence fired the little Fletcher rifle again and at last heard an answering whistle. It was Sam! As a boy he had mastered the art of giving a shrill whistle by putting two fingers into his mouth. He always used that whistle now as his special signal. Florence and the men shouted and fired again. Again a whistle! They fired and listened and fired again for long minutes, while Sam and his party stumbled toward them, using the sound to navigate in the darkness. When they came within sight, Florence rushed to embrace Sam, not caring what the men thought.

"Oh, my dear," she murmured lovingly, "I was so frightened that you were gone."

"Flooey," Sam replied sweetly, "I couldn't leave you. I couldn't ever leave you. Let's go back to camp." He was bruised and scratched and disheveled but every bit alive.

They walked hand in hand for the three miles back to camp while he told her his story. Aggahr, normally among the surest-footed of horses,

had stumbled and turned a complete somersault while they were chasing elephants over rough terrain. Sam was thrown to the ground, hard and suddenly. Aggahr struggled to his feet and galloped wildly off into the bush, leaving Sam lying on the ground trying to catch his breath. He was in the elephants' path and nearly beneath their feet. He expected them to be crushed at any moment. Instead, his wild dismount had frightened the elephants and they bolted in the opposite direction as if they had seen a monster. The gun bearers thought Sam would be killed and ran off. They were hopeless cowards, Sam told Florence; they never learned to stand their ground and prepare another rifle. The gun bearers regained their courage and returned once they realized he was still alive.

Theirs was a bad situation. They were seventeen miles from camp; it was late in the day; and they were missing a good horse that could not be easily replaced. They called and searched for Aggahr for hours. Finally they lit the dry grass on fire, hoping to drive him toward them. That too proved hopeless, for the wind shifted and the fire moved until its burning front lay between them and camp. Their only chance was to forge a new path back to camp in the dark, through rocky, unfamiliar territory. Those with horses had to lead them, the terrain was so poor. The horses and men stumbled repeatedly, catching their feet in hidden crevices and tripping over rocks and logs. The men walked into thornbushes so often that blood ran down their arms and legs. They had no food, no tents, and no water, and no one in the camp knew where they were.

What joy Florence's rifle shot had given them, and what hope! Sam learned that the woman he had chosen did not give up in the face of danger but ran to fight it. Florence learned what lay in her heart: a commitment to Sam so deep she would willingly risk her own life for his.

On May 19, 1862, a year after leaving Korosoko, Florence and Sam evaluated their progress with pride. They had visited every river that flowed into the Nile from the east: the Atbara and its tributaries, the Settite, the Salaam, the Angarep, and the Royan. They had also followed the Rahad and the Dinder. They had traveled hundreds of miles on a previously unknown river system and had made detailed observations on the climate, the terrain, the people, the animals, and the plants. True, they had suffered numerous fevers and ailments, but that was to be expected. They had hired and managed a large crew of natives, put down a mutiny

or two, mastered the riding of camels, horses, and donkeys, and collected specimens of many of the mammals that inhabited that region of Abyssinia. The expedition was a wholesale success. So was the partnership, for Florence and Sam had forged an unbreakable bond.

As they grew closer to Khartoum, the conditions of their journey seemed more unbearable. They were so tired and worn out, emotionally and physically, that even little things became major irritations. As Sam wrote:

MAY 31. The most trying part of African traveling is the want of servants. You cannot teach either Arabs or any of the natives I have seen to be *clean*. No matter how common the food let it be *clean* only and I am content but these beasts revel in dirt—and dirty they will ever remain. One wooden bowl is all I ever want to drink out of and this is never clean unless I wash it myself.

On June 8, 1862, they arrived at Khartoum, only to find it was actually June 11.

"How peculiar," remarked Florence whimsically. "I should have thought we had had quite enough days of travel! Where did the other ones disappear to?"

Sam laughed and shook his head. They were happy to be back in a town with houses and streets and luxuries they had not seen in over a year. The Nile seemed beautiful, the many vessels sailing upon her picturesque, the date groves dark and luxuriant. Of course, the streets were filthy and dusty, the smell of sewage and offal indescribable, the houses mean and in poor repair. No matter; it was Khartoum and a city of some thirty thousand inhabitants.

Their first priority was to locate the British Consulate, the home of John Petherick and his new wife, Katherine, who had promised them help and hospitality. They found a walled compound with the shield of the consulate crudely painted above the door, complete with the lion rampant and unicorn. It was a most welcome sight.

Despite their absence—they had gone down the Nile to rescue Speke and Grant—the Pethericks had invited Florence and Sam to stay at the consulate. In the consulate courtyard the weary travelers were greeted by

John and Katherine Petherick (1869). The British consul at Khartoum, John Petherick, and his new wife, Kate, suggested that Florence and Sam stay in the consulate compound, though the Pethericks had left to travel upstream to meet Speke and Grant at Gondokoro with supplies when Florence and Sam arrived.

a comic footrace, performed by a pair of deranged pet ostriches that had escaped from their cage. It was an oddly irregular welcome to a peculiar sort of place. The rest of the menagerie—two wild boars, two leopards, one hyena, and a baboon—watched the footrace with the greatest interest and longing. Florence and Sam soon learned that one or the other of these wild animals got loose at regular intervals and wreaked havoc, attacking the dogs or the cattle, eating totally unsuitable items (the ostriches once devoured a basket of valuable trading beads), or trying to demolish the walls of the courtyard and break out. Accustomed to such chaos, the Pethericks' housekeeper walked across the courtyard calmly. She welcomed them and led them into large, cool, airy rooms that were to be their quarters.

Florence and Sam found that the Pethericks had not left Khartoum until March 20, 1862, though they had agreed with the RGS to be in Gondokoro by November 1861. They were accompanied by a Scot, Dr. James Murie; an American, Dr. Clarence Brownell, who was interested in tropical botany; and a few other Europeans. Word had come back that their boats were leaking and that they had encountered abundant areas of papyrus, which marked the beginning of the nearly impenetrable swamp known as the sudd, much farther north than they had hoped. Progress was so slow that they had abandoned the river and were proceeding overland. No one could tell when the Pethericks would reach Gondokoro—or if they would reach it. No one had heard from Speke or Grant either.

Florence and Sam were pleased at the thought of being with other

Europeans after months of living under camp conditions, but they soon found that the social resources of Khartoum were thin. The city's total European population was fewer than one hundred souls, and of these there were only ten prominent European merchants. None except Petherick had a European wife, though nearly all had African mistresses and clusters of half-caste children. Sam and Florence were a bit shocked to find that Petherick's attractive housekeeper had been his mistress prior to his recent wedding. How she felt about serving under Petherick's new wife—or how Petherick's wife felt about her staying on as housekeeper—was a subject of much conjecture. Khartoum might house consuls from France, Austria, America, and England, but it was a very minor colonial outpost much given to gossip. No one ever inquired too closely into anyone else's business, since much of it was of dubious legality. Given the prevalence of irregular marital arrangements, nobody ever questioned Florence's status as Mrs. Baker.

By far the most intriguing people Sam and Florence met in Khartoum were three remarkable Dutch explorers: the Baroness Adriana van Capellan; her sister Harriet Tinné; and Harriet's daughter, Alexine. They were "Dutch ladies . . . traveling *without any gentlemen*," as Sam wrote his brother John on June 16. "They must be demented! . . . A young lady alone with the Dinka tribe . . . they really must be mad." Florence, having spent many happy hours in the company of a Dinka, her *lala* Ali, found Sam's opinion of the dangerousness of the Dinka amusing.

The youngest Dutch lady, Alexine, was the driving force behind the expedition, but it was Harriet's apparently endless flow of money that made it possible. They were charged extortionate prices for everything, from the steamer they rented for one thousand pounds—versus the forty pounds Sam later paid for one—to accommodations, supplies, and boatmen. Their agent, the French consul Georges Thibault, dutifully produced inflated receipts for everything, and they never suspected any irregularity. They did notice the surprising expense of living in Khartoum. Though men thought them foolish, the Dutch ladies proceeded with a sangfroid that Florence greatly admired.

Harriet Tinné, for her part, was astonished by Florence. She wrote a candid portrait of Florence in her diary:

A famous English couple have arrived. Samuel and Florence Baker are going up the White Nile to find Speke. They have been traveling in Ethiopia and I hear she has shot an elephant!! She wears trousers and gaiters and a belt and a blouse. She goes everywhere he goes.

When the Tinné party left Khartoum in mid-June, they hoped either to find the source of the Nile or to rescue Speke and Grant at Gondokoro. They obligingly took a letter from Sam to the Pethericks and promised to return with news.

After a few weeks Florence and Sam realized that Khartoum was a more wretched place than either of them had imagined. Superficially it was picturesque, for the city lay at the junction of the Nile's two major branches, the Blue Nile and the White Nile. From Khartoum northward they flowed as a single, great river to debouch at Alexandria. The Blue Nile was the lesser of the two branches, and its origin east of Khartoum at Lake Tsana in highland Abyssinia had been well known since the eighteenth century. It was the White Nile, which flowed from some mysterious source to the west and carried travelers to the lands where slaves and ivory could be acquired, that was of greater importance.

Up close Khartoum had little to recommend it. Government in the city was a debacle of corruption and blatant dishonesty. Technically, Khartoum was under the control of British Egypt, but it was of course the governor-general, Moosa Pasha, who ruled with despotic power. A Turk, he combined "the worst of Oriental failings with the brutality of a wild animal," Sam wrote in his journal. Moosa Pasha lied and lined his own pockets with aplomb; he had no interest in improving his country whatsoever. He ignored Sam's *firman* from His Eminence Said Pasha, the viceroy of Anglo-Egypt, completely. Indeed he seemed to wish to prevent Sam and Florence from venturing farther south rather than assisting them.

Even the representatives of the British government proved a great disappointment, as Sam recorded in his journal.

Went to see Halil el Shami—Petherick's agent. Surely a full consul should have a consulate and clerk who can speak some European language to act in his absence!!! Otherwise the consulate of the Sudan is a mere farce, there being *no English* and *no office*, but the simple fact of £400 per annum salary!!!

Sam's idea of the salary Petherick drew as consul was greatly exaggerated; it was in fact less than three hundred pounds per annum, so low that Petherick had to conduct trading on the side to earn a reasonable living. There might be no proper English consul, but Khartoum bustled with Sudanese troops and a thriving trade in all the raw products of the region. Morally the worst and financially most desirable commodity was black slaves. Dealers routinely shipped loads of kidnapped men, women, and children up the Nile from farther south. They were chained, beaten, poorly fed, and inhumanely housed; the ones who survived were sold.

The whole ghastly trade formed a pathological undercurrent in the city that disgusted Florence and Sam. To be paid in slaves was customary for the Egyptian officers. When Sam tried to hire men for his expedition, he found that they too expected to be paid in slaves. The tentacles of slavery reached into every crevice of Khartoum like a mythical hydra. Sam recorded his impressions in his journal:

> AUGUST 17. . . . There is no doubt that the slave hunters commit horrible atrocities, but should slavery be by force abolished the Sudan will be ruined. It would be positively impossible to live here without slaves—every house is full of them—they grind the corn, make the bread for the men and do all the household work. As to hiring female servants it is impossible as a permanency. Every slave is a prostitute, and *this by choice*. Do away with the slavery and they must all become concubines, i.e. they will be engaged by men as such, and still work as at present—or they will keep doing a shop (brothels) on their own account, but honestly, to work for their living, they never will. A life of concubinage delights them and under this form alone can the work of a household be carried on should slavery be abolished. Nice prospects for European ladies whose unhappy lot may cast them here, that they will be unable to get female servants under any other agreement.
>
> The slaves are pretty well treated, and were it not for the horrors attendant upon their capture their lot is not so deplorable as it is the fashion to imagine.

Since constant raiding was necessary to procure new slaves, the trade made the tribes of the White Nile very hostile to outsiders. White men

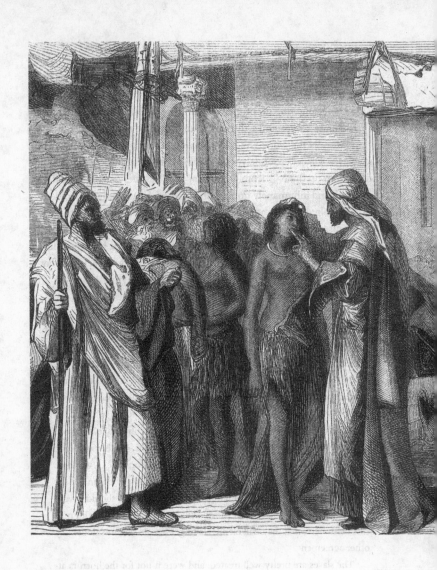

The Slave Market at Khartoum (ca. 1860). The slave trade was deeply embedded in Sudanese life and black slaves were sold openly in the market in Khartoum. Female slaves were exhibited partially clothed and could be intimately inspected by potential buyers.

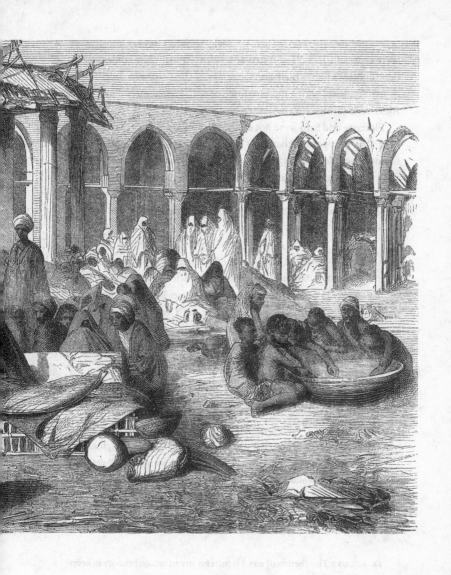

were especially hated and distrusted, since Turkish slave traders were the only lighter-skinned men ever seen along the southern Nile. Sam was advised to travel with a military force of well-armed men. The viceroy in Alexandria refused his application for soldiers.

Florence and Sam were not easily deterred from their plans, especially now that it appeared that they might be needed to rescue Speke and Grant. They decided to form their own small army of forty-five men, who would wear uniforms of Sam's own design and literally march to his beat on the drum. Recruiting men for a long and arduous journey proved to be an exasperating task. In a state of supreme aggravation, Sam wrote in his diary:

AUGUST 24—I do not believe in the possibility of civilizing the natives of this country: they have not sufficient character, and to compare them to dogs would be insulting to the canines. I never saw such a thoroughly d_d country—deserts; trees without shade; not a leaf without a thorn; no water on earth; no charity among mankind; one tribe preying upon the other, and selling them into slavery; no honesty even in name; but idleness, sin, debauching, rapine, and murder . . . while every black revels in mischief up to his throat.

I do not pity the slaves as they are merely victims of their own system: their own tribes being slave hunters. As to anything romantic ever being written connected with them is a mere 'bosh:' they know no feeling of real love, the instincts of their nature develop themselves in high acts of passion in either lust, or avarice, affording us an instance of self denial as a proof of affection; and rarely one of gratitude.

A few days later, Sam was again aggravated, this time by a man who had deserted after receiving pay in advance.

28 AUGUST This [betrayal] was a return for my misplaced charity in keeping him on at full wages when sick, instead of discharging him as useless. Verily this land is accursed; gratitude is unknown. All the blacks of every grade are alike in the Sudan; acts of kindness toward them are "pearls before swine." One abhors the principle of slavery, but one cannot pity the individuals; they enslave each other and therefore they deserve to be

enslaved themselves. The whole land is veritably d_d; no other word will express its condition.

I have great trouble in finding men for the White Nile as they know that I will not allow slave hunting, and the servants of White Nile expeditions are paid in *slaves*, which they prefer to cash, as they receive them at about a half or a third their value.

By October 20 Sam had finally managed to round up forty-five soldiers, plus an additional forty men to work as sailors, and ten servants. He hired a German carpenter, Johann Schmidt, to be headman, or *vakeel*, making a total of ninety-eight expedition members including himself and Florence. All of the men were Arabs except the black African Richarn, who had formerly worked for the hunter Florian Mouche. Richarn was to prove one of their most capable and fearless men. His only shortcoming was a weakness for drink, but when kept sober, he was honest and faithful to his employers.

To transport this immense expedition, Sam engaged three vessels for their voyage: two sailing barges, or *noggurs*, and a decked *diahbiah*, or paddle steamer, with a comfortable cabin. The boats were loaded with provisions for four months, plus extra corn and supplies in case they met up with Speke and Grant. They planned to carry twenty-one donkeys and four camels on the boats to eliminate the problem of hiring teams of porters along the way.

While provisions, trading goods, uniforms, and equipment were being assembled, Florence sewed clothing for herself and Sam, compiled and checked off lists of supplies, figured out what would be packed with what, and collected information on the local tribes. Sam designed the uniforms for the men, but it was Florence who saw to it that the uniforms were properly made. Sam drilled his men daily, trying to turn them into a serviceable military unit that would give him unquestioning obedience.

In late October Sam received some letters from his family, bearing the sad news of his father's death in August. He was terribly grieved and solemn. To his sister Ellen he wrote:

Your letter of 17th August arrived yesterday, breaking the sad truth so gently, that I longed to be with you again, away from this wild land, and

to share together our common grief. . . . It breaks my heart to think that I was his only child absent, at the hour when his children must have been his comfort. . . . God rest his soul!

Nothing but death shall prevent me from discovering the *Sources* of the Nile . . . under God's guidance I shall succeed . . . full of gratitude to Him for a share of health unnatural in this climate, and for a success up to this time of which I am not worthy. I shall resolutely push on; and I trust that I shall return to you all with the distinction of being the "discoverer" of the long-hidden mystery of the "Nile Sources."

You know what I always was,—made up of queer materials, and averse to beaten paths; unfortunately not fitted for those harnessed positions which produce wealth; yet, ever unhappy when unemployed, and too proud to serve: thus, the latent ambition to do what others have not been able to perform directed me to this difficult undertaking. I say *difficult*, but I do not believe in what are generally called difficulties: they dissolve like specters when faced.

By early November Sam and Florence were thoroughly sick of the Europeans of Khartoum. The Khartoumers drank too much, and they had little intellect, no natural curiosity, and a penchant for sly gossip and half-truths that was distasteful. Florence called them fearful scoundrels, and she was right. They were all of them up to their necks in the slave trade, if only by virtue of buying slaves to run their households. Accusations of misdeeds flew as thick and troublesome as mosquitoes. Petherick was regularly slandered because he was absent and unable to defend himself. He had apparently made the mistake of arresting several notoriously brutal slave traders like Abdul Mehjid and Amabile de Bono. The latter was not only the nephew of a well-to-do Maltese merchant, Andrea de Bono, but he was also the son-in-law of the French consul, Georges Thibault. Arresting him was considered nearly unforgivable, though Petherick's duty as British consul included enforcing the antislavery laws. As a result of Petherick's zeal, all the "hatred, malice, and uncharitableness of Khartoum," as Sam termed it, was directed toward discrediting Petherick so he would stop making trouble. With truly African irony, a formal complaint was submitted to the British government accusing *Petherick* of slave trading, signed by almost every other European in Khartoum.

On November 19 the Dutch ladies returned from Gondokoro. Virtually everyone on their boat had fallen ill. They had seen neither Speke and Grant nor Petherick, but they heard that the American doctor with Petherick, Clarence Brownell, had died of fever on May 22. He was buried on one of the only dry spots that could be found during that season, a massive termite hill. His grave was marked with a brass plaque that had once graced his medical office in East Hartford, Connecticut.

By late November a prodigious quantity of medicines, tools, guns, ammunition, cloth, trading goods, and cooking and camping utensils had been assembled and carefully enumerated in Sam's book. Ninety-six men had been hired and, insofar as it was possible, instilled with European rigor and discipline. Sam copied down notes from Burton's publications, including a list of the tribes they expected to encounter and potentially useful information about rivers, lakes, and other water sources.

On December 2 Sam again wrote out his will, leaving goods and money to Florence. He had the will legally witnessed by Johann Schmidt and Mr. Hansall, the Austrian consul. Halil el Shami, the acting British consul, put the official consular seal on the document. Sam thought with satisfaction that his Flooey would be provided for if he died. In the next two weeks Sam wrote to his family and friends in England, confirmed the arrangements for his checks to be honored through a bank in Alexandria, and drew out a large sum of money that would be needed for supplies and pay.

During the very last week before departure, a small black boy named Saat attached himself to the expedition's strength. One day while Florence and Sam were having late-afternoon tea in the consulate courtyard, Saat walked in quietly and knelt down at Florence's feet in supplication. He begged to be allowed to work for them as their "boy," doing whatever errands or odd jobs they had. He was dirty and ragged and looked to be perhaps twelve years old, no more than four or five years younger than Florence herself. He told them an extraordinary history.

When he was about six years old, Saat had been captured by Arabs while tending his father's goats in Kordofan, deep in the Sudanese interior. He was carried hundreds of miles in a sack to Cairo, where his captors intended to sell him for a drummer boy in the military. The traders in Cairo rejected him as too young and thin for this job. While his fate was being

pondered, he managed to escape and make his way to the Austrian mission, where he was taken in by the fathers. They sent him first to the mission at Khartoum and then farther upriver to another mission in Shillook country. Thirteen missionaries died there in six months, so the Shillook mission was closed and the boy was sent back to the Austrian mission in Khartoum. Recently, he had been turned out of the mission because there had been a spate of thievery, though he protested his innocence.

Florence was moved by his terrible story of kidnapping and slavery, but Sam suspected the boy was simply a rascal. He refused to take the child in until they had talked with the Austrian missionaries about his character. In the meantime, Saat was sent to the cook to be fed. Patiently awaiting his fate, the boy appeared at teatime the next day and again knelt next to Florence's chair, touching his head to the ground in homage. "*Sitt*," he pleaded, using the address for a much respected lady, "I be your boy, good boy, work hard. Let me stay with you."

Florence's eyes filled with tears at his heartfelt request. "Sam," she insisted, her hand on the boy's head, "we must do something. This is a good boy, I think, one much mistreated. Tomorrow we go to the mission to ask, yes? Please?"

"Yes, Flooey," agreed Sam. He could not refuse her. To his surprise, the mission duly vouched for Saat's honesty and the truth of his wretched past. They admitted that, shortly after turning him out, they had discovered that he was not the thief. Other than this mistake, they had had no complaint against him.

Saat became Florence's particular boy. She made him clothes and taught him how to sew; she saw to it that he washed and kept himself clean; she fed him until he grew sleek; and she instructed him in moral values. He was devoted to Florence, his savior, his *sitt*, and would do anything for her. By coincidence, the other black African on their crew, Richarn, had been schooled in the same Austrian mission in Khartoum, which was where he had first met Florian Mouche. Richarn and Saat were naturally thrown together as the only two Africans on the expedition, the other men being Arabs. Richarn became like Saat's older brother, teaching the boy the intricacies of waiting on table, washing up, and helping the cook. Sam instructed the boy in beating the drum for military commands, in marching,

and in shooting. He was so helpful and obedient that Sam eventually gave him his own gun, which became his most prized possession.

On December 18, which was by Arab superstition an auspicious day for beginning travels, Florence and Sam were ready to start on their journey. Everything was in order, and the animals were loaded onboard. "I shall be off tomorrow or next day," Sam wrote in his journal. "God grant success; if He guides I have no fear." At the very last moment, an emissary from the unhelpful governor-general, Moosa Pasha, appeared, demanding a poll tax. Sam was not about to pay it and pointed out forcefully that he and Florence were neither Turkish subjects nor traders. He ordered the Union Jack to be hoisted on each of his three ships and then invited the tax collector to leave his ship voluntarily or be thrown overboard; the man wisely left.

Minutes later, a government boat collided with the *diahbiah* and smashed its oars. Another dispute ensued, which ended with Sam going onboard to give "a physical explanation to the captain," an enormous black man from the Tokroori tribe. The captain felt the force of Sam's argument and replaced the oars. The voyage began with a wonderful display of bravado and strength.

Florence and Sam and their personal servants were on the *diahbiah*. The carpenter, Johann Schmidt, commanded one *noggur*, and Saati, a headman similar only in name to the boy Saat, commanded the other. When the *diahbiah* passed the Dutch ladies' steamer—they were off to explore the Bahr el Ghazal—the Europeans waved merrily to one another. They did not cross paths again. Fever claimed the lives of nearly all the Europeans on the Dutch expedition: the two older ladies, their maidservants, and two European men, Dr. Steudner and Signor Contarini. Only Alexine Tinné, the youngest, survived the voyage. She was killed by Tuaregs on a subsequent expedition through the Sahara Desert.

Florence and Sam sailed through the same pestilential climate as the Dutch ladies, and their expedition was not spared fever. Johann Schmidt had been suffering for weeks with difficulty breathing and a cough so severe that Sam had suggested he remain behind in Khartoum to recover. Schmidt refused; he was as disenchanted with Khartoum as were Florence and Sam. He felt that the climate of the foul city was doubtless more in-

jurious to his health than traveling and insisted on coming. Despite taking quinine, he grew steadily weaker and thinner. On the last day of 1862 Johann died and was buried by moonlight in a grave marked with a cross made from a tamarind tree. Florence attended his last hours, comforting him as best she could and listening to his thoughts of his family and loved ones in Germany. The entry in Sam's diary—"At 4.15 pm Johann died"— was outlined heavily in black.

The White Nile was a killing ground. Its hot, swampy backwaters were a nursery for disease-bearing insects; its water was contaminated by human and animal refuse and inhabited by hungry crocodiles; its shores were populated by hostile tribes, brutal traders, and dangerous animals. Not only the Europeans died; so did the Arabs and the Africans, by uncounted thousands.

8

A PERFECT HELL

\mathcal{D}uring the first month of the voyage, the White Nile was a broad river dotted with clumps of floating vegetation. As they passed further south, the current slowed, the river became shallower, and in places the grass was tall enough to block the wind. Mile after mile, the floating mass of plants grew denser and the stench of rotting vegetation ranker.

"What on earth can have induced the Dutch ladies to visit the White Nile a second time?!" Sam wondered aloud. "Beastly naked savages; and marshes teeming with mosquitoes, without anything of either uncommon interest or beauty." He mopped the streaming sweat from his face and neck with a handkerchief that was already soaked. There was no breeze to dry the perspiration, and the air was only slightly less humid than the water below.

"They say, you know, that Miss Tinné conceived of this journey because her heart was broken by some cad," Florence mused. "If that is so, she has certainly chosen a poor place to meet a replacement in her affections." She swatted irritatedly at a swarm of mosquitoes buzzing around her face. Her face, neck, and hands were already covered in small red welts.

Encountering the Sudd (1874). A mass of living and rotting vegetation made the White Nile impassable part of the year. Florence and Sam often saw the strange saddlebill stork, an odd bird with a stout, hooked bill especially adapted for eating lungfish, which inhabited the swamps.

"Hasn't she just!" Sam chortled, his sour mood vanishing.

When they passed the mouth of the Bahr el Ghazal, Sam noticed that the current died completely. The fetid smell of stagnant water and decaying vegetation was stifling in the still air. No water flowed out of the Bahr el Ghazal into the Nile in that season. Even the main channel of the White Nile was sluggish. The marshes were endless and the grass too high to see anything. It was hotter and more miserably humid than before, even at night. Their clothes were soggy with sweat and their hair stiff with dripping salt. The boats could not sail any longer, as there was no wind to fill their sails, so they had to be dragged ahead by brute strength. Florence and Sam began to understand Petherick's difficulties with the sudd, Sam complained in his journal.

> Nothing can be more laborious than the method of progress in this spot. The river winds like a tangled skein, and the wind being naturally against us in certain turns, several hours are required to advance one mile. This is accomplished by men swimming with a rope which they attach to the reeds ahead, and those on board haul the vessel along.

Lacking other reasons for celebration, Florence and Sam drank to

holidays or to absent friends, using the last of their precious wine. They knew such luxuries would not last. "It is grand in African travel," Sam pronounced with a smile, "to watch how one by one the wine, the spirits, the bread, the sugar, and everything else are dropped like the feathers of a molting bird, and still we go ahead contented."

"We do not need luxuries," Florence agreed, "and it is fortunate, for we have none." She fanned her face with her hat for a moment, exposing her sweat-soaked hair to the attentions of sweat bees and flies.

They traveled for some weeks in the country of the Nuer, Shillook, and Dinka tribes. Their villages were collections of low, rounded mud-and-thatch huts that looked for all the world like a colony of inverted birds' nests. Florence kept an eye out for Dinka villages where she could question the natives and see if perhaps anyone remembered a small boy named Ali who had been stolen by traders. She reminded herself that he had been stolen perhaps as much as thirty years before and that probably no one would remember one small boy who vanished. She wanted to find Ali's people but, sadly, never met anyone who admitted to knowing him. *If you know his family,* she would say, *tell them he is a good man, a kind man, and he is well.* She fervently hoped she spoke the truth.

When the boats emerged into a region free of marshes, they put ashore at a station belonging to Herr Binder, an Austrian subject. The boats of Circassian trader Koorshid Aga were already pulled up there. Aga was well known in Khartoum and said by many to be a slave trader. He was bound for Gondokoro, as they were, and had stopped on a mission of mercy. He was returning a Dinka girl who had been kidnapped from the nearby village of Kytch.

Kytch held some of the most wretched people Florence and Sam had yet encountered. Sam wrote in his journal:

> The misery of these unfortunate blacks is beyond description. They will not kill their cattle, neither do they taste meat unless an animal dies of sickness; they will not work, thus they frequently starve, existing only upon rats, lizards, snakes, and upon such fish as they can spear. . . . Most of the men are tall, but wretchedly thin; the children are mere skeletons, and the entire tribe appears thoroughly starved. The language is that of the Dinka. . . .

The whole day we are beset by crowds of starving people, bringing small gourd-shells to receive the expected corn. The people of this tribe are mere apes, trusting entirely to the productions of nature for their subsistence; they will spend hours digging out field-mice from their burrows, as we should for rabbits. They are the most pitiable set of savages that can be imagined; so emaciated that they have no visible posteriors; they look as if they had been planed off, and their long thin legs and arms give them a close to gnat-like appearance....

Starving Boy of the Kytch Tribe, Begging (1866). Florence and Sam were appalled by the skeletal children in the Dinka village of Kytch, where everyone was starving.

So miserable are the natives of the Kytch tribe, that they devour both skins and bones of all dead animals; the bones are pounded between stones, and when reduced to powder they are boiled to a kind of porridge; nothing is left for even a fly to feed upon, when an animal either dies a natural death or is killed. I never pitied poor creatures more than these utterly destitute savages.

Florence was horrified and deeply saddened, for these were Ali's people. Had he been captured from a poor village like this? Did he try to run on stick-thin legs from his captors? Only the strong survived capture and castration. Perhaps for him slavery was a better fate than starvation, but life had surely been cruel to Ali. She and Sam distributed as much food as they could spare in Kytch, but it was not enough. After they moved on, she could not rid her mind of the image of the starving children with pleading eyes, holding out their empty bowls. Even the scenery along the White Nile spoke of failure and cruelty: "malaria, marshes, mosquitoes, misery; far as the eye can reach, vast treeless marshes, perfectly lifeless," in Sam's words.

They pulled in next at an Austrian mission station to deliver a letter to Herr Franz Moorlong, the last remaining missionary. The entire station consisted of about twenty grass huts surrounding the grass church and a cluster of pathetic graves. Moorlong's view of his congregation was harsh and unforgiving: they were lying, deceitful, and greedy. In all their years of effort, the missionaries had never made a single convert. Fifteen of the seventeen missionaries who had been assigned there died; the surviving two retired in broken health. Now the mission was closing forever. That very morning Moorlong had sold the entire place to Koorshid Aga for thirty pounds; the buyer would use it as a trading post. Among his remaining odds and ends was an unwanted thermometer, which he kindly gave to Sam.

The missionary offered news that Petherick had reportedly reached the village of Niambara for the first time and set out for Gondokoro. Sam protested that Petherick had surely been to Niambara earlier; he had described it vividly in his recently published book, *Travels in Central Africa*. But both Moorlong and Aga were certain that Petherick had never been to Niambara before. Florence and Sam were nonplussed. Was Petherick, then, a fraud?

"Where the truth lies in this detestable country it is hard to say," Sam confided to Florence.

"We travel among liars and thieves," Florence responded. "I suppose we must judge only by what we know or have seen ourselves. I know Petherick kindly gave us advice and offered us accommodations in Khartoum. Perhaps nonetheless he is a slave trader and a liar, as some have painted him. Perhaps not."

The missionary Moorlong dined with Florence and Sam several times. Over a bottle of wine one night, he admitted that the mission station was a pretext, a way for Austria to obtain a foothold in the country and spy out the possibility of forming a colony there. There was no serious intention of converting the heathen.

"Well done, Jesuits!" Sam exclaimed when Moorlong had left. " '*In vino veritas.*' Bravo humbug!"

With a bitter, Germanic turn of phrase, Florence replied, "So one cannot trust even a priest. If priests are spies and liars, who is honest?"

On February 2 they reached Gondokoro. Though an improvement upon the dreadful swamps, the former mission station had little to recommend it. All the buildings, the garden, and the orchard had been neglected and were now fallen into disrepair. Gondokoro was simply a wretched place marked by a few grass huts and a swarm of traders, sweating, drinking, cheating, and fighting one another in a steaming and unhealthy climate. The brawls were so continuous that the sound of gunshots was considered ordinary. Bullets regularly buzzed through the air, barely missing innocent bystanders and once killing a boy sitting on one of the boats. It was not the first time, or the last, when someone was shot by accident in Gondokoro.

Because Sam was English and the English were outspoken opponents of slavery, he and Florence were regarded with deep suspicion. The traders did not want an Englishman poking his nose in their business and trying to get the antislavery laws enforced. A bullet fired through Sam's brain *by accident* would rid Gondokoro of an unwelcome presence, Florence worried. On the surface, Gondokoro was a perfectly legal ivory-trading station. The problem was that the ivory trade was so intimately linked to the slave trade that one could hardly exist without the other. The only three items of great value in the region were ivory, slaves, and cattle. Ivory could not be obtained in trade for anything except cattle or slaves. Conveniently, all three could be gotten in a successful raid on a village or group of villages if the illegality, brutality, and danger of raiding were discounted. Quite simply, trading in ivory meant trading in stolen cattle and stolen people.

In Gondokoro, Aga allowed Sam to deposit his supply of corn in one of his granaries and promised to give one half of it to Speke and Grant if they arrived in Sam's absence. There was no sign of Petherick, but rumor was that he and his *vakeel*, or headman, had been murdered. The story was so persistent that it reached England and was repeated at the Royal Geographical Society. Florence and Sam also asked for any news of Speke and Grant. From one of the porters, Sam heard that there were stories in the interior, to the south, of two white men who had been taken prisoner by a chief or sultan. It was said that these men had "wonderful *fireworks*" but that both had fallen very ill and one had finally died.

"It has to be Speke and Grant," Sam said to Florence. "Don't you think so?"

"Yes," she replied. "There are no white men trading south of Gondo-koro; who else could it be?" Yet they wondered. So far south, the phrase "white men" was ambiguous. It might include swarthy Europeans, like Turks, Greeks, Maltese, or Armenians. Where truly pale-skinned, north-ern Europeans like Sam had rarely been seen, "white" might mean noth-ing except "not black African."

"The closest trading station to the south is fifteen days' march away," Sam said. "De Bono's caravan is expected to return from that station in a few days. If we wait for them, perhaps we could hire their porters to take us back south and save our pack animals."

"Then we shall wait," Florence declared. "We must wait for them. Perhaps in the meantime we'll discover more about white men with fire-works."

They spent the time riding through the region and learning as much as possible about the local tribe, the Bari. They had thick lips, flat noses, and dark skins. Both men and women rubbed a paste of red ochre and fat over their bodies, which called attention to their elaborate patterns of raised scars. For beauty, cuts were made in the skin and then rubbed with ash to encourage the formation of raised scars or keloids. The men shaved their heads, leaving only a tuft at the crown into which they inserted feathers or other decorative objects. The women were nearly naked, save a small bead apron in front and a tail of ribbons of leather or twine behind.

Because they lived so close to Gondokoro, the Bari had been raided incessantly for cattle, tusks, and slaves. They were excellent bowmen and tipped their arrows with a poison made from the juice of a euphorbia tree. They tended to shoot strangers on sight, unless they were accompanied by a large force of men. Once an arrow struck, the skin around the wound swelled rapidly; then the muscle, skin, and flesh rotted; finally the affected part of the body dropped off. There was no known antidote. Even this ferocious tribe accepted Florence and Sam with little ill will once they learned their aim was exploration, not exploitation.

The traders' solution to the Bari's hostility, which they had created in the first place by their raiding, was to capture any archers they could, bind them

hand and foot, and hurl them from a cliff into the rapids on the river. If they did not die from the fall, crocodiles waited eagerly to finish off the job. Of course, those captives likely to make good slaves were spared. Brutality was met by savagery and tempered by greed: a despicable state of affairs.

The Bari told Florence and Sam that the traders were hiding huge numbers of slaves in the interior until they left Gondokoro. This was no surprise. Every time Florence or Sam approached a trader's camp, they heard shouting and the loud clanking of fetters as the slaves were hidden from open view. Attempts at concealment were often halfhearted. Florence and Sam often saw slaves chained cruelly to their fellows to prevent them from running away. The fetters produced ghastly sores, which dripped pus.

Florence and Sam grew suspicious of the ships that passed daily without stopping, surmising that these wretched vessels carried loads of slaves crowded together belowdecks. Although Gondokoro was a usual stop for such vessels, the sight of Sam's Union Jack hanging from the mast of their *diahbiah* may have persuaded many captains not to pull in and be seen.

"Gondokoro is a perfect hell," Florence remarked in disgust. "I know now what the Devil looks like and how he lives."

"Worse yet," Sam added, "it is a hell known to and ignored by the Egyptian authorities. They prefer, no doubt, to take bribes and ignore the slave trade rather than engaging in a bloody battle to stop it."

Their men became quarrelsome and unruly after only a few days mingling with the blackguards in the traders' camps. To each man Sam hired, he had explained carefully that raiding for cattle, ivory, or slaves would not be permitted. Now his men had conveniently forgotten the point and demanded to be allowed to conduct raids. If not, they would desert.

The next morning Sam assembled the men on deck to punish the ringleader of the mutiny, an Arab named Eesur. For his disobedience and troublemaking, Sam ordered Eesur to be given twenty-five lashes. Eesur protested and the others grumbled sullenly and threateningly. Outnumbered forty to one, Sam strode confidently through the mass of rebels. With one well-placed punch, he knocked Eesur to the ground. A few more blows from Sam seemed to quash the ringleader's sense of liveliness. Arising, Sam now ordered the *vakeel* to bring a rope to tie Eesur up for his punishment.

All of the mutineers were not yet cowed. Though she lay ill in the

cabin below, Florence heard the fracas and immediately responded. She rushed up on deck, summoning several men by name to give assistance. The men were confused. Disobeying Sam was one thing; he would yell at them or hit them, which was entirely to be expected. Disobeying the *sitt* was another, for Florence was regarded with an almost mystical respect and fear. They did not know what to do.

Once Florence had joined Sam, he ordered Saat to strike up the beat on his drum as he had during the endless drills in Khartoum. "Fall in!" he called, as loudly and firmly as he could. Out of habit, two thirds of the men did as ordered. The remainder wanted to carry off Eesur, claiming his wounds needed attention. "*Fall in!*" Sam repeated steadily, staring them down. The rest of the men complied.

Florence could see that the men's obedience and acceptance of Sam's authority was balanced on a knife edge. A single wrong move now would destroy the expedition completely, for no man would ever follow orders again if the mutineers triumphed. *Sam has been brave and straightforward,* she thought, *but now he must not be too stern. It is time for a show of grace and a touch of lenience.*

"Oh, Sam," she begged prettily, taking Sam's hand, "could you not forgive this man if he apologized and begged for pardon?" When Sam hesitated, she added, "If he kissed your hand and promised to obey from now on? Could you not spare him further punishment?"

The men waited to see the measure of their master. After a long pause, Sam spoke again, with great dignity. "Very well," he conceded, "since you ask it of me." *Heart of a lion,* he thought, recognizing that Florence had saved him from a bad mistake: *heart of a lion.*

Florence took the ringleader by the hand and led him over to Sam to apologize, promise obedience, and kiss Sam's hand. Sam magnanimously dispensed forgiveness and treated Eesur's wounds himself. The mutiny was over. That night Sam purchased a few fat oxen from Koorshid Aga and put on a feast for the men, despite their surly behavior. He knew now that the men were not to be trusted. They were a rabble of villains and would mutiny again.

On February 15 Florence and Sam heard the rattle of musketry and gunshots to the south. The boy Saat came running to tell them that someone was arriving. Sam described the scene later in his journal:

Guns firing in the distance; De Bono's ivory porters arriving, for whom I have waited. My men rushed madly to my boat, with the report that two white men were with them who had come from the *sea!* Could they be Speke and Grant? Off I ran, and soon met them in reality; hurrah for old England!! They had come from the Victoria N'yanza, from which the Nile springs. . . . The mystery of ages solved. With my pleasure of meeting them is the one disappointment that I had not met them further on the road in my search for them; however, the satisfaction is, that my previous arrangements had been such as would have insured my finding them had they been in a fix. . . . All my men perfectly mad with excitement, firing salutes as usual with ball cartridge, they shot one of my donkeys; a melancholy sacrifice as an offering at the completion of this geographic discovery.

Speke and Grant staggered weakly into Gondokoro. They had had a sleepless night surrounded by maddened and murderous Bari. Even before that, the explorers were half dead. On the outskirts of town, they met Koorshid Aga and inquired for Petherick, but the trader tactfully evaded the question. Speke and Grant plodded on, walking toward the bank of the river where the boats were pulled up. How delighted they were to see that one flew the Union Jack! Even though they were months late, they expected Petherick to be there. When they saw a burly, bearded, white man running toward them, they assumed it was he. Of course it was Sam—not only unexpected, but also bearded and ten years older than when he had last met Speke.

"Jack Speke!" Sam boomed, hurrying toward his friend with open arms. "Speke, you have made it!"

"Sam?" Speke replied incredulously, shading his eyes to see better. "Sam Baker? Is it you?"

Sam wrapped him in a bear hug. "Yes, it's me, old fellow, Sam Baker." He clapped the bewildered Speke on the shoulder so heartily that the man nearly lost his balance. "I am here to rescue you and Captain Grant—this is Captain James Grant whom I have the honor to address, is it not?" he asked.

"Yes, sir, pleased . . ." Grant mumbled, too stunned to answer at length. They shook hands. Sam was shocked at how little strength there was in Grant's handclasp, how weak and emaciated they both looked.

"Good, good," Sam enthused, walking them toward his boat. "You look nearly done in, you two. I suppose you'd like a nice cup of tea and some food and a wash and a rest, yes? This *diahbiah* is mine, gentlemen. Welcome aboard."

For a moment Speke thought his eyes had failed him completely. There was a beautiful young white woman on the boat. She was smiling as she stood beside a table spread with more food than Speke had seen in months

and set with cloth napkins, silver-ware, and a pretty china teapot. *It is not possible*, he thought. *I am hallucinating.* Then he realized that the woman was real, a companion of Sam's. Speke blurted out in amazement, "Sam, I thought your wife was dead!" An awkward silence followed and Florence flushed slightly.

Tea on the Nile at Gondokoro (ca. 1866). When Speke and Grant staggered into Gondokoro half-dead and starving, they were surprised to find Sam there—and still more surprised to be served tea on a diahbiah by a beautiful young woman, Florence.

"Yes," Sam answered a trifle stiffly. "My wife, Henrietta, died of typhus some years past. This, gentlemen, is Florence. Florence, this is my old friend Captain Speke, of whom we have so often spoken, and his compan-ion Captain Grant." Speke and Grant looked confused and befuddled, so Sam explained proudly, "Florence is my intended, my *chère amie*."

"Captain Speke, Captain Grant," Florence said, acknowledging the

introductions as graciously as she could. The mention of Henrietta was embarrassing, the implied question very rude. "I can see you are quite fatigued and probably you are very hungry. Pray let me pour you some tea while you help yourselves to a meal." She noticed the men's gaunt and sunburnt features, their ragged clothes, and their wiry thinness. *The journey has treated them most harshly,* she thought. *This is very nearly a rescue from death.*

Speke and Grant sat and began to eat like the half-starved men they were. Bread, fruit, cold meat, rice, tea, soup: everything put before them disappeared in short order. Sam kept Saat running back and forth until the men were sated.

Eagerly, Sam started to question Speke and Grant about their discoveries. He congratulated them heartily on their extraordinary accomplishment in proving that the Victoria N'yanza was the source of the Nile. Speke and Grant were near exhaustion. Once they had eaten, they could hardly sit upright. Sam stopped his questions and ordered water to be drawn for their baths, tents to be erected for them, and beds to be made up so they could sleep. New clothes were laid out for them to don in the morning.

Their talk resumed the next day, when Speke and Grant had had a long and well-deserved sleep. Their first thoughts were for Petherick: where was he? Why was Sam at Gondokoro instead? Petherick, Sam explained as best he could, had had great difficulty coming up the Nile. Finally he had been forced to leave the river and proceed overland to Niambara, where there was a load of ivory for him to collect. He was expected in Gondokoro any day, Sam assured them, hoping this information would forestall the anger he could see building in Speke's face.

"So Petherick, with twelve hundred pounds raised to rescue me, went off to collect ivory for his own enrichment?" Speke asked pointedly. "I see. And you, who had not a cent of public money, came at your own expense to succor me?" Sam was forced to admit that this was the truth. "And what is this strange story I hear about some Dutch ladies?"

"Ah," Sam replied eagerly, glad to change the subject. He described the Tinnés' attempt to rescue them and the illness that had forced them back to Khartoum. "Now they are exploring the Bahr el Ghazal," he added.

"*Two* expeditions came forth to meet me, voluntarily and at their own

expense," Speke asserted in a voice of doom, "while Petherick—who pledged to be here—is nowhere to be seen. The man is a scoundrel."

"I think you are a bit hard on him, Jack," Sam interjected. "The sudd was terrible this year."

"But he could have left earlier, could he not?" Speke replied acidly. There was no denying his point: Petherick had left too late.

"In any case, Captain Speke," Florence reminded him sweetly, "you shall have all the supplies and medicines and food we have brought for you. You need not go without."

"Indeed," agreed Speke, curbing his anger. "We are deeply indebted to you. I was told Petherick left supplies in the warehouse for my use. When I sent a man to inquire this morning, the *vakeel* would not release them unless I agreed to *pay* for them. These are the supplies that Petherick bought with the money from the public subscription! It is an outrage. And, of course," he continued bitterly, "there is no boat for us, though Petherick agreed to have one waiting. I don't know how we shall return to Khartoum."

"That difficulty is easily resolved," Sam offered. "You could go back to Khartoum in one of our boats, if you like. The *diahbiah* is comfortably outfitted."

"That is a most generous offer," Grant said gratefully, hoping Speke's tirade had not offended Sam and Florence. "We should like to accept, I think." He looked at Speke, who nodded.

"Yes," agreed Speke heartily, "and you may be sure we shall never forget the kindness you have shown us." He put a hand on Sam's shoulder for a moment to show the depth of his emotion. In gratitude, when Speke published his account of this epic meeting and rescue in his 1863 book, *Journal of the Discovery of the Source of the Nile*, he deliberately omitted all mention of Florence's presence lest Sam be embarrassed by the truth. It never occurred to Speke or Grant that Sam actually intended to marry Florence. Her strong German accent gave her away as a foreigner, and they took her for one of the ladies of dubious reputation who frequented Cairo.

Speke and Grant were eager to hear the news of the world and to share their observations and discoveries with someone else. Florence stayed to listen, though she spoke little, while they told their stories of the hardships they had endured, the places they had seen, and the people they had met.

Sam genuinely celebrated their success, but he could not help but be downcast. Florence could read the wistful disappointment in his face. The great endeavor in which he had hoped to participate was over, and he had had no part in it. Speke and Grant had made a noble effort that would earn them much honor, without doubt, he said. Finally, Sam felt compelled to ask the question that filled his mind: "Does not one leaf of the laurel remain for me?"

With characteristic candor, Speke explained that there was an important matter as yet unresolved. Using the map of their route, Speke and Grant pointed to the purported position of the lake Luta N'zigé, which natives had reported to them in some detail but which they had been unable to visit. It was their belief that the Nile flowed from Lake Victoria into the Luta N'zigé and out again. Such an arrangement would make the Luta N'zigé a source of the Nile second in importance only to Lake Victoria itself.

"But you know, Sam," Speke remarked a trifle irritably, "those armchair geographers who sit at home in London will be full of criticism. I can hear them now. 'Yet again,' they will carp, 'Speke has failed to investigate an important lake that has a direct bearing on the Nile question.' They have no idea how difficult travel in central Africa is or how intractable the natives are."

"Surely no one will criticize you, Jack," Sam said loyally. "It would be too cruel of one who has not risked his life in exploration to disparage you, when you have made not one but two epic journeys of discovery."

"You are too big-hearted to ever do such a thing, Sam," Speke responded gratefully. "But mark my words! There will be complaints and not just from Burton. Unless . . ." Speke stopped tantalizingly, looking at Sam.

"Unless?" Sam asked.

"Unless you decide to undertake a journey to the lake yourself, to clarify the point."

Sam beamed with delight. "It was always my fond wish to further the understanding of African geography and the source of the Nile," Sam replied, happy as a child with a wonderful new toy. "Exploring and mapping the Luta N'zigé would be an honor. Florence and I have come fully prepared for such a journey and can think of nothing we would like better."

Speke began to sputter in astonishment, looking at Florence. "Surely, *surely* you don't intend to take her with you, Sam! Not . . . you can't . . . Have you any idea of the dangers she will face on a journey of months, possibly years in central Africa?"

"Florence has already traveled with me every step of the way from Alexandria," Sam replied proudly. "We have been a year in Abyssinia. She can ride and shoot as well as any man and speaks better Arabic than I do. She is entirely fearless. You should see how well she manages the men! Some of them positively worship her. No, wherever I go, Florence goes too. That is the way things are. I know you're surprised, but you will see when you know her better that Florence is no ordinary English lady."

It was obvious that Florence was not English, and certainly Speke was of the opinion that Florence was no lady, but he was disinclined to say so. Sam would hear of no criticism of her or of her participation in the proposed exploration. On that point Sam stood resolute.

"Very well, then," Speke answered dubiously, "if you are determined. But I do not think it wise. Still, I had better leave you our map and a list of instructions and advice. Here, let me write it all out in your journal for you." He took up Sam's pen and wrote page after page of detailed directions and advice: what translators Sam would need; where he would find antelopes to shoot; how many days' march would take him from one village that would trade for food to the next; which chief ruled where; and what information to gather or confirm.

Later, when Florence was elsewhere, Speke again urged Sam not to take her into the interior. He spoke of the dangers and perils she would face. He also spoke warmly of the beautiful women of King M'tesa's tribe. He had spent five months at M'tesa's court, three of them without Grant. The queen had given Speke two nubile young virgins as wives because she wanted to know what color the babies would turn out to be. Speke grew fond of his older wife, Meri, during their liaison. But when he discovered her feigning illness in order to obtain a goat for sacrifice, he cruelly sent her to be the slave of one of his porters. Speke also managed to become a favorite drinking and sporting partner of the queen herself, which helped his position immeasurably.

Sam was scandalized by Speke's attitude. How could Speke disapprove of Florence and yet find no dishonor in accepting two young African girls

as wives? What exactly had passed between Speke and the girls, Sam did not ask, but Speke had traveled with them for months. How could an honorable man abandon his "wives"—or pass them on to his men when they no longer pleased him—without shame? Now Speke dared suggest he abandon Florence, a disgraceful and insulting idea. Sam could only assume that Speke's brain was disordered by deprivation and disease—or else his morality was distinctly shaky. He decided to let Speke's remarks pass. Florence did not learn of them until much later, but Speke's attitude toward her suggested censure.

On another day, Speke and Grant took Sam painstakingly through the use of surveying instruments, instructing him in the way to calculate latitude, longitude, and altitude, when and how to take readings from the sun and the stars with the sextant, and so on, to make sure his observations would be compatible with theirs. Florence paid close attention in case she needed to make observations herself. Speke never considered that she was fully capable of carrying out such a technical task. He not only failed to perceive the depth of the commitment between Florence and Sam, he also badly underestimated her intelligence.

Still, it was a handsome gesture for Speke to pass all of this information along, freely and unasked-for. The source of the Nile was already a matter of bitter dispute. Sam would always make a particular point of publicly acknowledging the helpfulness and lack of jealousy displayed by Speke and Grant. In his book, published in 1866, Sam wrote: "With their true devotion to geographical science, and especially to the specific object of their expedition, they gave me all information to assist in the completion of the great problem—the 'Nile Sources.'" Speke also told Sam to ask Kamrasi, chief of the Banyoro tribe, for some supplies and a medicine chest—including quinine—which had been left in his care to be held for the next white man who asked for it.

"It seems churlish to take your supplies, Jack," Sam demurred.

"That quinine might well save your life, though, Sam," Speke answered. "The fever is very bad thereabouts. I pray you to take advantage of our depot in Bunyoro."

On February 20 Petherick and his expedition arrived in Gondokoro. He was considerably surprised to find Sam, Florence, Speke, and Grant in residence. With the addition of Dr. Murie, who had accompanied Pether-

ick and his wife, Kate, on the voyage, there were more Britons assembled than Gondokoro had ever seen before.

The Pethericks arrived weak, feverish, and in tatters, Kate wearing a ragged red dress made hastily from a piece of Arab calico. Petherick immediately threw open the stores to Speke, reprimanding his *vakeel* for not having done so before. He had baskets of goods packed and sent from the storehouse to Speke's tent, along with a list of items enclosed, but Speke returned them with a haughty note saying that "all the articles enumerated had been packed up [for me] by friend Baker." Petherick began to realize the extent of Speke's vengeful condemnation for their absence upon his arrival.

Hoping to make amends, the Pethericks invited Speke, Grant, Dr. Murie, Sam, and Florence to dinner on February 22. Kate cooked a large ham they had brought out from England, a tremendous treat that she had saved for this very occasion. With good food and gentle words, she tried to soften Speke's attitude and persuade him to accept goods and assistance from them.

At last Speke remarked, with casual cruelty, "It is no use, Mrs. Petherick. I do not wish to recognize the 'succor dodge.' "

Seeing that Speke had not the slightest mercy for Petherick, Florence made a point to remember that he was not one to forgive. That he and Grant had arrived eight months after the end of the period during which Petherick was instructed to wait for them made no difference in Speke's eyes. Petherick was to have been their rescuer, and he had not been there to rescue them when they arrived.

Insulted and despairing, Kate stood up shortly and left the table, knowing her husband was a ruined man. The others made excuses and left as well. Florence and Sam were embarrassed by the exchange yet unsure whose side to take. They had been told so many contradictory things about Petherick that they knew not what to believe. Better than anyone else, they knew Petherick had not been at Gondokoro when Speke and Grant arrived.

On February 26, 1863, Speke and Grant left for Khartoum in the *diahbiah* brought down by Florence and Sam. "God bless you!" Florence and Sam cried, waving until the boat was out of sight. "Godspeed!" cried the Pethericks, hoping in vain that Speke's anger might relent. On May 6

Murchison at the Royal Geographical Society received a telegram from Speke via the Foreign Office in Alexandria: "All is well. The Nile is settled."

Speke's behavior in England was worse than Kate Petherick had feared. He praised Sam's timely and heroic rescue and publicized Petherick's failure to meet him. Speke repeated the vicious allegations that had circulated in Khartoum that Petherick was involved in the slave trade, implying that Petherick was capturing slaves when he should have been awaiting his arrival. So scathing was Speke's condemnation of Petherick that Petherick's brother-in-law, P. B. M'Quie, wrote to *The Times* in protest.

> Acting under the advice of Sir Roderick Murchison, I suppressed Petherick's very important version of his meeting with Captains Speke and Grant at Gondokoro, which tells, and truly tells, a very different tale. . . . Captain Speke has not shown a like delicacy, in fact, he has treated with cruel injustice one who risked his all, even life itself, in an expedition to afford him aid.
>
> Consul Petherick has been for some months confined to his bed at Khartoum, unable to move. The last mail brought rather better accounts and I am authorized to state to the Royal Geographical Society, to the public, and to his friends, that if God is pleased to restore him his strength, his first effort will be to convince them that their confidence was not misplaced when they confided to his energy, the task of succouring Captains Speke and Grant; that failure, if such it can be called, was the result of adverse circumstances; that there was no lack of good faith or honest purpose.
>
> I have earnestly to request that those who may be in this matter unfavorably impressed by a perusal of Captain Speke's book, will suspend their judgment until Consul Petherick is able to furnish his report.

Speke replied sharply, declaring Petherick's current illness to be irrelevant to his failure to fulfill his agreement.

Kate Petherick wrote pleadingly to Murchison in January 1864, explaining why they had been delayed in reaching Gondokoro. Murchison was only faintly sympathetic and asked Petherick for a full report and accounting; he hoped the subscription monies had not been wasted. Desperate to clear his name, Petherick also decided to file suit against Speke for

defamation of character. When Petherick's lengthy report duly arrived at the RGS, Murchison concluded that Petherick had been unjustly accused of misdeeds. By then, however, Petherick's reputation had already been badly damaged. The consulate at Khartoum was shut down on February 1, 1864, before Petherick had a chance to defend himself. The Nile claimed another victim.

9

ARE THE MEN WILLING TO MARCH?

*F*lorence and Sam spent the following few weeks readying themselves for the next stage of their journey. Obtaining porters was their biggest difficulty. Finally Sam approached Mahommed, who had been the *vakeel* of de Bono's caravan and had traveled with Speke and Grant. Mahommed agreed to recruit fifty porters from those who had carried de Bono's ivory. They would travel with Sam's men back to Faloro, the nearest station. In return, Mahommed asked that Sam assist him in collecting ivory and give him a handsome present at Faloro.

Mahommed's fifty men plus the forty-five Sam had brought from Khartoum as an armed escort made a satisfyingly large party. Faloro was reckoned to be some twelve or fifteen days' march south. Before the caravan left Gondokoro, both beasts and men needed to be in top condition. One horse had already become mysteriously paralyzed and had been put down. As the day for departure approached, the men were more and more negligent about attending to the pack animals. Sam was puzzled and angered. What other than sheer indolence could excuse their neglect of the animals? Those animals would take much of the load, sav-

ing the men's strength. Sam calculated that the expedition had fifty-four hundred pounds of goods, the heaviest items being the beads and copper for trading and the ammunition. Fifty porters could not possibly carry such a load.

Florence, Sam, and at least half of the men were struck down with bilious fever, a miserable, enervating illness. The epidemic was fostered by the filthy living conditions at Gondokoro. Once the men recovered, they began to feel insolent and struck for a pay raise: from forty-five piastres per month in the dry season, as they had agreed in Khartoum, to one hundred piastres per month. Without this outrageous increase, the men again threatened to desert. Irritated by this blackmail, Sam reluctantly agreed but made a note to himself to appeal to the government when they returned to Khartoum for rectification. As Sam later wrote, with the advantage of hindsight:

> Everything appeared to be in good train, but I knew little of the duplic-
> ity of these Arab scoundrels. At the very moment that they were most
> friendly, they were plotting to deceive me, and to prevent me from enter-
> ing the country. They knew, that should I penetrate the interior, the *ivory*
> *trade* of the White Nile would be no longer a mystery, and that the atroci-
> ties of the slave trade would be exposed, and most likely be terminated
> by the intervention of European Powers; accordingly, they combined to
> prevent my advance and to overthrow my expedition completely. . . . The
> men belonging to the various traders . . . fraternized with my escort, and
> persuaded them that I was a Christian dog, that it would be a disgrace for
> a Mahommedan to serve; that they would be starved in my service, as I
> would not allow them to steal cattle; that they would have no slaves; and
> that I should lead them God knew where.

Those set on rebellion pointed out that Speke and Grant had started with two hundred porters at the coast and had reached Gondokoro with only eighteen, so the rest must have died on the road. None of the men wanted to go on a suicidal trip. Only the two Africans, the boy Saat and Richarn, remained faithful to Florence and Sam.

Petherick too was desperate for porters, as he wanted to go back to Fa-loro to collect more ivory. He asked to join Sam and Florence's expedition,

but for some reason the men declared they would not budge if Petherick joined their company.

"I am again threatened by my own people, Florence," Sam said. "What shall we do? There is no traveling or working with these villains. They have wages in advance and can do what they choose, the game being in their hands."

"Why do the men object so strongly to Mr. Petherick?" Florence inquired. "Perhaps they have reason and we do not want to travel with him either. We must ask Dr. Murie how Petherick behaved on their journey. If there is no harm in him, we must find a way to make the men follow orders. Petherick could not leave now anyway, as he is very ill and so is Kate."

The next morning the boy Saat approached Florence at daybreak and warned her that Mahommed and all the porters who formerly worked for De Bono were planning to leave secretly before Sam was ready; Sam's own men planned to desert. Saat had heard them scheming in the night. Florence was frightened by the news but knew this was no time for weakness. As soon as she saw Sam returning from checking on the animals, she boldly approached the *vakeel*.

"Are the men willing to march?" she asked firmly, rather in the manner of a severe headmistress.

"Oh, yes, *Sitt*, they are perfectly ready," he glibly assured her.

"Then order them to strike the tent, and load the animals; we start at this moment," Florence commanded, clapping her hands twice for emphasis. "There shall be no delay," she announced, mustering every ounce of dignity and authority she could.

The man hesitated and cast about for a suitable excuse, but Florence would accept none. "I see you are not ready to march," she reprimanded him, "though you have said that you are. You are a perfidious scoundrel."

He started to protest his innocence, but she continued without hearing him out. "Is it not true," Florence accused him boldly, "that, in the night, you and the entire company of men agreed to mutiny and desert us?" The *vakeel* had no ready denial, for her accusation was true. "Didn't you all agree to fire upon us with our own guns and then make off with our arms and ammunition?" Florence glared at him.

He attempted to answer Florence's charges, but the charade fell apart

when young Saat stepped forward. With manful bravery, he declared that both he and Richarn had overheard the entire conspiracy the night before.

Sam sprang into action. He ordered that an *angarep* be placed outside the tent under a shady tree. Upon it, he deliberately placed five double-barreled guns, fully loaded, a revolver, and a saber. He took a sixth rifle in his hands, handed two more to Richarn and Saat, who stood behind him to either side, and sat down upon the *angarep* to wait. Florence stood behind Sam, watching the mutineers intently.

The drummer was ordered to start the beat to call the men to fall in, ready to march. One of Sam's clever inventions for the expedition was a special piece of waterproof mackintosh that was fitted over the locks on the guns to prevent moisture or dirt from getting in. These mackintoshes were always in place, per Sam's strictest orders; they were only to be removed when the men were ordered to prepare to fire. Now anyone touching a mackintosh would be shot without mercy.

Only fifteen of Sam's forty-five men answered the drumbeat and lined up. When they assembled, Sam ordered them to lay down their arms. Not one complied. Only insolent looks acknowledged Sam's command. "Down with your guns at this moment," Sam bellowed like the wrath of God, "you sons of dogs!"

In Islam, dogs are unclean animals; sons of dogs are worse yet. Sam had fearfully insulted the mutineers. Before they could decide how to respond, he cocked his rifle. He, Florence, Richarn, and Saat stared at the men and waited. A few laid down their guns and sat upon the ground, arms folded; others retreated; still others disappeared. Sam stood up, ordering Richarn to disarm those who still had their guns. Richarn passed his gun to Florence and approached the men. Seeing him standing resolutely before them, hand out, the mutineers capitulated, on the agreement that Sam would give them a written discharge. This he happily did, writing the man's name and the word *mutineer* on the paper above his signature as leader of the expedition. He copied the same word into his ledger next to each man's name. There would be no doubt who had mutinied when he returned to Khartoum and sought action against them. Only Saat and Richarn remained to accompany Florence and Sam into the interior, along with the *vakeel*. Nobody trusted the *vakeel* anymore, but there were no better men with whom to replace him in Gondokoro.

Florence and Sam questioned Dr. Murie the next day about Petherick's practices on the march. Murie admitted that Petherick had allowed his men to conduct cattle and slave raids in payment for their services. Seventeen or eighteen girls had been captured in raids and "married" to Petherick's men. In one particular slave raid, three natives were shot dead in their desperate attempts to avoid capture. Dr. Murie reluctantly confessed that, at Petherick's request, he cut the heads off the dead men and boiled the skulls clean, so that they might be sent home to the College of Surgeons for sale as scientific specimens.

Florence was disgusted by this display of callousness. As soon as they left Murie, she exploded in anger at Petherick's actions. "This is the British consul and his wife in Africa! This is the man who accuses others of slave trading, when these are his own abominable proceedings. I will have nothing to do with him or that savage, Dr. Murie. He is supposed to be a medical man, a healer, and he boils heads for skulls."

"You are perfectly right, Flooey. How can I expect any man to follow my rule of strict honesty when they see that the British consul himself steals cattle and allows his men to take slaves? My men naturally wish to do the same, and try to desert me, as they know I will never permit such atrocities. All the great expenses that I have gone to are entirely wasted."

"We shall not let it go to waste. We shall find a way to go, even if it is to travel alone with Saat and Richarn," Florence replied stoutly.

The next day their new distrust of the Pethericks provoked quarrels and accusations that only confirmed Florence and Sam's conviction that they wanted nothing further to do with the couple. "Verily," Sam wrote in his journal, "these are dangerous people. A liberal abuse of Speke both by her and Petherick closed the conversation which will be one of the last I intend to have, as I am afraid my friends are not of the cleanest hands."

The next day Koorshid Aga sent a messenger to tell Florence and Sam that Mahommed and de Bono's men had started without him. Not only had they failed to wait, but they left behind a taunting warning that they would fire upon Sam and his party if they attempted to follow. Sam sent a message back to Aga, asking if he might spare ten men to join Sam's expedition. The men flatly refused to work for Sam, calling him a spy and a madman. They predicted he would be murdered by natives in distant and

unknown countries. The only help Koorshid Aga could offer was a small slave boy from the interior who could go with them as an interpreter.

Sam was utterly downcast by the ruin of all his hopes; he could not proceed without men as soldiers and porters. Florence could not bear to see him looking so weak and beaten. She tried to persuade him not to blame himself. He had organized the expedition most carefully, from the saddles and pads for the transport animals, which had been made under his inspection, to the arms, ammunition, and supplies, which were abundant.

"I worry that this expedition has already been so costly and may come to nothing," Sam said. He was by nature a generous man, but the expense involved in this expedition had been prodigious. "This expedition is being ruined by the very people whom I engaged to protect it. How can we proceed with so few men? Oh, Flooey, I do not worry for myself, but you are my greatest care, my greatest treasure. What would become of you if I were killed?"

"I am not helpless," Florence maintained bravely. "I can ride and shoot and march as well as any man, you know I can. Who has been at your side every step of the way on this expedition? Have I not faced down mutineers and commanded them into obedience? Am I helpless?"

He could not deny that she had made vital contributions to the expedition in many ways, not the least of which were her knowledge of Arabic and her familiarity with Arabic and African customs. Somehow, too, having a woman with him had changed the natives' perception of him. He still hesitated to risk her life on a quest that he had chosen.

"We shall not fail," she announced firmly, "and we shall not be frightened by a rabble of blackguards and villains. We are going to the Luta N'zigé. I will never go back to the harem, and I will never be captured to be someone's slave, I assure you."

Sam borrowed some courage from her determined manner and her bold words. Very well then, with Florence by his side he would continue and he would find the Luta N'zigé, an important source of the Nile. He would ask the chief of the Bari to give him protection in his tribe's country. With two fast camels for Richarn and Saat, and two horses for himself and Florence, they would race through Bari country in three days to arrive among friendlier tribes at Moir. They would travel light, carrying only

beads, ammunition, astronomical instruments, and a minimum of supplies. Richarn thought the plan reckless, but he would go wherever Sam ordered. Sam went to see the Bari chief.

"Ah, Baker Effendi, I am pleased to see you," the chief said. "I have heard of the white man who does not steal cattle or kidnap slaves. But force is necessary in this country. All people say that you are different from the Turks and traders, but that character will not help you; it is all very good and very right, but you see your men have all deserted, thus you must go back to Khartoum; you can do nothing here without plenty of men and guns."

"You see I am an honest man," Sam replied, "who means your people no harm. If you offer me your protection, I could ride fast through your country with only my wife and my two servants."

"Impossible!" the chief answered, shaking his head in astonishment. "If I were to beat the great *nogaras* (drums), and call my people together to explain who you were, they would not hurt you; but there are many petty chiefs who do not obey me, and their people would certainly attack you when crossing some swollen torrent, and then what could you do with only a man and a boy?" He added the discouraging news that the Bari would trade only for cattle, of which Sam had none.

Sam returned and told the *vakeel* he must persuade at least twenty of the original forty-five men in his charge to return to their duty. By afternoon, the *vakeel* returned with seventeen surly men, but they would not march southward into Bari territory and would go only eastward, where they deemed it safer. That night, while Florence and Sam slept restlessly, the men plotted once again to desert them after a few days' march. Sam later described in his inimitable way what happened next.

That night I was asleep in my tent, when I was suddenly awoken by loud screams, and upon listening attentively I distinctly heard the heavy breathing of something in the tent, and I could distinguish a dark object crouching close to the head of my bed. A slight pull at my sleeve showed me that my wife also noticed this object, as this was always the signal that she made if anything occurred at night that required vigilance. Possessing a degree of *sangfroid* admirably adapted for African travel, Mrs. Baker was not a *screamer*, and never even whispered; in the moment of suspected

danger, a touch of my sleeve was considered a sufficient warning. My hand had quietly drawn the revolver from under my pillow and noiselessly pointed it within two feet of the dark crouching object, before I asked, "Who is that?" No answer was given—until, upon repeating the question, with my finger touching gently upon the trigger ready to fire, a voice replied "Fadeela." Never had I been so close to a fatal shot! It was one of the black women of the party, who had crept into the tent for asylum.

Upon striking a light, I found the woman was streaming with blood, being cut in the most frightful manner with the *coorbatch* [a hippo skin whip]. . . . Hearing the screams continued at some distance from the tent, I found my angels in the act of flogging two women; two men holding each woman upon the ground by sitting upon her legs and neck, while two men with powerful whips operated upon each woman alternately. . . . Seizing the *coorbatch* from the hands of one of the executioners, I administered them a dose of their own prescription, to their intense astonishment, as they did not appear conscious of any outrage;—"they were only slave women."

If Florence and Sam had retained any illusions about the nature of their men, this episode destroyed the last vestiges of their faith. They were to be accompanied into the interior by liars, mutineers, and brutes.

Aga's caravan departed on March 26, led by his *vakeel*, Ibrahim, who left yet another warning that Sam and Florence's party would be fired upon if they dared to follow. They paid no more attention to this taunt than they had to the previous one from de Bono's *vakeel*, Mahommed. Immediately, Sam told the men to strike camp, load the animals, and prepare to start.

They left Gondokoro at nightfall. Florence rode Tetel, the horse Sam had hunted with in Abyssinia, and Sam rode another named Filfil, or Pepper. The camels were overloaded, the men were insolent and unwilling, and only Saat and Richarn seemed really lighthearted. By moonlight, Sam and Florence led the way. Behind them strode a man carrying the British Union Jack to make it easy for the rest of the caravan to follow them. It was a poignantly brave beginning to a dangerous journey.

They had no guide but knew they should pass to the east of the mountain of Belignan ahead. They were able to hire an interpreter at the

town of Belignan, and some hours farther on, they met with two men of the Latooka tribe who had absconded from the Turks' caravan after being beaten. Sam had spoken with these men in Gondokoro, and now they willingly joined the expedition, hoisting two baskets containing fifty pounds of beads each onto their heads with little effort. They agreed to serve as guides and translators all the way to their home village.

Florence and Sam intended to march all night in hopes of getting ahead of the Turks, who they feared would stir up bad feelings against them. Navigation by night was difficult. They passed through a woodland of acacia trees with yellow, thorn-covered branches that ripped and tore the carefully packed bundles of goods on the camels and horses, necessitating frequent stops for repairs. After that, they came to worse terrain: a range of high, rocky hills interspersed with ravines too steep for the camels to negotiate fully loaded. At each ravine, the camels were unloaded in the dark, dragged across to the opposite bank, and then reloaded. This exhausting and disheartening procedure was repeated over and over.

The clever donkeys soon learned that the cry of "halt!" was the signal for a pause while the camels were unloaded. Being lazy, the donkeys promptly lay down whenever they heard the command. Donkeylike, they refused to get up again without massive persuasion. The men hauled on the animals' halters, shouted at them, and beat them with sticks. The donkeys' recalcitrance added another wearying step to crossing ravines. Finally, men and beasts alike were too fatigued to go further and stopped for a few hours' rest. In the early hours of the morning, Sam arose to rearrange the loads; he threw away everything that no longer seemed essential. When the rest of the expedition awoke, they marched for a few more hours until they arrived at a dry riverbed where the Latooka said water could be obtained by digging. It took hours to water all of the animals and people, but the rest and refreshment were much needed.

Florence and Sam rode ahead of the caravan with the guides. In the late afternoon, they emerged from the forested country to a prominence where they could see the attractive valley of Tollogo. A high, perpendicular wall of gray granite formed the east wall of the valley; great boulders that had spalled off from it dotted the meadow that formed the valley floor. Villages were scattered among these natural defenses. Mountains formed the western edge of the valley, through which a sluggish river

flowed, creating enough moisture to nourish huge fig trees. Florence and
Sam descended to the valley floor, accompanied by the Latooka guides,
and sank gratefully down to rest under one of the large fig trees. Within
moments, hundreds of natives appeared seemingly out of nowhere. Flor-
ence and Sam made an amazing spectacle: a sunburned, blue-eyed, fair-
haired couple of Europeans sitting on a Turkish carpet. A hunchbacked
man was among the spectators and conducted an inquisition in broken
Arabic.

"Who are you?" he asked Sam.

"A traveler."

"You want ivory?"

"No, it is of no use to me."

"Ah, you want slaves!"

"Neither do I want slaves." Sam's reply provoked cynical laughter
from the crowd, who had never seen a stranger who was not after ivory
or slaves.

"Have you plenty of cows?"

"Not one; but plenty of beads and copper."

"Plenty? Where are they?"

"Not far off; they will be here presently with my men."

"What countryman are you?"

"An Englishman."

"I have never heard of such people. Are you a Turk?"

"All right, I am anything you like."

"And that is your son?" The hunchback pointed to Florence.

"No, she is my wife."

"Your wife! What a lie! He is a boy." This was not the first time this
mistake had been made. Not only was Florence young and slender, she
was also wearing a hat, a loose blouse, and riding britches like Sam's. Be-
sides, no white woman had ever been seen in that country.

"Not a bit of it, she is my wife, who has come with me to see the
women of this country."

"Katab!" The hunchback sneered, using the Arabic word for "lie."

Fortunately, the conversation was interrupted by the chief's arrival
before anyone could demand proof positive of Florence's sex. To Sam's
delight, the chief was a man he had treated kindly in Gondokoro, not

knowing his rank. Now the chief gave them a local beer called *merissa*, honey, and an elephant's tusk as welcoming gifts. No sooner had greetings been exchanged than Sam's caravan came into view and the attention was transferred from Florence and Sam to the camels. Camels were unknown animals in this region and were taken to be the giraffes of the Europeans' country. Upon seeing the prodigious loads the beasts were carrying, the natives cried in amazement. Sam and Florence gave beads to the chief and the hunchback, to their great pleasure and the crowd's intense interest.

The expedition left early the next morning to face the difficult rocky pass between Tollogo and Ellyria, territory into which no white person had ever ventured. Florence and Sam felt certain that their forced march at night had put them ahead of the Turkish caravan. Once again, they rode ahead, taking one Latooka guide with them and leaving the other for the men. The path went through a difficult, narrow valley choked with granite boulders and broken by steep ravines. They were forced at times to dismount their horses and walk; they knew the camels would need to be unloaded and reloaded to negotiate the hostile terrain.

Once they had ascended the upward slope of the largest ravine yet, Florence and Sam were rewarded with a lovely view of the beautiful, broad valley of Ellyria, about a mile distant. Beyond it, they could see a long chain of mountains continuing to the south. The sight lifted their spirits until they spied yet another narrow passage through the rocky hills, with high walls. If anyone wished them harm, it was a perfect ambush site from which escape would be almost impossible.

"I do not think, Sam," Florence suggested, "that we should continue without the rest of the caravan. Though we must wait for them, it is better to arrive in a large party than merely the two of us all alone with our guide. That hunchback in Tollogo was not very impressed with us until the others arrived."

"I hate to wait here, though." Sam was impatient to get on with the trip, and waiting went against his nature. "There is our goal, so very close. Perhaps if we went ahead, we could meet with the chief and assure him of our good intentions before he sees how large our party is."

"Yes, that's true. But if he is disposed against us, then arriving with so few will encourage attack," Florence said thoughtfully. Sam regretfully

conceded she was probably right and settled down to wait, fidgeting irritably.

When they heard men's voices and the rattle of loaded animals, they rejoiced that the rest of the caravan had come through. When the caravan came into sight, to their dismay it sported not the Union Jack but the red flag and crescent of the Turks they had worked so hard to pass. The Turks marched right past them with 140 armed men and 300 Latooka porters. Not a single man made a polite salaam or called a greeting. If the Turks allied with the natives against them, Florence and Sam and their small party would be vastly outnumbered.

Sam was furious at being bested at the last moment and red-faced with indignation at the insolent way the men refused to acknowledge him. The very last man in line, riding upon a donkey, was the *vakeel* Ibrahim, the leader of the expedition. He too ignored Sam and Florence pointedly.

"Sam, you must call to him, talk to him, or we are ruined," Florence begged in a whisper. "We cannot travel this route in his footsteps without even trying to establish friendly relations."

"I cannot, Flooey," Sam replied, his face set like stone. "I will not plead with that impudent scoundrel." It took a considerable effort for him to keep his voice low so that Ibrahim would not hear his remark.

"Well, if you will not," Florence replied pluckily, "then I will. I won't allow him to ruin our expedition." Sam looked at her in some surprise. "Ibrahim," she called, raising her voice. "Ibrahim!"

Sam promptly decided he had better follow suit. "Ibrahim!" he shouted, and the man stopped and approached them. After exchanging the usual flowery Arabic greetings, Sam tried to explain his point of view.

Ibrahim, why should we be enemies in the midst of this hostile country? We believe in the same God, why should we quarrel in this land of heathens, who believe in no God? You have your work to perform; I have mine. . . .

Transact your business, and don't interfere with me: the country is wide enough for us both. I have a task before me, to reach a great lake—the head of the Nile. Reach it I *will* (*inshallah*). No power shall drive me back. . . . Should you be hostile, I shall hold your master responsible

as your employer. Should you assist me, I will befriend you both. Choose your course frankly, like a man—friend or enemy?

Before Ibrahim could open his mouth, Florence loosed a torrent of words in Arabic. She told him that he did not know what Englishmen were, that nothing would drive them back from their aim. The great British government watched over and protected its people wherever they were, even here in the Sudan. He should not dream that he could act against them with impunity. She also asserted firmly that Sam would never lie or deceive, that he was an honest man, and no ivory trader. Sam jumped back in and offered Ibrahim a new double-barreled gun and some gold, if he would but help them.

Ibrahim replied that his men were all suspicious, thinking that any misdeeds would be reported in Khartoum, but that he believed Florence and Sam spoke the truth. He agreed to meet them later, under a large tree they could see below them, after both caravans had settled separately in the valley. Perhaps they could come to an agreement. It was the beginning of a long and mutually useful alliance.

As soon as both caravans entered the valley, they were deluged with natives. The chief, Leggé, was a most villainous-looking man, "the greatest rascal that exists even in Central Africa," Sam called him. He demanded copper rings, ten pounds of beads, and a bottle of spirits, which he downed in one sitting. Though Sam had presented gifts, as was customary, Leggé ignored his reciprocal obligations. He offered no goods, neither goats nor fowls, and helped himself to a large quantity of the rice and honey they fed their men, from their precious stores.

The pattern of a chief demanding an excessive number of gifts for the privilege of entering his country, and of refusing to part with foodstuffs of equal value, became a recurrent theme of Sam and Florence's journey. So too were the threats of mutiny from the Arabs who had come reluctantly from Gondokoro. They tried again to mutiny when the expedition encountered the caravan of a second ivory trader, Mohammed Her, thinking that by joining the ivory trader they would gain more cattle and women. Sam temporarily stymied that rebellion by knocking out the ringleader. He then commanded the men to load the animals and march on, but within a short time five of his men had deserted, taking with them

precious guns and ammunition. Sam indulged his temper in a fit of verbal abuse aimed at the mutineers, ending with the curse, "*Inshallah*, the vultures shall pick their bones!"

In early April they stopped for some days in Tarrangollé, one of the principal towns of the Latooka tribe. The town consisted of about three thousand bell-shaped houses with high, peaked, thatched roofs. The insides of the houses were very clean, the dirt floors being swept daily, but dark, as there were no windows. Each house was fortified with a stockaded courtyard and sometimes a wooden palisade, but the cattle were kept communally in *kraals*, or corrals, surrounded by *zareebas*. The main drawback to a Latooka house was the doorway, which was only about two or two and a half feet high, necessitating that the inhabitant crawl in and out on all fours. The people were fine and well-built warriors—"the finest savages I have ever seen," Sam declared—who averaged nearly six feet tall, making it a wonder that they chose to make such dwarf-sized doorways. Their main weapon was the lance, tipped with a metal blade, their chief defense a shield of giraffe hide. Though Sam thought the warriors manly and handsome, he found the women short and rather homely. Their hair was shaved and their scalps covered in ochre; their cheeks were decorated with rows of scars; and their lower lips were pierced and adorned with long, pointed crystals that stuck out in front of their faces about four inches.

Sam and Florence received the chief seated in chairs placed on a Persian carpet. Sam wore full Highland dress in the tartan of his friend the Duke of Atholl, with a plume of ostrich feathers in his bonnet. He formally presented the chief with copper bracelets, colored handkerchiefs, and beads, but the chief requested additional beads for his various wives, who also wished the honor of visiting Florence. Fearful of receiving dozens of bead-demanding wives, Florence agreed to entertain only the chief's favorite, Bokké, and her daughter.

"A prettier pair of savages I never saw," Sam pronounced when they arrived the next day. The ladies were astonished by the beautiful carpet and stroked it with their hands. They had never seen such soft and colorful textiles. They were also most interested in Florence. After inspecting her closely, Bokké asked how many other wives Sam had—and laughed heartily at the foolish answer that he was contented with one.

"She is rather plain," Bokké remarked to Sam candidly. She suggested Florence's appearance might be greatly improved with a little care. She should at once remove the four front teeth from her lower jaw, shave her head, and smear her scalp with ochre. Then if she pierced her upper lip and wore a proper ornament, Florence might be reasonably attractive, Bokké thought. Accompanied by gestures that made her meaning clear, even without Ibrahim's adept translation, Bokké's recipe for beauty was the cause for much hilarity.

"I am grateful, Sam"—Florence giggled—"that she did not also wish to scarify my cheeks! What would your sisters say if you brought home a woman with missing teeth, a pierced lip, and tribal scars on her cheeks?"

Though the Latooka had received the English caravan and Ibrahim's caravan with courtesy, Mohammed Her's caravan had met with grief. They attacked the village of Latome, intending to steal slaves and cattle, but Mohammed Her's men were driven back into one of the narrow rocky passes and trapped. The Latooka killed every one of the invaders. Hearing of this massacre, Sam and Ibrahim sent men to inquire.

The men returned, green-faced from the evidence of slaughter that they had seen, to say the story was true. They dropped at Sam's feet two guns, both of which were marked on the stocks with his numbers and had been stolen by deserters. "Are they all dead?" Sam asked.

"All dead."

"Food for the vultures?"

"None of the bodies can be recovered."

"Better for them had they remained with me and done their duty," Sam intoned magisterially. "The hand of God is heavy." Florence solemnly crossed herself.

Florence later commented, "That was excellent, Sam, very good. If we cannot rule these brutes by honesty and decency, let us rule them by magic and humbug."

All the men were convinced that Sam's curse, "The vultures will pick their bones," had doomed the deserters. They began to treat Sam and Florence with the utmost care.

Ibrahim was very nervous that his party would be attacked, yet he needed to return to Gondokoro to pick up a large supply of ammunition he had left there in depot. Finally he departed for Gondokoro, leaving

thirty-five of his men in Tarrangollé under the command of a man named Suleiman. With Ibrahim gone, the Arabs in his party began to abuse the Latooka freely. They cheated the natives in trading, they stole full water jars from the women rather than fetching their own water, and one day an Arab raped one of the women. Not long afterward, in retribution, a large group of Latooka women set upon the rogue and threw him onto the ground. Three sat upon him and the others pummeled him for good measure. Others grabbed his gun, pouring mud and excrement down its barrel and plastering over the locks and trigger. He was disgraced and humiliated before his comrades and demanded that they attack the Latooka.

"We shall be dragged into fighting by the brutality of those Turks," Sam worried. "They make no distinction between Ibrahim's men and us; we are all foreigners to them."

Florence feared he was right. All the women and children vanished suddenly from the village, as if a fight was expected. Sam went to the chief, who said that the Turks had acted so badly that he could no longer insure his people's peaceful behavior.

"Have any of my men, the ones in the brown uniforms, stolen anything or mistreated the women?" Sam asked carefully.

"No, there are no complaints of them," the chief replied, "but I cannot guarantee your people will be left unharmed if fighting breaks out."

It was April 20. The night was deathly still but for the calls of animals. Even the usually boisterous Turkish camp was quiet. Then out of the dark, silent night came a low-pitched, ominous sound. The great *nogara*, or war drum, was struck three times: *boom-boom-boom*. After a pause, the signal was repeated. It was answered by another drum a mile or two distant; then another drum, and another, took up the rhythm. It was a signal for warriors to gather and attack.

Sam sent for Suleiman, the lieutenant in charge of Ibrahim's men. "Call your men out," Sam ordered him, "and have your drummer answer the *nogara* with our beat to assemble in the quadrangle." Suleiman did as he was told.

Because they were habitual warriors, the Latooka had built the town to be readily defensible. It was surrounded by a wall with only a few entrances. The streets were narrow and there were watchtowers spaced at intervals. Unthinkingly, the Latooka had stationed Sam and Florence's

expedition in the central square, one of the most advantageous positions. Soon there were sentries posted at each corner of the quadrangle, patrols in the main streets, and men up the watchtowers. In case of attack, Sam instructed, the sentries were to set fire to the huts surrounding the quadrangle, which would prevent any large party of men from making their way into the center of the town.

While Sam laid the strategy, Florence readied the guns, laying out neat rows of cartridges, buckshot, powder flasks, wadding, and boxes of caps next to the supply of excellent guns and rifles. Saat took up his prized rifle and gleefully prepared for his first big fight.

While the troops collected, inside and outside of the town, a war of nerves broke out. The *nogaras* sounded, deep and threatening—*boom-boom-boom*—only to be answered by the determined martial beat of the expedition's drum—*rat-a-tat-tat, rat-a-tat-tat*. Back and forth the drumbeats battled. About midnight, the chief approached the quadrangle asking to speak with Sam. He was unnerved that the *nogara* had been answered by a drumbeat from the quadrangle. The preparations for a fight that the chief observed looked formidable. He claimed that the war drum had been beaten without his command. Now he wished to keep the peace.

Sam concurred and asked the chief to silence the *nogara*. If he would do that, Sam would silence his drum and would answer for his own men; they would not attack. However, he cautioned the chief, he could not take any responsibility for the behavior of the Turks, whom he could not control. The chief agreed to these terms and departed to disperse his warriors.

The next morning the town returned to normal. The women filled their water jugs and the children played in the dusty streets, as always. Sam lectured the exhausted Turks—who had been awake all night—on their intolerable behavior, fiercely pointing out that they had nearly provoked a vicious fight. They were frightened and therefore penitent, but Sam had no hope their best behavior would continue for long.

To get away from the Turks, Sam and Florence decided to move their camp well outside of Tarrangollé. At Sam's instruction, the men constructed a fresh *zareeba* eighty yards long and forty wide near a stream so they would have plenty of water. In a few days there was a good hut for Sam and Florence, with a person-sized door, and new huts for the men.

Their new camp was soon comfortable and homey. Florence sowed a garden of cabbages, melons, yams, beans, lettuce, onions, and radishes from seeds they had brought with them. The shoots she tended with loving care in hopes they would stay long enough to harvest vegetables. Milk was cheap and abundant, as there were at least ten thousand head of cattle in the town, but the Latooka steadfastly refused to trade cows for beads or copper. To provide meat for the camp, Sam shot small game and wildfowl—cooing pigeons and doves, pink-tinted spoonbills, tall blue herons, ducks with large red wattles on top of the beak, and large black and white geese—all of which were abundant in the small marshy ponds near the stream.

Despite the delicious domestic peace and tranquillity Florence and Sam finally established at Tarrangollé, they grew no fonder of the Latooka people. The chief pestered them incessantly to assist him in raiding some neighboring village. Like the Turks, he never considered that his own aggressive behavior brought much trouble. Sam wrote in his diary:

I wish the black philanthropists of England could see Africa's heart and entrails as I do; much of the sympathy would subside. Human nature viewed in its crude state as pictured among African savages is quite on a level with brute nature, and not to be compared with the noble simplicity of the "dog." There is no gratitude; no pity; no love; no self denial; no idea of duty; no religion; but greediness, covetousness, ingratitude, selfishness, cruelty. All are thieves; all are idle; all are envious, and ready to plunder their neighbors. Nevertheless the Latooka are superior to many in mildness of manner, although the heavy iron bracelets armed with spikes and dagger blades six inches long and claws of the same metal four inches long bespeak a latent cruelty of disposition.

So, too, did the matching scars on the backs of their wives.

10

A GORILLA IN LONDON

*F*lorence and Sam had been in Tarrangollé for just over
a month when a messenger arrived from the chief in
the neighboring district of Obbo. The chief had sent gifts
for Sam, Florence, and Ibrahim as well as an invitation to
visit him. They decided to go together, to see what the
Obbo country was like. Five of Sam's few men were left in
charge of the camp and effects; Sam also asked the chief of
Tarrangollé to look after the safety of his people and goods.
"I have no fear of trusting all to your care," said Sam, flatter-
ingly. He noted in his journal: "Savages will seldom deceive
you if thus placed on their honor, this happy fact being one
of the bright rays in their darkness, and an instance of the
anomalous character of the African."

For the first eighteen miles, the going was easy as they
passed through the beautiful, parklike valley of Latooka. At
the end of that distance, they had to ascend into the moun-
tains and traveled uphill for twelve miserable miles in the
pouring rain. Everyone was soaked, the men complained
bitterly of the cold, and the donkeys protested most loudly
of all. At the summit—about twenty-five hundred feet
above the valley floor—they were rewarded with beautiful

scenery, lush, flowering vegetation, and delicious ripe fruits on every tree. They had arrived at the main village of Obbo.

The natives looked different from the Latooka and spoke a different language. Both men and women were nearly naked. The men favored a skin slung across their shoulders and an elaborate headdress resembling a beaver's tail, made of their own matted, sewn, and ochred hair decorated with the occasional plume. An unmarried girl went completely naked or, if she was wealthy, wore a few strings of white beads as a covering for her genitals. Married women were more modest, covering their private parts with a bunch of green leaves stuck into strings about the waist. Some of the women were very pretty, in Sam's estimation, with fine facial features suggesting an admixture of Somali blood.

The people were friendly and peaceful. Their chief, Katchiba, was an aged, amusing man of perhaps sixty years, a master of the art Sam called humbug. Though he acted the clown, he was a renowned sorcerer and a rainmaker and he ruled his people firmly through magic. The people sought his treatment for their ailments or misfortunes and his blessings for any undertaking. He was also sent a great many pretty girls as wives to curry his favor. To prevent domestic warfare, Katchiba wisely set up a separate compound in each village, one for each wife and her children. Katchiba claimed a total of 116 children, a number that greatly impressed Sam. Each of his grown sons ruled a single village.

Katchiba tried to persuade Florence and Sam to stay in Obbo for the next six months, until the rains stopped. He was a wise old man, his country was lush, and his people were peaceable, but Florence and Sam needed to return to Tarrangollé to collect the goods and supplies they had left there. First, however, Sam was tempted to make a flying reconnaissance to the south, where the Asua River lay, and, beyond it, the station at Faloro.

"What do you think, Florence?" Sam asked. "I could travel fast, hunt some elephant, and scout out the best way to get to Faloro."

Florence nodded, thinking his plan was good. He could travel now, before the rains got too heavy and the streams too full to cross. It would be easier to reach Faloro in the dry season if they knew the way.

Sam hesitated to speak for a moment and then blurted out, "But, Flooey, *what about you?*"

"What about me?"

"I could travel faster if I went with only a few men," Sam explained. He did not want to say that she could not match him and the men for stamina, but it was true and they both knew it. "If you do not come with me, then I'll have to leave you here alone."

"Yes," Florence answered calmly, "I shall stay here until you return. Katchiba is a remarkably civil old rogue, and our hut here is waterproof and tidy. There is plenty of food in the village, and I can shoot for the pot if need be. Besides, I will not be alone; I will have Saat and the other eight men."

They both knew that eight men and a boy could never protect Florence against an outright attack, but she had no fear of one. Sam looked at Florence admiringly. What courage she had! Even Speke and Grant experienced some difficulties when separated from each other. *She is, indeed, the most remarkable woman I have ever met,* he thought. "I shall speak to Katchiba, then, and make him responsible for your safety and comfort while I am gone," Sam vowed.

On May 7 Sam and his men set out through broad savannahs and grasslands full of game. They hunted hartebeest and elephant, camping under the stars by night. They were welcomed at Farajoke by the chief. Unfortunately his welcoming ceremony involved singing incomprehensible incantations while waving a live fowl around Sam and his horse Filfil. Poor Filfil found the squawking, flapping fowl and perhaps the unmelodious singing to be alarming. Sam had to ask for the ceremony to be abbreviated to prevent the horse from bolting in terror.

Once the greetings were over, and his men fed and rested, Sam asked questions about the Asua River, which was well known to the inhabitants of Farajoke. They swore it could not be crossed in the rainy season and were equally adamant that there was no other route south to Faloro. After learning these facts, Sam decided to return to Obbo and Florence as fast as possible. Though he would not admit it to anyone, he was just a little worried about her. The next day he led the men on a forced march of thirty miles, returning to Obbo only nine days after they had left. When they came within earshot of the village, Sam gave his trademark whistle to alert Florence to his presence.

As the party arrived back in Obbo, Florence was there to greet them,

in excellent health and spirits. Katchiba had looked after her well, as promised. He had put a spell on the door of her hut, to prevent evildoers from entering. Each night he had posted some of his sons as sentries outside her hut as well. To thank Katchiba, Sam gave him a pile of beads and bracelets, a pair of sun goggles, a china teacup, and a mirror.

"Welcome home, my dear," she said. "I have been quite well while you were gone. Katchiba has been a perfect gentleman. He could not have looked after his own daughter any better—and perhaps not so well!" She happily led Sam to the spotlessly clean hut, where she was comfortably settled in. Several fat sheep—one destined for that evening's supper—and a number of fowls awaited Sam's arrival. Like the most gracious hostess in London serving tea, Florence offered Sam a large gourd full of beer to refresh himself after his long journey. He was much relieved and pleased to see her. Somehow she looked more beautiful to him than ever. He wrote: " 'Dulce domum,' although but a mud hut, the loving welcome made it happier than a palace; and that draught of beer, or fermented mud, or whatever trash it might be compared with in England, how delicious it seemed after a journey of thirty miles in the broiling sun!" While he drank, Sam thought how lucky he was, to find domestic bliss in a small thatched hut in the middle of Africa.

They packed and returned to Tarrangollé, finding the camp, depot, and men in fine shape, but the situation soon changed. The rainy season was a dangerous time. The horses died, first Filfil and then Tetel. Five donkeys and two camels succumbed to the same mysterious ailment. Florence made little jackets out of tent cloth to cover the remaining donkeys' backs, hoping to keep the birds from pecking their sores, but still animals died. While the Latooka were overjoyed at this windfall of fresh meat, Florence and Sam knew they were now in real trouble. Dependence upon porters for transport was a bane for all African explorers of that era; now Florence and Sam too were forced to rely on the unreliable.

Within days of their return from Obbo, Florence was bedridden with a painful stomach ailment and Sam was laid up with fever. Smallpox broke out among the Turks and spread fast; men began to die covered in hideous pustules. Only by strictly prohibiting his men from having anything to do with the Turks did Sam manage to keep the smallpox out of his camp.

In the midst of these disasters, Sam made a happy discovery. When he

had arrived in Latooka country, he had noticed that all the Latooka men decorated their hair helmets with cowry shells. Wani, a Latooka man who had traveled a good deal, told Sam that the cowry shells came from a place called Magungo, on a lake.

"Florence, wait until you hear what I've found out!" Sam cried as he rejoined her at their camp. "You remember that the Bari interpreter told us the cowry shells came from a large river? He mistook the Arabic word *birké*, meaning lake, for *bahr*, or river. According to Wani, Magungo is situated on a *lake* so large that nobody knows its limits. If you journey two days east or the same distance west from Magungo, land is still visible in three quarters. To the south its length is utterly unknown."

"But, Sam," Florence objected, "that cannot be correct. Cowries do not live in freshwater lakes or rivers. They live in the sea."

"Ah, yes," agreed Sam. "But Wani says that the cowries arrive at the lake by trade. Large vessels arrive at Magungo with men from distant and unknown parts who bring cowry shells and beads to exchange for ivory. White men have been seen on these boats, but they have not come for the last two years. This lake is the Luta N'zigé; I feel sure of it!"

"And the 'white men,' are they Arab traders? Do they come overland from Zanzibar on the Indian Ocean with these shells?" Florence speculated out loud.

"I think so," said Sam happily, "I think so. He told me where Magungo was; it seems to be about two degrees north latitude, which agrees with Speke's map position for the Luta N'zigé. As soon as the rains have stopped, we shall march on south and west and find our lake."

Long before the rains stopped, Florence's garden flourished and began to provide fresh vegetables. Game was still abundant but the rains left puddles and pools, perfect breeding grounds for disease-carrying mosquitoes. Both Florence and Sam came down with fever, which was beginning to seem like a regular occurrence in wet season. Before long, the whole country was up in arms again anyway because Koorshid Aga's Turks could not resist joining the Latooka on raids of neighboring villages; cattle and women were captured in great numbers. The peace and tranquillity Florence and Sam had briefly enjoyed was disturbed daily by the perpetual quarreling of Aga's Turks.

"It is remarkably pleasant traveling in the vicinity of the traders," Sam remarked ironically one day. "They convert every country into a wasp's nest." They decided to leave Tarrangollé for Obbo. Because the forty porters they needed would not sign on to a small party, they decided to travel back in company with Ibrahim and his men.

They left for Obbo on June 23, though Florence was dangerously ill again with bilious fever. She could neither ride nor walk. Sam made a snug palanquin for her out of an *angarep* fitted with an arched frame that was covered in hides. *She will be sheltered from sun or rain, like a snail in its shell,* Sam thought.

Being carried in a palanquin, Florence discovered, was neither as pleasant nor as comfortable as it sounded. The men lurched and stumbled along in an alarming fashion and sometimes dropped her. She could not see where they were going, so she could not anticipate their unsteadiness. The smell of the profusely sweating men filled her tiny shelter. The journey left her weaker and sicker than when she had started.

After five long days, they arrived again at Obbo. The rains were so torrential and constant that the rich land of abundant food they had left two months earlier was now a country of starvation. Little food could be obtained without cattle to trade, and the expedition had no cattle. The only thing they could get was a small, bitter grain called *tullaboon*, which could be pounded into flour and made into a sort of unleavened bread. Smallpox raged here too, but the expedition stayed separate and no one contracted it. Florence and Sam both suffered badly from bilious fever and ague, though. Katchiba dutifully tried to heal them with spells, to no avail. Their formerly tidy and comfortable hut swarmed with rats and flies that drove them nearly mad. Sam put out arsenic to poison the rats, which crawled into their holes beneath the tent to die. The stench of rotting rat was worse than the living creatures had been. It still rained incessantly. Most of the men fell ill. The remaining donkeys and the last horse grew sick and died. The horse's tail was much coveted as decoration, and Sam managed to obtain a cow in exchange for it.

Idiotically, Ibrahim's Turks decided to alleviate their boredom and misery by organizing a raid on one of the neighboring tribes. Though Katchiba warned against it, his people were hungry for cattle and decided

to join in this useless fighting. Florence and Sam feared that the raiding would turn southward and ruin their chances of traveling toward the Luta N'zigé in the dry season.

Weak, feverish, and depressed, Sam became obsessed with the idea that his faithless *vakeel* was to blame for all of their troubles since leaving Khartoum. He began to rant and rave to Florence about the injustices Mahommed had done them.

"Had he fulfilled his contract, we would not be in this fix. With the forty-five sound men that he was supposed to hire for us, we could have gone anywhere, independently of these scoundrel traders. Our agreement was very specific; I was most careful about that. *He* was responsible for choosing the men and for their subsequent behavior. He swore to me he knew each man and could vouch for him. He knew from the outset we would allow no slaving or cattle stealing, so why did his men continually ask to do these things?" Florence shook her head helplessly; she had no answer for Sam.

Sam continued, unappeased. "Was he not told in Khartoum that the journey would take over one year and that only men prepared to stay the entire time should be engaged? And where are they now? They mutinied, over and over, and threatened to abandon us or shoot us. There's fine gratitude for five months' pay in advance, plus uniforms and guns! And he had the gall to insist that we buy slave women to grind corn for the men. Should he not have told us that he and some of his men owned the very women we paid for? *He* must have known the supply of beads we carried was inadequate; why did he not warn me in Khartoum?"

"Sam," pleaded Florence weakly, "don't waste your strength in anger. Write all your objections down and we shall take them to the Divan for justice when we get back to Khartoum. Write every detail, every accusation, in your book, so you do not forget. He shall not go unpunished, I promise you. But I can't bear any more of your shouting just now, I am so very tired. Please let me sleep."

Consumed with guilt, Sam scribbled down his objections over the next few days. They took the form of a legalistic series of seventy-four questions that were to be addressed to the treacherous Mahommed when they returned to Khartoum. The answers would prove the man's guilt and his responsibility for the expedition's troubles.

In mid-August Sam discovered that one of the Turks owned a slave woman, Bacheeta, who had come from Bunyoro, the country of the chief Kamrasi of whom Speke had told him much. He asked to speak with her. Bacheeta told him that the lake they sought was called not Luta N'zigé but Kara-wootan-N'zigé. The lake reached like "a white sheet as far as the eye could see," she said. Unlike other bodies of water she knew, its behavior was strange. If she put a water jar on the shore, Bacheeta said, the lake would come up and carry it away; *waves*, Sam thought. She also spoke of the "Gondokoro River," which both entered and exited the lake, and told of "a great roar of water that fell from the sky" at one end. Florence and Sam longed to see these things and verify the information.

In August and September the last camel and the last donkey died. The only animals still alive were three riding oxen, whimsically named Beef, Suet, and Steak, all of which were badly debilitated. Unless they could obtain porters, Florence and Sam were effectively marooned at Obbo. To stave off depression over this grim reality, Sam tried to objectively describe the illnesses that wracked their bodies. In shaky handwriting he recorded:

For some days one feels a certain uneasiness of spirits difficult to explain; the secretions are perfectly healthy to the last moment, urine clear and a pale color; bowels in good order; digestion ditto; but after the slightest exertion the action of the heart and pulse rise in an extraordinary degree. No further symptoms take place until the day or two days before the attack when great lassitude is felt and a desire to sleep. The nights [are] not as good: rheumatic pain in hips & legs & bad dreams; including a desire to stretch and frequent yawning and a sense of great weakness attacks you, and a cold fit comes on very quickly. This is so severe that it almost immediately affects the stomach, providing painful vomiting with severe retching, generally all fruitless. The eyes are very heavy, the head hot & painful; the extremities pale and cold, pulse weak and slow about 56 beats per minute, the action of the heart distressingly weak. This shivering and vomiting lasts about two hours, reducing the patient to extreme weakness with great difficulty in breathing. The hot stage then comes on, the retching still continuing with the difficulty of breathing, intense weakness, and restlessness for about an hour and a half, which if the remedies take effect,

terminate in profuse perspiration and sleep. The attack ends, leaving the stomach in an awful state of weakness, and muscular strength quite prostrated. . . . The enormous quantity of bilious vomit is beyond belief and vomiting assisted by warm water is repeated generally eight or ten times.

As for treatment, Sam recommended quinine—of which he had very little left—and basic nursing.

The head should be cooled by cold applications, the hands and feet bathed in very hot water during the cold stage and the *hands* and arms alone bathed in *cold* water during the hot stage, the feet being bathed with hot water in both stages. *Nothing equals the relief of this treatment.*

In December Sam wrote gloomily in his journal: "The Obbo kills everything. Old Beef's name I changed to Bones shortly before his death."

Florence and Sam spent Christmas Day in worry and fever, wishing for news from his family and a break in the miserable weather. Still they planned to start south in the new year, leaving most of the heavier equipment at Obbo in Katchiba's care. Ibrahim promised them porters to take them as far as Bunyoro. On New Year's Day, 1864, Sam was so weak from fever that he could hardly stand. He swallowed the last dose of quinine in their medicine chest. On January 5 they finally gathered enough porters to start. Sam tried to walk, but the eighteen-mile march on the first day was too much for him. He had to buy an ox from the Turks. Florence had started on one of their remaining oxen, which threw her to the ground when it was bitten by a large and vicious fly. Ibrahim kindly agreed to exchange her beast for one of his with a better temperament. As they traveled southward, the natives had been harassed less and less by slave traders, so they were more friendly and open. Shortsightedly, Ibrahim's men saw this as an opportunity for easier cattle raiding.

They stopped in the town of Shooa, which was a lovely place where fowls, butter, and goats were readily available in exchange for beads. The people in Shooa cultivated sesame and built cleverly designed granaries for storing the seeds. They were very frightened of Kamrasi and filled the porters' heads with tales of his power and ruthlessness until the porters

deserted and ran home. Florence and Sam abandoned yet more of their goods, including their prized sponge bath, and marched on.

They were both very weak and sickly. On January 21, for the first time, the expedition had to stop for Sam's illness. Florence was greatly worried, for Sam did not lightly declare himself too ill to travel. In a few hours they marched on through black and smoking lands that had been burned to clear the dead grass. The ashes stank and stuck to their sweating bodies; the sharp stems of burned vegetation poked through bare feet, trousers, boots, and gaiters, leaving filthy, bloody wounds.

Burned areas gave way to verdant swamplands thick with mosquitoes and mud, where they slithered and slid along precariously. In places the mud was over the oxen's girths and the luggage had to be carried through the sucking swamp on an *angarep* by a team of twelve men. Florence flatly refused to mount the *angarep* like a piece of luggage again. Gentlemanly as ever, Sam offered to carry her piggyback, as if she were one of his daughters, and she clambered onto his back with her arms around his neck. Halfway across, Sam began to sink. There seemed to be no firm bottom to the swamp, only deeper and slimier mud. He could not extract his feet and he could not move. Soon the water was up to his waist, so Florence dismounted to lighten his load. Sam stopped sinking but could not free himself. Soaked and filthy, Florence floundered like an inept frog in the shallow, muddy water. In the end they had to be dragged out of the swamp with a rope pulled by a team of men standing on firmer ground. Neither had dry clothes to change into, so they trudged uncomfortably on, the wet and muddy garments chafing their skin.

After a time Sam grew suspicious that the guide was trying to mislead them; he did not seem to be going in the direction Speke had indicated on his map. "I think, Flooey," Sam said quietly, "that he is trying to take us to the country of Kamrasi's rival, Rionga."

"Call his bluff right away, Sam," Florence advised. "If he knows we have an idea of where we're going, he will not dare be deceitful." She was wrong in this assessment.

Sam corrected the guide several times and was joyful when, on January 22, they arrived at the section of the White Nile that Grant had called the Somerset Nile. Speke and Grant believed that the Somerset Nile joined

Lake Victoria to the Luta N'zigé, but proving it was up to Florence and Sam. The expedition turned west to follow the river to the Luta N'zigé, thinking they had triumphed over the guide's sabotage until the first natives they met included Rionga's own brother. If Kamrasi learned they had visited Rionga's country, he would doubtless forbid Florence and Sam to travel through his own, which was the only way to reach the lake.

They determined to leave as soon as possible, but no one in Rionga's country would answer their questions about the lake. They said simply it "was not far," a vague phrase as likely to indicate an utter lack of knowledge as to reflect geographic distances. Finally, one native told Sam that there was a way to cross the river into Kamrasi's territory at Karuma Falls, a day's march away. Because Sam and Florence announced their intention to go to Karuma the next day, Rionga withheld their food.

Their hungry morning march along the river was lovely. Scenic waterfalls and rapids dashed over rocks and through gorges, making beautiful patterns. The river's edge was thick with green vegetation. Nonetheless, Kamrasi's people, the Banyoro, soon spotted the expedition. They ran along the opposite shore, gesticulating, shouting, and shaking their spears ferociously to intimidate these strangers. At the crossing place, a canoe full of men paddled partway across the river to see if Florence and Sam were friend or foe. Bacheeta, the slave woman who had been raised in this country, shouted that Speke's brother had arrived to visit Kamrasi, bearing many valuable gifts. Sam had tried to heighten his resemblance to Speke by donning a tweed suit. The people remembered Speke well and started dancing and singing in celebration. Bacheeta also announced that Sam had brought an English lady, his wife, to see the great king Kamrasi and to thank him for his kindly treatment of Speke.

Florence and Sam invited the canoe party to come ashore to talk. Sam distributed bead necklaces liberally, to the delight of the Banyoro. He told them that there must be no insulting delay in his being presented to Kamrasi. He knew that Speke and Grant had waited fifteen long days for an audience.

The headman raised a small difficulty. Only a few days after Speke and Grant had left, Rionga's people and the Turks had viciously attacked Kamrasi's people. Kamrasi had subsequently ordered that no stranger was to cross the river upon pain of death. He could not permit Sam and Flor-

ence and their party to enter Bunyoro without permission, and the king was three days' march away in his capital at M'rooli.

"We cannot wait here," Sam argued. "We expected hospitality from the king, for he is famous for his kindness to Englishmen. We have nothing to eat and my men are starving. This is a most inconvenient spot. You can surely see we are white people, like Speke and Grant, not brown people like the Turks." He rolled his sleeve up to reveal his very fair upper arms, which had not been darkened by the sun. Still the headman insisted he could not take Florence and Sam to Kamrasi or bring them food without permission.

"Very well," said Sam nonchalantly. "We have a great many beautiful presents for Kamrasi, but if he does not want them, we are sure another chief will accept them." He ordered a large and colorful Persian carpet to be unfolded and displayed. Its brilliant red and blue colors evoked exclamations of wonder. In the middle of the carpet he heaped a selection of choice bead necklaces, all new varieties for this region. Florence was relieved to see a look of avarice come over the faces of the Banyoro, including the headman.

"Oh, no!" the headman cried. "You must not leave and take your gifts with you. If you do, Kamrasi will . . ."—and here he pantomimed having his head cut off, complete with horrible noises and grimaces. The crowd took up the gesture and repeated it endlessly.

Sam made a show of consulting with Florence. "Very well," he said. "We shall wait, but only until the sun is there"—here he pointed to the position of the sun at three o'clock. "If my party has not been brought across the river by then, and welcomed properly, we shall depart for another country *with our gifts.*"

Kamrasi's people reboarded the canoe and paddled for the opposite shore to consult with their fellows. For the next few hours a boisterous discussion raged, their voices plainly audible across the river. The basic tenets of the argument were obvious even at a distance: Would they be beheaded if they accepted these strangers? Would they be beheaded if they did not? How could they obtain those wonderful gifts?

A messenger came to ask if Sam would leave his armed men behind and cross the river alone with Florence. His answer was that he could not, for he and Florence were great and important personages who must be

accompanied by their servants and entourage. It would not be fitting for them to enter Bunyoro without their escort any more than it would be for Kamrasi to travel without his. Sam suggested that he and Florence would come across with a load of gifts for Kamrasi. To this the headman posed no objection. Sam spoke quietly to Richarn, Ibrahim, and Saat, explaining that he wanted them to load and arrange the luggage, which included some rifles and ammunition he had concealed earlier. The three of them were to get onto the canoe while loading, then stay onboard and cross with Sam and Florence. The other men were to remain ready to swim the river and take up their arms should there be a general attack.

Night fell as the small party crossed the river in the laden canoe. A fire on the opposite shore guided them to the landing place. Then they were directed up a precipitous path to a modest courtyard in front of the headman's residence. They were offered plantain wine and a basketful of ripe plantains, most welcome gifts because they had not eaten all day and had not seen plantains in months.

The other tribes Florence and Sam had encountered were nearly naked, but the Banyoro were clad in beautiful bark cloth arranged rather like a Roman toga. When the people complained of the attack by the Turks, Sam assured them that neither Speke nor he had anything to do with it. Still the Banyoro were suspicious.

"Tell me," he challenged them. "Did Speke or Grant ever deceive you?" The answer was no; they had been upright and honorable men.

"Then you *must* trust me, as I trust entirely in you, and have placed myself in your hands; but if you have ever had cause to mistrust a white man, kill me at once! Either kill me or trust in me, but let there be no suspicions." It was a bold move, typical of Sam. He and Florence were sick of lying, conspiracy, and cheating; they would have no more of it. Besides, they had come too far to give up now.

After some consideration, the Banyoro accepted that their visitors were trustworthy. A few came and spoke to them of Speke, whom they called Mallegé, or Bearded One—a nickname that they soon applied to Sam as well—and Grant, known as Masanga, or Elephant's Tusk, for his length and slenderness. When Sam mentioned the finger that Grant had lost in the Indian mutiny, a murmur ran through the crowd; they all knew of this mutilation. Sam must indeed be the brother of Speke and

the friend of Grant! Florence and Sam slept that night on a pile of straw in a small hut, covered only with a Scotch plaid blanket each, while Saat, Richarn, and Ibrahim stood guard in turns.

The following morning Sam, Richarn, Saat, and Ibrahim arranged themselves on the Persian carpet beneath a large and shady tree some small distance from the village. An immense crowd of about six hundred thronged to gape at them. The travelers' arrival and their fabulous gifts were the most exciting event in the country since Speke and Grant had been there. Though many stared, none of the natives would speak to Sam or answer any of his questions. When he asked that food be sent over to his men on the far shore, who were starving, no one moved to help. Knowing the meat hunger of the people he was dealing with, Sam explained that the canoe must go across to fetch his three oxen, as he intended to slaughter them. He knew one was fatally lame already. The natives sprang into action. Sam sent a message to his men that three of them, with guns and ammunition, should come across in the canoe leading the swimming oxen by ropes tied to their horns. That would put a total of seven of their party on the Bunyoro side of the river.

Suddenly the entire crowd jumped to their feet and rushed off, yelling and screaming. Sam and the others stood up and ran after the crowd, to see what was happening: was the village under attack? The mob was not headed toward the crossing point on the river, but for the hut where Florence was. Sam dashed forward to protect her, pushing his way through the crowd with his strong arms.

That morning, as she was alone for once with time on her hands, Florence had taken the opportunity to let down and wash her long blond hair. Now she stood in the strong sunlight at the door of the hut, brushing the shimmering, golden curtain of her hair as it dried. Such a thing had never before been seen in Bunyoro. She was a sensation. After that, the natives took to calling her Myadue, the Morning Star.

"They seem quite taken with you," Sam observed genially once he had discerned that the crowd showed no hostility, only excessive curiosity.

"Yes," agreed Florence cheerfully, braiding her hair and pinning the plaits up upon her head. "A gorilla would not make a greater stir in London than I appear to here. We must add dressing my hair to our list of magic tricks. And how is your fever this morning, my dear?"

"A little improved, thank you," Sam replied, smiling, "but not on account of the luxury of our accommodation last night. I have ordered the oxen to be brought over and slaughtered. Some of the men will come with them."

"Ah, good," Florence approved. "An ox will get us a great deal of flour, beans, and sweet potatoes."

The lame ox was duly slaughtered and cut up into useful portions. The Banyoro women were eager to trade for meat and brought tidy baskets of produce in exchange. The women were clothed in fine bark cloth arranged as modest petticoats and cloaks. Once the bargaining was completed, Sam sent a canoeful of provisions across the river to the others.

Permission to trade for provisions daily was the best arrangement that Sam could negotiate until word came from Kamrasi, so they waited. People came in droves from all the nearby villages to see Florence and observe her ways, which she found very trying. Everything she did—walking, washing, sitting, sewing, sleeping, even attending to her necessary bodily functions—was watched by dozens of pairs of dark brown eyes. There was no escaping her audience. The bolder ones tried to touch her. When Sam shouted at the people to leave them alone, they would shrink back for a few minutes and then slowly creep nearer again. If he covered the door to the hut with a blanket, they pried spy holes through the thatch of the hut to watch Florence.

"I am not an excessively modest woman," Florence declared finally in exasperation, "and I think I may fairly claim to be patient. This is too much. You must demand of the headman that I be allowed some peace, Sam, or I shall go mad."

Sam went to the headman and told him that they must be permitted some time to themselves in order to conduct dangerous, secret ceremonies. Any outsider who caught even the slightest glimpse of what he and Florence were doing would face an indescribably horrible death. He proposed to give the people fair warning, by putting his hat on a stick and ramming the stick into the ground in front of their hut. When they saw that signal, they must all stay far away until the hat was removed, or they would be cursed. The ruse proved quite effective.

Florence and Sam were impressed by the comparatively civilized life the Banyoro lived. They made lovely cloth and wore clothes. They had

complicated music—not pleasant to European ears but obviously accomplished—and long poems, which they recited at ceremonies. They produced attractive black earthenware, which they decorated and fired, and excellent tobacco pipes. Their huts were very grand, being about twenty feet in diameter with high ceilings, unlike the meager huts of the Latooka and other tribes. Most impressive of all, the Banyoro blacksmiths were very skilled and able to draw fine wire from the thick copper and brass trading coils as well as manufacturing many useful metal objects. The blacksmiths used bellows, worked by a few small boys, to keep their fires hot.

After nearly a week of waiting for Kamrasi, Sam and Florence ran out of patience. Wherever M'rooli was, it could not be so far that Kamrasi had been unable to reach them in a week. They decided it was time for a show of temper.

On January 29 they received yet another message from Kamrasi. This one claimed he was unable to come to them and ordered them to travel to M'rooli to meet him. Before this could happen, Kamrasi needed to verify that Sam was Speke's brother. By midday, a huge force of his men had arrived, including three who had worked for Speke. The three men looked Sam over carefully, from head to toe, as slowly and thoroughly as possible. They conferred solemnly and then pronounced him to be Speke's own brother. Even so, they were not prepared to take Sam and his party to meet Kamrasi. Yet another message must be sent and replied to before anyone could move; it would take four days at least.

This was the perfect cue for Sam's display. He stormed about the village, shouting at the top of his voice. "Dust!" he bellowed. "Kamrasi is nothing but dust! He is no real king." Then he turned to his men and shouted, "Load all the gifts back into the canoe. We shall be leaving immediately! I have no wish to see anyone so devoid of manners as this so-called king Kamrasi." His men leapt to obey his commands.

To the headman Sam declared, with a red-faced grimace, "You may count on it: no other white man shall ever visit this wretched place again. You are rude, ignorant savages and I don't believe you have a great king. I shall leave today and you will have to answer to your Kamrasi."

The night before, sensing that Sam was running out of patience, the headman had ordered the canoe to be hidden. When Sam's men returned

to say the canoe could not be found, he exploded again in rage. "If you do not turn the canoe over at once, and bring all my party from the opposite shore so that we may see Kamrasi, we shall seize the canoe by force," he insisted menacingly. From the corner of his eye, he could see that the women and children had already withdrawn from the village and the men were scattering to avoid the impending fight. Seeing that the headman was ready to give up, Florence played the peacemaker once again.

"Sam, I think this man is ready to be sensible. If he will participate in a peacemaking ceremony, bring our men over, and have the people bring in plenty of supplies, may we end this argument without bloodshed?" she pleaded sweetly.

"He has treated us very badly, like servants or liars," Sam said, crossing his muscular arms over his chest and sulking for effect. He stamped his foot like a small, angry boy.

"Yes, he has," Florence agreed, petting his arm soothingly. "He can see now that he was mistaken, that you are indeed the brother of Speke." She turned to the headman and ordered, "Tell Sam that you were mistaken in your treatment of us."

The headman humbly agreed he had made a fearful mistake.

"And do you now promise to treat us with respect and courtesy befitting great and important visitors?" Florence asked.

The headman nodded and mumbled his assent.

"Very well, then," conceded Sam. "Let one of the men who worked for Speke exchange blood with one of our men, to mark that we are now brothers and allies." The ceremony was conducted and peace restored. Most of Sam's men were ferried across before dark and the rest in the morning, when the Banyoro brought baskets and baskets full of supplies for the expedition.

Still they waited for Kamrasi.

11

TOCK-TOCK-TOCK

On January 31 the expedition left the shores of the White Nile to march to M'rooli. They passed through rich cultivated land, densely populated with villages, hiring on new porters in each village. The trip should have been one of the easier and most pleasant of the entire journey, but Florence fell seriously ill with a return of bilious fever.

By February 2, Florence was so sick that she again submitted to the discomfort and indignity of being carried on the *angarep*. After a few more days Sam was almost as bad. To ride for even a few hours he required two men, one on either side, to hold him on his riding ox. The long journey, rugged traveling conditions, and inadequate food supplies had seriously undermined their health. Almost the entire expedition was ill with fever, and the slave woman, Fadeela, died of malaria. Florence's condition deteriorated every day. On February 5 she was so weak that she could not even bear the litter and the expedition rested for a day. Sam was deeply worried. "Heaven help us in this country!" he wrote in his journal. The next day Florence was slightly better and they were able to march for a few hours. They arrived at a village that was among the filthiest and most wretched they

had yet visited. They were housed in a hut bedded with dirty, used straw clotted with animal droppings.

Illness prevented them from making any consistent progress. The expedition marched when they were able and rested when they had to. Contradictory messages arrived from Kamrasi daily. He seemed unable to make up his mind whether the visitors were friend or foe and was too cowardly to meet them. Sam called him a fool and threatened to leave. Kamrasi begged them to come on, asking them to leave the bulk of the luggage behind and send an advance party. When the advance party—consisting of Sam, Florence, Ibrahim, Richarn, Saat, and about twenty men—reached M'rooli, they were ferried across the river to an isolated, swampy flat. Once there, they found that Kamrasi had gone. He had retreated to the far side of the river for safety, taking all the canoes with him. They were marooned in the most unhealthy habitat imaginable. Too late, Sam remembered that Kamrasi had played this same trick on Speke and Grant.

Climbing up an anthill to gain height, Sam surveyed the region with his telescope. The opposite bank was black with people; he could see about a dozen huge canoes, which might carry fifty men each, or more, preparing to come in their direction. Ibrahim was sure that Kamrasi had summoned his warriors to attack them. He and his men were close to panicking. "Fools!" Sam cried. "Do you not see that the natives have no *shields* with them, but merely lances? Would they commence an attack without their shields? Kamrasi is coming in state to visit us." Nonetheless, he concealed men with guns behind thorn hedges in case fighting broke out.

When Kamrasi and his entourage arrived, Sam was too weak to stand. His men carried him to the Banyoro king and laid him on a mat on the ground. This placed him at a severe disadvantage. Kamrasi was a tall, handsome, dignified man in a long bark-cloth robe. His attendant spread a carpet of leopard skins on the ground and placed a royal copper stool upon them for Kamrasi to sit upon.

Through the interpreter, Sam explained the purpose of his journey was to find the source of the Nile, which he believed lay in the lake Luta N'zigé—a name quickly corrected by the king to M'wootan N'zigé. The lake, Kamrasi solemnly informed him, was six months' march away. Kamrasi regretted that he could not let Sam proceed because he would die on the road and then Sam's king would retaliate against him.

"I have no king," Sam asserted bravely, "but a very powerful queen who watches over all her subjects. She will indeed be angry if I die in your country, so you had best send me on to the lake as quickly as possible, before I die." As further inducement for cooperation, Sam ordered the men to unroll the much-admired Persian carpet and to lay out the many gifts he had brought for Kamrasi. Kamrasi was most pleased with a double-barreled gun, which he ordered to be fired. He laughed heartily when his people scrambled and ducked in terror at the gunshot. He presented Sam with seventeen cows, twenty pots of plantain cider, and many loads of unripe plantains.

Finally Sam inquired about the item he most desired: had Kamrasi still the medicine chest that Speke had left with him?

"Alas, no," Kamrasi replied carelessly. "This is a most feverish country, and we have been obliged to use up all of his medicines ourselves."

It was a very hard blow. Sam and Florence had been relying on Speke's foresight to save them. Sam had the men carry him back to the hut, where he and Florence lay in feverish misery throughout the night. The next morning, feeling somewhat better, Sam had another interview with Kamrasi, who asked Sam to let his men join in a raid on Rionga's men. Sam refused, saying he was there only to discover the lake. Possibly Ibrahim's men would oblige. Sam emphasized that his party was entirely separate from Ibrahim's and explained to Kamrasi the concept of trading ivory with Ibrahim for goods to be brought back from Gondokoro.

The rain came down with the force of a waterfall. Sam and Florence lay miserably in the wet hut while its muddy floor turned into an unpleasantly fragrant soup. By February 16 all of their porters had deserted and the rivers were filling up with rain. If Kamrasi did not supply them with porters soon, it would be impossible to cross the Asua River before the next dry season. They might have to spend another year in M'rooli.

"We can do it," Florence muttered bravely one night as they discussed their plight. "We can do it if we have to, Sam." She was almost too weak to speak any longer.

"We must leave very soon, Flooey, or we shall fail," Sam answered her bluntly. "This place will kill us if we stay." They both knew it was true.

Their spirits lifted a little the next day, when one of the natives told them that the lake was only ten days' march from M'rooli, not six months'

as Kamrasi had claimed. "Even a man carrying a heavy load of salt can make the journey back from the lake in fifteen days," he asserted. Sam hoped fervently that the man spoke the truth. Certainly Kamrasi made no display of his better side in their presence. Every time he visited he demanded more and more gifts, especially coveting Sam's sword, his compass, and the favorite little Fletcher rifle. When those requests were firmly refused, Kamrasi retorted that he could not supply any porters in that case. Ibrahim and his men left for Gondokoro with loads of elephant tusks, leaving Florence and Sam and their party alone.

After they had lived for ten days in the mosquito-infested swamp, Kamrasi allowed Florence and Sam and the others to cross to M'rooli and promised to send them to the lake on February 22. In response, Sam took off his sword and promptly presented it to the chief, as evidence of their friendship. Still, he was greatly disheartened by Kamrasi's boundless avarice.

"Every day, I must *give!*" Sam complained to Florence. "To the Turks, *give!* To the natives, *give!*" He did not need to say, for she knew it well, that Kamrasi was the greediest of all.

On February 23 Sam, Florence, and their very small party started out, with a guide and porters supplied by Kamrasi. The king sent a message that they were to wait for him to bid them good-bye—no doubt another excuse to demand gifts. When the chief appeared, accompanied by his retinue, he led them to a humble blacksmith's shed, the only available shelter from the blazing sun. Kamrasi opened the conversation by asking for a pretty yellow muslin handkerchief Florence wore upon her head. It was one she had treasured from her days in the Ottoman Empire, a finely woven piece with silver drops sewn around the fringe. Its color and delicate texture had cheered her through many a trying hour in the last few years, and she was not inclined to part with it. Kamrasi had already been given several fine handkerchiefs, she pointed out sharply, and this was the last remaining one in their possession. Kamrasi insisted. Weary of the battle and of his company, Florence reluctantly took off the handkerchief and handed it over. Kamrasi inspected their luggage to see what goods they had and begged for beads and Sam's watch.

"I cannot part with my watch," Sam demurred, "as I cannot take my geographical measurements without it. We must leave now. It is time for

you to fulfill your promises to us. If you compel us to wait another year in your country, we shall both die of fever. My wife has been brave and self-sacrificing; it is not right that she should die for her devotion. We have arranged for a boat to wait for us at Gondokoro, and if we miss the season, they shall not wait. *You must let us go,* as you have promised."

In reply, Kamrasi calmly told Sam that he might proceed to the lake, but he must leave Florence behind to be Kamrasi's new wife.

Sam pulled his revolver and pointed it straight at Kamrasi's heart. He explained with deadly calm, "None of your people can save you if I pull the trigger. If you dare to repeat that insult, I will shoot you right here and now. In my country, such insolence calls for bloodshed, but as you are an ignorant ox who knows no better, I shall let you live provided you never suggest such a thing again."

While Sam made his measured threats, Florence flew into a rage. All of the slang and rude, colloquial Arabic that she learned during her days in the harem came back to her instantly. She gave Kamrasi a dressing-down such as he had never heard in his life. Standing fully erect and shrieking at him, Florence called him a son of a dog, a lecher, a lying savage, an impotent eunuch, and a dozen other things. She denounced his morals, his character, his intelligence, and his hospitality; she criticized his people, his manners, his personal hygiene, and his honesty, of which there was none. All of the frustration she had suffered over three years of hard traveling came out in one volcanic burst. She did not stop until her words and anger were exhausted, and then she glared at Kamrasi with pure fury. Bacheeta had great difficulty translating Florence's tirade, but her meaning was entirely clear.

Kamrasi wanted no part of such a troublesome woman. "Don't be angry!" he pleaded, backing away from the harridan before him as if she might tear him to pieces. He turned to Sam. "I had no intention of offending you by asking for your wife; I will give you a wife, if you want one, and I thought you might have no objection to give me yours; it is my custom to give my visitors pretty wives, and I thought you might exchange. Don't make a fuss about it; if you don't like it, there's an end to it; I will never mention it again." He ordered the porters to take up their loads promptly and move out. Florence and Sam mounted their oxen and rode off with every ounce of dignity they could command. As they approached the next

village, they met with an extraordinary apparition. Six hundred warriors came rushing out, screaming and jumping and shaking their lances and shields. They were dressed like demons: antelope horns strapped to their heads, paint on their bodies, and costumes of leopard and monkey skin. They behaved like madmen, capering, whirling about in the air, and leaping in mock feints. They were a sort of savage farewell parade.

"This is," Sam quipped, "Kamrasi's satanic escort. He must have taken you for the very wife of the devil, Florence."

"I'm sorry if I behaved badly," she said with unnatural meekness, as she tried to suppress an impish smile, "but I was most annoyed with him."

"Yes, I noticed that," Sam replied dryly, grinning at her. Florence would

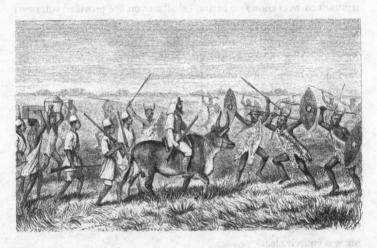

The Start from M'rooli for the Lake with Kamrasi's "Satanic Escort." (1866) When Kamrasi finally provided porters to take Florence and Sam from his capital to the lake, he also sent six hundred warriors whom Sam called "the Satanic escort."

not feel wholly safe until they left Kamrasi and his satanic escort far behind.

When they came to the river on February 27, it was thick with grass, reeds, and floating vegetation. They could not be sure where the water began and where the land ended, nor could anyone see where the water was too deep to wade through. The men found that if they ran quickly, they could dance their way across on the plant mats, sinking no deeper than to their ankles. Sam decided to lead Florence across, begging

her to follow in his very footsteps. The river was only about eighty feet across. After crossing twenty yards, Sam heard a strangled noise behind him. He turned to see Florence sinking into the water, her face fixed and distorted, her skin purplish in color. She dropped as though shot through the heart.

Sam and the men rushed to her side. Florence was insensible and unresponsive. Sam grabbed her by the waist and threw her over his shoulder to haul her to the shore. He moved slowly, step by miserable step, while the vegetation clung to her and pulled her backward. Sam placed Florence tenderly under a tree and bathed her face with cool water, hoping she had merely fainted. She did not regain consciousness but stayed open-eyed and cataleptic. Her face was dark red; her teeth were bared in a stiff grimace and her hands were clenched into fists. She had sunstroke. Sam sent for an *angarep* for her to lie upon and a clean change of clothes, for hers were muddy, wet, and thick with green slime. He rubbed her chest, hoping to strengthen her heartbeat, and the slave women rubbed her hands and feet. Except for emitting occasional choking noises, Florence might have been a corpse.

They carried her as carefully and gently as they could to the next village, where Sam put her to bed. She could not swallow, so he soaked a cloth and placed it on her tongue to moisten her mouth. The singing and carrying-on of the satanic escort was insufferable; Sam threatened to shoot them all if they didn't return immediately to Kamrasi. Sam was terrified that his beloved Flooey would die. Though feverish himself, he slept little that night. He awoke feeling helpless and beaten. Florence's condition was unchanged.

They marched again that day, carrying Florence on the *angarep*, and slept in another village. Sam was cold and shivering from repeated wettings, from fever, and from the impending end of his hopes and dreams. He watched over Florence all that night by the light of improvised candles made of fat and a broken water jar, with a rag for a wick. There was no peace in her face; it was gaunt and immobile. She no longer looked like the beautiful, mischievous girl from the harem he had fallen in love with. What had he done to her? Had he been so stupid as to kill the thing he loved in a fruitless quest for some *lake?* Sam was overcome with grief and guilt. He had no one to blame but himself and his ambition. He should

never have brought Florence here. Everyone had warned him, but his pride would not let him hear their cautions. He prayed to God to spare Florence, to return her to him out of mercy.

After two days of unconsciousness, Florence suddenly awoke. "Thank God!" she whispered hoarsely. Sam rushed to her side, filled with joy, but Florence's eyes were wild and unseeing. She was delirious and did not know him. Sam's heart sank. The expedition rested one more day and marched on again. Florence still raved and her manner was so disordered that she looked like a lunatic in Bedlam—properly the Hospital of St. Mary of Bethlehem, the infamous London insane asylum. On the seventh day after her sunstroke, Florence was wracked with violent convulsions. This was surely the end.

That night Sam laid her down on the *angarep* in the dryest hut he could find. He covered her with a Scotch plaid and fell into a sleep of sorrow and exhaustion on the mud floor beside her. The men busied themselves fitting a new handle to the pickax so that they might dig her grave in the morning. Sam was so weary that he slept past dawn.

He awoke with a start to hear the mournful *tock-tock-tock* of the pickaxes as the men dug Florence's grave. *It might as well be my grave,* he thought. *I shall have nothing to live for now.* Florence had probably died in the night, and he castigated himself for falling asleep. *I should have stayed awake to comfort her in her last hours,* he thought in grief and self-accusation. He felt sick as he crawled slowly to her *angarep*, expecting to see the distorted, dead face of the one he had loved and killed.

Instead, he saw a smooth, unlined brow and a serene countenance; Florence breathed slowly and peacefully. She made a slight noise and then her eyes flickered open. "Sam?" she asked thinly, her voice strained from not speaking. "Sam? I heard the pickaxes this morning. Are the men digging my grave?"

He fell to his knees, embracing her. "Oh, yes, my dearest Flooey, they are," he said, weeping. "I was so afraid you were dead and had left me here all alone. Oh, my dear, my dear."

"I would never leave you, my own, my Sam," she reassured him sweetly, trying to dry his tears with a gentle hand. "Where you go, I go too, just like Ruth in the Bible." In a moment she added, "You know, I am rather hungry. Have we any breakfast?"

Sam dashed from the hut. "She is well! She is well!" he cried, and the others came running. "The *sitt* is hungry!" The women brought some fresh bread and quickly heated up a nutritious soup for Florence. For two days the expedition rested in that village while Florence ate and gained strength. Then, with hearts high, the expedition marched off toward the lake.

They knew they were drawing near their objective. They rested one night in a village called Parkani and made an early start the next day, March 14, in hopes of reaching their goal. They set out on their oxen across a deep valley, and the animals groaned slowly up the opposite hill. Soon they dismounted to walk and spare the oxen, Sam helping Florence along. They reached the summit, and suddenly there it was before them:

a lake like a sea of quicksilver. It glittered in the sunlight some fifteen hundred feet below them, an enormous lake with a southern end that melted into the horizon

The Lake (1866). Too weak to stand without assistance, Florence and Sam finally reached a summit on March 15, 1864, from which they could see a huge glittering lake. They named it the Albert N'yanza after Queen Victoria's late beloved husband.

without a visible shoreline. Looking across the lake, they could make out a range of great blue mountains, fifty or sixty miles off, Sam reckoned, that rose high above the water's surface. The men cheered at the sight, but Sam and Florence were too overcome with emotion to join them.

"We have done it, Flooey," Sam said very quietly.

"We have, Sam; we have done it," she replied. They stood hand in hand and admired the lake, their beautiful elusive lake.

"I think we should call it Lake Albert," Sam suggested. "If the one Speke found is Victoria, what better than to name this lake for her late beloved husband?"

"What a good idea," Florence concurred. "Let it be a tribute to faithful love."

Later Sam wrote a much more flowery account of the finding of the lake.

> It is impossible to describe the triumph of that moment; here was the reward for all our labor—for the years of tenacity with which we had toiled through Africa. England had won the sources of the Nile! . . . Now that I looked down upon the great inland sea lying nestled in the very heart of Africa, and thought how vainly mankind had sought these sources throughout so many ages, and reflected that I had been the humble instrument permitted to unravel this portion of the great mystery when so many greater than I had failed, I felt too serious to vent my feelings in vain cheers for victory, and I sincerely thanked God for having guided and supported us through all the dangers to the good end.

The descent to the town of Vacovia on the shore was twisting and steep. The oxen could not possibly manage it with riders aboard, so the men led them while Florence and Sam went on foot despite their weak condition. Sam cut himself a stout bamboo stick, and Florence leaned upon his shoulder. Together they tottered and stumbled down the precipitous rocky path. Two hours later they reached the level plain below the cliff and walked to the shore. Waves swished up upon the white pebbly beach, just as Bacheet had told them. Wearily they rushed into the lake, welcoming its cool refreshment and taking a deep drink. The men and animals followed suit, plunging headlong into the water. They had reached their very own source of the Nile.

12

THE WATER CABBAGES ARE MOVING

*T*he lake water was not salty. "Sam, didn't that man in M'rooli tell us the Banyoro came here to collect salt?" Florence asked, puzzled.

"He did, Flooey," Sam replied in wonderment. "You have noticed it too, then? This is freshwater, not salt."

"I don't understand," Florence commented. "Why would he lie about something like that?" Sam had no answer.

The path had led them to a place only a quarter mile from a fishing village, Vacovia, where they went to find accommodation. Vacovia reeked of dead fish. Fishing equipment was strewn everywhere in careless disarray. Harpoons leaned against the huts; fishing lines made of plantain stems were strung up all around, drying or in a state of repair; bundles of heavy hooks and floats lay piled in heaps. The harpoons and floats were used for large fish or hippopotamus, a favorite food; the great water beasts were speared from canoes and tracked by the floats as they ran and dove to get away. The ground of the village was littered with waterweed, fish bones, and smashed hippo bones. Fish lay split and drying on racks everywhere. Some men were

beating a huge, muscular catfish they had just landed, trying to kill the ugly creature while it slithered and wriggled in agony. Overhead, large fish eagles—white-headed, brown-winged birds—cried and soared, occasionally dropping down to try to snag a fish out of the water or a tasty morsel from the beach.

They could see no sign of cultivation—no gardens or plantain groves at all. Nothing would grow there, for it was not the lake but the soil itself that was thick with salt. In days to come Sam studied the natives' ingenious method of collecting salt. They dug the black, sandy mud from pits and placed it in earthenware jars made with fine holes in the bottom. Then they poured water through the jars and collected the barely filtered mixture in a solid-bottomed jar positioned underneath the first. This procedure was repeated and repeated until a salty brine was achieved, which they then boiled until all the water evaporated. The dried precipitate in the bottom was salt—bitter and metallic-tasting, but vastly preferable to no salt at all.

Sam exchanged a quantity of blue beads with the chief for a fine goat. Together with one of the ailing oxen, the goat provided enough meat to put on a triumphant feast for the men. There were now only thirteen men left, counting Richarn and Saat. It was miraculous that they had traveled so far and through such hostile country with so small a force. They celebrated heartily at having reached the lake by the sweat of their brows and the courage in their hearts.

The next morning Florence and Sam arose early to survey the lake with his telescope and to discuss matters with the chief. Sam did all of the talking through a translator. First he asked about the lake. It was so wide that even with his telescope they could see little of the opposite side, save two slender silver threads that cleft the mountains opposite: waterfalls. Did the chief know its breadth? He replied that canoes sometimes came across the lake, but the crossing required four days of hard paddling and good weather. There were great storms upon the lake, he cautioned, with large waves and fierce winds. Many men had died in such storms, and they should not try to cross the lake, he said firmly. As for the south end of the lake, the chief himself had not been there but he had heard that there was a village called Karagwé in the country of Rumanika. Formerly men had come from Rumanika's tribe as far north as Magungo, but recently they

had come only as far as Utumbi, well to the south of Vacovia, to collect ivory. This point corroborated information Speke had given them. The chief also helpfully recited the names and chiefs of the other tribes that inhabited the eastern shore of the lake, describing where their territories began and ended.

Sam's most crucial request, as always, was for transport. The chief agreed to provide canoes and paddlers to take their party to Magungo, where a great river flowed into the lake. Florence and Sam believed that the river he spoke of was the Somerset Nile, which they had last seen at Karuma Falls. The chief warned them that it was not possible to paddle up the great river at Magungo because there were many cataracts between that place and Karuma Falls. All of these geographic features were well known to him. Florence and Sam knew they must confirm these facts by their own observations and then take proper readings and measurements. In their hearts, they were already certain that they had captured this source of the Nile.

On the way back to their hut, Florence and Sam saw that the beach was newly littered with the fresh and stinking remains of crocodiles. They had not thought of crocodiles when they had rushed into the lake the day before. The natives swore the scaly beasts were numerous and vicious. Women never dared enter the lake—not even up to their knees—to fill their water jars. In vivid pantomime, they showed how foolish women were seized and eaten by crocodiles.

"Wouldn't that have been a joke, Flooey?" Sam jested. "There we would have been, the great discoverers of Lake Albert, chewed off at the knees by crocodiles!"

"God must have been protecting us. After all our troubles, perhaps He finally decided we needed some help."

Now began again the endless cycle of begging for help and waiting for it to be given. The expedition languished at Vacovia waiting for canoes and paddlers. Fever struck almost everyone, and for a week, Sam was too weak to move except for a few hours a day. Still Sam sent their guide north with the riding oxen; he would meet them at Magungo with the animals.

On the eighth day, March 22, two canoes made of hollowed-out trees finally arrived and Sam was called to inspect them. He selected the best of them and fitted it with an arched framework of long, thin, flexible

wands of wood attached to the gunwales. Reed thatching, such as was used to roof huts, covered the framework, and ox hides were laid over the thatch to make a crude cabin. He fitted the floor with logs and a pile of thick grass and a Scotch plaid to sit upon. "It's like the shell on a tortoise, Flooey," Sam declared proudly, showing her his handiwork.

She was strongly reminded of her snail-shell *angarep,* and she hoped it would be more comfortable. What she said was, "That is very clever of you, Sam. I'm sure we shall be glad to be sheltered from the wind and sun and rain."

Infuriatingly, the men had watched Sam work with mild interest but showed no inclination to help him. He decided to leave them to improve their own canoe as they wished; he would not do it for them.

Each canoe required four skilled paddlers, two at each end. Florence, Sam, Richarn, Saat, the slave women, and the interpreter, Bacheeta, went in the lead canoe, the men went in the other. They set forth on March 23, 1864, when the surface of the lake was like glass and the overcast sky promised some relief from the extreme heat they had experienced lately.

The trip began pleasantly as they watched the scenery go by: mountains; huge rocks of granite, gneiss, or red porphyry; then flats of sand and bush; then areas lush with giant euphorbias, strange, angular trees like overgrown cacti. They passed the queer, saddle-billed stork, numbers of elegant, white egrets, plump hippos, and sinister crocodiles sunning themselves upon the banks in great numbers, but Sam stifled his desire to shoot because he knew how much delay it would cause. They needed now to travel fast, to verify that the river entering the lake was the Somerset Nile and then to hasten to Gondokoro in hopes of meeting the rescue boats before 1864 was out. At dusk the paddlers steered them into a smooth but steep sandy beach where they set up a pleasant camp and ate dinner.

In the morning the paddlers had gone. Fortunately, Sam had mounted a guard over the canoes and paddles the night before, so at least they still had a means of transport, if not the men. The nearby village was entirely deserted. By afternoon Florence and Sam gave up hope of finding boatmen and ordered their own men into the canoes.

Though some were familiar with *noggur*s and *diahbiah*s, these men knew nothing about paddling. The canoes waltzed and pirouetted like drunken sailors while the men tried to master the arts of steering and pad-

dling in rhythm. By nightfall they had made discouragingly little progress. Exhausted, they put ashore on a small promontory infested with mosquitoes and other biting insects. Soon rain began to fall in torrents. Lying beneath a blanket was sweltering; removing the blanket meant a soaking and a skin covered in welts. Everyone awoke, miserable and itching, to more rain.

Immediately after breakfast Sam fitted the lead canoe with an improvised rudder, mast, and sail to help with steering and propulsion. Because the men sulked under the dripping ox hides, shivering and huddling over their pipes, Sam decided irritably to leave them to modify their own canoe if they wanted to.

"We are leaving now," he announced loudly when he was done. "We shall not wait for you." He loaded his party and their meager supplies into the improved canoe, which held a satisfyingly straight course in the light wind. They were able to glide along at about four miles an hour by Sam's reckoning. The other canoe corkscrewed as hopelessly as the day before. They labored hard but their lack of skill and understanding meant they covered little linear distance. At the next village they saw strong men hoisting paddles over their heads in a sign of willingness to help, so Sam asked the chief to send six of them back to the foundering canoe. Delighted with such cooperation, Sam decided to cut straight across the bay to the next promontory, rather than hugging the shoreline.

By midday, a heavy swell began to move the boat. The men looked worriedly at the darkening sky to the west and the rising wind that filled the sail. Clearly there was a storm ahead, and they were at least four miles from shore. "Stroke," Sam encouraged them like a coxswain in a sculling race. "More power! Stroke! Stroke! Pick up the rhythm now. Use every paddle. We must go as fast as we can. On, boys, on!" Every man took up a paddle and put his back into it; no resting and paddling in turns now. The swell grew larger and more ominous; the sky blackened.

"*Inshallah*, there shall be no wind," the men declared against all reason. Sam knew better and ordered the sail to be taken down as being more dangerous than useful. When the wind rose, the improvised mast cracked and disappeared. The heavy, bulky canoe labored in the white-capped waves. The men paddled as hard as they could while Florence, Sam, and Saat bailed furiously with gourd shells. If the rain didn't swamp the

The Storm on the Lake (1866). The expedition paddled north along the eastern shore of Lake Albert to verify that the Nile both entered and exited the lake. A sudden, ferocious storm very nearly drowned them all.

canoe, the waves flowing over the sides would.

The sky was so black they could hardly see, except during brief flashes of lightning. Sam's voice could no longer be heard above the boom and crack of thunder. Their only hope was to make directly for where Sam thought the shore should be. When they were close enough to see the terrain in the flashes of lightning, Sam spied a small sandy beach at the foot of a row of steep cliffs. The men pulled with all their strength and finally grounded the canoe upon the beach.

Sam insisted on unloading the canoe immediately for fear it would be swept away. Once it was emptied, they hauled the vessel well above the waterline and secured it to a tree. Everything on the boat had been ruined by water except the gunpowder, which was kept in tin canisters. They were all trembling with cold, exertion, and fear. Where was the other canoe? By the light of the next lightning flash, they spied the second canoe only about a half mile behind them and following their course. When that too had beached safely, the miserable party found some empty huts and started blazing fires. They huddled close to the flames for warmth as their clothes dried on their shivering bodies. For dinner they stewed a fowl that had been drowned in the canoe.

At each stop paddlers deserted and Sam would again plead and negoti-

ate with the local chief or headman for more paddlers. Food was scarce and inadequate in some villages, abundant and strengthening in others. At Eppigoya they were able to obtain hundreds of eggs and fowl for an equal number of blue beads—a surprisingly good barter. Florence thought this had ended their food troubles, for if they allowed some of the eggs to hatch, they might have a near-constant supply of fowls. She hadn't reckoned on the suicidal habits of African birds. Day after day the chickens either jumped overboard or lay down in the water at the bottom of the canoe and drowned there; why they did so, she could not imagine.

Both Florence and Sam were very weak from sunstroke, fever, and malnutrition. After eleven trying days, they were near the north end of the lake. The surface of the water was covered in floating vegetation and papyrus that reminded Florence and Sam vividly of the sudd. There seemed to be no current at all, yet the men asserted that they were at Magungo. How could the Somerset Nile empty into Lake Albert and produce no current? The men paddled until the water was shallow and then hopped overboard to haul the canoe slowly and painfully through the thick beds of reeds. Suddenly the vegetation parted and they arrived at a small rocky beach. There stood the chief of Magungo and their faithful guide, who had walked from Vacovia with the oxen.

Once ashore, Florence collapsed under a shade tree to rest. She thought perhaps she would never move again, just sit there blissfully still forever. She could not remember being so exhausted before, not even on the long dusty walk to Viddin when she was such a small girl. The villagers soon arrived with a goat, more fowl, eggs, sour milk, and even butter, a luxury Florence and Sam had not tasted in a long time. The chief was delighted with the beads they gave in return and showed them to huts in the village. The village stood at a higher elevation than the lakeshore; from there they could plainly see the Nile exiting from the lake at Koshi. What remained to be verified was whether the Somerset Nile flowed into the lake at that strange area of dead water and floating vegetation.

"I cannot understand it," Sam puzzled. "We saw the Somerset Nile at Karuma Falls, and it was a large and swiftly flowing river. When it came through those gorges and over those rocks it made a great waterfall and lots of spray. How can the same river empty into the lake here and produce no current? It isn't possible." Florence, who was very frail and felt often

as if her mind was working as poorly as her body, had no answer. If they did not go to the Somerset Nile and verify its identity for themselves, then their journey was in vain. If they did go, and the traveling took too long, they might not arrive at Gondokoro before the sudd closed the White Nile for the year. Another year in Africa would kill them, they knew; their fever was too continuous and there was no quinine. Sam suggested they go to the Somerset Nile and then abandon the river and their luggage to make a fast march for Gondokoro.

"No, I do not think so," Florence answered slowly, with effort.

He was struck with a cold fear that she was more ill than he knew, that he might yet lose her. "Are you feeling badly, my dear? Don't worry. We shall stay here and rest up, as long as you need," he promised immediately.

"I didn't mean that," Florence clarified. "I meant we should not abandon the Nile once we have confirmed it *is* the Nile. We must follow it all the way to Gondokoro or else we shall not be sure of our evidence. Seeing is believing, don't you English say that? Then we must see for ourselves. Then we will know."

"Neither of us is strong enough for that," Sam replied. "My latitudinal measurements confirm that this should be the Somerset Nile. If we go up it and find the waterfalls and cataracts, as the natives describe, then no man but a fool and a knave would doubt that we have proven that the Somerset Nile empties into Lake Albert, and we have already seen the Nile leaving the lake at Koshi. Then we must try to save ourselves." He patted her hand lovingly. She lay back, exhausted and grateful that they would not have to take the longer, more arduous route toward home. She slept for hours.

They set out the next morning for the area of dead water. Merely walking down to the rocky beach for departure caused Sam's legs to shake so badly that he required assistance. His attacks of sweating and trembling came several times a day, with hardly any periods of comparative wellness. The paddlers took them due east into the broad channel that they claimed came from Karuma Falls, which would make it the Somerset Nile. Whatever it was, the body of water soon narrowed to only about five hundred yards wide. By afternoon, Sam was so ill that he was carried ashore unconscious on a litter, as Florence had so often been. She stag-

gered after him, leaning on Saat. Despite her own fever she watched over him and sponged his burning forehead through the night. The next morning neither of them had the strength to walk. Sam scribbled in his journal: "Laid down with bad fever—God help us in this horrid land."

They were carried to the canoes and set out upstream once again. In a moment of lucidity, Sam thought to himself regretfully that they looked like departed spirits being ferried across the river Styx. The river narrowed again, to about two hundred yards in diameter, but there was still no current. They slept that night, exhausted, on a mud bank thick with mosquitoes.

In the morning Sam opened his eyes to see a thick fog covering the water. He lay still, watching it slowly lift. Suddenly he realized through his febrile confusion that the floating water plants were *moving*—slowly, but moving nonetheless—to the west. There was indeed a current here, moving toward the great expanse of the lake. "Flooey," he said softly without getting up from his *angarep*, "look. The water cabbages are moving."

She opened her eyes and gazed at the water, then she smiled contentedly. "There is a current, Sam. This is the Somerset Nile." They then fell back into an exhausted sleep.

When the men awoke, they warned Sam that there was a huge waterfall just ahead that was too dangerous to approach. They wanted to turn back, but Sam insisted they take him and Florence to the waterfall. "I must see it for myself," he said.

Again the men carried them to the canoes and reluctantly began to paddle. As the river narrowed further, the men paddled more and more slowly. Suddenly they stopped paddling altogether for a moment. "Listen, Baker Effendi, listen!" one man said. There was a sound like distant thunder.

"I must see it," Sam repeated shakily. "Seeing is believing."

The once-flat riverbanks were now steep cliffs at least 180 feet high. The sound grew louder as they moved upriver. Ahead of them lay a bend in the river, beyond which they could not see. "We shall go around that bend," Sam ordered. "I must see the waterfall." No matter how the men protested, Sam held firm and finally they paddled on.

What they came upon was a stunning vision. On either bank the rocky cliffs rose rapidly to a height of about three hundred feet, the rock over-

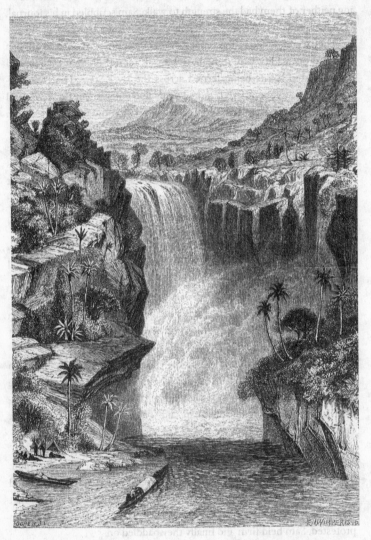

hung with lush vegetation. Gushing through a narrow cleft in the rock, the river cascaded through the gorge at tremendous velocity. The turbulence of the rocky riverbed and the jagged gorge made the water look snowy white. The vast volume of water plunged straight down about 120 feet into a pool so deep it appeared still.

"It is magnificent, just magnificent," whispered Florence, her eyes wide and her face dampened with the misty spray that filled the air.

"We have seen it; we have seen it at last," Sam murmured in awe. "We shall call it . . . we shall call it after Sir Roderick Murchison of the Royal Geographical Society, I think," announced Sam, his chest swelling with pride. "This shall be Murchison Falls, the most important geographic feature on the entire White Nile."

"Poor Speke!" Florence added. "Poor Grant! To think they missed seeing this. And have you seen the crocodiles?" She pointed to the sandy banks, where dozens of huge, knobbed creatures lay still in the sun. Some held their mouths open like statues of ferocity; others lay as if dead, perhaps opening a single, slitted yellow eye occasionally. But all were waiting for some foolish creature to mistake their stillness for absence and come within striking range.

Sam could not resist taking a shot at one giant crocodile. The unexpected noise so alarmed his boatmen that one dropped a paddle. In the confusion, the stream turned the canoe and pushed it into the reeds near one shore, from which a huge hippopotamus erupted to protest their intrusion on its territory. The boatmen scrambled to retrieve the dropped paddle and made a hasty retreat downstream.

Sam sketched the falls as fast as he could while the men paddled back around the bend. There could be no more stunning visual proof that the Somerset Nile flowed into Lake Albert than Murchison Falls.

Murchison Falls (1866). Florence and Sam discovered a stupendous waterfall where the Somerset Nile plunged into Lake Albert. They named it after the president of the Royal Geographical Society in London.

13

MY LEGS ARE BUT USELESS THINGS

That night they stopped at a village to allow the guide and the oxen, which were walking in the pouring rain, to catch up. The cattle were wretched, thin, and covered in welts from tsetse-fly bites. They trudged along with their heads down and left runny droppings. They could not be ridden in this condition. Florence and Sam would have to walk back to Gondokoro or stay where they were.

On April 7 they arrived at an island known as Patooān. By the time they reached the ferrying point, neither Florence nor Sam was well enough to stand, and they could not exert much influence over the course of events. One of the oxen had fallen into a pit trap designed to catch an elephant, from which it seemed useless to try to extract him. The miserable hut they were offered had holes in its thatched roof, and the nightly deluge soaked Florence and Sam, who were already shivering and nearly delirious with fever. In the morning they learned that Kamrasi and Rionga, the two great chiefs, were once again at war. Kamrasi had persuaded Ibrahim to side with him, while Rionga had formed an alliance with another powerful chief, Foweera. Patooān lay exactly on the border between

Rionga's territory and Kamrasi's, and no porters from either side would venture there.

Florence and Sam took more measurements and observations while they were delayed, but they were so befuddled with fever that each begged the other to check the calculations. They determined that the river fell a total of 475 feet from the altitude of Patooān, at 3,195 feet, to the shores of Lake Albert, which they had measured at 2,720 feet. Since the drop at Murchison Falls was at least 120 feet, and possibly more, the slow uphill climb from Murchison Falls to Patooān must account for the difference of 355 feet. While the calculations were satisfyingly consistent, making them did nothing to improve their hopeless situation.

They were prisoners on the island of Patooān. Florence was deathly ill and Sam was badly weakened. None of the natives would agree to carry them to Shooa for any price or for everything they had. Sam offered all of his beads, about fifty pounds, and every remaining scrap of baggage, but no one would consent. On April 14 Sam scrawled despairingly in his journal: "I am in a great fix—no porters, no headman, and today again is lost while time is precious. Three of my riding oxen died yesterday, and today tsetse bitten. Only one remains—he is sick. There are no supplies here, and the natives have bolted from the village."

At length a few men agreed to carry them, but Bacheeta warned Sam that their true intention was to take them to the opposite side of the river and abandon them to starve in the desert. Another headman promised fifty porters, but they did not materialize.

Florence and Sam began to discuss their coming death. Sam made notes in his journal, directing the disposition of his effects. He instructed the headman to take his journal, maps, and observations to the British consul at Khartoum—was it still old Petherick? he wondered idly—so that his work should not be lost. Neither Florence nor Sam wanted to survive alone, so they kept the revolver loaded and close at hand. Death began to seem like no more than a cessation of the terrible struggle and misery that they had endured for so long.

By the end of April, Florence and Sam blamed Kamrasi for their dreadful situation. He sent no provisions to them and provided no porters, yet his lies arrived by messenger almost daily. Kamrasi had plenty of men and plenty of food, but without his approval no one would lift a finger to help

them. Sam and Florence grew so thin they looked like skeletons. Most days, all they had to eat was a sort of gruel made from moldy *tullaboon* seeds that they had found stored in an underground cache. Sometimes they had the energy to gather some spinachlike plants to boil and eat. Sam made a kind of tea out of wild herbs, and sometimes the men brought them a little honey to sweeten it. They had no milk, no meat, no fat, no protein. They were nearly dead.

Lying helpless on their *angareps*, they dreamed of food at home. Sam longed for English roast beef, with gravy and potatoes, and a bottle of pale ale—delicacies Florence could hardly imagine. She remembered lovely dishes of rice, spiced meat, and dried fruit from Viddin, succulent veal dishes with sour-cream sauces, and noodles from Hungary. The last of their oxen died, but they refused a portion of its meat for fear of acquiring another ailment or parasite.

Kamrasi continued to send messages. Now he promised to send food if only they would agree to fight with him against Rionga and Foweera. What he wanted were Sam's guns and the last of his men. Sam himself was no use to anyone. On May 21 he recorded his pitiful condition in his journal: "Oh my legs, they are but useless things, I cannot move twenty yards. It is misery in this country that an English beggar does not suffer [at home]."

At last Sam and Florence decided they must give in or die. Pleading would not influence a coward and a liar like Kamrasi, only bold demands. They sent a man to Kamrasi with a message.

"Tell him," Sam instructed carefully, "that he has treated me badly. I am a more powerful chief than Kamrasi, and yet he has insulted me by sending only messengers and not coming himself. If he requires my alliance, then he must deal with me in person. He must send fifty porters at once to carry me, my wife, and my effects to his camp, where we can talk in person." Sam asked for a token to accompany the reply, so he might know the message had been truly delivered to Kamrasi himself.

When the reply came, it was accompanied by a gourd containing some pages from the English Church Service, translated into Kiswahili by Dr. Krapf and annotated in Speke's hand. Better still, Kamrasi said his men would carry Sam and Florence to his camp the next day. He sent a thin ox

too, which was slaughtered and eaten that night—the first meat they had had in a long time.

On the morning of May 28 the weary explorers began the tedious journey to Kamrasi's camp. As ever, the porters bolted and deserted at every opportunity. The rain fell incessantly. There were no huts or villages to shelter in, for every village and town had been burnt in Foweera's raids. After five days they arrived at Kamrasi's camp. The Turks came out to meet them and marvel at their survival. Ibrahim was especially surprised and pleased to see Florence, as he had heard she had died some days before. A hut was prepared for them and a fat ox was slaughtered for a welcome feast.

No sooner had they finished eating and retreated to their hut than Kamrasi himself appeared. His manner was distinctly odd; he seemed amused at their ragged and emaciated state and tried to make a joke of it. Sam was feeling stronger from the food he had, but he had no patience for such idiotic foolery. He told the chief bluntly that he had behaved like a petty and disgraceful scoundrel.

"Never mind," Kamrasi replied glibly. "It's all over now; you really are thin, both of you; it was your own fault; why did you not agree to fight Foweera? You should have been supplied with fat cows and milk and butter, had you behaved well. I will have my men ready to attack Foweera tomorrow. The Turks have ten men; you have thirteen—thirteen and ten make twenty-three. You shall be carried if you can't walk, and we will give Foweera no chance. He must be killed. Only kill him and MY BROTHER will give you half of his kingdom."

Sam was confounded; no brother had ever been mentioned before. "Your brother?" he exclaimed, and then asked who this brother might be. When the man answered that his brother was the great chief Kamrasi, Sam's confusion knew no bounds. They had been dealing with this man for months under the impression he was Kamrasi. "If you are not Kamrasi," he blurted out, "pray, who are you?"

"Who am I? Ha-ha-ha!" the man answered nervously, pretending to laugh. "That's very good; who am I? Why, I am M'Gambi, the brother of Kamrasi. I am the younger brother, but *he is the king.*" The real Kamrasi had been afraid Sam might kill him and sent M'Gambi in his stead.

Outraged, Sam sent for one of the Turks, who confirmed this story but added that even he had never seen the real Kamrasi. Sam was exceedingly insulted. He announced he would deal no more with M'Gambi, as he did not care to be made a fool of. "If a woman like my good wife," Sam concluded angrily, "dared to come far from her own country and live among such savages as Kamrasi's people, what sort of weak king is he that he does not dare to show himself in his own country?" If Kamrasi wished to talk to Sam, he must send provisions and he must come to Sam himself.

Messages flew back and forth, but eventually a milk cow and young calf appeared at Sam's hut, followed by a fat sheep and two pots of plantain cider. Kamrasi asked for Sam's little Fletcher rifle, his watch, and his compass, but he wisely did not request Florence. The refusal was automatic. In the morning Sam donned his Highland dress costume, which he had somehow preserved through the entire journey. He ordered the natives to carry him and Florence to Kamrasi's camp, accompanied by all their remaining men. People thronged to gape at this amazing spectacle. Knowing Kamrasi's propensity for sitting on his royal stool, Sam had one of the men carry a stool for him too so that he might not sit lower than the chief.

The true Kamrasi was a regally handsome man, tall and well made, dressed in a fine cloak of well-tanned goatskins. He had great presence but Florence and Sam felt he had no honesty or decency. None of his people were permitted to stand in his presence; they lay on their faces, sat, or crawled on their hands and knees to address him. None dared to look at their king too boldly, so fearsome was he. He immediately began to beg Sam for the rifle, his watch, and his compass. Sam gave him ammunition, a box of caps, and a few bullets but refused to part with the other items. Kamrasi reprimanded him that such things were of no use when he had no guns, and Sam reminded him that both he and Speke had given him guns.

"I had heard," Sam told the king insultingly, "that Kamrasi was a great king, but you are acting like a mere beggar. I doubt you are Kamrasi; you must be another imposter. I shall not visit you again." He ordered the men to carry him back to his camp.

Kamrasi ordered flour, a goat, and two jars of plantain cider to be sent to Sam and Florence in their camp at Kisoona. For June, July, and August,

Sam and Florence stayed at their camp, provisioned by Kamrasi, and regained their strength. Milk and butter greatly helped their recovery, and they were even able to obtain delicious coffee. Still, day after day, Sam was flattened by episodes of fever at about 2 P.M. At the recommendation of one of the Turks, he tried vapor baths. He rigged a kind of tent over a pot of boiling water, laced with pounded leaves of the castor-oil plant, and inhaled the steam. Sam believed this treatment made him stronger.

The real Kamrasi was as avaricious as his brother had been in his stead and used every ploy to try to extract more gifts from them, including threats to withhold food. His main objectives were always Sam's little Fletcher rifle, his watch, and his compass, though he happily relieved them of beads, combs, mirrors, needles, and any other items they might yet own. Kamrasi badgered Sam incessantly to kill Rionga and Foweera. "I know a high cliff," Kamrasi suggested cunningly, "upon which you could stand and pick Foweera and his people off with your fine little rifle. Now, if you are feeling too ill to go yourself, you could simply *lend* me your gun and I should do it myself." Sam was far too experienced to fall for such a flimsy ruse and said so. He repeated that he would not attack Rionga or Foweera, though he would assist in Kamrasi's defense if they attacked him.

One day Kamrasi stopped by to inform Sam that the traders were now involved too: de Bono's men, under a man named Mahommed Wat-el-Mek, were allied with Rionga and Foweera. Wat-el-Mek's force was far greater than Kamrasi's, Ibrahim's, and Sam's put together. Kamrasi was preparing to run; he was dressed in a short blue kilt that Speke had given him, the better to move swiftly. Sam laughed and called Kamrasi a coward. What sort of king was he, who proposed to run in his own country?

Sam ordered his headman to raise the Union Jack on a tall staff in the courtyard, signaling to all that this country was under British protection. Then he sent a message to de Bono's men, saying that he and Florence were in residence at Kisoona and that he wished to negotiate. In two days a group of ten men from de Bono's party returned to see if the author of this message was really Sam Baker, since they had heard that he and Florence had died months earlier. Quite reasonably, they suspected Kamrasi of duplicity.

When they saw the British flag and Sam and Florence themselves, de Bono's men realized the message was genuine. Sam asked these delegates

how they dared to invade a country under the protection of the British flag. He announced that Bunyoro belonged to him by reason of discovery—a dubious but effective claim—and that Ibrahim had exclusive rights to the elephant tusks and other produce of the country. Anyone else was an invader, who would be repelled and reported to the authorities in Khartoum.

De Bono's men replied that they had not known Sam and Florence were in Kamrasi's country or that Sam had taken it under his protection. They had been given slaves and ivory by Rionga, Foweera, and another chief, Owine, on the condition that they kill Kamrasi. Sam sent a message directly to Wat-el-Mek, upon receipt of which he and his men had twelve hours to quit the country. This they did, grudgingly.

Kamrasi was awestruck by the power of Sam's magical flag and immediately demanded that Sam give it to him. Not surprisingly, Sam refused, but Kamrasi rewarded Sam with huge quantities of ivory. Having always sworn he wanted neither ivory nor slaves, as the two trades were inextricably intertwined, Sam would not keep the ivory. He would not make himself a liar, even for the great wealth the tusks represented. He gave them to Ibrahim's people.

Foweera, Owine, and Rionga were fairly easily defeated by Kamrasi's men after de Bono's force withdrew from the conflict. What was very trying for Florence was the parade of captured natives. One of them was a wife of one of the chiefs, who had a beautiful little boy about twelve months old with her. They were doomed to be slaves now. The enemy chiefs themselves had been murdered in the most horrible ways, with much gleeful celebration that disgusted Florence and Sam. There was nothing they could do.

While Kamrasi's gratitude was running high, Sam tried to persuade him to send them on to Shooa, which had a healthier climate and was closer to Gondokoro. Kamrasi would not let his prizes go yet. He had more intertribal wars to pursue. On September 6 M'Gambi came to tell Sam that a huge army of the Baganda, known to Kamrasi as the Mwa people, had already crossed the river into Kamrasi's country. Kamrasi's Banyoro were deathly frightened of the Baganda, who were renowned warriors. The leader of the Baganda was King M'tesa, in whose court Speke had lived for months and whose wife had presented Speke with

two young wives. Now he wanted a visit from Florence and Sam, Speke's brother. King M'tesa claimed he had heard that Kamrasi was preventing Florence and Sam from leaving Kisoona and bringing him many fine gifts. It was a story not far from the truth.

Kamrasi determined to flee and ordered a complete evacuation of the country in a few days. As he led crowds of women, men, and animals away, Kamrasi set fire to his own villages. Florence, Sam, and their men were left to wait for porters, as always. With typical cunning, Kamrasi marooned Florence and Sam and their expedition between himself and the invading force. The porters appeared only after Sam threatened to ally himself with the Baganda. Florence had to be transported on a litter and Sam in a chair, which meant they soon fell far behind the other porters, who hurried to catch up with the main party at the village of Foweera.

Before long Sam and Florence were left to struggle on with the few of their own men who remained. They had little food, less water, and very few guns. The villages where they stopped along the way were either burned or deserted. One day Richarn went in search of porters and failed to return; a pool of blood and a broken ramrod from his gun were the only traces of him that could be found. They waited until nightfall in hopes that he could make it back to camp, but there was no sign of him, dead or alive. Fatigue, hunger, and grief seemed about to overwhelm Sam and Florence. Richarn had been one of their most faithful men, a stalwart who had always been loyal and honest. Now he was gone too. Without Richarn, their situation was markedly worse.

Florence suggested that they should abandon all their luggage and make a forced march to Foweera that night. They could reach it by daybreak. Once at Foweera, they would be with the main party, which had food, ammunition, and plenty of men. The journey was twelve or thirteen hard miles. To cover it at night, through high grass and enemy territory, would be very difficult for well and strong travelers. They were still weakened and ill. Could they make such a journey now? The alternative, to sit and wait, went against all their natural inclinations. It was a desperate gamble, all or nothing.

They piled the luggage into one hut, save a single canvas bag that held blankets and a jar of water. They set out at 9 P.M., after the moon came up. The path traveled by the mass of people following Kamrasi was obvious

for most of the way, but after some hours they lost the road. One of Sam's men, Moosa, managed to capture a native to serve as a guide, and they labored on, stumbling in the darkness. Florence was so weak that she kept falling; her clothes were heavy and wet with dew, and she could hardly stand in them. All she could think of were her long journeys on foot as a child: from Nagy-Enyed, where she had lived with her grandfather, to the army camp in winter; from Temesvar, where the Transylvanian army had been defeated, to Orsova and Viddin in the hot, dusty summer. She had been exhausted and hungry and frightened. If she could make those journeys as a child, she could do it now. All she had to do was get up when she fell and then walk until she fell again. She had no father or mother to help her, but she had Sam and Sam was everything. Tomorrow there would be food and water and rest.

After eight hours of marching, Sam thought he could hear the roar of the cataracts on the Nile. They must be very close to Kamrasi's camp. He tried to lift Florence's spirits with the news. "I can go no farther," Florence whispered miserably in reply. "I'm sorry, Sam, I know I said we should do this, but I can't carry on. It is too much; I'm too weak. We must wait here for a while." She could not bring herself to say what she thought: that she would never be strong enough to march again.

Sam asked the men to bring some blankets for Florence, so she could lie down. At that moment the guide came back to say that Kamrasi's camp was only two hundred yards ahead. Joyously, Sam gave his trademark whistle to alert the men, so their approach would not be taken as hostile. The fools had not posted any sentries, and his whistle awakened them from their sleep. Knowing from the whistle that it was Sam's party, the men came for them and carried Florence into the camp. There was plenty of food, a change of clothes, warm fires, and a blessed chance to rest at last.

Miraculously, a few days later Richarn walked into camp, not dead at all. He had been set upon by the chief of a village who was hiding some of the runaway porters. They had struggled over his gun, which Richarn was determined not to lose. When the chief stepped back to kill him with a lance instead, Richarn fired and then ran away, leaving the ramrod clasped in the dead man's hand. The blood Sam found had been the chief's. Richarn had traveled for days to intercept them. On the journey he had man-

aged to emulate Sam, making an excellent wooden ramrod so that his rifle continued to be useful.

On September 22 the second miracle occurred: Ibrahim reappeared, having gone to Gondokoro and come back. He was carrying letters and packages for Sam from England. Sam read the letters and newspapers aloud to Florence with keen pleasure while she rested. Everything had been written more than two years previously, except for a letter from Speke, which was more recent. Speke had enclosed the July 4, 1863, copy of the *Illustrated London News* featuring a fine article and a drawing of himself and Grant addressing a large crowd at the Royal Geographical Society.

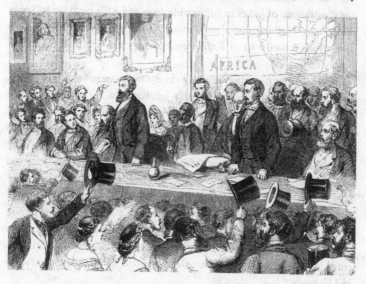

There was too a delicious article from *Punch* about the discoveries made by Speke and Grant. For a whole day Sam reveled in reading and rereading his post. Florence, sadly, had no one who might write her, but she took joy in Sam's pleasure.

The Explorers Honored (1863). Speke and Grant were hailed by an enthusiastic audience at the Royal Geographical Society for discovering Lake Victoria. Florence gave this illustration to Kamrasi, who treasured it.

Ibrahim also brought some luxuries: a bolt of cloth to make fresh clothing, which Florence and Sam sorely needed, a large jar of honey, some rice, and some coffee. As they expected to stay for some time at

Foweera, Sam improvised a still to make whiskey from sweet potatoes, which were locally abundant. The product was very fine—or so it seemed after long abstinence. Several of the men, especially Richarn, begged to be allowed to "attend" the still and were frequently found sound asleep next to it, with the fire out. The spirit seemed to make a marked improvement in the health and spirits of both Florence and Sam.

Ibrahim had also brought enough gifts to temporarily assuage Kamrasi's greed, and the chief reciprocated by giving Ibrahim several immense loads of ivory. Florence had the happy thought of giving Kamrasi the copy of the *Illustrated London News*, which he prized almost as highly as the illustrations of ladies in fashionable dress as for the portraits of Speke and Grant. Nothing distracted Kamrasi from his primary bloodthirsty aim, which was now to kill Kalloé, yet another chief who had become his deadly enemy.

In November the rains drew to a close. On the seventeenth, Florence, Sam, their men, and Ibrahim's party left Foweera. So much ivory had been collected that seven hundred porters were required to carry it and provisions for a five-day march through uninhabited country. They had a military escort of another eighty armed men. Seated on some riding oxen they had bought from Ibrahim, Florence and Sam were foolishly delighted to be out of Kamrasi's odious company. They stopped in the village of Shooa, where they had left supplies on the way out, and were greeted with dancing and celebration. They settled in for some weeks, during which Sam struggled to convert his rough sketches and measurements into final maps, a tricky task in a land without tables. Sam's Christmas entry in his journal showed the reflective mood that had settled on him and Florence.

Xmas day! No beef nor plum pudding and all those most dear far, far away, but my heart is with them, and full of gratitude to God for his protection and guidance throughout the past weary years. Last Xmas day I was still at Obbo, full of anxiety, broken down in health and spirits, my work still all before me; and hope of success but faint, the season so far advanced that to return and not to advance would have been wisdom. My quinine [was] exhausted; fever in my very marrow; no hope of reaching Gondokoro in time for the annual boats should I proceed to the Lake [and] disgrace

should I be beaten back. Before me, difficulties, dangers, and disease—and utter uncertainty in the untrodden country in which I believed the lake lay hidden. This Xmas may well be one of thanksgiving. A hand not unseen has led me when I was lost, has raised me when I was broken down, and guided me through all dangers to success. My heart is light, my limbs are strong, and in all humility proud of having won a hard fought struggle I sincerely say "thank God, and trust not to forget his blessings."

Fever returned with the new year. They stayed in Shooa until February, trying hard to break the natives of the insidious habit of slaving and failing utterly. The woman who had been captured in the attack upon Foweera—the one Florence especially noticed on account of her beautiful baby boy—tried again and again to escape. On her fifth attempt she was badly beaten and sold separately from her child to one of Mahommed Wat-el-Mek's people.

The motherless child, Abbai, gravitated to Florence as so many African children did. He followed her everywhere. His great friends were two little girls, also slaves, who now belonged to Ibrahim; the three of them used to eat together and share their food like English children playing at tea party. Florence had a great influence on the children. She sewed them clothes, washed and fed them, and taught them manners and morals. Others flocked to this kind *sitt,* and before long there were six little children in her brood. Their innocence and sweetness—the utter lack of the avarice and venality that made their elders so repellent—were a balm to Florence's wounded soul. As Saat had done when he was small, Abbai fell sweetly asleep under Florence's chair every evening.

In February, Florence and Sam packed their few remaining possessions and set out for Gondokoro. They decided they must leave the children behind, all except Saat, who was nearly grown. It was a tearful parting. "Take me with you, *Sitti!*" little Abbai begged, in a tone that wrenched Florence's heart. She knew she could not take him. Better to leave him here, with people that he knew and a language that he spoke, than to abandon him in the wicked streets of Gondokoro or Khartoum. Taking him back to England would be worse yet, for he would never be accepted there.

After nearly a month of hard traveling, fever, and attacks by natives,

they were at last close enough to see the small conical mountain that stood within twelve miles of Gondokoro. Once Gondokoro had been a perfect hell; now it looked like salvation. The next morning everyone rose early and donned the best of their remaining ragged clothes. They proudly hoisted the Union Jack and marched for Gondokoro with joy in their hearts. The boy Saat ran ahead. He was thrilled to be returning to Gondokoro in triumph, with a party that everyone had predicted would fail. Everyone had said his beloved mistress and her brave husband could not live through such a journey, but they had.

"I see the masts of the vessels!" Saat cried, elated. Everyone vented their joyous feelings at the tops of their voices.

"El hambd el Allah!" shouted the men. "Thanks be to Allah."

"Three cheers for old England!" shouted Sam.

"And for the source of the Nile!" added Florence. The men joined them in the ovation, then fired their guns into the air in celebration, receiving an answering salute from a Turkish party of traders at Gondokoro.

The first inquiries from Florence and Sam were for the boats: were they there, as promised? Perhaps letters from home? Supplies? Medicine? Their high spirits crashed like a duck shot in flight. No boats, no letters, no supplies awaited them at all.

Everyone had long since believed them dead. They had been gone for four years, and vague reports of their deaths had even reached Khartoum once or twice. To the weary travelers, reaching Gondokoro had assumed an incredible importance. Time and again they had said to each other that if only they could reach Gondokoro, hellhole though it was, their troubles would be over. From Gondokoro they could proceed by boat down the Nile in comfort and triumph. Now they were in Gondokoro and here was no help. Sam's disappointment was so acute that his eyes filled with tears.

"Nothing?" he asked in a voice choked with disappointment. "Is there nothing waiting for us here?" He had left money with an agent in Khartoum and had an agreement with Petherick to guard against just such a disaster. No, came the answer, we thought you were dead.

"Did no one believe in us?" Florence inquired desparingly. "Did *no one* hold out hope that we might yet arrive and need help?" The answer was self-evident.

Now they understood exactly how Speke and Grant had felt on reaching Gondokoro. How sharp Speke's resentment had seemed, how cruel his indictment of those who had made an agreement to succor and failed to keep it! And now they realized how welcome it must have been for Speke and Grant to find them at Gondokoro, with food and supplies and medicine and boats. Florence and Sam collapsed beneath a tree in shock and despair.

"What have we done, then, Flooey? What was the point of our struggles and bravery? No one credited our ability. No one even bothered to try to rescue us, so sure were they of our failure. Have we wasted these years of our lives?"

"I don't know, my dear Sam," Florence tried to comfort him. "This is a bitter outcome indeed after all we have been through."

They sat in silence, ruined in health and exhausted beyond telling. They had given everything but their lives to find the source of the mighty Nile River. Was it now only a meaningless quest? The only comfort seemed to be in their unity, their having done it together and being able to rest together here, side by side.

"I know this, though," Florence offered after some minutes. "We did not do it for anyone else but for ourselves. We wanted to find the source of the Nile. We wanted to fill in that great, white void on the maps, and we have. Everyone told us our goal was impossible, but we reached it. I think that is enough for you and me."

Gratefully, his face brightening, Sam turned to the remarkable woman who had been through so much with him. "You are right, Flooey, as always. No one else's applause is needed. We have done it, together, when all around us scoffed. That is enough."

Slowly, softly, they applauded each other. *Clap, clap, clap*—just a little sound that did not travel far in the African wilderness. It reached their hearts, and that was far enough.

14

LIFE SO UNCERTAIN HERE

Gondokoro was in a new state of horror, full of slaves waiting for boats to take them to Khartoum. Lately one *diahbiah* and two *noggurs* had made it south to Gondokoro, and they carried dreadful news. The Egyptian government had suddenly, inexplicably, decided to enforce the antislavery laws. Seeing the arrival of the English expedition, the traders were now filled with an awful suspicion that Sam had brought this about somehow. In Khartoum, four steamers full of slaves had been seized, the crews had been imprisoned and tortured, and the slaves—this was the point that really shocked the traders—had been appropriated by the Egyptian authorities. The three thousand slaves assembled in Gondokoro were now completely worthless.

Worse yet, the plague had come to Gondokoro with the crews of the boats and was sweeping through the town. The close and horrid conditions under which the slaves were kept in Gondokoro fostered the rapid spread of the disease through the population at large. The victims were thrown over cliffs into the river as soon as their illness was detected, but even this draconian strategy could not stem the tide of contagion as it overtook the filthy, misery-ridden town.

Florence and Sam saw they had to leave Gondokoro as soon as possible. Sam managed to rent the lone *diahbiah* for forty pounds, since the slave traders had no further use for it. He refused to take possession of the boat as she stood, though. She was scrubbed with boiling water and sand, then fumigated with burning tobacco. These were the best sanitary measures Sam could think of. The expedition loaded up and left as soon as possible.

As the *diahbiah* glided effortlessly down the Nile and the pestilential atmosphere of Gondokoro fell farther and farther behind them, Florence and Sam felt the dawning of a peace and contentment they had not known for a long time. Even the endless, dreary, mosquito-ridden marshes—so tedious and terrible on the voyage out—held a certain harsh beauty. Sam busied himself writing letters to be posted from Khartoum and reviewing the data they had gathered on the Nile, putting his observations into a unified form and considering the geographic implications. As he worked, he thought again and again of Speke and his great kindness to them. Without the information he had given so freely, Sam and Florence could not have reached Lake Albert and verified its role as a Nile source: that much was certain. He and Florence were looking forward to a reunion with Speke, so they might tell him of their findings and thank him profusely for his lifesaving generosity.

In idle moments on the long afternoons, Florence and Sam discussed the biggest problem: how exactly they were to arrive in England. It was a matter that required some thought. The logistics were not at issue: they would take a boat from Alexandria to Marseilles, then take the train to Paris, and from there catch the train to the Dover ferry to England. What was at issue was how Florence was to be presented to Sam's family and English society.

Their tranquillity was destroyed on April 14 when one of the boatmen started bleeding uncontrollably from his nose, a sure sign of the plague. Next Saat, by then a strong young man of fifteen years and Florence's special pet, complained of pain in his back and limbs. Then the nosebleed came on. By nightfall he was delirious with fever and howling in his misery. The blood vessels in his eyes burst, giving him a ghastly appearance. Florence nursed him tenderly, but she could only ease his discomfort and show her affection for him. There was neither remedy nor treatment for this plague.

On April 15 they arrived at Fashoda, where there was a new government station. They were delighted to find that they could obtain lentils, rice, dates, and goats—all welcome luxuries that would strengthen the sick and the healthy alike. The plague was most worrisome, though. Florence and Sam were both still weak and vulnerable from their years of deprivation and struggle; they both still suffered frequent bouts of fever. It was especially hard that Saat had been struck down; he was the last of Florence's African children and the one of whom she was most fond. There was no avoiding exposure. Florence would not leave Saat's nursing to others, and Sam was in contact with the men most of the day. No one could tell who would be infected and who would remain immune. Most victims of the plague would die, but some would manage a long, slow recovery.

Sam decided he must take some action to protect Florence, in case he too contracted the plague or succumbed to fever. He could not bear the thought of her suffering any more hardship than she had already endured so bravely. On April 16 he recorded in his journal:

> The fever is so dangerous here, and life so uncertain, that I have given to Florence B. Finnian two checks for £300 and £200 upon the Bank of Egypt Cairo branch—this is in addition to moneys and effects left her by my will made in Khartoum previous to my departure. I have drawn on S. Baker and Co. London in favor of the Bank of Egypt for £500 to cover the two checks of £300 and £200. I have made this arrangement as one is utterly helpless should the fever attack one, and then I would be incapable of action in business matters—and she would be in great trouble in Egypt and Khartoum in case of my death.

Though Sam first wrote only "Florence" in this passage, he immediately realized this would not suffice for formal identification and inserted "B. Finnian" above the line. His handwriting was strong and clear. Sam intended his words to be read by public officials in case of need, so he wrote in a formal style that differed greatly from his more casual entries. This was no place for emotional outbursts, vivid descriptions, or humor. He wrote this passage as a set of legal instructions, so that Florence might

act in case of his being incapacitated or dead. To be sure it was completely legible, Sam mixed up a fresh bottle of ink before writing.

After a week of agony, Saat died. Florence washed his body gently and dressed it in his best clothes, the ones that he had been saving for Khartoum. Then, tearfully, they pulled the *diahbiah* up to the shore so that a proper grave could be dug for Saat. He had given them so many years of faithful and honest service. Florence still remembered the skinny and mistreated boy who had sought refuge at her feet in the consulate courtyard in Khartoum. What a fortunate day that had been for them! Saat brought so much laughter to their days. He had stood by them through mutiny, warfare, hunger, and disease with unbounded loyalty. They could not have managed without him. She wept over his grave, for him and for all the lost, abandoned, mistreated children of Africa.

The *diahbiah* arrived in Khartoum on a date that Sam believed to be April 28. They had once again lost some days; it was really May 5, 1865. The entire European population turned out to see this extraordinary couple, who were in their view returned from the dead. Florence and Sam had accomplished the impossible and come back alive.

Rather than going to the Pethericks' compound, Florence and Sam stayed in a house owned by Monsieur Lombrosio, the manager of the Khartoum branch of the Oriental and Egyptian Trading Company. Dosing themselves with quinine and recuperating occupied a good part of the two months they spent in Khartoum. Communicating with England was the other important task. Sam wrote letters to Murchison at the Royal Geographical Society, to Wharncliffe, to his brother Valentine, his sister Min, and his daughters. Though he announced his success in triumphant terms—and sent Murchison a rather formal eight-page treatise—he still made no mention of Florence. Sam was hoping for acclaim when he returned to England as a successful explorer, perhaps something like the treatment Speke had enjoyed.

Upon his return to England in 1863, Speke had been celebrated by the Royal Geographical Society at a special meeting on June 23. The crowd trying to get seats in the hall was so large that some of the windows were broken in the crush. Speke had already received a gold RGS Founder's Medal in 1861, for his explorations with Burton, but this time the queen

sent her personal congratulations and the Italian king sent a special Medal. In 1864, peculiarly long after the fact, Grant was honored with the RGS Founder's Medal.

What Florence and Sam wanted to avoid was the unfortunate aftermath of Speke's glory. The publisher Blackwood rushed Speke's book about his journey, *Journal of the Discovery of the Source of the Nile*, into print in 1863, after some judicious editing of passages that might shock the Victorian reader. This annoyed Murchison, in particular, since as Speke's sponsor, the RGS expected to have the right of first publication of Speke's writings about his expedition. The article Speke offered the RGS was pathetic compared with his book.

Speke could not resist publicly attacking Burton's theories about the source of the Nile, and Burton responded with equal energy and venom. Burton reissued his 1860 *Lake Regions of Central Africa*, which offered abundant criticisms of Speke, and appended a number of essays and reviews written by James M'Queen, who revealed some stunning weaknesses in Speke's geography. Writing in a virulent and sarcastic style, M'Queen used Speke's own measurements to show that the Nile would have to flow improbably *uphill* unless the data were in error, which undermined Speke's credibility in scientific circles.

M'Queen was scathing about Speke's failure to visit the outlet of the Nile on Lake Victoria when he spent five months at M'tesa's court nearby, implying that Speke was drinking and womanizing rather than exploring:

> Captain Speke was at the time mentioned amused and employed in drinking *pombe* [native beer], courting the Queen Dowager, shooting cows, reducing to order his rebellious female intimates. . . . It is almost incredible that any man who had come one thousand miles to see the position of the outlet of the Nile, should remain five months within eight miles of it, without hearing or seeing something certain about the great object of his research, or have found some means to see it.

More damned still were the passages that implied that Speke had enjoyed sexual dalliances with African women. M'Queen drew attention to every questionable passage in Speke's book that had escaped his editor's excisions, such as those in which he measured the dimensions of the na-

ked and extremely fat wives of King Rumanika while he carried on what Speke himself called a "flirtation" with the king's stark naked daughter. M'Queen highlighted the fact that Speke had accepted two nubile virgins who were presented to him as wives by the queen of Uganda, who desired to see what color the offspring would be. Speke's two Ugandan wives, with two other women who survived the voyage, were pictured in an engraving in the closing pages of Speke's book. Victorian England was thoroughly scandalized. Speke had probably done nothing that many others had not done, but it had become publicly known, and that was unforgiveable.

When copies of M'Queen's outspoken attacks on Speke caught up with them, Sam was staggered. Florence was not surprised. She had seen in Speke a certain hardness and inflexibility, a willingness to judge others overharshly that she did not find attractive. She was also personally aware of the low value he placed on women. His fate had been determined by his character.

While Speke was embroiled in this ugly and embarrassing conflict, he was also publicly denouncing Petherick for failing to meet him at Gondokoro. Speke began to look like an uncharitable, ungracious, and immoral man. His good name was seriously tarnished.

The damage to Speke's reputation was a warning that had to be taken seriously. Florence and Sam had been together for six years since Viddin, without the benefit of marriage, and they too might be facing a florid scandal. Florence broached the subject one day when they were sitting alone quietly. "Sam," she said, "we must make a plan."

"What for?"

"For England."

"We can marry by special license very soon after we return to England, if you will do me the honor," said Sam immediately. "Do you trust me so much?"

"Yes, Sam."

"Then there is no difficulty. Once we are legally married, that will legitimize your position and no one would be so rude as to ask for the date of our wedding, surely. We shall tell them we married when we first met in 'central Europe' in 1860. No one can prove we did not, so many towns and records were destroyed in the revolution."

"Sam," interjected Florence a little sternly, "you have seen how Speke's stories about the native girls hurt him. M'Queen tried to ruin him over it. What will people say when they learn you kidnapped me from a harem auction?"

"But you were never in the harem, not as people in England understand it. You were a certified virgin at that sale, which is more than one can say for many English brides," Sam remarked with an ironic grin. Over the years, he had gotten so used to their unconventional life that he had forgotten, perhaps, how unforgiving English society could be.

"The full truth will not do, and you know it," Florence said. "People will ask where I came from and who my people are. We must have something to tell them."

"I shall never leave you, no matter what people say." Sam thought she wanted reassurance, but he misunderstood her point.

"Sam, my dear, I shall never leave you," Florence answered him sweetly. "But for your sake, we must devise a strategy. We cannot allow your reputation to be ruined because people do not understand the harem system. We must move in society. Your daughters must be able to hold their heads up and find good husbands. You should be lauded for discovering Lake Albert, as Speke was for discovering Victoria. Will you be honored if people think I was a common prostitute?"

"I would cheerfully kill any man who called you such a thing!" Sam growled ferociously.

"Ah, you have been taking lessons from the bloodthirsty Wat-el-Mek!" Florence teased him, laughing a little. "Or is it the courageous Kamrasi you imitate?"

"Very well, I take your point," Sam conceded. "What do you think we should do?"

"I think that we must give them something else to talk about, so they won't ask awkward questions. Now let me think . . . The obvious point is my age. How old is your eldest daughter?"

"Edith is now . . . my goodness, she's now seventeen years old!" Sam exclaimed.

"I am very little older than she is," Florence reminded him. "We cannot tell people that we married in 1860 and tell them my real age; it would be too scandalous. Do you think I could pass for thirty?"

"No." Sam smiled at her, noting her youthful beauty, which she was regaining daily with rest and proper food. "Even after central Africa, no one will believe you have that many years behind you. I think we must say you are twenty-three or -four, that you were eighteen when we married. Certainly people will comment on how very young you look—and that I have married a girl less than half my age. They can occupy their minds by guessing whether I married you before you made your debut."

"Very well, then," she agreed, grinning. "I shall be twenty-three, if anyone asks. Do you think people will say I am after your fortune?" She looked at their pathetic remaining possessions and the poor garments they had been able to procure in Khartoum.

"Undoubtedly," Sam agreed. "Undoubtedly!" And then the two of them burst into laughter so ringing that a servant came to ask if something was wrong.

Over the next few days they elaborated their plan for presenting Florence in England. They felt a need to do more than hide Florence's youth and the date of their legal marriage. They needed something to provide a diversion, something relatively harmless yet so compelling that everyone's attention would focus on it.

"Sam," Florence asked one day, "if you married the perfect woman, what would she be like?"

"Why, like you of course!" Sam patted her hand affectionately.

"No, I mean the perfect woman *in the eyes of society*."

"Well, she would be English and well brought up, from a good family. She would be pretty, demure, devoted to me and my daughters, and above reproach morally. In an English family, it is the wife who maintains the standards, who exemplifies duty, honor, and grace. She makes a comfortable home for her husband, runs it without undue expense, sees to it that the servants are well trained and discreet, and insures that the household tasks are executed properly. She entertains for him gracefully and charmingly, when it is required, and makes their guests feel welcome. Her world is the home; her joy is the good behavior of her children and the success of her husband. I think that pretty well describes the perfect English wife." Sam smiled a little at the paragon of virtue he had described.

"Then I shall be it," Florence declared, "at least as much as possible. I cannot be English, of course, but we can allow people to assume that

if they don't hear me speak. We are already spoken of as the 'English couple.' What if, instead of hiding my role in our expedition, we call attention to it?"

"The English wife has no role outside her home and society," Sam objected, "and she would never seek acclaim for herself."

"No," agreed Florence, "but suppose it were *you* who praised me? What if you painted me as the dutiful wife so devoted to her husband that she goes anywhere he does, even into the depths of darkest Africa? Think how sweet the picture is: how I followed you in health and nursed you in illness, how I bore hardships and dangers for your sake and never faltered through disease, deprivation, warfare, and loneliness."

"Very clever, old girl, very clever," Sam replied thoughtfully. "If you were the personification of the ideal wife, no one would dare to criticize you. What a sensational ending it would make to a lecture on the sources of the Nile! I could even call you up onstage and introduce you to the audience. Oh, I think it would work admirably." His eyes gleamed at the thought of another bit of fun that he and Florence could share. They would give a convincing performance that would ensure Florence's acceptance.

When Florence and Sam arrived back in Khartoum on May 5, 1865, there was important business to attend to. Murchison had to be notified of their success, and Sam was eager to share the news with his family and with Speke and Grant. Murchison had arranged honors for Sam even before he received Sam's letter from Khartoum. On May 22, 1865, Sam's brother John accepted the Patron's Gold Medal of the RGS on Sam's behalf. Murchison also requested that Sam give a special lecture before the RGS upon his return.

Shocking news awaited them in Khartoum. Though Sam's daughters and siblings were well, among the letters was one announcing Speke's tragic death. It was entirely unexpected.

A public debate between Speke and Burton on the sources of the Nile had been scheduled for a meeting of the British Association to be held in Bath on September 16, 1864—one of the days that Florence and Sam had spent languishing near Foweera for lack of porters. Many expected Burton to triumph, as he was the better public speaker and had a quicker wit, but the outcome was never determined. The very day before the

debate, Speke was in the Wiltshire countryside shooting on the estate of an old friend. Speke apparently stumbled while crossing a low stone wall and shot himself in the chest. No one saw the shot, but a friend was close enough to hear the report and run to Speke's side. The explorer died within minutes.

On the morning of the meeting, Murchison came into the crowded room and announced Speke's death. Burton, deeply shocked, collapsed into a chair and exclaimed, "By God, he's killed himself." The debate was canceled.

The Times, in a cunningly written article that ran on September 19, managed to hint that Speke had committed suicide while ostensibly denying the allegation. Speke was, *The Times* declared,

> a gallant soldier, who has borne himself bravely in some of the bloodiest battles in our Indian Wars, and a sagacious and enterprising traveler, who had by sheer pluck and endurance solved a problem which has vexed the curiosity of all mankind since the dawn of history, has in the full vigor of manhood fallen lifeless in a moment, the victim of a paltry, commonplace accident. . . .
>
> Speke was the last man who could have been expected to succumb to so poor a peril as this. He was a veteran sportsman. Even his zeal for adventure sprang originally from his ardor for the chase. . . . Such a man must have lived always in the midst of dangers; firearms must have been to him familiar as the pen to the writer, or the brush to the painter. Perhaps it was this great familiarity which produced the momentary incaution which has had such fatal effect. Poor Speke has fallen a victim to a commonplace act of carelessness which in every successive shooting season destroys some score of tiroes [rank beginners] who insist upon carrying a gun without knowing how to carry it safely. Thus may great dexterity and great clumsiness sometimes produce a like result. . . .
>
> This unfortunate accident will put an end to the controversy which was to have amused the Geographers at Bath. Captain Speke and Captain Burton can no longer be pitted against each other for a gladiatorial exhibition. It must be very hard for Captain Burton, who has won so many laurels, to reflect that he was once slumbering under the shadow of the very highest prize of all while another and a less experienced hand reached

over him and plucked the fruit. But so it was. . . . Speke had the happy sagacity to guess the vast importance of the discovery upon which he had lighted. . . . In future time Captain Speke, whose loss we deplore, must be remembered as the discoverer of the source of the Nile.

What Florence and Sam found incredible was the means of Speke's death. That Speke—the great hunter, the superb sportsman of several continents—had made such an elementary and foolish mistake as to cross a stone wall with a loaded and unbroken gun in his hand seemed impossible. Speke could no more do such a thing than Sam could. It was unthinkable! The act was not only foolish but also unlucky in the extreme, for who would have supposed that an accidental shot would catch him full in the chest and sever the main arteries? Questions swirled about Speke's death. Had he taken his own life? Could the man who had braved central Africa, not once but twice, be so desperate to avoid a confrontation with Burton that he shot himself? Had the talk of sexual misconduct wounded Speke so heavily? No one would ever know for sure.

Sam sadly looked over the letter to Speke that he had drafted in his journal:

I cannot tell you how rejoiced I am at having accomplished the work which you had planned. To have failed would have made me miserable for life. My evidence will, I trust, be a weighty addition to yours in confirming the origin of the river. I was delighted to see that you and Grant had received the welcome you so well deserved. Pray remember me very kindly to Grant, whom I trust I may meet again. I gave Kamrasi his portrait and also yours, cut from *The Illustrated London Times*.

Later, Sam was deeply touched to learn that Speke had thought of him on the day before his death. In early October 1864 John Tinné had received a letter from Speke dated September 14. It was published posthumously in *The Times*. Speke had written:

I have great fears about the fate of Baker. He ordered Petherick to place a boat for him at Gondokoro this and last year. The boat was there, and the men with whom Baker went into the interior must have returned to that

place, else we could not have heard of Baker's having gone to Bunyoro. This being necessarily the case, how is it that Baker did not send a line by them to Petherick, unless some foul play can answer the question.

On June 30, 1865, Florence and Sam left Khartoum for Berber by boat. They made their way via Souakim and Suez, stopping in Shepheard's Hotel in Cairo to enjoy the luxuries: *"sheets and pillowcases"* and *"Allsop's Pale Ale* on draught!" It was everything they had dreamed of at their lowest ebb. They were still accompanied by Richarn, who since their return had married a tall Dinka woman named Zeneb. Richarn was most impressed by the hotel and especially by the ladies' large and fashionable chignons. Sam arranged for Richarn to be taken on as a personal servant of the hotel manager. Then Florence and Sam left Cairo for Paris, knowing that the sole remaining faithful member of their expedition was contented: rich with the balance due of his wages for four years' service, happy with his new wife, and pleased with his job.

Sam sent a telegram to James, his youngest brother, asking him to come to Paris; he needed James's assistance, with what he did not specify. Sam wisely instructed James to come after they had had a week or so to settle in, buy new clothes, and adjust to Paris. In that interval, Florence made a surprising discovery.

"Sam," she cried suddenly at breakfast one morning, "I must have a birthday!"

"Of course you must have a birthday, Flooey," Sam replied cheerfully. "Everyone has a birthday. I don't believe we've ever celebrated it before. When is it?" Through the four years of their African journey, they had dutifully toasted the birthdays of various friends and relatives, but they had never celebrated Florence's.

"That's just the thing," Florence explained. "I don't know when my birthday is."

"Have you never had a birthday party?" Sam asked.

"Not that I can remember," she answered slowly.

"Then today seems like a good day to me," Sam suggested, "August sixth. We shall celebrate today. Today you are . . . twenty-four."

"Yes." She grinned. "I am twenty-four. I was born in 1841, in Transylvania."

"What an old lady you are, my dear!" Sam teased. "I shall be the subject of jokes, with such an elderly wife on my arm." Florence blushed, and they set about having a glorious day.

When James arrived in Paris and met Florence—an unexpected apparition of youth and beauty—he understood Sam's problem.

"Here is the thing, James," Sam said, phrasing his request carefully. "Florence and I need to marry under English law. We want to be sure our vows are accepted as proper and legal. We do not want a scandal, so it must be done very quietly. I wonder if you might approach the Archbishop of Canterbury on my behalf, asking if we might be granted a special license to marry without posting the banns. We thought we might be married in St. James's Church, Piccadilly, on some quiet afternoon when there would be nobody much around."

"Of course, Sam, of course," James answered. He was already charmed by Florence, and any woman who had accompanied Sam on his explorations deserved to be his recognized wife. Besides, James could see this was no marriage of convenience; it was a love match. Sam was carefully ambiguous about whether or not they had married abroad, in a ceremony that would not be recognized in England, but James was unconcerned. "I think it might be best if you wrote a formal request and then I made an appointment to present it to the archbishop," James suggested.

"Excellent idea," Sam replied. He thought to himself: *If James and his wife support us, winning the acceptance of the rest of the family will be easier.* "I greatly value your assistance. Do you think Louisa . . . that is, would you and Louisa be willing to act as our witnesses? I do so much want someone from the family to be there. I'd prefer to introduce Florence to everyone after the wedding. I fear that Min and the others might look harshly upon her."

"I'm sure Louisa will take Florence to her heart," James assured Sam. "I can see that Min might find the change a little difficult, however. She is a bit particular, you know—likely to worry about what people will think. And she has been looking forward to being your hostess when you return to England in glory. After these years of raising your girls—she loves them dearly, of course, but it has been a lot of responsibility for a spinster—she is likely to be a trifle disappointed."

"I hadn't thought of it like that," Sam said, worried. "Of course she would expect to run my household and be my hostess, as my sister and the one who has cared for my children. She cannot have expected that I would remarry." He hesitated and then addressed what was perhaps the most awkward issue of all: his secrecy. "I didn't mention Florence in my letters because I wanted to wait until you could all meet her and see what a wonderful woman she is." Here he beamed at Florence with open affection. "We must go gently with Min and the girls and give them time to learn to love her as I do." James was dubious about Min ever accepting Florence or any woman Sam married after Henrietta.

That afternoon the three of them went to a fashionable photography studio to have a portrait taken. The men stood, tall and handsome and somber, on either side of Florence, who was seated on a settee. On her head she wore a chic toque—a flat-topped, brimless hat—with a light-colored veil thrown back to reveal her lovely face. She wore a becoming striped blouse with long sleeves, a high white neck, and matching cuffs, and for adornment, earrings and a brooch. She arranged her hands so that the right concealed the left, which meant that no one could inspect it to see if she wore a wedding ring. The photographer draped a fringed paisley shawl artfully over her dark skirt. On the whole, she looked like an extremely beautiful and well-bred woman. There was something about Florence that hinted of the exotic, perhaps a touch of the Gypsy. Her face was unlined and serene yet strikingly individual and self-confident. She had faced Africa with the man she loved. If a portrait by a Paris photographer and her looming entry into London high society held terrors for her, it did not show. Her position—half-turned toward Sam, back toward James, with her elbow resting gracefully on the back of the chair—was brilliantly revealing. Sam was hers; James was a comparative stranger.

On October 14 Florence and Sam arrived at Dover. They made their way to London and took rooms in a most respectable lodging house at 13 Arlington Street in fashionable Mayfair. This made them residents of the St. James's Parish, as required by law. For the next fifteen days, until they could wed, they lived very quietly. They saw only Murchison, who had to be apprised of Florence's existence, and James and Louisa, who also lived in Mayfair. Louisa took to Florence at once. She helped her shop

for clothes and other items essential for a wife of a prominent man; she coached Florence on the manners and customs of the upper class, so she might fit into English society.

In the meantime Sam attended to his duties. He paid up his club membership and traveled to see his daughters and sisters. To the girls, he said nothing yet about their new stepmother. In private he told Min he was soon to marry under English law so that she would not be caught by surprise. He described to her Florence's heroic bravery during their African journey. He also told her that he and Florence wanted the children to come live in their new home as soon as it was established.

Min said nothing. She pressed her lips tightly together, making unbecoming wrinkles at the corners of her mouth, and sat rigidly erect with her hands folded in her lap. She could not help feeling a little resentful at being so suddenly displaced. She had made a home for the girls, cared for them, and loved them as if they were her own. How could she withdraw from their lives—or they from hers—now? Though Sam tried to express his sincere gratitude to Min, she felt like she had been declared an inconvenient, unwanted sister, thrust aside for some pretty woman to whom he had taken a fancy. Since Sam had never mentioned Florence in any of his many letters, Min couldn't help but think she was, in Victorian parlance, "no better than she should be"—a woman of besmirched character. She believed that Sam would have written of it much sooner if he had married Florence years ago.

What of the girls and their reputations? How could Sam consider exposing his daughters to such a woman? Min wondered anxiously if he really meant to present Florence to society. It was her way, though, to think carefully before speaking, and so she said nothing.

Sam saw Min's hurt posture and read it correctly. He supposed no matter what he had said or done, Florence's existence would be a shock to Min. And certainly she would hate to give up the children. But they were his daughters and Florence his wife; the girls would live with them. He hoped optimistically that Florence would charm Min and that his sister and new wife

Florence, James, and Sam in Paris (1865). In Paris, Sam introduced his brother James to Florence and asked for his assistance in arranging a quick and quiet marriage upon their return to England. (From left: James Baker, Florence Szász, and Sam Baker.)

could be friends. If Min came often to stay, she would not miss the girls so much.

On November 4, the day of Florence and Sam's wedding, Min wrote an emotional letter to her sister Ann.

What a happiness that I can now unburden to you over the subject which as you may suppose fills my heart and thought just now, but of course I could not write to you about it until you had heard it from dear Sam's frank, affectionate self. Indeed it *is* a romance; of course, he ought to marry her at once, and we must all receive her with kindness and affection, which will not be difficult after her marvelous devotion; but as to further arrangements, I feel there would be something to sadden all concerned, in any case; my view of it is this, the children must know and love her, but Sam must not place her in a mother's position towards them.

He must make up his mind to have a separate establishment for her in London and be contented to divide himself between the two houses; I know this is sad but after thinking & praying for a right and just decision I feel that the unhappiness caused in this case will be far less to *all,* than seeing the children coldly looked upon and slighted, which they would be in this harsh world; for you know my darling that there is no point which [the world judges] so unmercifully [as immorality]; and during this hereafter might embitter Sam, & Florence might also then be unhappy and full of remorse. . . . I am sure you believe no thought of my own future is mixed up, or influenced my judgment. If Sam brings her to head his children's home, I feel it will wrong them sadly, however angelic and good she may be; the cruel world will fling stones at her, which would rebound on the poor dear children. . . .

I hope, darling, you will not fancy from what I have said that I feel hardly towards the poor girl, for indeed God forbid that I should do so; I pity, and love her, for all her tender devotion, and do not even blame her. She was so young and unprotected; but you also know darling how all powerful is my love for my four darlings, and the bare possibility of unhappiness for them makes my heart ache sorely; . . . from a letter just received from Sam, I expect they are married whilst I am writing, & that when Sam comes today he will break it to the children, poor little darlings! especially for Edith in this case I feel . . . however I will try to soothe & comfort them. . . .

I am feeling very weak and sickly just now, which is most provoking as [I] should have liked to go to London to see Florence whilst Sam was away, so Louisa has done all in the way of affection alone.

Min's letter was a perfect exposition of the moral standards of the day by which Florence would be judged, were her full history ever to become known. Because of her affection for Sam and his children, Min was inclined to forgive Florence for traveling with a man before marriage. Nonetheless, her words carried a clear undercurrent of moral disapproval. Her pronouncement "we must all receive her with affection and kindness" must have sounded to Ann more grimly dutiful than heartfelt.

Men were allowed far more sexual license than women in English society, which was why Florence needed forgiveness for having been seduced while Sam, the seducer, needed none. Min's suggestion of maintaining two separate households for the sake of the children was exactly the sort of discreet arrangement men often came to with mistresses. To a legitimately married woman, this was an insult.

By that afternoon the wedding was a fait accompli. Sam had collected the special license for Samuel White Baker to marry Florence Barbara

Maria Finnian from the office of the archbishop the day before. With only Louisa and James in attendance, Sam and Florence were wed circumspectly in the Church of St. James's, Piccadilly.

Marriage Registry of St. James's Church, Piccadilly (1865). Florence and Sam were wed on November 4, with only James and his wife, Louisa, as witnesses. Florence faltered as she signed the registry in an unaccustomed name: Florence B. Finnian.

In the registry Florence was listed as the daughter of the late "Matthew Finnian, Gentleman," a designation combining her real father's forename, Mathias, Anglicized to Matthew, and her "adopted father's" surname,

Finjanjian, altered in spelling to the Irish Finnian, as on her passport. Sam's signature on the registry was bold and confident. Florence made three attempts, writing "Forence Baraba" and then "Florenz B" before she managed a properly British "Florence B. Finnian." It was not that she was illiterate; she had learned to write in Viddin, which is why "Florenz" came more easily to her pen than "Florence." What she had not done before, ever, was sign this hybrid chimera of convenience as her name, on a document of such enormous import. Little wonder her hand shook and her spelling deserted her.

The vicar pronounced them man and wife in the eyes of God. Sam kissed the bride, and Florence walked back down the aisle as the perfect Victorian wife, Mrs. Samuel Baker.

15

A COURAGEOUS LADY

*T*he newlyweds dined that night with the Murchisons. The president of the RGS thought "Murchison Falls" had a lovely ring and was flattered by the honor. He promptly commissioned an oil painting, based on Sam's sketch, to hang in the RGS building.

Murchison was one of the most influential scientific men in England, and winning his backing was crucial. In their first performance as an exploring couple, Florence and Sam succeeded in charming him.

As a founder of the RGS and a lifelong promoter of its aims, Murchison had brought the organization from petty insignificance to one with two thousand members. Sponsoring or encouraging African explorations—a topic of wide general interest—was an excellent way to continue to enlarge RGS membership and enhance its prestige. Murchison loved hobnobbing with aristocrats and royals, and counted it as a personal triumph when he occasionally managed to attract the Prince of Wales or the Duke of Edinburgh to RGS events. RGS special lectures became highlights of the London season. Murchison was also a great believer in science in the service of empire building, and to

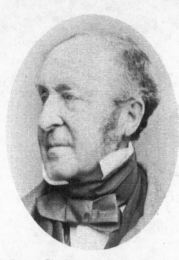

Sir Roderick Murchison. Murchison, president of the Royal Geographical Society, was an influential man. His endorsement of Florence and Sam was key to their acceptance in society and their subsequent celebrity.

do that, scientific men needed the backing of lawmakers, aristocrats, and royals.

The Bakers provided exactly what Murchison had been looking for. Although the RGS had been decidedly lukewarm about Sam's original plan to rescue Speke and Grant, Murchison was all too eager now to publicize Sam as one of the RGS's own. Murchison was in sore need of a hero, an attractive, articulate, and preferably amusing man who would appeal to the middle as well as the upper classes. Burton was far too intellectual and unconventional; Speke had turned waspish and prickly before his death; Grant was not articulate enough. Sam was perfect. Not only did he fit all of the criteria for promoting the cause of science, he boasted the additional advantage of a beautiful and devoted wife. The image of the brave couple, marching through darkest Africa side by side to discover the source of the Nile, was well nigh irresistible. Murchison became the Bakers' staunchest supporter.

Taken as he was by Florence's beauty and grace, Murchison was not blind to her extreme youth and somewhat shadowy past—and decided to ignore them. He was in some confusion as to Florence's age, but described her to a friend as Baker's "little blue-eyed Hungarian wife who he picked up when abroad and [who] had accompanied him during his five years in Africa and is still only twenty-three years of age. We all like her very much."

Murchison made his approval and sponsorship public in his gracious introduction to Sam's RGS lecture on November 13, 1865. A transcript of the introduction, complete with parenthetical remarks to indicate the audience's reception, was printed in *The Times* on the following day:

Let me call your attention to one or two salient points in the conduct of this man who is now happily among us, and who, by his devotion to geographical science has worked out, entirely at his own cost, this grand addition to our previous knowledge (cheers). Mr. Samuel Baker was no sooner acquainted with the perilous and exhausted condition in which Speke and Grant were supposed to emerge from Equatorial Africa . . . than at his own cost, he fitted out an expedition and carrying adequate supplies, was the first to relieve them of their wants (cheers). It was for this noble conduct, as well as for the gallant and determined manner in which, undaunted by all the dangers through

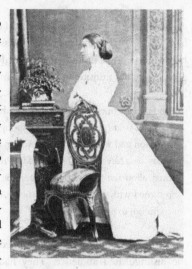

The Beautiful Mrs. Baker (ca. 1865). When Florence entered English society, she was very young and beautiful. The style of her dress and the bouquet of flowers, wrapped with a wide, trailing lace ribbon, suggest that this may be a wedding portrait.

which Speke and Grant had struggled, he resolved to go forward into the country of King Kamrasi, there to work out that important part of the course of the Nile, which was left undetermined, that we awarded him our Patron's Medal. . . . I have here to announce and with a pleasure and gratification that will, I know, be shared by everyone in this assembly, that in all his arduous and perilous travels our medallist was accompanied by Mrs. Baker (cheers) to whom, as he himself has told me, much of his success is due, and who, by her conduct, has shown what a courageous wife can do in duty to her husband.

Always an engaging raconteur, Sam surpassed himself on this occasion. He opened by acknowledging gracefully the great kindness of Speke and Grant in directing him toward Lake Albert. He then spoke of the geography, of thrilling encounters with wild animals, of the natives and their strange customs, and of the tremendous hardships of African

exploration. His humorous, anecdotal style won the listeners' hearts, for here was a great man who nonetheless could enjoy a joke, sometimes at his own expense. The audience listened in rapt attention, their admiration growing by the minute. In closing, Sam turned to Murchison, and said:

> And there is one other whom I must thank and whom I am truly glad to thank in your presence, one who though young and tender has the heart of a lion and without whose devotion and courage I would not be alive today to address you tonight—Mr. President, my Lords, ladies, gentlemen, allow me (and at this moment he walked to the wings, bowed, and returned with a lovely young woman on his arm, perfectly dressed and coiffured) to present my wife.

This masterful performance evoked an overwhelming response from the distinguished audience. They had heard a great adventure story, learned of a solid piece of scientific work, and now they were offered a brave explorer and a beautiful, devoted wife, in one nicely wrapped package.

The fame of the exploring Bakers grew rapidly. At a subsequent lecture in Nottingham, Florence and her wifely devotion were such an attraction that the audience demanded her presence by clapping and cheering every time she was mentioned. Finally the moderator went into the audience and led Florence, blushing prettily, up onto the stage. As theater, it was brilliant. As a diversion to prevent anyone from inquiring into Florence's past life, it was massively effective. Once Florence was embedded in the hearts of the public as the perfect Victorian wife, no one would dare to speak against her.

In December the Bakers traveled to Paris where Sam was awarded the Gold Medal of the French Geographical Society. Once again, Florence was an especial favorite of the crowd, who applauded her every mention. When the Marquis de Chasseloup-Laubat formally presented the medal onstage, Sam brought the house down by turning to Florence and tenderly giving it to her. Florence was an international heroine.

Not surprisingly, London society lionized Sam and Florence; they were the celebrity scientific couple of the season. The *Illustrated London News* ran a lengthy and most flattering article about them on December 5, 1865.

Sam's old friends Lord and Lady Wharncliffe and the Duke and Duchess of Atholl welcomed him and Florence into their social set, as did many other notables.

Wharncliffe was among those to whom Sam had written from Khartoum in May 1865. He was one of the first Sam told of his marriage, though obliquely by simply dropping a reference into the letter as if his marriage were a known fact. Now Sam wrote:

> I arrived a few weeks ago [in England], quite recovered from all effects of African fever—Also my wife who has been through every footstep of that dreadful journey with me. She had suffered much, but the change of air and the warm welcome from all my family have quite altered her. I had never mentioned my marriage to any of my people by letter as I thought it much better to introduce her to my children as "un fait accompli" instead of harassing them on such a subject from a distance.

Sam received a most gracious reply. Wharncliffe obviously forgave him for concealing Florence's presence and wished to renew their close friendship. Sam replied in kind, remarking:

> The fact of being remembered so warmly by old friends after so many years of absence dispels all the recollection of African hardships and suffering. Customarily when in the midst of difficulties and thousands of miles from all I loved I have thought of you, and as my wife will some day tell you, your name has been repeatedly before her in hours of good sport when I recalled old stories of Ceylon in the middle of Africa.

The Bakers were accepted by high society without demur. There was, of course, much remark made upon the youth and beauty of Sam's new wife, and there were rumors that they had not married in 1860. David Livingstone, the great explorer, repeated a story to William Cotton Oswell that "Baker married his mistress at Cairo and from all accounts she deserved it after going through all she did for him. I heard about his woman, but it was not made public and if she turns out well, better it never should." Once Cotton Oswell had met Florence for himself, he was completely won over and referred to her as a "trump" and a "beauty." He

endorsed the general sentiment that Florence's character and accomplishments were remarkable enough to justify ignoring any unsubstantiated rumors about her past.

On January 12, 1866, Murchison wrote to James Grant, now reunited with his regiment in the Punjab, about Sam's honors.

> It would have done your heart good to witness the warm reception we have to the good & excellent Sam Baker and his nice little Hungarian *wife*. As this young Lady, (now only 23) of whom you had never spoken to me (nor had I heard of her) was announced by himself as Mrs. Baker & received as such by all his family, *we* were of course rejoiced to beg her early attention & she has been dining with Lord & Lady Dufferin, ourselves, & many other people & we all like her much as well as himself.

Between the lines of this letter, Murchison was recommending gentlemanly discretion on Grant's part. Murchison knew Grant had met Florence in Gondokoro in 1863 and, if Grant knew something unsavory about the lady, Murchison thought it better left unsaid.

The former consul of Zanzibar, Colonel Rigby, had learned of Florence's existence in 1861. Colquhoun had mentioned her in a letter, along with Kate Petherick, but subtly omitted the word *wife* in reference to Florence. In mid-February 1866, Florence was suddenly in the news and Rigby thought his knowledge of her a juicy piece of gossip to repeat to Grant.

> I was at the meeting when Baker read his paper, it was densely crowded, he looked as well as if he had never been out of England, many could not understand what *Mrs.* Baker he referred to, he has married the Wallachian lady, she was present at the meeting. Baker's Lake appears to be a very large one, but all statements respecting its extent North and South are purely conjectural, for he himself only saw a small portion of it. . . .

The use of the term "Wallachian" to describe Florence was a purely gratuitous slur, as the Wallachian peasants were stereotypically barbarous, crude, and ignorant. In Rigby's next letter to Grant, he continued in the same catty vein.

Baker has certainly blown his own trumpet rather loudly, & is not one to hide his own light under a bushel; he has also put his wife very prominently forward and this has taken wonderfully with the English public; had poor Speke only possessed Baker's skill with his pen what a different reception his book would have met with.

Neither Sam nor Florence was much discomfited by these whispers. They were busy finding a suitable home in Hedenham, setting up a household, and forging a loving relationship between Sam's daughters and Florence despite Min's protests. Florence and Edith, Sam's eldest, became especially close confidantes, probably as they were also close in age.

Sam devoted most of his time to transforming his lively journals into a book, *The Albert N'yanza, Great Basin of the Nile, and Explorations of the*

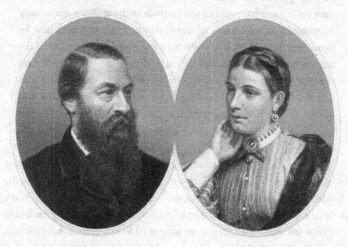

Nile Sources. It was published in July 1866 and was an immense success, combining all the elements of his RGS lecture and publication with excellent lithographs based on Sam's sketches. Remembering

The Devoted Couple (1866). Sam's lively book The Albert N'yanza, Great Basin of the Nile, and Explorations of the Nile Sources *presented Florence as the perfect Victorian wife. The frontispiece was adorned with these matching engravings of Sam and Florence gazing lovingly at each other.*

the scandal caused by passages about African women in Speke's book, the Bakers considered carefully the effect of every anecdote Sam included.

The book opened with a pair of matching oval engravings of Florence and Sam, arranged so that they appeared to be gazing lovingly at each other. The photographs on which the engravings were based had been taken in Paris at the same time as the portrait with James, perhaps to serve as *cartes de visite*. The title page followed, then the dedication to "Her Most Gracious Majesty THE QUEEN" with her permission, a sure sign of official approval. As further insurance against misinterpretation or scandal, Sam penned a clever introduction addressing the reader, whom he promised to lead along the rough and perilous path of adventure.

> I have written "HE!" [*sic*] How can I lead the more tender sex through dangers and fatigues, and passages of savage life? A veil shall be thrown over many scenes of brutality that I was forced to witness, which I will not force upon the reader; neither will I intrude anything that is not actually necessary in the description of scenes that unfortunately must now be passed through in the journey now before us. Should anything offend the sensitive mind, and suggest the unfitness of the situation for a woman's presence, I must beseech my readers to reflect, that the pilgrim's wife followed him, weary and footsore, through all his difficulties, led, not by choice, but by devotion; and that in times of misery and sickness her tender care saved his life and prospered the expedition.

The book was a brilliant creation that presented Florence as the brave and dutiful Victorian wife to a yet wider adoring public. In its review, the *Morning Advertiser* made clear that she was the real heroine of the story, likely to capture the hearts of the eager readers. After reading the book, the politician W. E. Gladstone even suggested to Murchison that Florence deserved an honor of her own.

> Could we not have some Testimonial, by subscription, to her, or to him and to her? Baker has done us a very great honor in a distant and barbarous land; he had made another great discovery; the lives dearest to him have been imperiled; and he has achieved his work without costing the State a shilling . . . if it be worth while, consult with higher authorities. I know not whether the State can confer some mark of honor; but that need not clash with my suggestion . . .

Perhaps Gladstone knew that a knighthood for Sam was in the works. On August 15, 1866, the prime minister (the fourteenth Earl of Derby) wrote to Sam from 10 Downing Street:

I am commanded by the Queen to express to you Her sense of the services rendered to Geographical Science by your laborious researches in Africa; and to add, that Her Majesty will have pleasure in testifying Her appreciation of those services by conferring on you the Honor of Knighthood, should it be agreeable to you to accept it.

It was indeed agreeable. "Flooey, come quick!" Sam called out as soon as he read the letter. "Flooey!"

"Yes, Sam, what is it?" she asked, breathless from running into the room. "Is something wrong?"

"No, my dear, not wrong, not wrong at all. Look at this." He held out the thick paper with its impressive seal. She took it and started to read. He couldn't wait for her response and blurted out, "Would you care to be Lady Baker, my dear?" with a beaming face and open arms.

"Oh, yes," she answered, hugging him, "as long as you are Sir Samuel Baker."

In India, Grant was completely outraged. Speke had been awarded no honors whatsoever for his discoveries. Perhaps had Speke lived longer, and been less quarrelsome, he too would have been knighted; but perhaps not. Grant had been given merely a Companion of the Bath Order, and that ostensibly for something other than his African explorations. Jealousy poisoned Grant's mind, for he and Speke had accomplished much more as explorers yet enjoyed no such fame and adulation.

Grant's pique was aggravated by the fact that Sam's book was much more popular than Speke's *Journal of the Discovery of the Source of the Nile* and his own rather turgid *A Walk Across Africa*. Sam's book was far more entertaining and his illustrations more lively and vivid.

Worst of all, Grant felt, Sam was blatantly promoting an immoral woman. The combination of Sam's knighthood, his writing success, and Florence's fame was too much for him. In a fury, Grant began writing letters to many of his friends and contacts in England voicing his complaints. The most lurid of these was an eight-page diatribe addressed to

his publisher and friend, John Blackwood. In it Grant accused Florence of having been a common barmaid in a town where Sam had spent a year or two and of traveling with Sam without benefit of marriage. Grant asserted that he, Speke, and Colquhoun had all reprimanded Sam for taking Florence to Africa before marriage and implied he didn't believe they were married yet. As for Baker's behavior in publicizing his own discoveries to the cost of Speke and himself, Grant was harsh and unforgiving. He wrote:

> . . . it shows much more effrontery than Speke or I could . . . be capable of—To snatch this discovery from those who were so generous to him— to enhance his tale by introducing this lady's name—to bring almost abuse on us for never having publicly mentioned her, to snatch the attention of the public from our lake to his & get knighted in a few weeks after his return is, I again say, a transaction . . . which I should be very sorry to have had a part in.

Blackwood could see the situation more clearly than Grant could. The Bakers were a popular icon of British courage and a symbol of marital devotion. Sam was undoubtedly brave and charismatic, Florence charming and loyal, whatever faults they might have. To attack them would not only be useless, it would also make Grant look like a mean, sour-hearted cad. Venting his anger publicly would ruin Grant, so Blackwood addressed him bluntly.

> I have watched pretty closely what Baker has said and on the whole I think he has wished to act fairly toward Speke & you. . . . I saw him once in London & nothing could be more warm than the way he spoke of you both & what you had done. . . . You may rest assured that whatever this one or that one may say your names, Speke first and yours second, will stand to all time as the discoverers of the Source of the Nile & the men who first succeeded in piercing Africa through and through. That is a fact. . . .
>
> I strongly advise you not to enter into any correspondence and above all not to let out anything about Mrs. Baker's position. Whatever she may have been before, she went through a fiery baptism in Africa suf-

ficient to wash out the memory of any previous spots. She must be a
fine character.

Closer to home, Min was having to grapple with her jealousy and resentment. She was a genuinely warmhearted woman who was devoted to Sam and his daughters. Believing it in the girls' best interests, she tried again and again to block any permanent arrangement for them to live with Florence and Sam. In 1867, nearly two years after Sam's return, Min wrote another unhappy letter to her sister Ann, accusing Florence of being behind all her quarrels with Sam. Min sniped that Florence was "vulgar-minded" and "not a lady." Florence was certainly too young and too beautiful; she laughed too heartily and expressed her opinions too freely; and she had usurped the children Min had every right to think of as her charges. Min labeled James and Louisa traitors for their support of Florence. Sam's brother John was disgusted with the entire family for their endless bickering.

Despite envy, resentment, and rumors, the conquest of London by the famous exploring couple seemed complete. In February 1867 Sam asked Lady Wharncliffe to present Florence to the queen at court. Lady Wharncliffe agreed, but Queen Victoria did not; evidently she had heard rumors of intimacy before marriage. This fact had not blocked Sam's knighthood, but on the matter of receiving ladies of dubious reputation, the queen was uncompromising. She would not be seen to be associated with a woman with the slightest taint on her moral character.

Sam was excruciatingly embarrassed. He was also ashamed, both on Florence's behalf and on his own, for having put Lady Wharncliffe in an unsupportable position. He wrote an abject letter of apology to Wharncliffe.

I was very miserable when I left you, and am still—more especially on Lady Wharncliffe's account, as I am so deeply distressed that *she* should have any annoyance and heartburning for her kind intention of presenting my wife. Had I the slightest suspicion of the consequences of asking her, you know I should have been the last to have done so.

I cannot understand the laws of marriage, nor do I attach the least importance to the various forms that each country separately adopts as custom—

If a Scotch marriage is valid (and we know it is) even in England, and where the simple fact of registration before a magistrate, in *London* is itself valid—what form shall be adopted when one party is Roman Catholic and the other Protestant, and in a wild country like Hungary or Turkey?—this was our case until my wife became a Protestant—but the vows entered into were never more faithfully kept, or more devotedly acted upon through years of danger and trial than by us, and the very moment we entered England we were married according to the forms of our Church so that no custom of the country should be infringed. . . . Never was marriage more sacredly kept than it has been from the moment we first exchanged those vows. What care I for Kings or Princes!

For years I have been happy without the world, when we have been together with a poor hut or shady tree for home, thus with her I can be happy again and lay the world down at will and with satisfaction that my course has not been worldly-wise—To her I have done my duty, and for her I would sacrifice position, wealth, life—everything.

The next day, perhaps feeling he had been overly emotional in this letter to Wharncliffe, Sam wrote a second, in which he observed that his feelings toward Florence were "perhaps more intense than is often bestowed upon women by their husbands" and assuring his old friend that he would never expose Florence to the possibility of rejection again.

Wharncliffe continued to support Sam and Florence regardless of the queen's position, as did others. Only days after the queen declined to receive Florence, the American writer Julia Ward Howe met Sam at tea in the home of Lady Stanley. A few days later, Howe met both Florence and Sam at a dinner party.

She remarked on Florence's exotic attire: an amber tunic over a white dress and what Howe called "a necklace of lion's teeth," which was actually the necklace of lion's claws from the lions Sam had killed. In Africa, lion's claws were powerful talismans protecting the wearer against attacks from wild animals. In London, the attacks were more likely to come from society ladies than lions, but they might be just as dangerous.

Sam's eldest daughter, Edith, became engaged to marry Robert Marshall, the rector of the Church of St. Paul, Hedenham. Florence and Edith had a marvelous time planning an enormous wedding for the autumn of

1867. The guest list was so large that Sam decided to add a large conservatory onto the house to accommodate them. When he wasn't supervising the building, Sam was preparing a second book for publication, *The Nile Tributaries of Abyssinia*.

The following autumn Edith gave birth to her first son, Cyril, and asked Florence to be his godmother. Though she did not yet know it, caring for Edith's children was as close as Florence was ever to come to having her own. She was delighted to accept, and wrote to Edith:

> I feel towards you all quite the love of your real mother and I only hope the other children will love me when they grow up as much as you have done. . . . I cannot tell you how I long to see my little grandson, I have put his dear hair in my locket, where I shall always keep it. . . .
>
> We shall have a very gay party the week after next, as there will be two balls given for the Prince of Wales. It is so very kind of the Duchess to insist upon our staying so long.

In all, Florence and Sam stayed for a month with the Duke and Duchess of Sutherland at Dunrobin and became close friends with the prince and princess. It was perhaps a predictable friendship. The prince was already a friend of Sam's brother Valentine, now a colonel of the Tenth Hussars. Valentine was a founding member of the prince's fashionable Marlborough Club. Now, meeting Sam, he found additional members of the family to his liking.

Only a few days after the prince's arrival at Dunrobin, he received a scolding from the queen about his new friends and responded stoutheartedly:

The Royal Family (1863). Although the Prince and Princess of Wales enjoyed the Bakers' company, Queen Victoria disapproved of their association with the Bakers because of rumors that Florence and Sam had been intimate before marriage.

My dear Mama,

... Sir W. Knollys wrote to me that you had heard that Sir Samuel
and Lady Baker were here, and that you wished me to know that she had
been on intimate terms with her husband before she married. I had also
heard the report; and spoke to the Duke about it, and he assures me that
he and the Duchess had made enquiries into the matter and they had *no*
doubt that there was no foundation for the story, and the Duchess is very
particular about the ladies she asks and would certainly not have asked
Lady Baker to meet Alix unless she felt certain that she was quite a fit
person to know.

She is one of the quietest most ladylike persons one could see, and
perfectly devoted and wrapt up in her husband, and I think it is very hard
on both that this story should be believed, which must be most distressing
for him, and very dreadful for her. . . .

The prince's assurances might have carried greater weight with the queen
were he not known himself as a lady's man, susceptible to the attractions
of beautiful young women. He once dared flirt with Florence, by calling
on her, uninvited, when Sam was out. She instructed a maid to show him
to a sitting room and ask him to wait while she finished giving instruc-
tions for the laundry. As calling on a lady whose husband was out was
often the prince's way of embarking on a liaison, Florence's answer was
her way of making an oblique refusal.

SUPREME AND ABSOLUTE POWER

\mathcal{A}t Christmas of 1868 Florence and Sam celebrated a
special joy, for she believed she might be pregnant,
at long last. Florence's health had been badly compromised
by the years of deprivation and illness during their Nile ex-
ploration, so she must be very careful.

The Prince of Wales had invited the Bakers to join him
and Princess Alexandra on a trip to Cairo. The Waleses
were to pay an official visit to the khedive, or viceroy, of
Egypt, Ismail Pasha. Though Egypt was technically a part
of the Ottoman Empire, the khedive functioned nearly in-
dependently of the sultan as the highest ruler in the land,
and British influence over Egypt was steadily increasing. Af-
ter fulfilling their official duties, the Waleses and their party
wanted to go sightseeing and hunting up the Nile. Sam was
just the man to organize the trip, given his knowledge of
Arabic and his years of experience in Africa. Sam was de-
lighted by the idea, and Florence would be good company
for Alix. They got along very well and conversed happily in
German together. Now Florence decided she ought not to
go to Egypt. A prolonged journey in hot weather and expo-

sure to all the diseases with which the Upper Nile swarmed might be too big a risk. The trip was, as Sam remarked in a letter to Wharncliffe, "quite impossible for Lady Baker." Knowing how much Sam would enjoy the trip, Florence insisted that he go alone.

The final party comprised the prince and princess; a lady-in-waiting to the princess, the Honorable Mrs. Grey; equerries Lieutenant Colonel Teesdale and Captain A. Ellis; Lord Carrington; the Honorable Captain Montague; Dr. Minter, Mr. Brierly, and Sam. In addition, there were assorted attendants and aides. Queen Victoria protested that her son should not associate with the Bakers, but the prince defended his friends once again.

The prince and princess were well occupied in Cairo and Alexandria with formal meetings, state receptions, and banquets, but the Nile excursion was pure pleasure. The steamers supplied by the Egyptian government were ornately decorated—so ornately that, for decency's sake, Sam found it necessary to replace some of the furniture with more sedate, English goods. Otherwise, he joked to the prince, their steamer might be mistaken for a floating bawdy house, of which there were many along the Upper Nile. He organized everything beautifully.

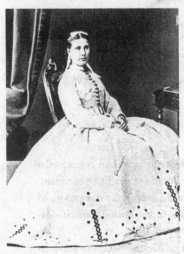

Florence in England (ca. 1868–1869). This photograph of Florence shows her with a fuller face and plumper figure than in previous photos; she may have been in the early stages of pregnancy.

The party glided along the Nile, watching birds, staring at or shooting prehistoric-looking crocodiles, and enjoying the timeless parade of landscape, people, camels, and palms. Sometimes the men went ashore to stalk wild game. Other times, the whole party disembarked to view some fabulous Egyptian ruin and to wonder at a fallen empire. The trip was a tremendous success.

The end of the trip was marked by a grand masked ball in Cairo, hosted by the khedive in honor of the English visitors. During the eve-

ning the khedive pulled the prince aside to put a weighty proposition to him. The khedive, educated in Egypt, Paris, and Vienna, viewed

The Royal Flotilla (1869). Sam organized a sailing trip on the Upper Nile for the Prince and Princess of Wales. On this trip, Sam was asked to become the Governor-General of Equatoria.

himself as one of the most enlightened and modern of rulers. He hoped to reform some of the evil and backward ways of his country. He wanted to send a military expedition to the great African lakes, to annex much of the Sudan and expand Egypt's imperial control southward. This ambition was part of his plan to eradicate the poisonous slave trade and to open up legitimate trade and security stations along the White Nile.

The prince agreed it was an admirable plan that combined humanitarian endeavors, which would be very popular in England and with the queen especially, with military and commercial expansion. Who did he have in mind to lead this expedition?

The khedive realized that the project would need firm and stalwart leadership. Frankly, he doubted that an Egyptian could accomplish such a difficult task, given the central position of slavery in Egyptian society. There was bound to be a great deal of sabotage and resistance. For that reason, the khedive thought perhaps an outsider, an Englishman, would do. Did the prince think the admirable Sam Baker would be suitable and willing?

The prince certainly did, and he undertook to present the idea to

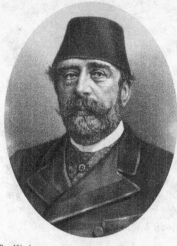

Sam himself once he was assured of the khedive's honest intent. Sam would be answerable only to the khedive. There would be no haggling over details, salary, equipment, or costs. The man who undertook the job would have an enormous salary of ten thousand pounds per annum for four years. He would be provided with a sizeable army, boats, guns, uniforms, supplies—anything reasonable he required. During the four years, the man would be the governor-general of the entire annexed region, which would be known as Equatoria. If Sam agreed to accept the position—knowing it was a formidable and difficult task—he should draw up a detailed, formal proposal for the khedive, who would arrange everything.

Sam was very pleased with the commission. He left Cairo in a hurry to return home to Florence, for he had been worrying over being away from her so long at this time. Now he could return home with a plan to make her smile. Sitting at home in England, comfortable and cozy as it was, had been too boring and confining for their restless natures. *Here* was a project worthy of their energy. Eradicating the slave trade and annexing the Sudan: those were challenges that would test their mettle. The commission also neatly provided a way for him and Florence to revisit Africa while making a great deal of money. What's more, they would be able to strike a serious blow at the heart of the African slave trade that Florence hated so deeply. Taking the baby with them would pose no problem in Sam's mind; they could find a good nursemaid to accompany them and take care of the child, as he and Henrietta had done in Ceylon.

Sam came home full of his exciting news only to learn that Florence was in poor health and low spirits. She had lost the baby or perhaps not

been pregnant at all. She had so hoped that she could give Sam his heir at last. She dreamed of bearing a son that would grow up with Edith's little boy, Cyril. The doctor pronounced gravely that she would probably never be able to carry a child to term. Florence and Sam spent his first night home in tears, clinging sleeplessly to each other and mourning the loss of those dreams.

Near dawn, Sam kissed her and whispered gently, "Never mind, Flooey; never mind. We have each other, we will always have each other. Think how jealous I'd be if I had to share you with a baby." But his voice broke on the last words and he revealed the sorrow beneath the sweet jest.

Florence felt hollow inside. She smoothed his hair back from his brow and tried to smile for his sake but failed badly. "We shall have each other," she repeated. Edith came as often as she could, bringing baby Cyril to cheer Florence, and the other girls tried to comfort and please their new stepmother. Florence felt that no one but Sam could understand the depth of her loss. She took solace in prayer and often went to sit in the church, asking God if this was her punishment for sinning. But she had only acted out of love, not selfishness, and she could not believe God would punish her for loving Sam.

Sam found it easier to assuage his grief by throwing himself into planning the new adventure. It was as if the khedive had offered him the chance to go back over the ground he had once won by sheer courage and determination. This time he would have men and equipment and supplies. This time he would prevail by planning and strength, not solely by bravado and doggedness.

Florence had a hard time interesting herself in plans for another African trip, even one that promised to be conducted in relative luxury compared with their first journey. For many weeks she had no taste for it. She felt uncharacteristically depressed, and empty. Finally Sam began to worry seriously for her mental and physical health, and Florence could see his concern. She could not bear to see yet another burden on his shoulders. For Sam's sake, she tried to lift herself out of her gloom. It was difficult to accept that life held no children for her when she was so fond of little ones, but at least she could save some children and give them free lives without the terrible fear of slave traders. There was a human purpose to this journey that had been missing before. She began to eat better and take

more exercise. She asked Sam to show her his plans and helped him write them out in an organized fashion. There was also the question of the other girls: Ethel, Constance, and Agnes. Sam refused to leave them with Min again, even though she had married at long last and was now Mrs. Cawston. He would not risk having to fight Min for his daughters again; Min was insulted that he did not trust her. Edith agreed to take her sisters in, and it seemed the best for all concerned.

When the details were finally worked out, Sam's charge from the khedive was extraordinary. His powers to annex territory, dispense justice, and stamp out slavery were almost unlimited. His *firman* from the khedive, which was finalized on May 16, 1869, read:

> We, Ismail, Khedive of Egypt, considering the savage condition of the tribes which inhabit the Nile Basin;
>
> Considering that neither government, nor laws, nor security exists in those countries;
>
> Considering that humanity enforces the suppression of the slave-hunters who occupy those countries in great numbers;
>
> Considering the establishment of legitimate commerce throughout those countries will be a great stride towards future civilization, and will result in the opening to steam navigation of the great equatorial lakes of Central Africa, and in the establishing of a permanent government. . . . We have decreed and now decree as follows:—
>
> An Expedition is organized to subdue to our authority the countries situated to the south of Gondokoro;
>
> To suppress the slave trade; to introduce a system of regular commerce;
>
> To open to navigation a chain of military stations and commercial depots, distant at intervals of three days' march, throughout Central Africa, accepted Gondokoro as the base of operations.
>
> The supreme command of this expedition is confided to Sir Samuel White Baker, for four years, commencing from 1st April, 1869; to whom also we confer the most absolute and supreme power, even that of death, over all who may compose the expedition.
>
> We confer upon him the same absolute and supreme authority over all those countries belonging to the Nile Basin south of Gondokoro.

In addition, the khedive gave Sam the honorable title of bey, the highest title he could dispense without special approval from the sultan in Constantinople, and the military rank of major general. Sam was almost immediately upgraded by the sultan himself to the rank of pasha, a title never before conferred on an Englishman in the Ottoman Empire.

The political situation was complex. Egypt was technically a part of the Ottoman Empire, yet operated within the empire almost as a separate nation with very close ties to Britain. The khedive ruled, yet did not rule Egypt unfettered; having approval from the sultan and the English royal family and government was important.

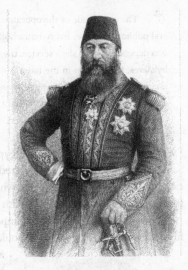

Baker Pasha (1874). Sam relied on the Khedive's authority, his own enormous personal courage, a magnificent uniform, and a small army to try to end the slave trade. The expedition met with fervent resistance.

In Sam's presence, the khedive also instructed his minister of the interior, Cherif Pasha, that Sam "was to possess supreme and absolute power, and that all that [he] might require should be supplied upon demand."

Sam's salary was fabulous, his rank exalted, his power practially unlimited. His expenses would be freely paid, and he would have plenty of men. The khedive's *firman* was clear in its meaning and amply demonstrated his full support for the undertaking. Sam wrote:

> It was obvious to all observers that an attack upon the slave-dealing and slave-hunting establishments of Egypt by a foreigner—an Englishman—would be equal to a raid upon a hornets' nest, that all efforts to suppress the old-established trade in Negro slaves would be encountered with a determined opposition, and that the prime agent and leader of such an expedition must be regarded "with hatred, malice, and all uncharitableness."

. . . The magnitude of the operation cannot be understood by the general public in Europe. Every household in Upper Egypt and in the Delta was dependent upon slave service; the fields in the Sudan were cultivated by slaves; the women in the harems of both rich and middle class were attended by slaves; the poorer Arab woman's ambition was to possess a slave; in fact, Egyptian society without slaves would be like a carriage devoid of wheels—it could not proceed.

Despite its intimate alliance with Egypt, the British government warned Sam that support must not be expected from them in the case of "complications." Achieving the impossible when all about them warned against the attempt had become habitual with Sam and Florence.

They were keenly aware how important personnel would be. Aside from himself and Florence, Sam would rely most heavily on his nephew

Julian Baker (1874). Sam's nephew Julian took leave from the Royal Navy to serve as second-in-command on the expedition. His natural authority, intelligence, and moral integrity were great assets.

and aide-de-camp, Lieutenant Julian Baker, on leave from the Royal Navy for one year at a salary of five hundred pounds from the khedive. He recruited a chief engineer, Edward Higginbotham, who would supervise six additional engineers, shipwrights, and boilermakers from the factory of Samuda and Penn, who had manufactured the engines for the six steamers. These men were James M'Williams, Charles Robert Jarvis, David Sampson, George Robert Whitfield, William Hitchman, and James Thomas Ramsell. At their request, the men had their wages paid in part or in full to loved ones in England while they were gone. The chief of the medical staff was Dr. Joseph Gedge, and the head storekeeper and interpreter, Michael Marcopolo.

For their personal comfort, Sam decided to bring a manservant, Lewis Peck, and Florence selected a lady's maid, Margaret Bullinaria. To insure that the English servants knew what they were agreeing to, Florence insisted that they read Sam's book on the Albert N'yanza from cover to cover before signing on. Finally, they hired four Egyptians: Hadji Harness as cook, and three janissaries, or soldiers, Mabruk, Suleiman, and Hossein.

The expedition was on a very different scale from the one he and Florence had led in 1861. In London, Sam ordered nine thousand pounds' worth of carefully selected supplies and provisions, including vast quantities of tinned food and dry foodstuffs sufficient to feed the Europeans for four years; blankets, sheeting, canvas, bolts of cloth, quantities of scarlet flannel shirts and linen trousers, already made up; matches, candles, wicks, and lamps; an ample medicine chest; tarpaulins; bottles; shoes and boots; enameled tin plates, cups, saucers, bowls, dishes, et cetera; copper saucepans and kettles; silver drinking cups; assorted chamber pots; locking tin or copper boxes; axes, picks, hoes, hammers, crowbars, metal rods, drills, and hatchets; needles, thread, scissors, and buttons; mosquito gaiters; blank books and journals; tanned tents, awnings, sails, and lines; guns and ammunition; scarves and handkerchiefs in gaudy colors; colored prints; tin spoons; cheap watches; batteries; combs, zinc mirrors, knives, harness bells, fish hooks, razors, finger rings, magic lanterns, an assortment of toys, and several music boxes.

Sam would command a force of 1,700 men: 710 of the First Egyptian Regiment and 500 of the First Sudan Regiment; 200 cavalry irregulars; an artillery of three batteries of mountain guns, or 210 men; and another of rocket batteries comprising 80 men. On this journey Sam had a private army—a far cry from the paltry 14 men and boys with whom he and Florence had pushed through to the Albert N'yanza on the last voyage.

Delays and prevarications began almost immediately. Everything was deferred by the immense international festivities celebrating the opening of the Suez Canal, which proved a major impediment to the expedition. As Florence wrote to Edith from Cairo,

We came here on the 17, and on the 18 October Papa went directly to see the Authorities to inquire if all the vessels were ready to take the steam-

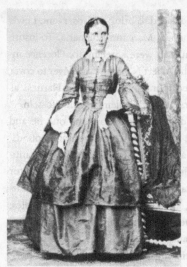

Florence in Alexandria (1870). Florence arrived in Egypt looking drawn and very much thinner than she had been a few months before. (Compare this photo with the one on page 248.)

ers and men up to Korosoko from Cairo. The answer was 'no, there are no boats ready for you now as we expect the French Empress in a few days, and she wishes to go up the Nile directly [when] she arrives here, so we must make preparations for her—and you must wait till she is gone up.' You can imagine that dear Papa was not pleased about it as all the Authorities are quite mad at the idea of the Empress. . . .

The Empress heard that Papa was still in Cairo, so she wished very much to see him before we should start for the expedition. . . . She was very gracious indeed to him and so kind. . . . She took such a great interest in the expedition. . . .

We thought her very kind and gracious, but we are very glad that she is gone, as the Authorities will now look after our work. We are really longing to be off. . . .

I am so glad that we are in Cairo instead of Alexandria, I like it so much better, there is more to see, it is also very much improved since I saw it last. Papa had a letter the other day from Mr. Lafargue and he writes that the slave trade is worse than ever upon the White Nile, but we shall quickly extinguish it. The slave traders are already in a great fright at the news of our expedition. We shall have plenty of enemies but if we only keep well in health I have no fear of the result.

Ever intrepid, Florence was far more interested in starting on their expedition than in hobnobbing with an empress.

Sam's plan was that the expedition should start in three divisions. The first comprised thirty-six steamers and sailing vessels that should have left Cairo on June 10, but no one would authorize use of the vessels until the khedive himself approved—and he was out of the country until August

29. The opening of the Suez Canal also interfered with these plans. No matter, for the English steamers in sections and much of the heavy machinery hadn't yet arrived on June 10.

The Opening of the Suez Canal (1869). The departure of the expedition was delayed by the massive celebrations to mark the opening of the Suez Canal, like the formal blessing of the canal shown here.

When eventually forty-one railway wagons full of steamer sections, boilerplates, and machinery reached Cairo, Sam managed to beg the use of a steamer to tow the equipment to Korosoko. At Korosoko the chief engineer, Mr. Higginbotham, assumed the unenviable task of hauling the load across four hundred miles of sun-blasted desert to Khartoum. However, because they had left Cairo so late in the year, they would have difficulties with the river being low and the sudd being thick. Once Higginbotham got the load from Korosoko to Khartoum, there was no assurance he could ship it up the White Nile to Gondokoro until the next season.

The second division, Sam, Florence, Julian, and their company, left Suez on an Egyptian sloop on December 5. They arrived at Souakim four and a half days later, and, after a week's delay to hire camels, crossed the desert to Berber, as Sam and Florence had done on their first trip. From Berber they sailed by *diahbiah* and steamer to Khartoum, the whole trip taking only thirty-two days. On the voyage south from Berber, ominous signs of the state of the countryside were plain. The riverbanks that had once been green and lush with cultivated fields were abandoned; veg-

The Camel Transport of Steamers and Machinery
(1874). The chief engineer, Edwin Higginbotham,
had the unenviable task of supervising the
transport of the disassembled steamers across
the desert and up the White Nile to Gondokoro.

etation was growing wild. Where there had once been sizeable, healthy villages at frequent intervals along this stretch of the White Nile, there were now only burned and abandoned huts, with no signs of human habitation. One of the richest, most densely populated regions of the Sudan lay in "terrible desolation." The ruthless slave traders had plundered and raided and despoiled until nothing was left.

Florence, Sam, and the others traveling with them arrived in Khartoum on January 8, 1870, expecting or at least hoping to meet the third division of the expedition—the soldiers, animals, and additional boats Sam had asked for. Sobered by the changes they had observed south of Berber, Florence and Sam were further disheartened by Khartoum. Once a city of thirty thousand, Khartoum had shrunk to about fifteen thousand souls. All of the European residents had died or fled, excepting the Austrian mission, the Austrian consul, and "an extremely tough German tailor, who was proof against the climate that had carried off his companions."

According to Sam's plan, twenty-five of the sailing ships and three steamers should have been ready in Khartoum and awaiting their arrival

for the last six months. There was no flotilla—indeed, not a single ship—in readiness. The governor-general of Khartoum, Djaffer Pasha, had been clearly instructed to provide them, but he maintained that so many vessels could not be found in Khartoum. The thinness of his excuse became apparent when Sam learned he had recently found eleven vessels to take a notorious slave trader, Kutchuk Ali, up the Bahr el Ghazal. At government request, Kutchuk Ali was forming a settlement near the lucrative copper mines at the border of Darfur. Sam observed cynically that the activities of one of the worst slave traders were apparently more important than his own. He suspected at once that Djaffer Pasha was working against him.

"Delay is one of the deadliest weapons available to the Egyptians that might be turned against the expedition," Sam said to Florence. "We shall not give in to this ploy."

He asked Djaffer Pasha to prepare the troops assigned to the expedition for inspection. The "irregular cavalry" were so very irregular that Sam dismissed the lot of them at once. The Sudanese soldiers were seasoned and used to military discipline, but the Egyptian soldiers were mostly convicts and felons being punished for their crimes. From this ill-assorted group Sam selected a special bodyguard of forty-six men. Despite the discrepancy in number, they soon became known as the Forty Thieves, after the famous story of Ali Baba and the Forty Thieves, because of what Sam called their "peculiar light-fingered character." However, Sam made it an honor to be among the Forty Thieves and turned them into an elite group. Over the next four years, the Forty Thieves distinguished themselves by their bravery, their first-rate skills, and their exceptional loyalty to Sam and Florence.

The delay in Khartoum was to be expected, Florence and Sam agreed. No matter how well they planned for every exigency, no matter how carefully they supplied their expedition, things would go wrong. To have them start that way was only a reminder of the essential nature of the process in which they were involved. The trials of their first trip had arisen not solely from naïveté and inexperience but from the contrarian nature of Africa itself. Rains came, or didn't come, or came too strongly; men volunteered, or hired on, or deserted; rivers ran dry, turned into endless swamps, or became raging torrents; animals thrived or dropped dead of unknown

The Forty Thieves Commanded by Lieutenant Abd-el-Kadr (1874). Sam chose an elite bodyguard of forty-six men from the Sudanese and Egyptian troops, his "Forty Thieves."

causes—all without reason. Little was predictable except perversity and hardship. Mere survival of an African journey was always in question. Success relied on strength of character and determination as much as anything else.

They sailed out of Khartoum on February 8, 1870, eight months later than Florence and Sam had hoped. They had only 650 of their men and four fewer steamers than they had planned on. Their flotilla consisted of two steamers and thirty-one sailing vessels, including the *diahbiah* on which they lived. One steamer was commanded by Sam's nephew, Julian Baker, and the other by Raouf Bey. Julian was fascinated by the wildlife, writing in his journal about the tall, ugly-headed marabou stork, which had a horribly naked head and an obscene-looking wattle that dangled in front of its chest. He was charmed by the delicate crested cranes with their crown of upright yellow feathers and foreheads of velvety black feathers. They passed hippos and immense crocodiles sunning on the banks, all new and exciting to Julian as they steamed down the broad, smooth river. The entire town of Khartoum turned out to see them off, perhaps as much to make sure that the potentially troublesome Bakers left as to wish them a good voyage.

After little more than a week they arrived at Fashoda, the first government station south of Khartoum. Florence condemned it as a "miserable

place" that was "full of fever" and "a good many people called the Shillook," a tribe related to the Dinka. She thought it "a horrid

The Departure from Khartoum (1874). The small navy of steamers and sailing vessels made a magnificent sight as they left Khartoum. They were stopped all too soon by the impenetrable sudd.

village to stop at," and Julian labeled it "the most miserable place that can be imagined, situated on a dead flat and surrounded by marshes." Their welcome from the governor of Fashoda, Ali Bey, was suspiciously hearty. He presented them with two fat sheep and assured them vociferously that he always followed the khedive's instructions faithfully. No slave traders' boats could pass his station, he insisted. Sam thought he was lying.

Shortly after leaving Fashoda, a crucial decision had to be made. Though the White Nile had been wonderfully clear and deep so far, when they reached the junction with the Sobat River—which Sam and Florence had explored before—it became obvious that the sudd was worse than ever that year; the vegetation almost completely blocked the river. Obviously the Egyptian authorities had done nothing to keep the river clear. Sam wrote:

> We now came upon a region of immense flats and boundless marshes, through which the river winds on a labyrinth-like course for about 750 miles to Gondokoro. . . .
> The Bahr Giraffe was to be our new passage instead of the White Nile. That river . . . had become . . . curiously obstructed by masses of solid

vegetation that had formed a solid dam . . . entirely neglected by Egyptian authorities. . . . The immense number of floating islands which are constantly passing down the stream of the White Nile had no exit, thus they were sucked under the original obstruction by the force of the stream, which passed through some mysterious channel, until the subterranean passage became choked with a wondrous accumulation of vegetable matter. The entire river became a marsh, beneath which, by the great pressure of water, the stream oozed through innumerable small channels. In fact, the White Nile had disappeared.

There was little hope that the large boats on this expedition would be able to get through these marshy flats. Guides assured Sam that the Bahr Giraffe was navigable and the White Nile was not, so the first steamer and the *diahbiah* pulled up at the junction of the Bahr Giraffe to wait for the rest of the boats and inform them of the new route.

The guides were wrong. The Bahr Giraffe proved to be, if anything, more thoroughly blocked than the White Nile had been on the previous voyage. The mosquitoes were rampant and vicious, the heat in the swamps claustrophobic, and the scenery monotonous, but at least the swamps were full of birds—pelicans, ducks, francolins, egrets, geese, plovers, and herons—for Sam and Julian to hunt. The men begged them to shoot hippo and crocodile, their favorite foods. Wood was relatively abundant, fortunately, as the steamers required vast supplies of wood every day.

After less than a week on the Bahr Giraffe, the lead boats had reached a total impasse. Sam ordered fifty swords and axes to be sharpened for cutting through the vegetation, and the next day the laborious effort began in earnest. On the first day, forty men worked all day cutting the canal, standing in the water up to their waists, hacking at the solid plant mass, and scratching and cutting themselves on the sharp leaves. Once the vegetation was downed, it had to be fastened into bundles with ropes and hauled to one side. Sometimes that was not sufficient and the men had to drag the boats through the shallow water and narrow canals they had just created, using brute strength and ropes slung over their shoulders. They managed to open up a pitiful 150 yards of river with this determined daylong effort.

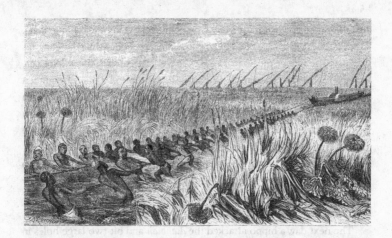

Day after day, the men labored. They were decently fed and cheered by a measure of grog in the evenings, but everyone was exhausted with the effort. As time passed, more and more men succumbed to fun-

Hauling the Number 10 Steamer Through the Canals in the Midst of Vegetable Obstructions. The men worked for days up to their waists in the sudd, hacking down vegetation and pulling the boats through the narrow channels.

gal infections, fevers, infected wounds, and sunstroke. Even Sam began to lose hope that they could defeat the sudd through hard work. On March 1 he went out in a small boat to see if he could find a better channel. Florence noted in her journal:

> It was in vain and to our horror we were obliged to turn back to the place where we last took wood in. It is quite dreadful to have to turn back again. We have to thank that horrid brute!! Captain Bedawi for all this as he is our pilot and he said in Khartoum that he knew the way well up to Gondokoro.

"Turn back" was not a phrase that ever figured prominently in either Florence's or Sam's vocabulary. To sail back over eighty miles that they had already covered with tremendous effort was especially bitter. Even knowing the horrors of the sudd as intimately as they did, they had underestimated the White Nile's power to foil their plans.

A day after they accepted defeat and turned back to seek another chan-

nel, they met up with Raouf Bey's steamer and twenty-five sailing boats. One of Raouf Bey's men had been taken by a crocodile while dangling his legs over the side of the boat. The slavers were worse than the wild beasts, however. Near the station of Kutchuk Ali, they found a pile of eighteen bodies. There were so many abandoned and burnt-out villages in the area that they could not even identify which the bodies had come from. Sam went ashore to talk with the few people who were left in the area, and they asserted loudly that this Kutchuk Ali massacred them with impunity. As he was the blackguard who had been hired by the government to set up a station near the copper mines, Sam was shocked at his behavior. Perfidy and collusion were to be expected, but the reality was appalling nonetheless.

The next day, a hippo attacked the *diahbiah* and bit two large holes in her side with its tusks. Sam quelled the ensuing panic by issuing orders. While the men manned the pumps, Florence and the English servants,

A Hippo Attacks the Boat at Night (1874). Territorial hippos sometimes attacked the boats ferociously.

Margaret and Lewis, rushed to empty the personal luggage from the boat and transfer it to the vessel that carried the wood. As there was a small area of dry grass on the shore, additional luggage was piled there haphazardly. Guns, telescopes, dishes, geographical instruments, books, maps, trunks, clothing, *angareps*, chamber pots, blankets, and mosquito nets—all of the impedimenta of

traveling life lay heaped in disarray. Sam and the engineers struggled to mend the holes while the troops worked in shifts to keep the boat afloat. By the next day the repair seemed solid and Florence proudly remarked that the *diahbiah* was "beautifully mended, not a drop of water comes in yet." The next time a hippo attacked the boats, it was at night, which made everything more difficult.

The river was little more than a stinking and poisonous morass of disease-bearing insects, rotting plants, snakes, biting ants, and slimy, smelly mud. By the end of the month, most of the expedition's vessels were traveling in convoy on a river that had narrowed to a mere fifty yards in width and little depth. After fifty-one days on the White Nile, they were in constant danger of running aground. The rains had begun and, with them, the time of fever and death. On March 9 the first soldier died of fever; two days later another died of sunstroke. The Egyptian troops rapidly lost heart and health. The Sudanese soldiers, being better acclimated, fared a little better, but disease was no respecter of nationality. Then men started dying almost daily despite all the treatment they could provide. Florence and Sam were growing increasingly anxious about the chief engineer, Mr. Higginbotham. He was following them with heavily laden ships and a smaller force of men; the loss of some to illness would be problematic. The sudd was maddeningly capricious, completely block-ing the river in one region and then, not far distant, opening up into a lake with no navigable outlet. Sam wrote in his journal on April 9, 1870:

> Who could believe the change? Some evil spirit appears to rule in this horrible region of everlasting swamp. A wave of the demon's wand, and an incredible change appears! The narrow and choked Bahr Giraffe has disappeared. . . . We now find ourselves prisoners in a species of lake, as we are completely shut in by a serious dam of dense rafts of vegetation that have been borne forward, and tightly compressed by the force of this new river. It is simply ridiculous to suppose that this river can ever be rendered navigable.

Once again, regretfully, Sam ordered the ships to turn back toward Khar-toum.

By April 13, they were back at the station of Kutchuk Ali. Sam made

a point of going ashore to explain his new authority to the slaver's *vakeel* and to put him on notice that slave trading would no longer be tolerated. The man was flatly incredulous that Sam had been authorized by the khedive to put an end to the slave trade. If that was true, why had his master been promoted and honored with business for the governor-general of Khartoum himself? Besides, slavery could not be abolished; the country could not run without slaves.

Florence and Sam knew what the man said was true: Egypt and the Sudan, as they were, could not run without slaves. Where they differed from the *vakeel* was in their conviction that such an enormous change could be effected. Described bluntly, the charge Sam had accepted from the khedive was nothing less than to provoke a massive social and financial upheaval. Free people did not know how to live their lives without slaves; slaves wanted only to be free, so they could buy and command slaves themselves. Almost no one envisioned a slave-free society; the concept was too revolutionary, too different from the reality they had always known. Forcing people into such a global change could be viewed as arrogant and cruel. Fortunately Sam possessed a full measure of the unshakeable British confidence in being right that characterized the Victorian age. He had no qualms about what he was doing, and Florence agreed completely. Their view of the morality of the situation was simple: slavery was wrong, freedom was right. Those who had engaged in slavery, been brought up with slavery, in a slave-permeated society, would have to be shown the error of their ways. If that involved force—and it surely would—and confusion, fear, social upheaval, and loss, so be it. Florence and Sam had no doubts that seizing control of "uncivilized" (i.e., non-European) countries in order to change them was a courageous and proper thing to do. This deeply rooted faith in their own superiority went a long way to explaining how their party—a handful of Europeans and a few thousand mercenary soldiers—could march relatively unmolested through vast areas of Africa.

The next day the expedition met up with slave ships belonging to yet another trader. "Sam and I went out for a walk in the afternoon," Florence wrote in her journal, "and we saw a number of slave women fetching water in the charge of one of these fearful scoundrels of slave traders. . . . I really hate the sight of them, whenever I see one of them it reminds me of olden times." Some of the men on their expedition had actually pur-

chased slave women from Kutchuk Ali's *vakeel*. Sam sent them back immediately. "If Sam would allow our troops to purchase slaves," Florence wrote, "the whole expedition would become a slave trading party, instead of suppressing the slave trade." Even their own men, who had signed on for an expedition specifically charged with eradicating the slave trade, did not understand the link between stated intent and action.

Most of the slave traders operating on the river must have thought that the expedition was stuck in the sudd by now, for they all came out of hiding. Only days later the expedition caught three vessels belonging to Ali Bey, the governor of Fashoda himself, while his men were engaging in a *razzia*, or slave raid, on a Shillook village. It was a terrible vision that Sam later described.

> The banks of the river were crowded with natives running away in all directions; women were carrying off all their little household goods, and children were following their parents, each with a basket on their heads containing either food or something too valuable to be left behind. I immediately went off in a rowing boat, and, after much difficulty, I succeeded in making some of the natives who could speak Arabic to stop and converse with me. They declared that the Turks had attacked them without provocation, and that the *Koordi* (as the governor of Fashoda was called) had stolen many of their women and children, and had killed their people, as he was generally plundering the country. I begged the natives not to fly from the district, but to wait until I should make inquiries on the following day; and I promised to restore the women and children, should they have been kidnapped.

The next morning Sam watched the governor's own vessels through his telescope as the troops drove captured adults and children onto the ships. He had his *diahbiah* towed up next to the *koordi*'s tent on the shore. The presence and ownership of their *diahbiah* could not be ignored.

While they waited on the poop deck under an awning for the *koordi* to appear, Sam remarked wryly to Florence, "You know, Flooey, I think our arrival is quite unexpected, and not very agreeable to the *koordi*!" When the governor duly appeared and came onboard, Florence was obliged to move out of sight to avoid offending the Turk, who did not talk business

with women. Instead, she was offended. Sam offered a pipe and coffee, broaching the true subject of the conversation only after a brief diversion of polite talk. Then he informed the *koordi* that the sudd had been too thick, so he had returned with his ships to wait until the river was higher.

"Allahu akbar!" the *koordi* exclaimed piously. "God is great! And, *inshallah*, you will succeed next year." He explained to Sam that he was at this location with five companies of soldiers and some cavalry, collecting the taxes. Unfortunately, he could give no account of the principles or system by which his people were taxed. Sam asked the *koordi* if he ever captured women and children, the way he might seize cattle in payment of tax. The *koordi* hotly denied he took part in such an outrage.

Sam seized this opening to order his aide-de-camp, Lieutenant-Colonel Abd-el-Kadr, to inspect the *koordi*'s vessels. The crew objected, loudly. The ensuing argument was drowned out by vigorous shouting from a crowd of slaves concealed belowdecks. These, plus the crowds of miserable creatures Sam discovered confined in the *koordi*'s encampment, numbered 155, of which 145 were women and children. Confronted with his own guilt—not to mention evidence of lying when he vowed he followed the antislavery restrictions—the *koordi* took refuge in questioning Sam's authority. He, the *koordi*, was the governor of the district; who was Sam to order him to liberate slaves or restrict his trade?

With the simplicity of one who is completely certain of his ground, Sam simply announced that if the *koordi* refused to liberate these 155 slaves, he would have to give Sam a written refusal to do so, which would in turn be presented to the khedive. At this, the *koordi* demurred; to commit oneself to writing over a questionable matter was always unwise. On April 22, accompanied by Julian and Mr. Higginbotham, whose boats had happily arrived intact, Sam returned to the *koordi*'s camp and demanded that the slaves be set free in front of him.

I ordered the ropes, irons, and other accompaniments of slavery to be detached; and I explained through an interpreter to the astonished crowd of captives, that the Khedive had abolished slavery, therefore they were at liberty to return to their own homes. At first, they appeared astounded, and evidently could not realize the fact; but upon my asking them where their homes were, they pointed to the boundless rows of villages in the

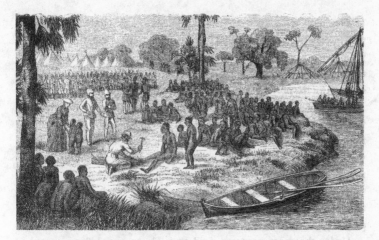

distance, and said "Those are our homes, but many of our men are killed, and all our cattle and corn are carried off." I could only advise them to pack off as quickly as possible, now that they had the chance of freedom.

Liberation of Slaves after the Capture of Slave Boats (1874). The first slave vessels stopped by the expedition belonged to the governor of Fashoda himself. One hundred and fifty-five slaves, mostly women and children, were freed.

The women immediately took up their little infants (one had been born during the night), others led the very small children by the hand, and with a general concert, they burst into the long, quavering, and shrill yell that denotes rejoicing. I watched them as they retreated over the plain to their deserted homes, and I took a coldly polite farewell of the Koordi. The looks of astonishment of the Koordi's troops as I passed through their camp were almost comic. I shall report this affair to the Khedive direct; but I feel sure that the exposure of the governor of Fashoda will not add to the popularity of the expedition among the lower officials.

The action did add greatly to Sam's reputation and popularity among the Shillook.

Two days later Sam picked the spot for his first station, which he named Tewfikeeyah after the khedive's eldest son, Mahommed Tewfik Pasha. He and Florence laid it out carefully, as they had many homesteads in Africa before. It was an area blessed with a number of large acacias, trees that provided excellent shade for the "English quarter" of the camp. In a matter

of days, tents were erected in neatly aligned rows for all the men, leaving pathways between. The ground was thoroughly swept every morning, exposing a hard, white, sandy surface that was pleasing to Florence's aesthetic tastes. Gardens were planted and magazines of galvanized irons were constructed for the protection of stores, under the direction of Mr. Marcopolo. A stable was put up to protect the transport animals from the relentless flies; a system of ditches for drainage and general sanitation was dug; and a five-hundred-foot-long quay for embarking or disembarking onto the ships was built. The men built a machine shop in which to manufacture or mend tools and equipment. Next to it was a fully equipped blacksmith's shop. All these buildings were made with timber from trees felled, sawn, and nailed together by the English engineers. It was Sam's most extensive building project yet and an impressive achievement.

Under the most generous-sized tree, Florence and Sam created a divan, or public area, for the comfortable reception of visitors; it was furnished with a carpet, a sofa, several chairs, and a few useful tables. Before long, the true king of the Shillook, Quat Kare, called upon them. He had been in hiding from the *koordi* and now appeared to claim his rights. He demanded the return of his kidnapped people: a task in which Sam proved instrumental. Sam stopped a ship belonging to Kutchuk Ali, which purported to be carrying corn, which Sam's officer Abd-el-Kadr found had an "awkward smell about the closely-boarded forecastle which resembled that of unwashed Negroes." Florence's pity and horror were provoked. "Poor things," she wrote in her journal, "they were concealed in every way, some of them were nailed down with planks, others were put in mats, two or three were put up into the sail, and a great many were hidden with elephant tusks." Many of the Shillook were found in iron fetters, which the English workmen enjoyed knocking off. With a certain glee, they replaced the irons on the ankles of the *vakeel* and captain of the *koordi*'s slave ship.

There was the problem of what to do with the slaves, as there were 150 of them. Sam gave each former slave an official paper of freedom signed by him, to wear in hollow reeds on strings around their necks. He offered them the choice of returning to their homes or staying at Tewfikeeyah and taking up a useful occupation, in which case he would see to it that

they were fed and clothed. Not surprisingly, most of the slaves stayed, as their homes were far distant. Within a day or two virtually all of the women had selected a man to marry from among Sam's troops.

It was a decent and kindly solution, but the principle could not be followed endlessly. The government stations and fort Sam intended to establish up and down the White Nile could not absorb all of the freed slaves. If his mission were successful, there would be an enormous number of displaced people with no money, no homes, and nowhere to go. What would become of them? Who would undertake to teach them useful occupations, to school them, or simply to doctor, house, and feed them? No thought had been given to this problem by the khedive, or at least there had been no mention of it in Sam's *firman*. Perhaps the khedive never expected Sam to make serious inroads against the slave trade, thus assuming such a problem would never arise.

Florence took to her heart a little girl of about three years old, Mistoora, who had been orphaned in a *razzia*. She also took on two sisters aged about fourteen and twenty-one as servants. The older girls wanted to stay together but had no other surviving close kin; they were delighted to remain with Florence. When she knew them a little better, they began to tell her of the conditions of their imprisonment and abuse by the slave traders. Florence was so horrified that she was reluctant to commit the details to paper, perhaps for fear the memories would haunt her. She wrote only: "I never heard such dreadful accounts as these girls gave me of what goes on in these horrid *zareebas* of the traders, the brutality and cruelty in every way is disgusting. I am sure nobody [at home] would imagine what goes on in some parts of the world."

Within a month, the station at Tewfikeeyah was proving a thorn in the side of the slave trade. Ship after ship was stopped and searched. Dreadful as it was to witness the brutal treatment of these poor people, Florence and Sam took tremendous satisfaction in freeing those who had been captured. Ship by ship, slave by slave, they accomplished their aims.

Florence's lady's maid, Margaret, was dissatisfied with her living conditions and appalled by the terrible scenes she had witnessed. She complained loudly to Florence about the great hardships she felt she had experienced, but her mistress was entirely unsympathetic:

I am very much afraid that she is only homesick, as she said once or twice to me that if she had known what she had to go through she would not have come for a hundred pounds. But she read the book in England and saw what we had to go through, but she says now she did not know that it would be quite so difficult as it is. I have not seen any very great difficulties that she has gone through as she has a *very* comfortable cabin in our *diahbiah* and eats exactly what we do, also she has a very large and comfortable tent, neither has she suffered from any very bad illness. Sam asked Lewis if he also would like to go back, as we noticed for a few days that they have settled it between them to return back together. Lewis said directly, "Yes, Sir Samuel, I should like it very much." Sam asked, "Why?" He said, "Oh . . . oh—oh, for many little things." Sam said, "Mention one." "Oh, one is that my wages are not enough." He is only about 19 years old, and his wages are now 30 pounds a year, and from the first of June he will get 40 pounds a year.

Experienced in living rough and courageous to the extreme, Florence had no respect for those less determined or adaptable than herself. By her standards, this voyage was incredibly luxurious. They had plenty of supplies and goods and had never once gone hungry. They were protected by an army of soldiers and sailors and had comfortable living quarters. Their mission was just, and they had the backing of the khedive himself. What was Margaret complaining about? She had never been kidnapped, starved, lied to, attacked, raped, or fallen weak with disease. Florence disdained Margaret's longing for the stuffy, safe, little world she had always known at home. As far as Florence was concerned, staying at home never cured the world's evils.

Every day Florence worked to bathe, clothe, feed, and educate the freed children. Distressingly often, their mothers abandoned them to her care, perhaps hoping she would adopt them permanently, perhaps seeing that Florence could care for their children better than they could. It seemed heartless. As more and more vessels were apprehended at Tewfikeeyah, Florence's little brood continued to grow. She never got used to seeing the hungry, skinny bodies and the frightened eyes when the children came in; they were so unused to any care or kindness. She knew the mothers were helpless to prevent the abuse of their children, but it pained

her deeply to see children who had been wrenched from their families, chained and beaten and marched for miles without food or water, much less a kind word. She could give them tenderness, food, and care now, and did so willingly, but what of their futures? There were no answers. She could not stay in Tewfikeeyah and run some sort of orphanage; she could not take the children home; she hated to send them away. She blocked the bigger questions out of her mind as best she could and concentrated on doing what she could for the children who were before her *now*. She hardened her heart, just a little, against becoming too attached to them, for she knew she would have to leave them someday soon.

In the station the numbers suffering from fever and other tropical diseases also grew daily. Dr. Gedge became so ill he could no longer attend anyone else. Sam, robust as ever, took over the medical duties. Chief engineer Higginbotham headed back to Khartoum to pick up more men, supplies, and goods that had been left there in depot. Later, Florence and Sam thought they should have sent Gedge back with Higginbotham, but that was merely hindsight. By September 1, Gedge was delirious with brain fever. Florence recorded sadly:

> The Englishmen are a little better today, but I am afraid that the doctor is quite out of his mind. He is always crying out for champagne and wine. He drank a whole bottle of champagne yesterday, and nobody knows how much gin and brandy. Mistoora is much better, she has no fever; but I am sorry to say that she suffers now from sores all over her poor little body, and they look as if she has been burnt with fire.
>
> Another of the English men got fever today, so Sam has a good deal to do in attending on them.

Over the next week Gedge grew worse and worse. Finally Sam decided that a *diahbiah* must be sent up to Khartoum with the doctor; perhaps he could receive better treatment there, and the climate would be a marginal improvement. Gedge was "a perfectly mad man" as he was led onto his boat, Florence observed. She wondered if he would die.

Sam was running out of patience. The flow of slaving boats past Tewfikeeyah was nearly constant. Neither the traders themselves nor even the *koordi* of Fashoda seemed to believe that the antislavery laws would be

enforced, despite the vast sums that had gone into equipping the expedition and setting up the station. As far as Sam could see, the governor of Khartoum, Djaffer Pasha, had done absolutely nothing to deter the slave trade and had, on every side, thwarted Sam's attempts. He and Florence would go back to Khartoum and confront the governor.

17

MY LADY AND I SHALL PROCEED ALONE

On September 21, 1870, Sam and Florence reappeared in Khartoum, seven months after they had set sail. The people of Khartoum were astonished and not very pleased to see them. Higginbotham had been back there for some time and was nearly mad with frustration. None of the assistance in obtaining more supplies, ships, and men that he had asked for had been forthcoming. There were only seven ships available, instead of the thirty Sam had requested months earlier from Djaffer Pasha, and they could not carry as much corn as was needed.

Sam requested an immediate audience with Djaffer Pasha. He was told, most interestingly, that the governor could not meet with him at this time because he was in conference with Ahmet Sheik Agad and his son-in-law Abou Saood, two notorious slave traders. To find Djaffer Pasha in apparent collusion with the very men whose livelihood Sam proposed to destroy stretched Sam's belief in the governor's good intentions.

To his amazement, Sam discovered that Agad had been granted a *firman*, or permit, for which he paid three thou-

sand Turkish lira, or approximately 2,459 pounds sterling, annually. This *firman* gave Agad the exclusive trading rights to ivory within the very part of the Sudan that Sam had been instructed to annex. In short, a *firman* had been granted by Egypt to trade in a region of ninety thousand square miles over which Egypt held no legitimate authority until Sam annexed it. More astonishing still, the *firman* entitled Agad to an ivory monopoly, and yet ivory could be obtained in no way other than in trade for slaves. Sam wrote:

> The curtain began to rise, and disclosed certain facts of which I ought to have been informed many months ago, when I first arrived at Khartoum. . . . It was hardly credible that such dust should be thrown in the eyes of the khedive, after the stringent orders he had given; but Egypt is celebrated for dust; the Sudan is little else but dust, therefore we must make some allowances for the blindness of the authorities. My eyes had evidently been filled with Khartoum dust, for it was only now upon my return from Tewfikeeyah that I discovered that which should have been made known to me upon my first arrival from Cairo to command the expedition.

When he finally came face-to-face with the governor, Sam was righteously angry and indignant. Finally and reluctantly, Djaffer Pasha explained that trading rights for ivory throughout the entire White Nile, from Khartoum to Gondokoro, were already leased. The system of ivory leases tacitly encouraged the slave trade and directly enriched the government. But as long as those trading *firmans* were in force, Sam's jurisdiction lay only south of Gondokoro. He had actually violated the law by seizing the traders' boats near Gondokoro and freeing their human cargoes, though he was acting well within the spirit of his charge from the khedive.

Sam felt he had been deceived or at the very least seriously misled. He forced the governor to agree that the government in Khartoum would no longer buy ivory, that it could instead be used to pay taxes until April 1872, when Agad's *firman* expired. It was a barely tolerable compromise for both sides. However, it allowed Djaffer Pasha to save face and maintain an air of compliance with the khedive's plans.

When Florence and Sam visited Dr. Gedge, they found he had deteriorated very badly in Khartoum and could not be moved farther north. Though a competent Greek physician attended him, Gedge looked past any hope of recovery. He died in November without ever recovering his senses. One of the few rays of hope during their Khartoum visit was that the British consul general was pressing for an inquiry into the conduct of the *koordi* of Fashoda. Another was that Empress Eugénie had kindly sent Florence a beautiful locket in remembrance of their meeting.

On October 10 Djaffer Pasha made a wonderful occasion of the departure of Florence, Sam, and Higginbotham from Khartoum, as if they were his dearest friends. He arranged for bands, cannon salutes, and a large crowd to see them off. Their boats arrived at Tewfikeeyah on October 22, carrying as much corn and other supplies as possible. The river was now at its highest—by Sam's measurements, up fourteen feet and one inch from its dry-season low. The ships were all repaired and repainted, in preparation for the push farther south, but many were very old and thoroughly rotten.

In early December Higginbotham returned again to Khartoum with the steamer, carrying the post, the disgruntled servants Margaret and Lewis, and little Mistoora, whom Florence feared was not old enough to survive the difficult part of the voyage yet to come. The expedition was ready to move south.

The station at Tewfikeeyah was dismantled and the stores reloaded onto the boats in carefully labeled boxes. Fever had begun; one of the horses died. Florence herself suffered from intermittent fevers before the first vessels started south on December 1. Every few days another group started until, on December 11, the *diahbiah* used by Sam and Florence brought up the rear of the flotilla of fifty-nine vessels. It was impractical for them to stay in close convoy, so no attempt was made, though Sam, Florence, and Julian tried to keep apprised of the situation with each group. The least reliable commander of a part of their little navy was Raouf Bey, commander of the *noggurs*, who seemed to have inordinate trouble with his men and boats. First one of the *noggurs* in his care sank, with a portion of one of the lifeboats on it, and then another, with a section of steamer.

On December 16 Florence recorded her reaction to the news.

It is dreadful to lose another boat, and not knowing if we are going to lose any more, as all the sailors are such horrid brutes! And don't care for anything. There was Sam day after day looking after the boats and asking "if they were all strong for their journey," and their answer was "yes, quite strong and good." But unfortunately all the people hate the expedition, and are only too happy if anything of that sort happens.

It had taken tremendous effort to haul the parts of the steamers and other boats intended to ply Lake Albert across the desert, and now they lay at the bottom of the river. Amazingly, Sam, Julian, and Higginbotham were able to refloat the wreck. Quat Kare, king of the Shillook, was deeply indebted to the expedition and sent hundreds of his men to help. Sam's ingenious plan was to partially fill the barges with water, so that they rode very low in the water within a foot of the wreck. Divers then attached the barges to the wreck with strong chains. As the barges were laboriously bailed out, they rose in the water and so lifted the wrecked *noggur* with them. The heavy metal sections of the steamer and other weighty cargo were removed from the *noggur*, again using iron chains that divers strapped around them, so as to lighten the hull. This work occupied several days including Christmas, and left many men ill with fever and exhaustion, but the results were wonderful. In gratitude for their invaluable assistance, Sam told the king that his people might use fully half of a large quantity of corn he had left in depot at Tewfikeeyah in their care. Soon the other sunken *noggur* was raised too, and a portion of the lifeboat saved.

Pleased as she was by this triumph, Florence saw that the men, even Raouf Bey, had to be forced to comply with each step the expedition took; they never adopted its aims as their own. She wrote:

It was quite glorious to see the boat towed up with her flag flying looking good and strong. . . . I must say that it seems to me very disgraceful and neglectful of Raouf Bey and all the other officers not to have tried to save her! When they had sixteen vessels with them, and 300 or 500 men. I am sure it will be a great disappointment and very bitter for them when they see the *noggur* sail up.

The men lacked Sam's ingenuity and doggedness as well as his whole-hearted commitment to ending the slave trade.

In early January the expedition was again at work cutting and dragging its way through the impenetrable sudd. Though the vessels drew a mere four feet of water, in some places the river was only two feet deep and a channel had to be hacked out of the muddy bottom by hand.

On April 14, 1871, a year and four months after the first boats left Khartoum, they arrived at Gondokoro. On her lovely, monogrammed, mauve writing paper, Florence described some of the journey to her stepdaughter and good friend, Edith:

It would be quite impossible by any description to give you an idea of the obstacles to navigation through which we have toiled with the fleet, but you can imagine the trouble when you hear that we were thirty-two days with 1,500 men in accomplishing a distance of only 2½ miles.

Formerly the voyage from Khartoum to Gondokoro was a weary and tedious journey but nevertheless it was only an affair of from forty to forty-five days. Now the great river has become blocked up by many miles of dense floating vegetation, which compressed by the force of the stream has formed a compact mass which thoroughly obstructs navigation. . . .

The whole force wearied with the hard work of cutting canals through the floating marshes. . . . There was no dry land—neither was there depth, nothing but horrible marsh and mosquitoes. Many of our men died. . . .

Thank God dear Papa with all the responsibility and hard work and anxiety of the expedition never lost his health—this was most fortunate or we should have been entirely ruined. On the day when all appeared hopeless he spent five hours in dragging a small boat over high grass and marsh with about fifteen men and he happily discovered a large lake of deep water the overflow of which formed the difficult channel through which we have been ploughing our way during three months.

The difficulty was "how to *reach* the lake?" The fleet was fast aground and [with] no navigable channel before us we now determined to cut a channel to the lake and then to make a large dam *behind* the fleet, so that not a drop of water should escape and the rise in the level would then float the vessels and enable them to pass up the shallow channel.

This solution to their seemingly impossible circumstance was one of which only a man of action and great vision could have conceived, much less carried out. Sam did nothing less than dam the river Nile temporarily. It was an absurdly ambitious task, and he accomplished it in a few days, using manpower and a framework of pilings stuffed with bundles of grass and mud and sacks of sand. Despite the calm tone of her letter, Florence's admiration and love shone through: Sam was genuinely a most extraordinary man, unstoppable. Had she ventured back up the Nile with any other man, she would probably have been long dead, and she knew it.

Florence ended her letter with some simple domestic requests. Would Edith send them the following, in care of the British Consulate in Cairo?

6 pairs of the best brown gauntlet gloves

6 pair of different color gloves

1 pair of the best rather short French stays with 6 pair of silk long stay laces

2 pair of yellow gloves for Papa, I think they are number 7½ but they must be the best you can get

2 dozen lead pencils . . .

6 pair of best steels for stays. . . . The stays to be 23½ inches. . . .

12 good fine handkerchiefs

6 for dear Papa. We are getting very short of handkerchiefs—in fact we are getting short of everything.

The region around Gondokoro was devastated. All the tidy, hedged villages with well-turned gardens were destroyed; nothing remained but the bones of former inhabitants strewn about carelessly and the great *nogara*, or war drum, abandoned in the ruins of a village near where Sam and Florence had set up their camp years before. The brick house built by the Austrian mission had been pulled down and pounded into pigment for body painting by the ferocious Bari tribe. The whole region was in a state of "wildest anarchy," in Florence's words, because of the wicked depredations of the slavers, especially Abou Saood. Sam drove everyone hard to build the station and get the crops planted, as there would be no hope of communication with anyone upstream until a year hence. Ismailïa—for so they named the new station, after the khedive Ismail Pasha—would have

to be an entirely self-sustaining community of some two thousand souls for many months to come.

One of the local chiefs, Sheik Allorron, was in an ambiguous situation. Some of his men had left for the interior in the employ of Abou Saood; the rest of his people had been driven out of their traditional homeland by other tribes and dared not return. When Sam told him that slavery was to be eradicated and peace would prevail, Allorron was skeptical.

"You had better go back to Khartoum," he advised Sam, "and I will eat the corn you have planted when it becomes ripe."

Sam explained that Ismailïa should become his headquarters and troops would always stay there.

"Then who does this land belong to—to you or to me?" Allorron asked.

"Your people had been driven out and had abandoned this land when I came here," Sam answered, "and you would not dare return were it not for the protection offered by me and my men. The land is not yours, therefore; it belongs to the khedive of Egypt. If you wish to resettle it, I shall see you get back your original land."

Allorron grunted in reply and thought a moment. "Who does this tree belong to?" he asked, gesturing to the one that provided the comfortable shade in which they stood.

"It belongs to the khedive of Egypt," Sam replied proudly, "who is now protector of the whole country, and I am his representative to establish his government."

Allorron sneered at this: "Then you had better be off to Khartoum, for we don't want any government here." There could be no question that the natives resented the attempt to annex and rule their country.

On May 26, 1871, Sam conducted an impressive ceremony in front of all the local chiefs to formally annex Ismailïa to Egypt. The basic framework of a well-planned and sanitary station had been erected, with attention given to both drainage and breezes, as Sam wrote proudly to Wharncliffe. His biggest problem, Sam confided, was that the natives were so mistrustful of all outsiders that they would neither sell nor trade nor give them anything:

The Bari were formerly notorious on the White Nile: they are now worse than before; as they have been for some years past the allies of the slave-

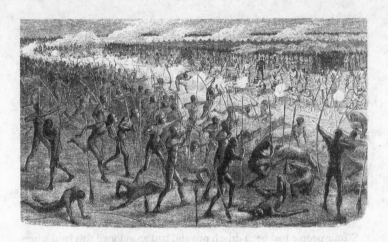

traders, who made Gondokoro the depot for slaves and cattle stolen from the Interior. These Bari are the enemies of all, except the traders, as they are employed by the latter in pillaging their neighbors. Such people would naturally abhor any government of law and order, because they are merely robbers employed by robbers; and they fatten on the spoil. They at once ridiculed the idea of annexation to Egypt; and coolly informed me that "no government would ever be established in their country."

The Bari, encouraged by Abou Saood, were persistently hostile to the expedition. They attacked the station regularly at night and many times tried to steal the expedition's cattle. They burned granaries; they killed sentries or isolated soldiers; and they were, in Sam's words, "irrepressible vermin that gave us no rest." Once the station was in good order, with a ditch and rampart and ten mounted guns to protect it, Sam took the action he had been postponing for weeks: he set out on a mission to subdue the Bari. Leaving Florence and fifty men—twenty of his Forty Thieves and thirty others—at Ismailïa, he moved against the entire Bari tribe. He took 450 men including the remaining twenty-six of his Forty Thieves, one field gun, and one rocket trough for Hales's three-pounder rockets. After less than a month, Sam had cleared an area near Belignan, set up

a temporary camp, and moved Florence and additional men there. The land he had captured was full of ripe fields of *dhurra*, and Sam thought it an excellent opportunity to fill his granaries. After another month, the Bari were thoroughly subdued and peaceable and ready to accept Sam's authority.

Abou Saood had also been trying to influence Raouf Bey, the officer who had abandoned the sunken *noggur*, to sabotage Sam's efforts. Raouf Bey was one of those left at Ismailïa, and when Florence and Sam returned from the brief war against the Bari, they received a troubling report from Julian. Sam later wrote:

On November 3, thirty vessels had left Gondokoro for Khartoum, taking about 1,100 people, including children, women, sailors, soldiers, and invalids.

In spite of my positive orders, that none but the really sick should be sent to Khartoum, Raouf Bey had in my absence sent away great numbers of troops who were in sound health, thus reducing the entire force of the expedition to 502 officers and men, including buglers, drummers, clerks, &c., exclusive of fifty-two sailors.

Thus an expedition that should have comprised 1,645 men was reduced to so insignificant a force, that it appeared impossible to proceed into the interior.

Raouf Bey was reprimanded, but it was too late to retrieve the men who had been sent away. The real fault lay with Abou Saood, in any case. Florence and Sam sat down together in privacy to discuss what was to be done next. "That trader has undermined our work once again, Flooey," Sam lamented. "I should have clapped Abou Saood in irons when I stopped the first of his slave ships."

"Perhaps that would have been wise," Florence replied solemnly, "but we didn't know then how determined he was to stop us. And now we must make our future plans. Your *firman* with the khedive runs only until April 1873. Can we hope to receive massive reinforcements from Khartoum in time to move further south?"

"I wrote the khedive, and Cherif Pasha, on October 8," Sam offered hopefully, "asking them to extend my *firman*. If that is granted . . ."

"The end of the year is approaching, Sam," Florence reminded him. "We may not hear from the khedive until well into 1872. We cannot assume he will agree to extend your *firman* in any case."

Sam's temper began to flare. "I shan't let Abou Saood defeat me, now that we have come so far and done so much. The White Nile is open and will remain navigable if it is not neglected. We have built good, solid stations at Tewfikeeyah and Ismailïa and freed hundreds and hundreds of slaves. We have stopped dozens of ships and filed accusations against the slavers. If we could get through to Bunyoro, and annex and pacify that country, the slave trade must surely falter and die."

Florence could see Sam's fierce determination coming to life. He was such a righteous man, her Sam, and so stalwart. "We went to Bunyoro before," she reminded him gently, "with fewer than two dozen men, you know. We could do it again with a few hundred. Abou Saood may not think we can manage, but he does not know us or he would tremble in fear."

"So we did." In a moment, Sam added brightly, "I think we'd better talk this over with Julian. He's bound to have some good practical ideas. And I shall write to the khedive, to remind him that the sudd on the White Nile must be kept clear, and to Djaffer Pasha asking for reinforcements. Even if they come late, they will be useful."

With Florence and Julian at his side, Sam no longer doubted that he could accomplish the mighty task he had taken on. If the khedive were willing to extend his contract, success would be more easily achieved. But communication with Khartoum, much less Alexandria, was so irregular and time-consuming that he could not afford to wait to hear the khedive's response to his letter sent so many months before. He was determined that Abou Saood's connivance would not paralyze his expedition, any more than the sudd had prevented him from sailing up the Nile. He and Florence had often done the impossible. This was but one more obstacle to be overcome.

With Julian's advice, Sam decided to leave 340 men—in the end, it was only 200—at Ismailïa in the charge of Mr. Higginbotham and Raouf Bey, whom Sam hoped to reform with responsibility. Sam, Florence, and Julian would march south with 212 men and officers, including the rest of the engineers. First they would make a station farther south along the Nile, where the Englishmen could stay with a small garrison. There, they could

construct the steamers and other boats that had been carried in sections over such great distances and with such great effort. These boats would be essential to establishing legitimate trade and an effective postal service along the Nile. Then, with as many irregulars as Sam could persuade to join them, the party would proceed farther south into Bunyoro, annex that country, and set up legitimate trade stations upon Lake Albert.

After months at Ismailïa, the household had inevitably grown in size. The two who had been with the Bakers longest were Karka, the old woman, and Abdullah, the Shillook cook. Six boys freed from slave ships had attached themselves to Flor-

ence and Sam at various points and now formed the "domestic staff" under Florence's management. The most promising of these was a handsome and intelligent Abyssinian boy, Amarn, who was devoted to Florence. He openly wished to return to England with his mistress. The others, of varying abilities, had learned Florence's rules well. Above all, they were honest and clean. Before serving meals, each boy changed into his fez or tarboosh and his uniform: shorts and a long blouse fastened at the waist with a long leather belt that might also serve as a strap or rope. They had dark blue uniforms

Amarn (1874). An endearing Abyssinian boy, Amarn, attached himself to Florence when he was freed from slavery. He returned to England with the Bakers.

with red facings for everyday meals; dress uniforms of pure white with red facings for special occasions; and traveling uniforms of plain brown. After every meal, each carefully folded and put away his uniform. Once the washing up was completed, they were free to play or dance with Florence's corps of six women and girls. The only one of these that gave cause for concern occasionally was Wat-el-Kereem, a rather pretty girl of "strong passions, either for love or war, [who] required peculiar management," in Sam's words.

Packing and readying for the foray south occupied the first few weeks of 1872. On January 22 they finally set sail. When they arrived at the foot of the cataracts a week later, the chief was very glad to see them and receive their many gifts. However, though he had previously promised them two thousand porters, he became suddenly uncooperative. Florence was indignant that the chief would accept their gifts and yet conveniently forget his own promises. "What a wretched brute!" she exclaimed. "How can he behave like this?"

Sam thought it a perfect example of "African diplomacy when work is required. The people say, 'We must receive orders from our sheik.' The sheik says, 'I am willing, but my people will not obey me.' It is this passive resistance that may ruin an expedition."

They were utterly dependent upon porters, and porters had been most firmly refused. They had no transport animals, due to Djaffer Pasha's gross inefficiency in providing vessels to transport the animals from Khartoum. What made the situation worse was that they had twenty-five hundred cattle and eighteen hundred sheep entirely suitable for eating but not for carrying loads. Sam had three impenetrable *zareebas* built to house the animals and protect them from theft. That very night, as he, Florence, and Julian sat on the *diahbiah* relaxing after dinner, an attack was made upon the cattle by a small number of natives, but the thorn-breaks and the well-armed sentries foiled the scheme.

Without porters, they could never transport the steamers to Lake Albert. Florence and Sam had both dreamed of starting a steamer service on their lake. Florence thought it "sad and heartbreaking, after all Sam's beautiful arrangements and trouble that we shall not be able to take a steamer on—of course nothing would be more delightful if we only had some transport animals, but we were obliged to start from Khartoum without a single camel."

There was nothing to do but send the English engineers back to Gondokoro with the steamer. They protested the order, offering to carry their own luggage if only Sam would let them stay, but he thought the strain of such a journey would be too much for their constitutions and insisted they return. The rest of the expedition was bound for Loboré, a town some sixty miles from their present location. To lessen the carried loads,

Sam decided to have carts built so that the available men could push and drag the luggage and supplies. This provoked a small mutiny.

"Are we camels, that we should drag carts behind us?" a self-appointed spokesman for the soldiers protested. "We are soldiers, military men, not beasts of burden. We will not do it!" His outrage was loudly seconded by most of the men.

Before Sam could answer the would-be rebel, one of the Forty Thieves came to the fore. "You may not be able to do your duty," he answered the man insultingly, "but we are ready to follow our pasha and do his bidding, whatever it may be. If he wants us to drag carts like camels and donkeys, then we shall do so."

The other men were chastened, feeling they looked like cowards or weaklings. Encouraged by Florence, Sam made another one of his stirring speeches.

> I recalled to their recollection how I had always led them successfully through every difficulty, and I assured them that the distance to Loboré was trifling, and that we should find good and willing natives to convey the baggage, if we could only once reach the desired tribe.
>
> Cries of "there are no good Negroes—they are all bad," interrupted my discourse. I nevertheless continued . . .
>
> "You *shall* do all that I command. I have changed my plans, and I order you to take the carts to pieces at sunrise tomorrow morning. All those who are afraid to follow me shall return with the vessels and carts to Gondokoro. I never turn back; and my lady and I shall go on alone with Mr. [Julian] Baker. I only require orderly soldiers, who know their duty; if you have forgotten your duty, you shall return at once to Gondokoro.

Hearing those words, the men were all too eager to stay with Sam and defend their honor. After consulting with Florence and Julian, Sam decided to march south with only one hundred of the best men. If porters could be had at Loboré, they could be sent back to get stores and baggage left behind. Yet another triage was conducted to determine which baggage should be abandoned.

On February 8 the boats left for Gondokoro. Florence wrote in her diary:

> My work has been for the last two months packing and unpacking; first
> I packed the boxes to be carried by natives who refused to have anything
> to do with us; then I had to pack the boxes again to be drawn by carts,
> and now I had to pack the boxes rather light as they have to be carried by
> sailors. . . .
>
> We started at 3 p.m. with 100 men and 1,000 cows, 200 calves, and 500
> sheep. . . .
>
> I was very sorry to leave my *diahbiah*, where we have been very com-
> fortable for two years and one month and six days.

She had not forgotten what marching through central Africa was like.

The tribes through whose territory they marched had not forgotten
Sam and Florence either. Word soon spread that Mallegé, the Bearded
One, and Myadue, the Morning Star, had returned. On February 18 they
reached Loboré and were able to obtain some porters; on March 1 they
reached the junction of the Asua River. Soon after that, they came upon
country where the slave traders had been. "It is really horrible," Florence
wrote in her journal, "but wherever we follow these traders, there is noth-
ing but desolation—the entire country from Loboré is destroyed, all the
villages having been burnt by the traders." The district was completely
depopulated, even the old place near Fatiko where Sam and Florence had
spent months in their pretty little camp on their first journey.

On March 6 they marched into Fatiko, all their men in full dress uni-
forms of scarlet jackets and snow-white trousers, with their flags flying
and Sam, Florence, and Julian at the head of the column. They led 212 sol-
diers, 400 porters, and a herd of 1,078 cattle and 194 sheep guarded by three
boatmen and the Bari interpreter. As they broke onto the great tableland
where Fatiko was located, they found that Abou Saood had erected a large
station of about thirty acres placed at the base of Fatiko Hill. The drums
and bugles sounded the advance as the stragglers came up from behind.
Waiting for everyone to assemble, Sam carefully watched the confusion
in the slaver's camp through his powerful telescope. As soon as the oc-
cupants became aware of the presence of a large armed party on the pla-

teau, long lines of slaves were assembled and quickly driven to the south, where they might be hidden. There was also a great deal of rushing to and fro by men carrying spears and shields.

Finally Abou Saood sent a messenger to greet them and inquire who they were. On hearing it was Baker Pasha and his expedition, the messenger ran hurriedly back to the station to report. Then another messenger, a man in rags, approached Florence and Sam as they sat on horseback. He came forward timidly, and then knelt down and kissed Florence's hand before he looked up tearfully. They recognized their old dragoman, Mahomet, once a guide on boats on the Upper Nile and now much changed. On their previous trip, Mahomet had been a somewhat useless translator but a source of much amusement before he ran away, after being chastised for carelessness by Sam. Now he had sunk very low and was grateful for a little kindness and food. Slowly other natives who had worked for them also came forward. Some were now employed as slave hunters by Abou Saood, they confessed, but they were willing to serve the new government now that Sam was back. They imparted the valuable news that Kamrasi, the king of the Banyoro, had died two years previously and been replaced by his son, Kabba Réga.

When Florence and Sam reached Abou Saood's station, the trader himself came to greet them. They were convinced that Abou Saood had plotted against them at every opportunity and suspected him of false friendliness. Obsequiously, the trader invited Florence and Sam to accept the hospitality of his settlement and use some huts he was having readied for them. Thinking that they would sooner sleep in a den with poisonous snakes, they refused and made a camp in a cool and shady spot about a quarter of a mile away. Their camp was situated on high ground that gave them a good view of the surrounding countryside. As a warning, Sam put the men through some military drills and sham attacks, ending with a vigorous performance of the band. The music was an irresistible temptation to the local Shooli women, who danced completely naked—even the rather aged and wrinkled women—with delighted abandon.

Abou Saood had only twenty days left on his trading *firman*, as Sam was pleased to inform the Shooli and other local tribes. The country was by then half ruined due to slave raiding and warfare, but the people had had no inkling that the slaver's reign was about to end. Now they

wondered if the pasha's words would come true, and Sam's reputation as a formidably strong and honest man lent them considerable credibility. Rot Jarma, the chief of the Shooli people, sent word that he would visit Florence and Sam and offer his allegiance to the new government. To Sam's face, Abou Saood swore undying loyalty and fidelity to him and the khedive, yet only weeks before the slaver had tried to incite the Bari, the Shooli, and other tribes to massacre Sam's expedition. Abou Saood even asserted that he would leave the country once his contract ceased. It was difficult for anyone to trust him.

Sam determined to keep a presence at Fatiko and eventually set up a fort to offer protection to the tribes. Though he judged there were perhaps one thousand slaves held nearby, he decided not to interfere with Abou Saood's operation, since caring for and returning so many captives to their homes would be an enormous undertaking that would delay the expedition for months. In a decision Sam would come to regret, he left Major Abdullah and a detachment of one hundred men at Fatiko, to set up a small garrison and look after the heavy baggage and much of the ammunition.

The expedition started for Bunyoro on March 18. They had managed to hire almost two hundred porters and left behind some boxes—"No. 46 with all sorts of provisions. No 48 with Rice. No. 34 with Coffee. No 10 with Sugar, a brown box," Florence noted meticulously—to await their return. Traveling was hard, as ever. Game was scarce, the water was muddy and foul-tasting, and the areas formerly thickly settled with neat villages and well-tended gardens were now abandoned and the fields lay fallow. Sam and Julian shot for the pot when they could as the expedition marched along. Florence's horse fell with her while crossing a "nasty muddy river," but proceeding on foot was even more trying. At some spots the water was so thick with sediment that even the horses refused to drink it.

On March 23 they reached the place where the Nile could be crossed just above Karuma Falls, opposite the ivory station of Abou Saood's *vakeel*, Suleiman. As elsewhere, none of Abou Saood's employees at this station had heard anything about the pending expiration of his *firman*, which was now only fifteen days away. Sam explained the new policies that were to be put into effect, to the amazement of the trader's people. Eventually sixty-five of them decided to enlist as irregulars with Sam; they would

form the nucleus of a small garrison at Foweera. An additional seventeen recruits were sent to Major Abdullah at Fatiko.

As they neared Bunyoro, one of the sheiks Sam and Florence had met on their first journey came to see them. He repeated the news that Kamrasi was dead and added that his sons had fought each other for power. The new king, Kabba Réga, had only recently succeeded in murdering his brothers, the rival claimants to the throne, with the connivance of Abou Saood. Though this story shocked Sam and Florence, murdering rivals to the throne was the traditional manner of settling succession among the Banyoro. Sam and Florence felt certain that great difficulties lay ahead.

Sam sent a few gifts to Kabba Réga, telling the messenger

... to advise Kabba Réga to behave in a different manner to the conduct of his father, the late Kamrasi. I had returned to this country to bestow prosperity upon the land; that if Kabba Réga meant fair dealing and legitimate trade, he must act honorably and sincerely; that if I should find any signs of unfairness, I should pass on direct to Buganda, the country of M'tesa, and he would receive the goods I had intended for Bunyoro.

Sam was not optimistic that these words would have any effect, but he was not willing to give up without a good try. In the meantime, he noted,

Negroes are great deceivers, especially the natives of Bunyoro. I have beads, cattle, merchandise, and every article necessary to purchase flour and potatoes; nevertheless, our wants are not supplied. The cattle are dying, as the change of herbage does not agree with them; this is a sad loss.

They were entering the country of their imprisonment, nearly fatal illness, and starvation at the hands of Kamrasi. Florence began to suffer from ugly nightmares of helplessness and cruelty. Even the presence of Sam, so calm and steady, and Julian, who was very dear to her, could not hold these demons at bay. Florence could not forget that she and Sam had nearly died in this place because of savage malice. They would soon be in the hands of Kamrasi's own son, and she could not quash her terror that it would all happen again. She made heroic efforts to control her feelings, but her fear seeped out in the privacy of her diary:

I am sorry to say that this country reminds me of great misery. When I see all the old faces then I cannot help thinking how we both suffered from illness and hunger. The smell of the people makes me perfectly miserable, because I remember how I was carried by them, when dreadfully ill, and thrown down often into the high grass and mud! But formerly all these people were dressed in beautiful clean bark cloth; but now they are all dirty and uncared for.

Within days the rains began, fever set in, and the cattle died in greater numbers. Kabba Réga followed his father's procedures and kept Florence and Sam and their men waiting, with little food, while he delayed receiving them. Their soldiers would not eat the meat of the diseased cattle, and the natives offered only potatoes—which the soldiers did not like—in exchange. One night Sam awoke to hear the sentry outside his tent muttering miserably during a downpour: "What a horrible, horrible country this is! Nothing but rain and roots! Roots and rain."

Nearly every day, Kabba Réga sent someone, often his commander-in-chief, Rahonka, to ask Sam to fight with him to kill his father's old enemy, Rionga. He occasionally sent food, but not much, and the porters he promised never appeared. It was all dreadfully familiar. The rain turned everything into a sodden mess, and Sam, Florence, and Julian succumbed to intermittent fever and illness. The men were miserable too, disliking the rain, the locals, and the food, for the potatoes gave them severe flatulence.

On April 11 they marched twenty miles to Kisoona, which Florence judged

a miserable dirty village without supplies for the troops. At 4.30 pm we have not yet had our breakfast. . . . We had a heavy shower just before we reached this, many of the things came in soaking. . . . The water is very bad here, it is quite impossible to drink and smells horribly, luckily one of the small sheikhs brought us a small pot of old sour plantain wine which was rather better than dirty water.

Of course, there was enough food neither for Sam's men nor to feed the two hundred porters, all of whom ran away in the night. Sam suspected that the travel was nothing but a decoy to lure him out of Karuma Falls

so that a shipment of Abou Saood's slaves might proceed north. Sam dispatched an angry message to Kabba Réga, saying that he and the expedition were leaving and would not acknowledge a wretched and ill-mannered boy such as he was.

This message provoked more false promises from Kabba Réga and from Suleiman, Abou Saood's *vakeel,* but no constructive action. After another ten days of intermittent travel, hunger, fever, and ceaseless rain, Florence wrote miserably in her journal:

> It all shews that Kabba Réga has no control whatsoever over his people. We are only about 12 miles from him, and the natives threw us down here without any food.
>
> Sam sent the soldiers out to look for potatoes, but there was none near here. The natives of this village took them all away, and cut all the plantains down when they heard that we were on the route.
>
> About 10:30 a.m. 60 men came to take us on, although they knew that we require 250 men. Sam thought to make sure of these men, thus he sent Abd-el-Kadr off with the sixty loads, and thirty soldiers in charge, with a message to Kabba Réga that if he wishes to see him he must send directly 200 more men or if not he should return to the river, and go to Rionga.
>
> At 11:20 a.m. a few more men came, with about one and a half loads of potatoes for 150 soldiers—and another fowl.

Day after day, promises were broken, horses and cattle died, porters ran away, the men went hungry and fell ill, and through it all, the cold rain continued. Fueled mostly by stubborn determination, the expedition crept ever closer to Masindi, Kabba Réga's capital.

On April 25, at long last, they arrived at Masindi, which Florence described as "a miserable dirty place overgrown with high grass, where one can hardly see [Kabba Réga's] huts." The expedition had traveled 322 miles since leaving Ismailïa. Days had passed since they had seen any cultivated fields or plantain groves. Florence's and Julian's horses had died on the way, and Sam's mount was so skinny they called it Rosinante, after the broken-down nag ridden by Don Quixote. The poor creature had a sore back and could not be ridden. Hundreds of cattle and tens of donkeys had died as well.

Kabba Réga had allocated a shabby hut at the trader's station for them, but Sam and Florence wisely refused to stop there. The expedition marched until Sam found a lovely banyan tree located only three hundred yards from Kabba Réga's own hut, which was a large beehive-shaped construction. Camping so close to the king's quarters would, he hoped, facilitate communication and make it impossible for Kabba Réga to claim they were too far away for him to send food or messengers. The main problem was that the whole area was overgrown with tall grass, about eight feet high, which blocked any breezes and, worse yet, offered abundant concealment for wild animals, snakes, scorpions, or would-be attackers. Sam's first order was to have the men cut down the grass and clear a large area where the tents would be pitched until proper huts could be built. He made sure they had a good, clear view in all directions, including a direct line of sight to Kabba Réga's compound.

In welcome, the king sent twenty-nine loads of *tullaboon,* a quantity of plantains, the hated potatoes, six thin sheep, and some fowls. It was a poor offering for such a large expedition that had been marching so long and hard. Florence complained that the king sent nothing to drink and that the water was very bad in Masindi. Florence and Sam both feared they would be effectively imprisoned by a lack of porters and deliberately starved by Kabba Réga, as they had been by his avaricious father, Kamrasi.

They had not forgotten that Kamrasi had very nearly killed them and that Florence had been threatened by his venality and lust as well. But Sam had a vision of establishing a service of mail delivery and trade by boat on Lake Albert connecting that region to the entire White Nile, and he could not or would not give it up. As the only way to the lake was through Bunyoro, through Bunyoro they would go. It was a brave, or perhaps irrevocably pigheaded, attempt. They had little reason to suppose that Kabba Réga would behave differently from his father, especially given that Abou Saood had convinced the young king that Sam was a monster who would eat his country.

NOT A GENTLEMAN
IN THE WHOLE OF AFRICA

The next morning Sam paid a brief official visit to Kabba Réga. He explained that his mission was to end the slave trade and bring peace and prosperity to the country, under the rule of the khedive. As a gesture of goodwill, he publicly returned to Kabba Réga's country a number of former slaves who had been seized by Abou Saood, and promised he would insist on the return of every slave. The most delicate subject of all, which Sam left for later discussion, was annexation. All the benefits of peace and protection could be guaranteed only to those who accepted the power and government of the khedive.

On the next day Sam had the men finish clearing a broad avenue between his tent and Kabba Réga's divan so that the king might return the visit, as etiquette demanded. The tent was as beautifully decorated as Florence could manage: *angareps* covered with carpets and cloths were nicely arranged to serve as sofas, the dirt floor was spread with more carpets and skins. For light and air, the sides of the tent were tied up so that it was little more than a tarpaulin providing comfortable shade. All of the men, wearing full dress uniform, were

aligned along the avenue. The band started playing, and Sam and Florence awaited the royal visit. Two hours passed and the king did not appear. Finally Kabba Réga sent a message that he preferred Sam to call on *him*.

"The unmannerly cub!" Sam sputtered to Florence. "He is actually afraid of foul play—here, in his own capital."

"He is a rank coward," Florence agreed. "He should know of our reputation. How can he think this is a trap?" Then she thought for a moment, and added, "Unless, of course, he feels guilty for his lies and expects the same sort of behavior from us."

"You are very wise, my dear." Sam nodded. "He is duplicitous himself and so cannot believe in our honesty." He called for the messenger and told him to tell the king that he would at once dismiss his troops, who had been waiting for *two hours*—here he looked sternly at the messenger—and would receive the king when he was old enough to know good manners.

When the bugler blew the signal for the troops to stand down, the messenger panicked and begged Sam to wait for the king a few minutes longer. He fled down the avenue to the king's divan, frightened by what this powerful and insulted visitor might do. Florence later wrote:

In about ten minutes we heard such a noise of flutes and trumpets and drums—and all sorts of other instruments—we knew directly that the young cub was coming—in a few seconds he arrived at the tent with about 3,000 men, all armed. They made the most tremendous noise! Sam and Julian went out to meet Kabba Réga—when he came into the tent he was trembling all over, and could not say a word, but just took his seat on an *angarep* which was prepared for him—a number of his own chiefs also came into the tent. We offered Kabba Réga some coffee, which he would not drink, and a shibbook, which he would not smoke. . . . He had not much to say for himself, except the old conversation about Rionga, that he must be captured or killed! If not the country by the river will never be at rest. Sam gave him a large brown box full of beautiful presents, which seemed to delight him extremely. He is a very clean-looking young man of about 18 or 19 years old, he keeps the nails of his feet and hands beautifully clean and wears a very nice bark cloth of a light brown color, and a necklace of very pretty small different colored beads. His skin is dark brown, his eyes are large, but they always have a frightened look.

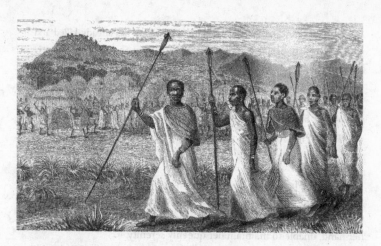

Having been forced into mannerly behavior, Kabba Réga was still very agitated and nervous. After giving formal greetings, he mentioned that he recognized Sam

Kabba Réga and His Great Chiefs Returning a Visit (1874). The young king of Bunyoro, Kabba Réga, had heard such frightening tales that he was afraid to visit Florence and Sam alone and came with an entourage.

and Florence because he had seen them set out from M'rooli for the Albert N'yanza when he was a boy. Sam thought him a "gauche, awkward, undignified lout . . . who thought himself a great monarch." As he came to know the youth better, Sam catalogued additional traits: "He was cowardly, cruel, cunning, and treacherous to the last degree."

Though Sam and Florence had long suspected that Abou Saood had worked diligently to influence Kabba Réga against him, they were most amused to hear the full story. When the conversation turned to Abou Saood, Kabba Réga admitted that the slaver had told him that the man they called "the traveler"—Sam—had died. Abou Saood swore that the man known as "the Pasha" who was now in central Africa was a very different person from the bearded man with the yellow-haired wife. The king repeated Abou Saood's description:

The Pasha is not like the traveler, or any other man. He is a monster with three separate heads, in each of which are six eyes—three upon each side. Thus with eighteen eyes he can see everything and every country at once. He has three enormous mouths, which are furnished with teeth like those

of a crocodile, and he devours human flesh. He has already killed and eaten the Bari people and destroyed their country. Should he arrive here, he will pull you from the throne and seize your kingdom. You must fight him, and by no means allow him to cross the river at Foweera. My soldiers will fight him on the road from Gondokoro, as well as all the natives of the country: but I don't think he will be able to leave Gondokoro, as he has a large amount of baggage, *and I have told the Baris not to transport it:*—thus he will have no carriers.

A plainer description of Abou Saood's plotting could not be offered. Sam's booming laugh startled Kabba Réga, who had expected many things but not such a resonant response. Even Florence giggled behind her hand, unable to maintain her queenly serenity.

"Did you hear that, Flooey?" Sam asked incredulously, still chuckling. "Eighteen eyes and three heads?"

"Yes," she replied gaily. "And I hope once you finished eating those nasty Bari you wiped your mouth properly."

"Perhaps if they had sent us more food, like any proper king would, I should not have eaten them," Sam joked, after warning the translator not to repeat these jesting remarks lest they be misunderstood.

In a moment they were able to return to more serious matters. When Sam asked Kabba Réga if he believed these stories, the king replied, a little hesitantly, that Abou Saood was a liar. Then the king added that Sam could prove he was a true friend by killing Rionga.

The request was so tediously predictable—so exactly a repetition of almost any conversation with Kamrasi—that the Bakers had trouble reacting graciously. As usual, Sam refused to lend his men to such an endeavor and explained once again his purpose: to eradicate the slave trade and open the region for commercial trade. He tried to educate Kabba Réga to the advantages of reciprocal trading. No matter how persuasively Sam spoke of trading, Kabba Réga's position was always that Rionga must be killed before any further arrangements could be made.

Negotiations continued over the next few weeks. In the meantime, one of the first priorities was for the men to build Sam and Florence a large thatched hut as a divan for receiving visitors. They also worked erecting clean and rainproof huts for themselves, planting gardens, and establish-

ing an orderly station. At Florence's direction, the inside of the hut was lined "with my scarlet blankets, and two large looking glasses, and 21 colored prints—and I have also a large and beautiful print of the Princess of Wales at the end of the room, which is the admiration of everybody." The *angareps* upon which she and Sam slept were covered during the day with carpets, to serve as sofas, and tables were improvised out of stacked boxes covered with blue cloths. The most colorful and gaudy trinkets, including a large music box, were arranged enticingly where visitors might notice them. Once he had seen its action demonstrated, Kabba Réga was eager to be given the musical box. Daily, his desire grew to obtain all the wonderful and exotic goods they had: mirrors, sewing kits, beads of many colors, watches, razors, cloths, and other merchandise. Wisely Florence and Sam did not display or offer everything at once.

Despite Kabba Réga's visits and protestations of friendship, Florence detected an air of menace in Masindi. They had approached the country with misgivings, based on their previous experiences, and the young king did nothing to build their confidence in his good intentions. Florence wrote in her journal, "I hate this place, it is quite impossible to sleep at night, on account of the horrible noises these people make! They never seem to go to sleep at night, they only yell and blow their horns and beat their *nogaras*." Florence knew that the *nogaras* were war drums, inciting the natives to fight. Tensions were building until an attack seemed inevitable. It was odious, when all she and Sam intended to do was bring peace and end the slave trade. Why were these people so dreadful to those who tried to help them?

As the weeks passed, Florence noticed that there were fewer and fewer women and children in Masindi, a sure sign of impending trouble. Kabba Réga continued to demand gifts and assistance in fighting Rionga, and the general hostility between the Banyoro and the expedition mounted. Soon Sam had the distinct impression that Kabba Réga was having their every move watched. The more the men cleared the high grass and prepared the ground for cultivation, the more agitated Kabba Réga became, as if the grass were an asset instead of a detriment. None of his own people showed the least interest in planting or raising crops at all.

On May 31 Julian took the soldiers to a central square in the town, at the back of Kabba Réga's divan, to stage a display of their marching drills.

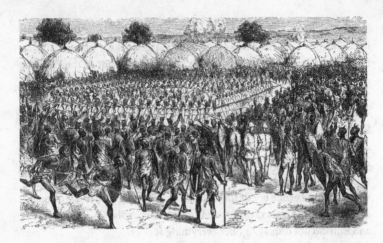

Sudden Hostile Demonstration—The Troops Form a Square (1874). Kabba Réga mistook a marching drill for an attack and flooded the town with warriors. Sam ordered his soldiers into a defensive square and pretended it was a dance.

None of the officers were carrying a gun, but Kabba Réga interpreted the drill as an outbreak of hostility. Julian sent for Sam and the remaining troops. Within minutes, Kabba Réga had flooded the area with five to six thousand warriors, all carrying shields and unsheathed spears. Left alone in camp, Florence swiftly moved into action:

> I immediately sent for the cattle, because I was sure that there would be a fight, and if the natives knew that there were very few men in the camp they would come and attack it. Thus I ran down to the troops' camp and called every man out, sick or not, even down to the stable boys, and gave them each a gun, and posted them in different places round the whole camp—I also had a few rockets tied and gave orders to some of the men who stood in front of the divan, thus if we should hear a shot they should set fire to the town.
>
> Everybody was excited and anxious to have a fight. We saw the natives pass in thousands close to our road, and the noise of the *nogaras* and horn together with the flutes, increased every second. Some of the natives came running down the road for ten yards with their spears in the air; but they had not quite the courage to come closer.
>
> When Sam reached the clear place, with his troops, he saw that the

whole town had collected for a fight—but when the natives saw the sol-
diers drilling they surrounded them all.

Sam ordered the men to form the famous, nearly impregnable British
Square. His soldiers stood shoulder-to-shoulder, facing outward with
bayonets fixed and lowered, in the shape of the outline of a square. Be-
hind each row stood another row of men, ready to step into any gap that
appeared in the line; and behind them, yet another row. Sam's eighty men
and handful of officers were completely surrounded by thousands of an-
gry, wild-eyed natives.

Suddenly Sam had the brilliant idea of pretending it was all a joke.
He called to one of the interpreters jovially, "Well done, Kadji-Barri! This
is famously managed; let us have a general dance. Ask [the chiefs] if my
band shall play, or will you dance to your own music?"

This question confused the Banyoro. Why was Sam not frightened of
their war dance, given in response to his own? While the natives hesitated,
Sam ordered his own band to play a lively air and offered to show how his
men danced. He begged the lesser chiefs who were present to explain to
the crowd that this was intended for amusement only, but that his men
needed some additional room in which to dance. As soon as the explana-
tion had been given, he ordered the men to advance double-time. The
rapid outward advance of bayonet-bearing soldiers quickly persuaded the
natives to move well back. Sam then asked to see Kabba Réga, who was
dragged out of a hut so "disgustingly drunk" that Florence noticed he
"could not say a word." The other chiefs, embarrassed, took him back to
his divan, and the bewildered crowd slowly dispersed.

Sam marched the men back to his encampment as if all had gone as
planned. He was proud to find that in his absence Florence had coolly as-
sumed the role of commander-in-chief, fortifying their camp and prepar-
ing their defenses as well as any man could have; she had indeed the heart
of a lion. A few hours later they received a peace offering and apology
from Kabba Réga in the form of twenty loads of corn for the troops. The
next morning this gift was followed with more corn, pots of native beer,
or *merissa*, and a so-called milk cow who gave no milk. This last was an
especially ironic touch, as Sam and Florence frequently begged for milk.
Kabba Réga always refused, using as an excuse that he had many wives

and that they must be fattened on milk to be beautiful. There was no milk to spare, he claimed.

Despite these outward indications of friendly intentions, Sam and Florence were now firmly convinced of Kabba Réga's hostility. It was no accident that his men had turned up on such short notice armed for fighting; they had obviously been planning an attack. Sam set about designing a proper fort in Masindi, which would feature a circular ditch, seven feet deep by ten feet wide, outside an earthen parapet which would be surmounted by a stout stockade fence. The inner circular court was to be thirty-six feet in diameter and would include three fireproof rooms made of earth-covered logs. These rooms would be used to store supplies and ammunition. Once the entire personnel of the expedition retreated into the fort, it would be very difficult to overrun them.

In the midst of the growing unease, Sam and Florence received two friendly envoys from M'tesa. They had sent a message to M'tesa previously, inquiring about the health and whereabouts of the missionary Dr. Livingstone, who had not been heard from in some time. Sadly, the messengers brought no reliable news of him. The envoys were most impressed by Florence's pretty little house and especially the large colored print of the Princess of Wales. The envoys carried home some gifts for M'tesa and a letter to be given to Livingstone if M'tesa should have word of him. They also took the news of the untimely death of John Speke, who was well known to M'tesa's people. "Wah! Wah! Speekēē! Wah! Wah! Speekēē!" they mourned as they walked.

The building of the fort at Masindi commenced immediately, on June 2, and was substantially completed by June 5. The entire expedition was on edge, nervously awaiting the next outbreak of fighting. They were seriously short of food. As the sense of malice and ill will intensified, Florence began to despair about the people among whom they found themselves.

> There is not a gentleman in the whole of Africa, I believe, unfortunate[ly] nobody knows what honor or good manners really are. They only think of lying and deceiving. . . . The longer I am in this horrible country the more I abhor it, as the people are bad.

Each day, Kabba Réga sent less and less food and then only after repeated

requests. On June 7 he sent only seven jars of plantain cider and a paltry quantity of flour. Sam at first refused these, saying he needed substantial food for the men, but in the end he accepted them because of a promise of corn the next day. The supplies were distributed to the men, and not long afterward Abd-el-Kadr came running to tell Sam that the men had been poisoned by the cider. Sam, Julian, and Florence moved swiftly to dose the men with tartar emetic, mustard, and salt, which had a "wonderful effect"—immediate vomiting—to rid the men's stomachs of the poison. All the sick men were carried into the fort for nursing, and the sentries were doubled. That night was eerily silent. Florence later described events to her stepdaughter Agnes:

I was rather afraid that there was some treachery hidden, so I went to my pretty house, and packed all my little things up. The night was wonderfully quiet, and at about ten o'clock in the evening we heard the lowing of the cattle, and the cry of fowls.

I could not sleep all night, so we were up very early: Papa went to see all the sick in the fort, and then walked up and down a beautiful road that we had made, which was about 100 yards in length, and at the end of it were a great number of castor oil plants which concealed the view.

I [had] just walked up to Papa, when we heard all of a sudden a savage yell of thousands of people quickly followed by two shots. We knew directly that the two messengers who were sent in the morning to fetch one of the chiefs, were killed.

Papa in an instant had the bugle sounded, but before the troops were able to collect, a fire was opened upon Papa from the castor oil plants. A corporal was killed by his side, and a soldier wounded close behind him.

We were immediately attacked on all sides by thousands of men, many of whom had guns, and the bullets flew about in every direction. A poor man fell mortally wounded from the fort.

Papa soon drove them out, and he and Julian, also Col. Abd-el-Kadr together with the Forty cleared the town. In an hour and a half, not a native was to be seen, and the whole town was on fire, (thousands of grass huts). The battle of Masindi was won. . . .

Our troops killed a great many natives, and we lost four men. Thus ended the 8 of June, dear Papa's birthday.

The battle was won, but what were we to do? We had neither guide nor dragoman, and only provisions for six days.

The town of Masindi lay in ashes, and Sam's small army had been saved from massacre, but it was a limited success. When Sam went back to the camp, he found Florence near hysteria. The violence, the smell of smoke, the flames shooting seventy feet into the air, the shots and yells and heat and confusion had provoked a visceral reaction of terror in her. Underlying it all was the same deep sense of treachery and betrayal, of evil and violence that had scarred her as a young girl, during the night of killing and burning in Transylvania.

"We must go, Sam," she pleaded tearfully. "We must run. This is not over. We can never trust these people, though we have tried only to help them."

"We shall go as soon as possible," Sam replied grimly. "The disgusting ingratitude of the Negro surpasses all imagination. What is to become of these countries? All our goodwill brings forth evil deeds." He had learned not to expect gratitude for his attempts to suppress the slave trade; he knew it was too deeply ingrained in the local cultures to be swept aside without pain. But that Florence had been so shaken, so wounded in her spirit, made him very, very angry.

Kabba Réga sent messengers the next day with two cows as a present, saying that the attack was made by his people, and that he knew nothing about it—but that he hoped the pasha would not think more about it, as his chiefs were collecting corn and cattle, which they would bring the next day. Kabba Réga might imply that the attack had been a horrible mistake, but Florence and Sam did not believe him in the least. Everyone in the expedition moved into the fort. With deaths and the absence of some men who had been sent back with the post in May, the number of soldiers was reduced to 101. The vultures collected around Masindi in great numbers, squabbling loudly over the dead bodies concealed in the tall grass.

On the morning of June 13 Florence returned to her pretty house to have a bath, thinking she might enjoy a few minutes of peace. She was naked and more vulnerable than ever when the natives attacked again. She grabbed her pistol and threw on enough clothes for decency before rushing into the fort to join the others. Again, the attack was repulsed,

but clearly Kabba Réga intended to kill them. They would have to flee for their lives.

Florence packed up all their inessential goods and possessions and placed them in huts, which they would set on fire as they left. Nothing would be left for Kabba Réga and his people to gloat over. Cloth, beads, ammunition, medicines, and other precious items were divided into loads, one to be carried by each person, even the women and children. There was very little food to sustain them on their flight, and they feared there would be no time to search for it. At this moment of despair, Florence shared some welcome news with the others: she had been hoarding flour for weeks. Somehow she had managed to save six large iron boxes' worth for just such an emergency. The men broke into spontaneous cheers for Florence, since at least they would have unleavened bread to eat for a while. After that, they would have to live on plantains or whatever they could shoot or scavenge as they fled to Rionga's country.

They left the next morning at first light, the few remaining horses and donkeys loaded heavily with supplies and ammunition. They hoped to leave Masindi before Kabba Réga's warriors were ready. Their strategy did not work. For the first four hours of their desperate flight, they fought every step of the way. The natives were concealed in the tall grass along the way and launched their spears at will. Only once they had revealed their position could the expedition shoot back. After four hours, the expedition began to pass through areas in which there were no attackers. The brief spells of respite did not refresh them much, for the terrain was difficult and marshy. The tall grasses were full of snakes and insects; grasses blocked all breezes, and their sharp leaves cut and abraded the skin. Most exhausting of all was the constant fear of ambush. Florence had not slept soundly in many nights, and she, like all the others, was now constantly vigilant, listening for a sound, a movement, a whisper that might betray the presence of the enemy. When the attacks came, there was no time to think of anything but running, shooting, and helping the wounded.

By the end of the first day, Florence's feet were blistered and sore, and her mind was weary. *I have done this all before*, she thought miserably. *How often shall I be chased out of my home by violence and evildoers? Is there no peace and safety anywhere, not even with Sam?*

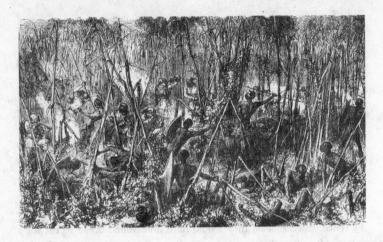

Attack on the Rear Guard by Ambuscade—Death of a Brave Soldier (1874). After many hostilities Florence, Sam, and their men fled Masindi at dawn, but Kabba Réga's men already lay in ambush. The expedition put up a desperate fight to escape.

After the flight from Masindi was over, Florence described the life-and-death journey in a letter to her stepdaughter Agnes. Between the deliberately calm words and optimistic tone, the fear and horror of what she had endured seeped through. It was a nightmare, a time of kill or be killed. She wrote:

It was very easy to pack up [after the battle of Masindi], but who was to carry the luggage? We had not one carrier.

It was necessary that we should not prolong our stay; affairs looked very dark, as no one knew the road.

We packed up a few changes of [clothes] and some provisions as our poor soldiers were obliged to carry the baggage, we did not take much of anything—as we knew that there would be a good deal of fighting on the march, until we should reach Rionga's country 78 miles distant.

We started on the 14th of June, at 10:00 a.m. after we had set fire to the station and effects—I must say that my heart was very heavy to see all my beautiful things burn.

It began to pour with rain, and we had to march through grass from ten to fourteen feet high on either side of the road, and low forest with

entangled creepers, and as it was in the middle of the rainy season, we had nothing but marshes to walk through. . . .

Papa had made capital arrangements for marching. Abd-el-Kadr, the colonel, marched in advance with a guard of fifteen Snider rifles and a bugler—then Papa followed with Julian and two more Sniders and a bugler. I walked close to Papa with some ammunition for a large rifle. Whenever Papa fired into the grass, we heard the natives groan. I also carried two bottles of brandy and two drinking cups, and two umbrellas and my pistol in my belt and a heap of other little things.

The boxes and ammunition were in the middle, and in the rear there was Mahomet Effendi, the Captain, with fifteen more Snider rifles and a bugler—thus we were able to communicate with the bugles.

We were hardly half a mile from the station, when we heard the rockets blow up, and the natives yelling after us.

My darling child, it is quite impossible to tell you about our weary march—I can only tell you that the entire population lay in ambuscades, and we had to fight for seven days through that dreadful country, where it was quite impossible to see the enemy—only showers of spears passed our faces.

This [first] day's march was most fearful the grass full of ambuscades. We could not get the cattle along, they strayed away as they were hungry. . . .

In the afternoon the natives speared Howarti, one of our best men: poor man he carried a box on his head, nevertheless he killed the native with a pistol.

We halted in the evening for the night in a plantain grove: everyone was soaking and cold, as it had rained all day: we made only ten miles.

Florence staggered along, overwhelmed by a feeling of helplessness in the face of evil. Even well after the fact, she had to muster a good deal of restraint and sangfroid to describe the situation to Agnes:

I will not give you an account of the whole seven days' march, but I assure you it was a very anxious time for me: I was always so dreadfully afraid that something would happen to dear Papa. What should I have done in

such a fearful case? Of course, I would have shot myself rather than fall into the hands of the natives.

Everybody would have been killed without Papa.

It was no accident that Florence carried a pistol. She would not march unarmed. If the unthinkable came to pass, and Sam were killed, she would shoot herself without hesitation. She could imagine all too well the degradation and torture to which she would be subjected as a slave, the wife of the defeated ruler. She had seen too much to allow that possibility to occur. Besides, life without Sam was not supportable. *Sam has brought me the only freedom, the greatest love, and the most lasting contentment of my life,* Florence thought, so deeply afraid that she was almost coolly rational. *There is no point in living if he is gone.*

She also needed the gun to fire at her attackers. During those days, she thought once or twice that she had killed a man. It haunted her to commit the sin of murder, to act in a way so opposed to her deepest beliefs. But she could not and would not let someone hurt Sam or Julian or herself without fighting back.

She came to understand war as she never had before. This, then, was what her father's life had been like during the Hungarian Revolution, when she was just a small child longing to have a family and feel safe in the world. If you were a soldier, you chose your side on principles, on right and wrong, and then you fought for your fellows as if they were your family. Sam and Julian and the expedition *were* her family here, and she would fight for them to the death. That was a soldier's morality.

War was not really heroic, no matter what people said, Florence realized. *No matter how good your cause, no matter how handsome the young men looked on parade in their beautiful uniforms with their flags and fine horses, war was simply survival.* It was a truth she had not wanted to learn, but she knew it from childhood. Now she knew too that she would kill if she had to.

The fighting continued intermittently for nearly a week. There were no set battles, no charges, no bugles and battlefields. As they marched from the interminable grass to the jungle and back again, the natives attacked unpredictably from every side. A man was there, throwing a spear or loosing an arrow, and then he was gone again into the green gloom.

The twang of a bow or the whoosh of a speeding spear came out of no-where. Victims were picked off indiscriminately. Men fell all around Flor-ence, in front of her or behind her, beside her one moment, marching in grim silence, and bleeding and dying the next. One of Florence's beloved "boys" was speared as he walked close to his mistress, his legs and body pinned like a grotesque chicken on a spit. He walked so close to her that his blood spattered over her clothes as he fell. There was nowhere to hide from the massacre, no way to avoid seeing and smelling and hearing it. She could not even stop to comfort those who were mortally wounded, for they all needed to keep moving as fast as they could. They carried the wounded if they had some chance of recovery, but the dead and dying were left behind. The loads that had at first seemed so light, so minimal, grew burdensome. Carrying a load made fighting nearly impossible; put-ting it down meant its contents were lost. After some days, Julian stopped and burned his dress uniform—he would not leave it for those savages, but having it no longer seemed necessary.

After the flour ran out, there was little food, mostly unripe plantains. On June 18, during a brief rest stop, Sam left the others to scour the area in search of food. He returned triumphantly, with a good quantity of ripened *dhurra* to be ground into flour. He found the Forty Thieves had taken mat-ters into their own hands. They had engaged in a "barbarous ceremony," removing the liver from a dead Banyoro warrior and eating it raw. They needed protein, but their act was not one of hunger. The men believed eating an enemy's warm liver would render every bullet the cannibal fired effective against his enemies. The men had strewn the remains of the mu-tilated corpse about as a warning to their pursuers. In an awful sort of way, Sam understood the men's bloodthirsty feelings. He could not even shield Florence from the facts; there was no time to hide the remains.

Florence knew what the men had done and why. She could not con-done it—she was revolted at the mere idea of eating a man's liver—but she too understood. They were defending their own, themselves, in the only ways they knew how. She never spoke of it to Sam; there was nothing that anyone could say, and they had to keep silent on the march in any case, lest they give their position away. Besides, she was exhausted, her feet painful, raw, and bleeding, her clothes torn and muddy and bloodstained. She had

no energy for moralizing. Still, her determination remained ferocious. Florence *would not* be beaten and could not turn back.

On June 19 they came out of the dark density of the grasses and jungle into the open of a sweet-potato field. There was daylight and breeze, and no place for concealment. They had reached Kisoona, a village that had seemed a wretched place on the way to Masindi but that now looked like paradise. Kisoona was only twenty-one miles from Foweera; they had come two thirds of the way without dying. Even the tiniest hint of optimism was a precious commodity. The idea of rescue drifted into their minds. Sam was sure Rionga must know they were coming by then and predicted that Rionga would soon send men and food for them.

Thin and haggard, weak with fear and fever, they set to work building a strong wooden stockade with posts sunk deep into the ground for protection. For six days they worked, rested, healed, and worked again, building the stockade so that at last they might sleep securely with only a few sentries on guard. They hollowed canoes out of palm logs, harvested plantains, and prepared flour from them. The plantains were starchy and tasteless in the only preparation they could manage, but still they were very welcome. They dug sweet potatoes and roasted them, or sliced them and dried them for future provisions. There was no game close to the stockade and they dared not venture far lest they encounter their pursuers, who still attacked them daily.

On July 1, a messenger from Rionga appeared asking for Mallegé, the nickname given to Sam on his first trip. Sam sent a message back, offering to put Rionga on the throne and to help displace Kabba Réga in return for shelter, food, and porters. By way of acceptance, Rionga sent back corn, sweet potatoes, a goat, some dried fish, and an ox. The ox was devoured immediately; so many weeks had passed since any of them had had good meat. Within days, Rionga sent canoes and porters to carry them up the Victoria Nile to his headquarters. They were saved.

Rionga formally welcomed the expedition to his stronghold on Kanyamaizi Island on July 18. On the next day, at Rionga's request, he and Sam sealed their alliance by piercing their arms with a knife and pressing the cuts together to exchange blood. Sam took great care to make sure it was very little blood, as he found the idea exceedingly savage and distasteful. Julian and Abd-el-Kadr underwent similar rituals with Rionga's son and

chief minister, respectively. Though they could not feasibly mount a successful attack against Kabba Réga until the end of November, Sam hastily declared Rionga the new ruler of Bunyoro on his authority as the emissary of the khedive. It was a tremendous display of bravado.

After a little over a week with Rionga, Sam decided to leave sixty-five soldiers under Abd-el-Kadr in the stockade at Foweera and return to Fatiko with the rest of the expedition. Rionga supplied six canoes to take them across the river and fifty porters to carry luggage. It was another long seventy-eight miles to Fatiko, through hip-deep marshes, high grass, forest, and swampland. En route, they met some messengers sent by Major Abdullah to find them. The men told them that Abou Saood was now planning to attack the station at Fatiko, since Sam and the others could not possibly have survived the attack in Masindi.

On August 2 the expedition arrived at Fatiko, stopping a half mile off to change into their best remaining uniforms. The bugle sounded, the

band struck up, and they marched into the fort, to the great relief of Major Abdullah. With only one hundred men, Abdullah had feared he would be overrun by Abou Saood and his

Fort Fatiko (1874). Fort Fatiko looked peaceful when Florence, Sam, and the others arrived, but they were soon attacked by Abou Saood's men.

three hundred men, who were camped in a station not far from the fort. One of Sam's first duties was to inspect Abdullah's troops and fortifications, which he did proudly and properly from horseback.

This task completed, Sam was about to dismount when Abdullah pointed out that a delegation of about 270 men was approaching from Abou Saood's camp, flags flying, presumably to pay their respects. Abou Saood's men settled two large cases of ammunition under a convenient tree and stood in formation, waiting for Sam to approach. In turn, Sam awaited them, as he was the visitor. Florence began to smell treachery; this was no respectful greeting, it was insolence and the preamble to an attack. Without warning, bullets began to whiz past Sam's head. Florence had already gone into a hut to get Sam's rifle and ammunition belt, which she handed to him as Abdullah's men mounted the counterattack.

At Sam's order, the bugler sounded the call for the men to assemble, ready to fight. Sam had no intention of simply defending the fort passively. He immediately ordered the men to swarm out aggressively and counterattack, using bayonets, rifles, and whatever weapons they had. This blatant display of courage unnerved the enemy. How could a force half their size counterattack and hope to win? Abou Saood's men retreated in confusion. Before the battle was ended, Sam and his army of fewer than 150 men had captured 50 guns and 45 prisoners, many of whom later testified against Abou Saood. In addition, Sam's troops seized 306 cattle, 130 slaves, 15 donkeys, and Abou Saood's entire station.

While the soldiers fought, Florence organized the protection of the fort. She placed sentries on high rocks with views of the entire countryside, to keep track of the battle and to report any threat of additional attackers. Then she had the cattle secured within the *zareeba*. Practical comfort was next on her list. She instructed the cook to prepare a hearty mutton curry that might be rewarmed at any time, to serve as breakfast for the troops when they returned. "Men must eat" had long been one of her mottoes.

Abou Saood himself was already on the way to Khartoum, where he boldly complained of Sam's behavior and spread lurid stories that the entire expedition had been massacred at Masindi. He repeated these stories in Cairo too, and they reached England in March 1873. On March 24, Sir Henry Rawlinson of the Royal Geographical Society expressed the society's distress at the reports that the Baker expedition was in serious danger. Rawlinson informed the members of the society that the khedive

had organized a relief expedition, which would start from Zanzibar. On April 17 *The Times* printed a near-obituary for the Bakers:

> The rumor of a lamentable tragedy has reached us, which we would fain believe to be at first the exaggeration of disaster. We give it currency with doubt & hesitation. . . .
>
> It is reported that Sir Samuel Baker, Lady Baker, and the few survivors of the band which set out with them now more than three years ago have been murdered by the savage tribes in whose neighborhood they have for some time past been lingering with their lives in their hands. A catastrophe so terrible cannot be credited until belief is forced upon us, yet we are obliged to confess that it is not an impossible, or even an improbable, issue of the situation in which SIR SAMUEL BAKER and his wife were placed when we last received authentic intelligence of them. Their force had dwindled to a handful, and this not so much from disease or from difficulty of travel as from the hostility of the natives. The survivors of the Expedition were blockaded in a small building, which they were struggling to hold against their enemies; but their members were painfully few and their resources well nigh exhausted. . . .
>
> The very consistency of the present story, that Sir Samuel and Lady Baker were obliged at last to surrender, and were murdered immediately afterwards, with the last intelligence of their condition received in Egypt allows us to entertain the hope that the report is no more than a foreboding of a tragic conclusion to a great enterprise, which has been translated into a fact in its passage down the Nile. . . .

Despite the news, there was room for hope, and the Baker family was good at hoping. Valentine checked with the Foreign Office, who were unable to confirm the rumors and considered them unsupported. A mere week later the *Daily Telegraph* said that the "latest and most trustworthy intelligence [was] that Sir Samuel and his party were all well at [Fatiko]," though on what they based their assessment was anybody's guess.

Unaware that their desperate battle at Masindi and their rumored deaths had been reported, the expedition settled in at Fatiko to await the dry season. Sam loved building things, so he set himself and the men to

constructing a truly strong and sturdy fort that could be maintained indefinitely. Now that Abou Saood's trading station was in his hands, Sam could build a new fort to take full advantage of the unusual topography of the region.

He chose an enormous granite plateau, which ended in a high cliff three quarters of a mile long and about one hundred feet high, as the western base of the new fort. The southwestern end of this structure was known as Fatiko Hill, and its wooded height commanded a marvelous view of the region. Sam fancied that the outcrop looked rather like a huge whale lying on a large grassy plain. The other three walls of the fort totaled 455 feet in length and were protected by a ditch, or fosse, eight feet wide and eight feet deep. Behind the ditch lay a packed-earth rampart surmounted with sharpened stakes. Three fireproof buildings—a powder magazine and two grain storerooms—were constructed upon the granite base and roofed over with a cement made from crushed termite hills, chopped straw, and water. Inside the fort, a natural rock shelter was walled in to serve as a jail; others were regularly used by the Bakers as bedrooms, sitting rooms, and a dining room. Fort Fatiko was completed by Christmas Day, 1872.

While Sam supervised the building project, Florence passed the autumn months sewing, for they had burned most of their clothes before fleeing Masindi, and gardening. She collected and pressed as many botanical specimens as she could; the sizeable collection she had amassed on the trip southward had been burned at Masindi. As always, she welcomed native children and women, clothed them, taught them, fed them, and treated them with tremendous kindness. Her reputation as a gentle helper and healer, established ten years before, revived rapidly.

No matter how peaceable her life became and however fond she grew of the small native children who flocked to her, Florence could not rid herself of the memory of what she had suffered: the betrayals, the starvation, the intentional cruelty. Every act of friendship or gratitude from an African was tainted by the lies she had been told by others and the naked greed with which her emotions had been manipulated. Her faith in the inherent goodness and kindness of Africans had been damaged. She distrusted them now and waited for misdeeds rather than looking for goodness, as she once had. "I think the natives are very bad people!" she

wrote on November 13, echoing a common theme in colonial thought of the day. She continued:

> Only about six weeks ago the sheik of Lobbo wished to come and pay Sam a visit; but he has a disease of the feet—thus he asked for the donkey, and begged if he might ride the donkey home, and send him back immediately; but from that day, we have not seen the animal, as the sheik refuses to send him back again.
>
> I am sure that it is quite useless to think that the natives in all those countries we have seen can ever be civilized, as men. I think that the children might learn, if it would be possible to take them away from their own homes—but if the native is once grown up, woman or man, he remains a savage, in manner and ideas.
>
> I am very pleased with all my boys; there could not be better boys in England, they do their work very well, and seem quite civilized now! But what will they be when we leave? Little Amarn we shall take home with us but we have quite given up the idea to take old Karka home, as she is too great a savage for Europe! She would be perfectly miserable to be among civilized people.

The decision to take Amarn home was a great departure from her previous policy. He was very obedient, intelligent, and beautiful, with the café-au-lait skin and fine features typical of Abyssinians. Amarn had been one of Florence's special boys for three years, since he was about eleven. He had asked, over and over, if he could go home with the Bakers when they left. Certainly there was no way to return him to his family, if any of them were still alive. Perhaps his good fortune owed something to the sad death of Saat at the end of Florence's first journey to Africa; perhaps it owed more to her recognition that she would have no children of her own.

Florence was thinking more and more of home. She complained in her journal that the rats were eating her handkerchiefs and, having destroyed them, had moved on to her stockings.

> I am dreadfully afraid that we shall be obliged to stay until the middle of July or the beginning of August—because we must wait here until Wat-el-Mek will return from Ismailïa with cattle, as the natives will not carry

anything for beads. It will take Wat-el-Mek six weeks at least to come back and then we shall require about two weeks to prepare for our voyage, which will bring us into the middle of January—and it will take fifteen days from here to reach Ismailïa, if we do not stop a day on the road.

I should not mind stopping a few months longer in the country, if my hair would not come out *so* dreadfully, but the climate does not suit it. I have lost more than half my hair since I came to Africa.

It was almost certainly malnutrition, not the climate, that caused her once-beautiful hair to fall out in clumps.

Through December and January, Sam and Julian went out happily hunting every few days—so frequently that Sam was petitioned by the native ladies not to go out, lest he be injured and they lose their protector. Florence settled disputes among the servants and organized her boys to conduct dreadfully successful rat hunts in the hut she and Sam occupied. Florence was emotionally spent and bored, with "nothing to do, except repairing a few old clothes"; she was longing to go home.

On March 8 much-anticipated reinforcements arrived from Gondokoro, bringing the total army under Sam's command to 620 men. He sent additional troops to the garrisons at several outposts and left a number of soldiers at Fatiko. Major Abdullah would continue to command Fort Fatiko, and Sam wrote out an extensive set of orders for him, including those involving regular maintenance of the ditch-and-rampart structure that provided the fort's main defense.

The men from Gondokoro also brought what Sam called "about 600 copies of *The Times*," full of news and gossip—lawsuits, the calendar of the royal family, announcements of concerts and other entertainments— that seemed fantastically absurd to readers in central Africa. They also brought letters from home, bearing sad news of the death of Roderick Murchison and the Duchess of St. Albans. Others described the coming-out ball of Constance, Sam's daughter, and the serious illness of Mary, Julian's sister. This was the first news they had had from England in well over two years—and no one in England had heard from them in even longer. Inexplicably, there was not a single letter from the khedive or his ministers in answer to Sam's urgent questions and requests—nothing at all from the Egyptian government.

Now there was plenty to do, as the expedition would depart for Ismailïa, the station at Gondokoro, as soon as possible. New uniforms were issued to all the soldiers from the stores. Remembering previous journeys, Florence decided to test whether the so-called riding oxen would carry a person who was using an umbrella as a sunshade. Her romantically inclined servant, Wat-el-Kareem, conducted the first test.

> She did not like the ox, nor did the ox like her, because he went off with her towards his *zareeba* as quickly as possible. Oxen are very uncertain animals to ride. Abdullah Effendi who is going to stay here, very kindly offered me his mule—which I think I shall ride if my saddle will fit it.

Two days later Florence observed that, although the Europeans were packed and ready to leave, the Africans and Egyptians were not:

> Nobody ever obeys orders in these countries—it is quite heartbreaking to give any orders, because they are certainly not carried out. I am quite sure that after we leave this, none of the directions that Sam gave to the officer in charge of the station will be carried out.
>
> Since we arrived in this country Sam has laid a good foundation, but after our departure the foundation will be broken up. It is like rolling a large stone up a hill, and after all the trouble and toil, it rolls down again.
>
> If the Viceroy will not place the command of the White Nile in the hands of a European, after Sam's service, the whole work that has been done in four years, will be destroyed.

They left Fatiko on March 20. The little mule behaved beautifully, but the oxen did nothing but "kick rider after rider off" until the expedition arrived safely at Ismailïa. It was April 1, 1873, the day that Sam's term as pasha expired.

THE LEGENDARY REPUTATION
FOR AMAZONIAN QUALITIES

*L*ying proudly in the river at the station of Ismailïa was the *Khedive,* a sleek and gleaming steamer that had been built by Higginbotham and his men. When Florence and Sam went to congratulate Higginbotham on this marvelous accomplishment, they learned to their great shock that he had died at the end of February, of rapid consumption. All the while that their own deaths had seemed imminent, it never occurred to Florence and Sam that Higginbotham and the men at Ismailïa were also in great danger. Virtually everyone on the expedition suffered from ailments—fever, injuries, or infections of various sorts, all complicated by poor food and simple living conditions. Inevitably, some died, despite the best planning possible. Still, the death of Higginbotham, their good friend and companion, hit Sam and Florence hard. The men had buried him in the lemon grove of the former Austrian mission. Sam erected a brick monument over his grave in his honor.

When Sam inspected the station he found that the protective ditch had been neglected. During their fourteen-month absence, it had been allowed to fall in and was now filled

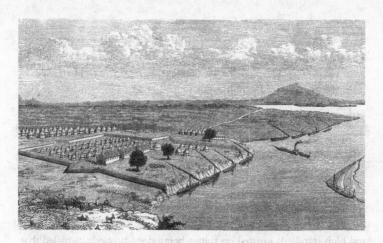

with rubbish and dirt from the equally neglected ramparts, which were crumbling. Florence and Sam were disappointed and discouraged. The ditch-and-rampart system was

Gondokoro, or Ismaïlia (1874). When they returned to Ismaïlia, Florence and Sam were discouraged to find that the splendid fort had not been maintained. The protective ditch had fallen in and the ramparts were crumbling.

an essential aspect of the fort's security; were they the only ones who saw them as important? The men had worked so hard to build the fort; Sam could not understand how the same men could fatally neglect its maintenance. Equipment, buildings, and animals: neglect and unconcern showed everywhere. Only the gardens had been kept up.

Florence was approaching despair that their efforts would produce any lasting effect. Everything in Africa, every hard-won inch of progress, seemed to sink back into chaos and filth as soon as their backs were turned. She tried to hide her feelings from Sam, but she couldn't fool him. He knew how hard the last year had been on her. He wrote to his sister Ellen:

> My heart has often ached for poor Florence, who has suffered so rough a time. For 130 miles she marched on foot . . . sometimes marching 16 miles in one stretch through gigantic grassed and tangled forests. She was always close behind me carrying ammunition in the midst of constant fighting—lances sometimes almost grazing her—one of her servant boys killed near her—the horsekeepers and horse killed just before her.

Seven days consecutively we fought during the march against the whole country organized in ambuscades in the terrible grasses in which an elephant would be invisible. My only fear was for her. At night a bundle of damp grass was the only bed—no food besides sweet potatoes and plantains. . . . No sooner had we arrived at Fatiko than Florence was in the midst of a storm of bullets, which happily avoided her. Through all these trials she had, thank God, been unscathed either by sickness or accident, and she had always been my little prime minister to give good counsel in moments of difficulty or danger.

Within some weeks, discipline and order were restored. As a station, Ismailïa was well designed and functional, if only someone with energy and high standards insisted on things being done properly. Satisfied that all was in good repair, at least for the moment, Sam, Florence, Julian, the English engineers, and little Amarn set off for Khartoum on May 25. There was an emotional farewell scene with the Forty Thieves, the group of ruffians that Sam had transformed into a crack military unit. Sam was terribly proud of them and they adored him. As Sam made his last inspection of the troops, they suddenly shouted in unison: "May God give you a long life and may you meet your family in good health at home!"

Sam had to brush tears from his eyes. The Forty Thieves were one of his real successes. By example, training, bellowing, and sometimes punishing, he had turned this ragtag collection of ne'er-do-wells into an elite fighting force. They were deeply fond of him and admired his steadfast courage and iron will, even when those traits landed them in difficult battles.

The *Khedive* took the *diahbiah* in tow and the explorers set off for Khartoum. They were delighted to find that the channels through the sudd, which had taken so many hours of grueling labor and cost so many lives, remained open, if narrower than before. With attention to annual maintenance of these channels, the White Nile could remain navigable all year round. Compared with the unrelenting struggle of their passage south, the voyage northward was relatively simple and pleasant. The *Khedive* could slip through channels that were too narrow for paddle steamers. With ships like this, commercial trade and mail delivery up and down the White Nile could be efficient and profitable.

Upon passing a station belonging to Abou Saood, Sam stopped to inquire for news. He was dismayed to learn that several of the slaver's ships, carrying about seven hundred captured slaves, had recently sailed northward. Sam and his expedition had been reported dead, and the captains of those ships were apparently certain that the new governor at Fashoda, Jusef Effendi, would not enforce the antislavery laws. Doubtless they believed a bribe would easily get them through.

Florence was righteously furious, scribbling in her diary:

> We hear that five boats had left the . . . station on the 16th of May for Khartoum. We are told that the boats are loaded with ivory, and with slaves! I trust that the latter is not true, because what are the authorities about in Khartoum?
>
> Sam has labored and had been exposed to great dangers in his district, to stop the slavery—and down here it seems to be as usual. The traders go backwards and forwards, as formerly. If the White Nile [trade] is not stopped at Khartoum it will be worse than ever after we leave.

This was more evidence of the basic problem they had faced all along: without a firm commitment from the entire government, none of Sam's victories would be lasting. Florence suspected that Sam had been hired to risk his neck so that the khedive could say with a clear conscience that he was doing everything he could to eradicate slavery. If that was so, then they were like sacrificial goats, tethered in a trap to catch a leopard. Florence resented that the khedive had so underestimated her Sam. He had not been killed; his expedition had not failed; and it was now up to the khedive to see that every one of his officials, from the highest to the lowest, insisted on the enforcement of the law. Frankly, Florence no longer believed the khedive had ever been in earnest. She felt she could trust almost no one except Sam and Julian.

When Sam learned that Abou Saood had left Khartoum to travel to Cairo and protest that Sam's actions had ruined his trade, his indignation burst forth. "Ruined his trade?" Sam bellowed to Florence. "I should think I ruined his trade. I certainly did my best to do so. My explicit charge in my *firman* as pasha was *to ruin the slave trade*. How can Abou Saood expect to receive a sympathetic hearing from the khedive who gave me that mission?"

"Perhaps," Florence suggested gently, "the khedive is not as good a man as you suppose."

"No." Sam shook his head. "The khedive would not lie to my face like that. I know Abou Saood would lie—he has lied and lied and lied since the first day we met him. But not the khedive. I won't believe it."

There was, however, a tiny, niggling doubt in the back of his mind. How was it that so many men broke the law so often and escaped punishment? How was it that the slave trade sprang back up as soon as he left a region? Abou Saood's audacity in registering a complaint was outrageous, even laughable. Surely he would receive no support from the khedive; surely the blackguard would get the justice he so richly deserved in Cairo.

The presence of Abou Saood's slave ships on the Nile, only a short distance ahead of them, provided a perfect opportunity to demonstrate the trader's guilt and to test the government's sincerity. The *diahbiah* made excellent time on the river, thanks to the steamer that towed them, and soon they passed the convoy of slave ships. They could smell the vessels from almost a mile downwind. Smallpox had broken out, and the odor of filth, disease, and death was revolting.

When they reached Fashoda on June 19, Sam immediately sought an audience with the new governor. Jusef Effendi assured him glibly that it was absolutely impossible for a slave ship to pass his station without arrest. Sam need not be concerned that these miscreants would escape punishment. With great intensity, Sam informed Jusef Effendi that *he* would be held personally responsible for the capture of Abou Saood's vessels and the arrest of the responsible individuals on those ships. Happily, Sam's trust in Jusef Effendi was rewarded and the ships were duly intercepted at Fashoda some days later.

The *Khedive* and the *diahbiah* left Fashoda and steamed on toward Khartoum, pulling over to the shore some five miles from the city. Sam selected a place where they could not be spotted from the city even with a telescope. He was determined to arrest Abou Saood. As far as they knew, the slaver believed that the entire expedition was dead. No letters or news from the Bakers had reached Khartoum in nearly two years. Sam did not want the slaver to have any warning of the expedition's arrival in Khartoum, lest he go into hiding and escape punishment. He intended to enlist

the new governor of Khartoum, whom Jusef Effendi had informed them was a man named Ismail Ayoub Pasha (formerly Ismail Bey).

"How often they change their governors in the Sudan!" Florence exclaimed. "I wonder if it is because they *do not* obey their orders, and cause trouble, or because they *do* obey orders, and cause trouble again? I don't know which would be more inconvenient to the khedive."

"Flooey, you are judging him unkindly," Sam said gently. "I have spoken with the man at some length; I am sure the khedive is sincere. Making such a sweeping change in Ottoman society is bound to be difficult. We have made a brave and bold start, and I am proud of our success."

"I'm proud too, Sam, but sometimes I think you're too good for this world," Florence answered, looking at his dear face. "You judge people by your own code of honor, even when they do not share it. But perhaps you're right. I am feeling not quite the thing today—the fever is troubling me again—and it makes me harsh in my judgments. Sometimes I feel . . . quite despairing." Sam looked at her pale, sweating face and promptly hustled her into their cabin so that she might rest. He gave her another dose of quinine and instructed the servants to check on her frequently.

Then he wrote the message to Ismail Ayoub Pasha, asking him to imprison Abou Saood *instantly* if he was in Khartoum or, if not, to telegraph Cairo requesting the same. He gave the message to an officer with an escort of ten men and sent them off to Khartoum by land and waited.

Ismail Ayoub Pasha paid a brief but secret visit to the *diahbiah* on June 28, after receiving Sam's message, but Abou Saood could not be found. Nonetheless, the governor prepared a lavish celebration for the triumphant arrival of the "dead Baker expedition" on June 29. Florence described the scene:

At 8.30 a.m. all the troops and bands were out also the whole town to see our arrival. Sam went on shore, and was received by Ismail [Ayoub] Pasha in full uniform, a salute was fired of eleven guns—after which Sam and the Pasha came on board with a number of Khartoumers came to see us.

This place is the same in dirt and dust, and the heat is tremendous.

We receive the post with the distressing news of poor Mary's death which is a fearful blow for Julian—but how shocking it must have been

for those around her, to witness her last minutes and the pains the poor creature must have suffered. But now she is gone forever, what gloom must it be for those left behind!! Poor Eliza to whom she had been fondest companion, what will she do without her?

. . . I was obliged to go this afternoon to the harem to pay a visit to Ismail Pasha's sister [&] a few other ladies.

While Florence was attending to her social duties, Sam sent a cable to Queen Victoria and another to the British Consulate in Alexandria. The acting consul, the Honorable H. C. Vivian, passed the information along to the Foreign Office in London. Both telegrams announced the safe arrival of the expedition in Khartoum and the success of its mission. They were read out in Parliament on July 5 to great applause. The next day Sam sent a message to his longtime friend and supporter the Prince of Wales:

My labor expended in cutting canals during the first voyage through the Bahr Giraffe has had a grand result. The rush of water has cleared away the sandy shallows and the channels are permanent.

I left all officers and troops in good health and spirits, and no trace of original ill feeling remains.

The troops prefer central Africa to Khartoum.

I have met with a good reception in the Sudan, and the expedition that commenced with evil auspices has, thank God, closed satisfactorily in every branch.

I trust your Royal Highness will be satisfied that although I have been unable for the want of transport animals to convey a steamer to the Lake, I have at least paved the way to future success and the expedition has taken firm root in the soil.

We are now on our way home and I look forward to the first duty of waiting upon your Royal Highness on my arrival in England.

Lady Baker joins me in presenting our humble respects to her Royal Highness, the Princess of Wales.

Though Sam and Florence knew better than anyone else how tenuous their success might prove, they were still justly proud. The White Nile had been opened to trade and commerce; government stations had been

erected; hostile tribes pacified; and the slave traders had been put out of business, at least so long as Sam and his soldiers were near. But the sudd would have to be fought annually and the canals kept open; the boats that could now move from station to station must be maintained and kept running; the hostile tribes must be watched, perhaps negotiated with, perhaps put down again; and, above all, the slave traders must be seized and punished over and over again, until the wicked trade in human cargo died out. If those things were not done, everything they had accomplished would crumble and fade. Florence was proud of their successes but weary of the endless fight. She wanted to go home.

The prince cabled back congratulations from himself and Princess Alix: "We both heartily congratulate you on your safe arrival in Cairo, after all the dangers you have been exposed to in your long and arduous journey." The khedive, who was in Constantinople, telegraphed his felicitations as well.

Despite or perhaps because of the khedive's absence, the ladies of his harem pressed Florence to visit them once again. She was not very enthusiastic about going, but such an invitation could not politely be declined. In her weak and disheartened state, she found the emotions raised by visiting the harem profoundly disturbing. The visit reminded her of her own magical yet claustrophobic days in the harem. Too many terrible things had happened and too many hopes cruelly killed for her to feel free and easy. In self-protection, she put on a stiff, British air instead of enjoying the ladies and the gossip, as she had on many similar visits before. She wrote:

> The Ladies at the harem gave me an entertainment today. I was very sorry that I was obliged to go, as Sam felt very unwell. I went at 12 a.m. [noon] and returned at 4 p.m., there were about 50 or 60 ladies collected, all in their best clothes. The band played close to the windows and we had a grand dinner which I did not enjoy, as my thoughts were for home—but when I came home Sam was much better, for which I was thankful.

The harem visit compounded the anguish Florence had been suffering for some months. It reminded her of the life she had once been raised to live as a pretty decoration in a rich man's harem—and how different her own

life had been. Must a woman choose between meaningless comfort or honor and hardship at the risk of death?

Her turmoil was heightened again when she found that two of her "boys" had stolen some of Julian's wine and were drunk. She was disgusted with them and flew into a rage. These were the best, her very own, the boys she had loved and bathed and brought up. She felt they had betrayed her, that her care and affection were misplaced. She could not see that their prank was one committed many times by English boys whose mothers and aunts still loved them.

It was her exhaustion and heartsickness that made her see the infraction as more serious than it was. Over the past four years Florence had been lied to, abused, shot at, starved, poisoned, and finally deprived of hope. She had been forced to run for her life and—perhaps worse—to shoot to kill as she and the others fought their way from Masindi to Foweera. The most bitter truth was that all they had achieved was probably ephemeral. In a week, a month, the slave trade might be running as smoothly as ever, ruining lives and destroying landscapes. She wondered for what she had sacrificed her health, her peace of mind, and very nearly her life. Where was the meaning in an honorable life if even her own boys fell into wrongdoing the moment she was gone? She wrote in her diary bitterly: "I am quite heartbroken sometimes, to see that kindness is wasted. . . . I have always taken a great deal of trouble with my people to teach them all that is good, but they will not learn. I shall be very glad never to see a black face again." Then she broke down in tears and wept. Sam heard her and came to comfort her.

"Sam, I am so sorry . . . I just can't help it," she whispered, still sobbing. "I feel so weak and I don't like it. Sometimes I can't believe or hope anymore."

"I know, Flooey, I know," he answered her. "Africa is very hard on hopes and dreams; it kills so many of them."

"Can we do nothing here, *nothing*? Are these people irredeemable?" she asked in anguish.

"We have done as much as we could, more than anyone expected of us," Sam replied. "We have fought the good fight."

LATER SHE WAS ASHAMED of the words she had written during her spell of despair. She sounded like those too fussy missionaries, who found all natives insufferable, smelly, and dishonest—in need of a good washing and a little Christian reform. Some natives were, and Florence had known them better than she would have wanted to. But she also knew that not all Africans were treacherous and dishonest. There were many who had proved their worth, whom she loved dearly: her beloved *lala*, Ali, little Saat and Richarn, Amarn, good old Karka, even the irrepressible flirt Wat-el-Kareem. And Sam's Forty Thieves were a success story no one could hope to improve upon. Who could ask for more? Amarn was the only one to come to England with her, and Florence hoped he was still young enough to make the transition without unhappiness, but she took great care to see that the others to whom she had close ties were well placed before she left.

On August 24 the khedive organized a ceremony at which Sam was given the Imperial Order of Osmanlie, Second Class, and Julian received a Third Class Order of Medjidie. Sam had hoped that Julian might replace him as pasha of Equatoria, but the khedive instead favored Colonel Charles Gordon, a hero of the Crimean War known as "Chinese Gordon" for his exploits in suppressing the Taiping rebellion. The khedive never revealed to Sam that he had written a letter in February 1872—a letter Sam had never received—extending Sam's contract until April 1874. It was more convenient now for Sam to leave.

On September 30 Florence and Sam left Cairo on a French mail ship, bound for home. They stopped in Paris to rest and refurbish their makeshift wardrobes. There a British correspondent from the *Daily News* caught up with them. He was obviously charmed by "Sir Samuel Baker and his gentle, though heroic wife, whom I found explaining to a youthful looking African [little Amarn, no doubt] the events which have taken place in Paris in the last three years. . . . She and Sir Samuel Baker are greatly amused at the legendary reputation she has most wrongly and undeservedly obtained for Amazonian qualities [on this and their previous journey]." A few days later, the *Illustrated London News* ran a large story featuring paired portraits of "this courageous and skillful pioneer of civilization . . . and his lady, who has long been accustomed to partake with him the hardships and perils, as well as the heroic delights and merited

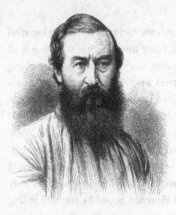
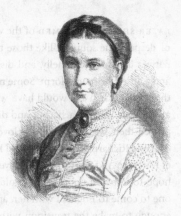

Sir Samuel and Lady Baker (1873). The Illustrated London News celebrated the Bakers' courageous endeavor "to suppress the cruel traffic in slaves among the savage tribes of that hitherto inaccessible region" of central Africa.

glories, of his most enterprising achievements in travel."

As ever, Florence caught the public's imagination. She had assumed a falsely demure role on her return from Africa the first time, in order to fit into Victorian society better, and her wifely persona proved immensely popular. The devotion to Sam was completely genuine, however. After this voyage, on which they fought their way out of Masindi, she was an Amazon, never mind her protestations to the contrary. She sometimes thought that even an Amazon can be frightened and discouraged.

Back in England, Florence and Sam were again honored for their achievements. Sam's address to the Royal Geographical Society on December 8 was a huge success. At the end, the Prince of Wales himself stood up to formally welcome

> my friend Sir Samuel Baker . . . and to tender him our warmest thanks and acknowledgment for his clear and interesting narrative. (Cheers.) . . .
> I will not say more but I must assure Sir Samuel Baker what pleasure it has given me to see him here this evening . . . I felt sure he would maintain the high character he has always held as a traveler, as a sportsman, and a Fellow of the RGS; but he now appears in a higher chair still, for as a philanthropist he has carried out a great work for the benefit of human kind. (Loud cheers.)

The prince's praise was echoed by that of the president of the RGS, who said the society

> welcomed back that evening one of whom it was not a small thing to say that England would never have reason to be ashamed. (Applause.) It was something to have lifted the veil from the wonderful country which Sir S. Baker had described, to have overcome such difficulties and done so much for the suppression of the slave trade. . . .
>
> We might also congratulate ourselves on the return with Sir Samuel of a companion in travel who had faced hardships and danger at which the stoutest and most manly heart among us might well stand appalled. (Loud applause.) The love and true affection which had been shown by a woman was a feature in this great work which would not be forgotten. . . .

Florence graciously acknowledged three hearty cheers from the enormous crowd, which brought the evening to a close.

The honors and acclaim continued. The Bakers were immediately invited to a house party at Sandringham given by the Prince and Princess of Wales. Through the new year, Sam lectured busily to the United Service Institution, at a banquet in his honor at Brighton; to the Turner's Company, who presented Sam with their Freedom and Livery; to the Grover's Company. He gave the Rede Lecture at Cambridge and received an honorary M.A., and he addressed the Royal Geographical Society again. He was voted a Fellow of the Royal Society and of the Royal Statistical Society. A flattering cartoon about Sam's antislavery campaign was published in *Punch*. The former Empress Eugénie, now deposed, sent a letter of congratulations, as did cabinet ministers, old friends like Wharncliffe, and even the explorer Richard Burton, who invited Florence and Sam to visit.

Because of Florence's poor health, she and Sam spent some months living quietly at Brighton, and they turned down a number of glamorous invitations. Sam worked hard at his book, *Ismailïa*, which was published in 1874; it was "almost as good a book as the *Albert N'yanza*," which had been hugely popular. He also wrote several letters to *The Times*. It was at Brighton in January 1874 that they first met the man designated as Sam's successor in the Sudan: Charles Gordon.

Gordon was to leave for Cairo in a matter of weeks. Though he was a

different sort of man from Sam—a soldier, a misogynist, and a religious mystic—the two leaders struck up a friendship and corresponded for many years. Gordon was among those who felt Sam had been too harsh in his attempts to stamp out the slave trade. He himself was determined to try an indirect approach. What's more, Gordon refused the same immense salary Sam had accepted, taking only two thousand pounds per annum; he also eschewed the showy uniform encrusted with gold braid that Sam used to impress the native chiefs. Doubtless the khedive thought Gordon a fool for slashing his own salary, but he was delighted to pay the fool less.

Over the summer of 1874, criticism of the harshness of Sam's tactics in the Sudan surfaced. *Ismailïa* had reached a significant public but was no humorous, happy romp through exotic locales like Sam's previous books. It was a more serious work, full of military details and comments about the slave trade, which was a subject of enormous public interest. Some members of the almost fanatical Anti-Slavery Society in England—most of whom had no African experience whatsoever and understood little of the difficulty and complexity of eradicating the slave trade—wrote vociferously and critically to *The Times* in response to Sam's book and lectures. The most shocking letter appeared on August 1 and was written by J. M'Williams, who signed himself "Chief Engineer, late White Nile Expedition." In reply to a letter of Sam's, enumerating the wicked deeds of Abou Saood, M'Williams wrote:

> Now as I am one of the unfortunate survivors of his expedition, I . . . hasten to give my testimony in the matter. . . .
>
> It is quite true that we overtook three boats with a number of slaves on board, and I have no doubt that the boats belonged to Abou Saood's firm. It was very fortunate for us we came up with the slave dealer, as without their assistance we could not have got through the *sudd* in the Bahr Giraffe until the river rose. Delay in that dreadful region would have been attended with great disaster in the state of health we were all in. The slave dealers gave their assistance with a hearty good will, and Sir Samuel rewarded the head man with suitable presents and parted with mutual good wishes.

The implication was that Abou Saood was either not such a scoundrel as he was painted or that Sam was free with his accusations only when he could no longer gain anything to his advantage from Abou Saood. M'Williams continued angrily:

> If Sir Samuel Baker wishes at any time for my testimony as to the barbarous manner in which the expedition was conducted, the wholesale murder, pillage, and ruin of the country, he is welcome to it; or should the Royal Geographical Society or any body of gentlemen wish for any information regarding that futile expedition, I shall be glad to give it previous to my departure from this country.

Sam declined to reply, but Julian stoutly defended Sam's actions in a letter published on August 5 with a no-nonsense appraisal of the situation:

> Sir Samuel always wished & endeavored to maintain peace, but when the Bari war broke out the only chance on success depended on military vigor. . . . If a military expedition is sent to annex an extensive country, war is a natural consequence, as the history of the world will testify.

Sam himself was not very perturbed by the second-guessing from those who did not know Africa or who had not been in command. Soft persuasion and half measures were not among his habits. To him, right was right and wrong was wrong, and he knew which side he would be on. This moral certainty was one of the traits Florence so admired in Sam.

Sam minded, though, that Gordon thought he had blundered. This opinion became evident when Gordon arrived in Khartoum on February 6 and promptly ignored most of Sam's advice. From the start, Gordon's poor command of Arabic handicapped his understanding of circumstances and his ability to size men up. After meeting with Abou Saood—against whom Sam had most firmly warned Gordon—Gordon asked for the slaver to be released from jail and put on his staff, hoping perhaps to reform him. However, Abou Saood's treacherous ways had not changed, and a mere seven months later Gordon was forced to fire him after writing out Abou Saood's many perfidies and misdeeds in a scathing letter.

In a letter to Sam shortly after firing Abou Saood, Gordon elaborated upon the situation.

You ask me why I took Abou Saood at all, after what you had said of him; and my answer is: that I saw the man, and mentally weighed him; and saw he was not a redoubtable being, and that I could manage him, or at any rate crush him without difficulty. . . . Everyone said "Do not take him, because he will ruin your expedition." From . . . many high people I had many warnings against him that he was a dangerous fellow. I do not think it, from my experience of him: he is a despicable sort of man, a great liar, and altogether insignificant. By his lies he might succeed for a time; but it could only be so for a time. I alone was responsible for his coming up here, which was at my own urgent suggestion.

Sam, knowing Gordon to be a stiff and very proud man, graciously accepted the tacit apology for what it was and replied in a letter on January 14, 1875:

Do not let us speak any more of that fellow Abou Saood. I am glad you have got rid of him; as I always feared he would intrigue against you. . . . Of course this wretched man was always contemptible; but even a mosquito may cause you annoyance; and minute vermin are more troublesome than important animals. . . .

Your position and mine are totally different. I had the brunt of the beginning: the river impassable, and the authorities and slavers determined to prevent the Expedition from taking root. With God's help, it *did* take root; and under your management I trust it will bear fruit.

In his second year in the Sudan, Gordon wrote to Sam,

I have gone through much trouble; and can now appreciate the worries you had with one-tenth my means. . . . I can now see how you were thwarted; and on my return, D.V. [*Deo volente*], if ever I return, I will state my opinion publicly about your mission so far as I can judge it. . . . I feel so beaten down by my worries in the opening of this route [on the White Nile], that I have lost spirits . . . it is *hopeless, hopeless* ever to do anything with these people.

In Gordon's words, "It certainly is the most difficult work, the administration of these [African] countries. No one can have an idea of it except those who have been here."

In November 1874 Sam and Florence found the country house that they would make their home for the rest of their lives. Located near Newton Abbot in Devon, it was called Sandford Orleigh and was a spacious structure of Bath stone with a superb view of the Teign Valley. After building the fort at Fatiko, Sam was always especially fond of commanding views. With the house came generous grounds where Sam and Florence had gardens planted, walks constructed, and an African-style thatched "palaver hut" built for informal entertaining. Florence was happy to settle down in a home of their own. She spent months buying furniture and decorat-

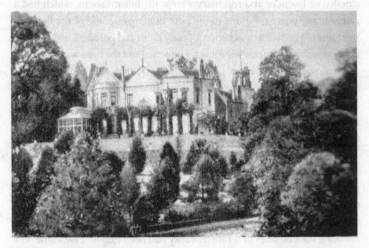

ing the rooms with their treasures and mementoes. The billiard room, front hall, and smoking room were enhanced by Sam's collection of animal skins and hunting trophies,

Sandford Orleigh (ca. 1874). Florence and Sam settled into a beautiful country house in Devon, Sandford Orleigh, where Sam's hunting trophies and mementoes from their trips mingled with fine china, elegant furniture, and beautiful rugs.

including an artfully stuffed crocodile Sam had shot, in whose stomach he had found a bead necklace that had belonged to the crocodile's last victim. The necklace hung from the crocodile's jaws. Arrows, spears, swords, headrests, shields, and other objects from various tribes were hung on the

walls or displayed in cabinets. The other rooms were furnished with fine, old oak furniture, opulent overstuffed sofas and chairs, beautiful carpets, a collection of blue and white china, and, in the drawing room, an especially large, floor-to-ceiling mirror that reflected the scenic view through the windows.

Florence resumed family life again. She visited her stepdaughters and their families, invited relatives or friends to stay, took on and trained the large staff a house like Sandford Orleigh required, and worked to establish a comfortable and peaceful home for herself and Sam. Amarn must have been something of a curiosity in Devon, but he had a secure home there until his death many years later.

Florence knew exactly how she wanted things to be. Every room smelled of lavender and rosemary, except the billiard room, which had a rather unfortunate odor due to the poor tanning of some of the lion and tiger skins. The house was kept spotlessly clean and polished, and the gardens were superb. Meals were always punctual and the food was abundant and delicious; the wine was good and freely poured. Dinner parties were formal affairs, and Florence presided over the table as hostess, retaining her beauty and charm as she aged. Her hair grew shiny and thick again, and she wore elegant gowns and jewels that Sam gave her. Visitors played tennis or golf and went on excursions to Hay Tor, Torquay, or a pleasant picnic spot on the Dart River. If they were statesmen and dignitaries seeking advice from Sam, they strolled in the gardens and chatted in the palaver hut. If they were young and mischievous, they climbed trees, like the Prince of Wales's sons, Edward (later King Edward VIII) and George (later King George VI), who earned themselves a spanking from Sam for breaking the branches of a rare tree they had been told to leave alone. On Sundays the family walked up the hill to attend church services.

Florence began to feel truly well and safe again. She could never entirely banish the dark shadows of the evil she had witnessed in Africa, no matter how English and how respectable she became, and she swore to herself she would never return there. One day a visiting friend asked where they were off to next, and Florence replied, "Oh, we have but one desire, and that is to keep chickens in Devonshire."

20

THAT DISGRACEFUL OUTRAGE

Among those who were always welcome at Sandford Orleigh was Sam's younger brother, Valentine, who had led the highly esteemed Tenth Hussars to great glory. He was in many ways the epitome of a cavalry officer—stylish, brave, and daring. He had a rakish manner and an eye for the ladies, but those were almost expected attributes of a cavalry officer. In 1872, at forty-five, Valentine stepped down from the colonelcy of the Tenth Hussars but remained a leading figure in British military and political affairs.

Florence and Sam also welcomed Valentine's wife, Fanny, and their two daughters, Hermione and Sybil, though Valentine frequently socialized without them. Florence was puzzled by Fanny's attitude toward the discreet romantic flings in which Valentine indulged from time to time; she never seemed to make the least attempt to reform her wandering husband. She actually encouraged him to go to London alone, saying she preferred to stay at home in the country with her children. Florence could not imagine doing the same. Florence would be mortally wounded if Sam carried on with another woman.

In the autumn of 1874 Valentine assumed a newly created position as assistant quartermaster general at Aldershot. It was the first large-scale, permanent military training camp in Britain, and the position was highly visible and much coveted. Among Valentine's most pleasant new duties was organizing a splendid military review to be held at Aldershot in honor of the state visit of His Highness Seyed bin Saed, the sultan of Zanzibar, which was planned for August 1875. Among the luminaries who were expected to attend were the Prince and Princess of Wales; the commander-in-chief, His Royal Highness the Duke of Edinburgh; and the deposed Empress Eugénie of France. The occasion would give Valentine a marvelous chance to show off the facility.

In the first half of 1875 the two brothers—"Baker of the Tenth" and "Baker of the Nile"—were among the most prominent and widely respected men in England. When Valentine's fall came, it was abrupt and shocking.

On June 17 a telegram from Valentine arrived unexpectedly at Sandford Orleigh just as Florence, Sam, and their guests were about to go in to dinner. The telegram simply asked Sam to come at once. Valentine would never send such a summons if his need were not urgent, so Sam made his excuses and left Florence to entertain the guests. When Sam arrived in London, Valentine related a catastrophic tale.

That afternoon he had boarded a train to London, intending to dine with the Duke of Cambridge and return that night. None of the first-class compartments were empty, so he had climbed up the steps from the platform and entered one that held a single occupant: Miss Kate Dickinson. She was a pretty young lady, and a mild flirtation, or what Valentine considered to be one, ensued. Valentine had chatted with the girl and, after she coyly—or primly—refused to give him her name, he had gone to sit next to her. Miss Dickinson had objected. Valentine had then attempted to kiss her, but the young lady had jumped up to ring the emergency bell, although no one answered. Valentine had forced her down upon the seat and persisted in attempting to kiss her. She later testified that he had not only succeeded but that "his body was on me the whole time. I was quite powerless . . . [and] I felt his hand underneath my dress, on my stocking, above my boot."

She had struggled free and had opened the window, putting her head

out to scream for help. The two young men in the next compartment had heard her and put their heads out of their window to see what the problem was. What they had seen was a distraught, almost hysterical young woman in a state of tremendous disarray. "When shall we reach the next stop?" she had asked them breathlessly; they did not know. Frantic to escape Valentine's attentions, she had crossed the carriage to the only route of escape, the outer door. Intentionally or accidentally, she had opened the door and had started to fall backward out of the carriage. Valentine had lunged forward, grabbing her arm and wrist to save her from falling to her death; the countryside swept by at forty miles an hour. She had screamed in terror as she struggled to stand on the topmost step outside the carriage.

When the train had pulled into Esher, everyone on the platform was mesmerized by the sight of Miss Dickinson clinging to the outside of the train. The platform guard had rushed over and helped her down. Valentine had murmured to her, "I pray you, say nothing—you will ruin me."

Nonetheless, Miss Dickinson had told the guard, "This man is insulting me and will not let me alone," and she had refused to ride further with him. The guard had seen her safely into another compartment, this one occupied by a clergyman, the Reverend Aubrey Browne.

Then the guard had locked Valentine into the compartment with the two young men who had spoken to Miss Dickinson earlier. It was those young men who had finally pointed out to Valentine that his trouser buttons were undone, except the top one. Perhaps the buttons had been opened with seductive intent; perhaps Valentine had fastened them insecurely after a trip to the bathroom and in the struggle to save Miss Dickinson . . . It hardly mattered, as the mere facts were so damning.

Upon reaching Waterloo Station, he and Miss Dickinson had been escorted to the stationmaster's office, where their names and addresses were taken and reports filed. Valentine had telegraphed Sam for help.

The next morning the Baker brothers went to the Guildford Police Station, where statements were taken. Miss Dickinson arrived in the company of her barrister brother, who refused to speak privately with Valentine about "settling" the matter. Both Dickinsons were determined that Miss Dickinson's reputation be restored and her complete innocence established. Valentine was charged with attempted rape, indecent assault, and common assault.

The newspaper coverage began the next day, with *The Times* headline EXTRAORDINARY CHARGE OF ASSAULT. New articles about the case appeared every few days until the trial, keeping the lurid charges constantly in the public eye. Opinion was strongly against Valentine, especially in the countryside, where people were more old-fashioned and deplored the fast, sophisticated ways of the fashionable Londoners and aristocratic officers. The prejudice against Valentine was so blatant that the magistrate was moved to comment on it, but Valentine's request for a special jury of his peers was refused.

Fanny was cruelly humiliated and embarrassed. The entire Baker family felt the notoriety and disgrace of the trial deeply, yet they all defended Valentine stoutly. *They have formed a British Square to protect him,* Florence thought. She had some doubts about Valentine's innocence; he probably considered his behavior harmless, but clearly it was not so according to the morals of the lady in question. Sam admitted to some qualms too. To Wharncliffe he acknowledged that Valentine had been "too amorous, incautious, and rash to the last degree."

A large part of the problem was the question of choice. While many would have seen Valentine's stolen kisses as harmless, Miss Dickinson did not and did not welcome his advances. To persist was ungentlemanly, caddish. Worse yet, the whole thing became public when the train pulled into Woking.

"I see now," said Florence to Sam, thinking aloud. "Is *that* why Fanny puts up with Valentine's . . . lady friends: because she is not embarrassed in public? Is his amorous behavior acceptable, so long as no one knows of it? What a very peculiar standard of morality!" With an urgency in her voice, she posed another question to Sam. "Do you believe that as well? That what matters is not right or wrong, but whether the world knows?"

"Flooey, have I ever acted like that?" Sam looked at her directly. His thoughts and feelings were often transparent to her, she knew him so well. "I have always acted from my conscience and I always will. You know that. A sin concealed is a sin nonetheless. But there is another consideration here. A brother is a brother—he is *family*—whether he is right or wrong. I cannot abandon my brother, no matter what he has done."

"Of course not," Florence murmured. "I know, Sam dear. We have always valued loyalty, you and I. We cannot turn our backs on Valentine.

But I think we must in all fairness bear in mind that he has brought this upon himself."

The trial on August 2 had the air of an execution. The Bakers were present in force; so too were Valentine's friends, including Sir Richard Airey, Sir Thomas Steele, Colonels Oakes and Shute, the Marquis of Tavistock, Lord Lucan, and Viscount Halifax. In addition to supporters for the defendant, the court was so packed with strangers and journalists that even the counsels could hardly force their way into the room. Those who had not claimed seats for the spectacle waited outside in the street.

The opening statement by Mr. Serjeant Parry, the prosecution's solicitor, was damning. He observed that the defendant, Colonel Valentine Baker,

is an officer of distinction, he is a married man, he is 50 years of age, and he stands at the bar charged with a cowardly and unmanly assault upon a young lady whom he met in a railway carriage on the 17th of June last. The charge is stated in a threefold way—attempt at rape, indecent assault, and common assault. The lady is 22 years of age. . . . The only question is whether he intended to violate the young lady—a grave and serious question for him, as to which there is a pregnant fact, proved by more than one witness, that his dress was unfastened. He was placed in a compartment with two gentlemen and they . . . both state that his trousers were unbuttoned.

The response from the crowd outside was boisterous. The judge ordered the bailiffs to clear the street so the trial might proceed with dignity.

As Miss Dickinson gave her testimony regarding the events in the carriage, Valentine sat erect and white-faced in the dock. He kept his eyes up and his posture proud, as befitted an officer, but he won little sympathy from the crowd. At his insistence, his frustrated counsel read aloud his written statement:

I am placed here in the most delicate and difficult position. If any act of mine could have given any annoyance to Miss Dickinson I beg to express to her my unqualified regret. At the same time I solemnly declare upon my honor that the case was not as it has been represented by her today un-

der the influence of exaggerated fear and unnecessary alarm. . . . I don't in the least intend to say that she willfully misrepresented the case, but that she has represented it incorrectly, no doubt under the influence of exaggerated fear and unnecessary alarm.

Valentine's lack of defense turned upon a question of honor. A gentleman did not cast doubt on a lady's word under any circumstances. Valentine would not refute Miss Dickinson's testimony directly and would not allow his counsel to cross-examine her. No questions were ever asked of Miss Dickinson, and they might not have affected the trial's outcome in any case.

In his summing up, the judge explained the legal definition of the charges to the jury: "If a man kisses a woman against her will, with criminal passion and intent, such an act is indecent assault. A kiss that gratifies or incites passion is indecent. . . . The mere laying of a man's hand on a woman amounts to criminal assault." Obviously, if Valentine were convicted of indecent assault, he was by definition guilty of common assault. The most inflammatory charge—attempted rape or, as it was sometimes referred to in court, "intent to ravish"—was the least clear-cut. The judge commented:

> Now, it is not correct to say [as the prosecution has done] that the question is whether he had determined to stop [his attentions to the lady] if her resistance go beyond a certain point; but the question is whether he intended to violate her, and he cannot be convicted of that offense unless you are satisfied that he had it in his mind to have carnal connection with her, but not withstanding any resistance she might make. . . . You, of course, can only tell what was in his mind by his acts or words. . . . He has always denied it, and therefore it must be inferred, if at all, from what he did.

After a mere fifteen minutes of deliberation, the jury pronounced Colonel Valentine Baker innocent of attempted rape but guilty of both charges of assault. Before the sentencing, the commander of Aldershot, Sir Thomas Steele, and Sir Richard Airey, adjutant general to the army, testified to Valentine's moral character and brilliance as an officer, but Valen-

tine was doomed by his conviction. He was sentenced to twelve months in a common prison, a fine of five hundred pounds, and repayment of the costs of the prosecution.

It was sad and bitter judgment for a proud man and his family. As Sam wrote ruefully to Wharncliffe, "I always knew that the 'trousers' would be the fatal point." Florence thought that, given the "trousers," Valentine was fortunate to be acquitted of attempted rape, whatever his intentions had been.

Queen Victoria was deeply shocked and horrified to read newspaper accounts of "that disgraceful outrage on Miss Dickinson for which Colonel V. Baker is being tried." There remained a question of Valentine's association with the military. The Duke of Cambridge, commander-in-chief of the army, wrote to the queen directly after the trial, asking that Valentine—one of the army's most brilliant leaders—be permitted to resign rather than being dishonorably discharged. He might yet be of service to the Crown after serving his sentence. Queen Victoria steadfastly refused all pleas on Valentine's behalf. Shortly a terse announcement appeared in the *London Gazette:*

> Lieutenant Colonel, Brevet Colonel Valentine Baker, half pay, late 10th Hussars, has been removed from the Army, Her Majesty having no further use for his services.

Baker of the Tenth was no more.

UPON VALENTINE'S RELEASE FROM PRISON in 1876, his friends took steps to help him. The Prince of Wales had a private word with the sultan, and Valentine was appointed major general and head of the Turkish Gendarmerie at Constantinople. He functioned as an unofficial British intelligence officer too, keeping the British government apprised of affairs and developments in that part of the world.

When Russia declared war on Turkey in 1877, Valentine was asked to take up the post of military adviser to war minister Mehemet Ali. The secretary of the Prince of Wales wrote to Sam expressing his congratulations, intending the royal message to be passed along. Valentine again

proved himself an outstanding officer with a stunning rout of the Russian forces that earned him the Order of Osmanlie. In yet another action, Valentine, with a force of three thousand men, managed to hold off forty thousand Russians for an entire day, until the main Turkish army could arrive. Before long, Valentine was known as "Baker Pasha" as Sam had been during his days in the Sudan. He oversaw a complete reorganization of the Turkish army. Though he was not yet approved of by the queen, who refused to reinstate him in the Royal army, Valentine had largely regained his reputation as an outstanding officer. He was restored to membership in the Marlborough Club in London. Fanny and her daughters stayed largely in the background.

21

YOU PROMISED YOU WOULD
NEVER RETURN WITHOUT ME

*A*fter the embarrassment of the trial, Florence and Sam had returned to their comfortable life at Sandford Orleigh, where Amarn grew to manhood and rose to head their domestic staff. They traveled into London for grand occasions—the tiaras, brooches, and earrings set with diamonds and other precious gems that Sam gave Florence were some indication of the number of grand events they attended—and during the winter months they often left the cold of Devon for travels abroad. Over the next two decades they lived for a year in Cyprus, giving Sam fodder for another book, and visited Egypt, India, America, and Japan, always traveling in a well-planned and highly comfortable manner. Gone were the days of wild ramblings and dangerous adventures; Florence would have none of it, though Sam was ever a little restless. He wrote more books, lectured, and gave extensive advice to members of the British government on foreign affairs, especially the "Eastern Question," as the problem of what to do about the faltering Ottoman Empire and the balance of power in western Asia was generally categorized.

Sam corresponded frequently with Gordon while he was in the Sudan, commenting wistfully in 1875, "If it were not for my wife, who has worked for me for nine years in Africa, and now deserves rest, I would begin again; although, perhaps, at fifty-four, I should not be so fit for the rough life." He knew full well that the journey to eradicate the slave trade along the White Nile had damaged Florence's spirit. She was yet indomitable, but she had been pushed beyond endurance and forced to murder to save her own life. To ask her to expose herself to such dangers again would have been cruel, and she was a woman he loved and admired above all others.

Gordon's two-year appointment as governor-general of the Sudan was renewed until 1878. He too found it nearly impossible to stop the slave trade. Late in his term as governor-general, he was still fighting the slave traders every day with every weapon he could muster. Sometimes he caught as many as two dozen slave ships in three months. "Still they keep on," he wrote Sam dispiritedly. He was frustrated by the inefficiency and slothfulness of the men around him and hindered by the lack of real commitment from the government. The khedive was ever unwilling to punish miscreants "unless the offender does something against H.H. [His Highness, the khedive] personally. *So convinced am I of this,* that I never ask him to punish anyone: I take the law into my own hands, so far as I can. . . . Now H.H. puts my reports quietly away; and overlooks the offenses."

One of Gordon's clear triumphs was that he finally managed to get a steamer running on Lake Albert in 1878. He wrote to Sam: "If you could come, how glad I would be to see you! . . . Come up and see the south end of Lake Albert. You could get here from Suez in 19 days. I would send a steamer to meet you at Berber. From here you could go to Lado in 15 days, in the *Ismailïa,* your own boat (such a picture she is!)."

Sam knew it was impossible. Later that year, when he and Florence stopped in Cairo en route to Cyprus, Gordon again begged Sam to visit, but he replied, "I should have much liked to run up and see you at Khartoum; but Lady Baker has had so many years of the Sudan, and, after all she has endured there, it would be selfish of me to persuade her." However much Sam protested, Gordon was to urge him again and again to return to Sudan.

Gordon, a lifelong bachelor and loner, never understood the close bond between Florence and Sam. He assumed that Florence was a hin-

drance who prevented Sam from doing what he wanted to do—that she was confining and taming him using womanly weapons like tears and pouts. He could not see that Florence was protecting Sam from further dangers as much as Sam was protecting her.

In their hearts, Florence and Sam both knew that their exploring days were over. It was time for Florence to be a godmother and grandmother, the doyenne of a thoroughly comfortable country house; it was time for Sam to be an elder statesman and adviser, not to mention a boisterous grandfather who entertained the children with exciting tales of his days in Africa. To be sure, Sam still sought out the exotic. He took to visiting traveling circuses and local Gypsy encampments. If on his rambles in Devon he came across a group of workmen, he would stop and talk with them for hours about their work and views of life. Sam loved swapping tales and enjoying the sort of masculine camaraderie that he had had in Africa. The more unusual his companions, the better he liked it. Florence never objected in the least when Sam brought home tramps, tinkers, or Gypsies that he had met somewhere. If they were too odoriferous, she simply asked that Sam give them tea in the billiard room, which already suffered from the odor of poorly tanned skins.

In 1882 Valentine had redeemed himself almost completely. He was offered the inviting position of commander-in-chief of the entire Egyptian army, which was being reorganized under British control. Valentine resigned his position in Constantinople in order to go to Egypt, only to find his appointment blocked by the unforgiving Queen Victoria. Another British officer, General William Hicks, known as "Hicks Pasha," was appointed in his stead. As consolation, Valentine was given the leadership of the far less prestigious Egyptian police.

Egypt and the Sudan were rapidly heading into a crisis, and heading the Egyptian army would have been an appointment of great importance. The Sudan, though still part of Egypt, was rapidly spiraling out of control. The khedive Ismail, under whom Sam and Charles Gordon had worked, had become so powerless that he resigned his throne. His son and successor, Tewfik, soon found that a useless army, dwindling treasury, and insecure loyalties offered no sound bases for governance. He too was unsure how to govern the Sudan effectively.

The serious problems were aggravated by the growing popularity of a

once obscure Sudanese man, Mahommed Ahmed ibn Abdullah. He had been born to the Dongola tribe, the son of a Sharif, and thus, like his father, he claimed direct descent from the prophet Mohammed. In 1881, after a year of fasting and Koranic study, Abdullah declared himself a legendary figure. He was, he said, the Imam, who had temporal authority over all Muslims, the successor to the prophet Mohammed, who had spiritual authority over all Muslims, and the Mahdi, or Expected One, a messianic figure whose appearance would restore the purity of the Islamic faith. He lived on Abba Island in the White Nile, some two hundred miles

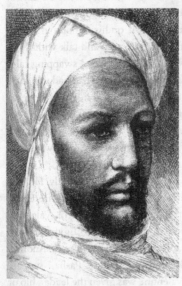

from Khartoum. He sent letters to all the sheiks and lesser rulers and a telegram to the governor-general, notifying them of his claims and calling upon them to follow him. He was either, it seemed, a lunatic or a prophet.

"Whosoever doubts my mission," the Mahdi wrote boldly, "does not believe in God or his prophets, and whosoever fights against me will be forsaken and unconsoled in both worlds." The timing of this announcement was carefully planned, as according to many prophecies 1882 was the very year in which the Mahdi would reveal himself.

The Mahdi (ca. 1882). In 1881 Mahommed Ahmed ibn Abdullah declared himself to be the Mahdi: the legendary, messianic successor to the prophet Mohammed. The Mahdi's fanatical religious movement threatened to overthrow the Anglo-Egyptian government of the Sudan.

The Mahdi was fanatical and charismatic. Followers flocked to him. His appeal was in part political and nationalistic, for he openly vowed that the Sudan was for the Sudanese and the foreign rulers—by this he meant primarily the Turks—must be cast out. He declared a jihad against the Turks. But the Mahdi's appeal was also religious. The mystically inclined Sufi sects of Islam had always thrived in the Sudan, and the Mahdi's words and actions fit the prophecies and superstitions well; he

promised eternal bliss to his followers. Finally, he offered economic and political gains. Most of the tribes living along the White Nile had been disrupted and ruined either by the slave trade or by the attempts to eradicate the trade. The Mahdi would free them of such abhorrent interference. In short, the time was ripe for revolution in the Sudan.

Although the British advisers and the central Egyptian government knew full well of the existence of this sect, they badly underestimated its strength and the danger of its appeal. Giegler Pasha, the Inspector General for the Suppression of the Slave Trade in the Sudan, wrote to Sam explaining that many in Khartoum at first considered the Mahdi a "harmless idiot, such as the country abounds in. When the news first reached Khartoum that this man pretended to be the Mahdi, the matter was considered rather a good joke."

That impression was soon to change. In July 1881 the current governor-general of the Sudan, Raouf Bey, sent the nefarious Abou Saood to Abba Island to bring the Mahdi to Khartoum for a reprimand. The Mahdi most vigorously declined to travel to Khartoum, so Abou Saood left and returned in August with a force of 240 soldiers. His soldiers were massacred, clubbed to death by the Mahdi's followers. Only a few men managed to reach the steamer, from which Abou Saood watched in horror. The Mahdi, no longer appearing to be a "harmless idiot," continued to expand his army and influence. He conquered El Obeid, the capital of the province of Kordofan, in January 1883.

Of course, the Mahdi's activities were the topic of much discussion between Sam and Gordon. Gordon depicted Egyptian affairs as "a small nest of sleeping devils in me," one that he did not wish to awaken, as if he wanted to stay out of it entirely. Nonetheless, he assured the foreign secretary that the rebellion was relatively insignificant. As a religious man, Gordon harbored a sneaking admiration for the Mahdi and felt that God was working out some intricate scheme to liberate the Sudan from the pashas.

Major John Hamilton Stewart of the Eleventh Hussars, sent out to gather intelligence on the situation, disagreed strongly. First, he warned the British government of the appalling state of the Egyptian army:

> I believe an army of old English-women armed with broomsticks would have beaten them. . . . You can have no conception of the crass ignorance

Enlisting Troops in Cairo (1884). Men to fight the Mahdi were
forcibly recruited in the streets and prisons of Khartoum and
Cairo. Their lack of training and discipline contributed to the
slaughter of General William Hicks and his troops and the
ignominious defeat suffered by Valentine Baker, who escaped
with his life and only 1,000 of his men.

of the officers, [who have] not the faintest idea of drill, maneuvering or outpost duty. Quite a third of the troops are ignorant of the use of the rifle and would be more formidable if armed with sticks.

Because of the pathetic state of the Egyptian army and the immense following the Mahdi was capable of commanding, Stewart strongly recommended that Britain and Egypt abandon the provinces south and west of Khartoum (Kordofan and Darfur) as indefensible.

Though the British ambassador to the Sublime Porte agreed with this recommendation, the Ottoman minister of war, Cheriff Pasha, did not. Rather than abandoning such lucrative and sizeable portions of the Sudan, the minister asked Valentine for his advice. Valentine was only the head of police, but he was acknowledged to be an outstanding military officer. After discussing the problem with Sam by letter, Valentine suggested that the first priority might be to send Hicks Pasha with an expeditionary force to protect Sennar, the rich grain-growing region to the east of Khartoum. Without Sennar to provide food, Khartoum itself was indefensible. Valentine cautioned specifically that Hicks's force should on no account cross the Nile and try to take the western provinces of Kordofan and Darfur, as the task was too difficult. The minister took Valentine's advice and sent Hicks Pasha to Sennar.

However, after reaping success in Sennar, Hicks Pasha found his orders were revised dramatically. The minister instructed him to invade Darfur and Kordofan and rout the Mahdi's army. Hicks Pasha spoke no Arabic and had about ten thousand ill-trained and reluctant troops under his command. He had had very little time to earn their respect or to teach them British military discipline. They were "perhaps the worst army that ever marched to war" in the opinion of some observers, but Hicks Pasha was a fine, brave, and obedient officer. On September 8, 1883, he led his force into Kordofan. On November 5 the Mahdi's army annihilated him, all his officers, and nearly all of his troops.

The news of the slaughter provoked a deep emotional response in Britain. A valiant soldier, a much-admired British officer, had been sent to his death. Worse yet, the decisive defeat challenged an arrogant but widespread imperial belief. Britons tended to assume that a good British officer or two could always lead native troops to victory, even when they

were outnumbered, but this was patently untrue. Besides, only those who had served in the Sudan knew how very difficult it was to make an effective army out of reluctant Sudanese recruits.

Sensing a catastrophe was pending, Prime Minister Gladstone decided that the British garrisons and civilians must be evacuated from the Sudan. In confidential reports within the government, in *The Times*, the *Pall Mall Gazette*, and similar influential newspapers, various men were suggested as candidates to oversee an orderly withdrawal. Most often mentioned were Sam Baker and Charles Gordon, the two men who had held the rank of pasha in the Sudan. Both had had extensive military experience in the Sudan; both were highly regarded as heroes.

Gordon was the choice of many. He was more than ten years younger than Sam and had more recent Sudanese experience. Gordon had a strange quality about him—a strong tendency to depression, combined with a disdain for pain or danger and a relentless energy. He also had a tendency to judge men impulsively, on first meeting, and to act irrevocably on that judgment. Yet he was a compelling leader of men. As an officer in the Royal Engineers wrote to the chancellor of the exchequer: "If the Mahdi is a prophet, Gordon in the Sudan is a greater [one]."

C. Wilson Rivers, in conversation with Lord Salisbury, commented: "If you want some out-of-the-way piece of work done in an unknown and barbarous country, Gordon would be your man." What Gordon was not was either an orthodox or an obedient soldier.

Sam was not everyone's first choice, but he had a formidable reputation for his military expedition along the White Nile. Florence was frantic at the suggestion that Sam should return to the Sudan. He was sixty-three years old and growing stout and gouty. Though he was still vigorous and immensely strong, she felt he was no longer the man to lead a daring and dangerous rescue mission, against enormous odds, in difficult terrain and with untrained troops. It would require youth, stamina, and endurance that Florence knew Sam no longer possessed. Besides, she could not bear the thought of life without him, and she could not possibly go to Khartoum with him on a military mission. Gordon kept urging Sam to go, even suggesting, in a letter on January 4, that he and Valentine should team up. He reiterated the idea in an interview published on January 9 by the *Pall Mall Gazette*. Gordon did not take the Mahdi as a serious threat,

writing: "The Mahdi has no backbone and if not molested in a rash way will fall to pieces."

Florence was deeply relieved when Sam wrote a letter published in *The Times* on January 16, 1884, that argued: "Why should not General Gordon Pasha be invited to assist the government? There is no man living who would be more capable or so well fitted to represent the justice which Great Britain should establish in the Sudan. . . . If General Gordon were in command in the Sudan, he would solve the difficulty." She trusted that his preference for Gordon to go was sincere, but she could not put aside her worries.

While the government tried to come to a decision and select a leader, events in the Sudan grew more critical. The garrison at Khartoum held six thousand men, with still more soldiers in other garrisons. Where were they to be sent, supposing they could be rescued? How long could the most sizeable garrison, the one at Khartoum, possibly hold out if the Mahdi's troops got that far north? In November a very nervous colonel in Khartoum suggested that they had food enough for only two months, should they be isolated, as the natives were all against them. An overland line of retreat seemed suicidal, yet the river might be closed to them at any time.

The khedive pressured Valentine to take his motley force of policemen, comprising some thirty-five hundred Egyptians and Turks, to try to rescue some of the garrisons near Souakim. They were completely unready for such a mission, and Valentine knew it. The night before the battle, he characterized his troops as "utterly worthless." Faced with the Mahdi's fanatical troops, the men simply turned and ran. Valentine and about a thousand of his men managed to escape alive; the other twenty-five hundred died. It was a humiliating defeat.

In the meantime, the khedive's government crumbled and his ministers resigned. A policy of evacuation seemed set. Sentiment for taking decisive military action in the Sudan also ran high in Britain. The question was: who to send? The Baker brothers might be capable, but they would be very awkward choices, sure to incur the queen's wrath. Gordon was a stalwart leader but also difficult to control and too inclined to follow his own lights rather than orders.

On January 12 Gordon decided to visit Sam at Sandford Orleigh to

discuss the matter in person. He took with him an old friend and spiritual adviser, the Reverend R. H. Barnes. Sam met the train with a carriage and took them for a long drive before going home for tea. As they drove through the peaceful Devon countryside, Gordon talked with his eyes alight about the Sudan and what should be done there. As he had time and time before, he pressed Sam to take on the job. Gordon said, perhaps untruthfully, that he did not want to go himself, as he had already agreed to go to the Congo on a mission for King Leopold of Belgium. Sam was tempted. *Gordon makes it sound like such a glorious adventure,* he thought in his still-boyish way.

When they arrived at the house, social obligations intervened and the serious conversation was postponed. Florence, serene and lovely as ever, greeted Barnes and Gordon warmly. Through Gordon's politeness, she saw the fanaticism that burned in his intense, pale blue eyes and thought what a very odd man he was. She also saw plainly that Gordon wanted to go to the Sudan himself. *He should go to Khartoum, if he wishes,* Florence thought. *He talks almost as if going into battle against overwhelming odds is a holy ritual—a way of offering his death to God, to see if He would accept it.* It was a strange impulse to self-denial, or perhaps a testing of fate, for him to try to persuade Sam to go instead.

Florence held no personal malice against Gordon, though she knew him to be dangerous. The danger lay in his nature, like the venom in a scorpion. He had no regrets when he contemplated dying, and so he assumed Sam would have none either. But she would never let Sam die in a hopeless cause, and the Sudan certainly appeared to be one. Dying for a cause was not glorious when there was no chance of winning; it was suicide. Gordon thought he would win Sam over, but she knew Sam as Gordon did not, and therein lay her advantage.

"Do you take milk or sugar, General Gordon?" she asked him sweetly. Like the perfect Victorian wife, she poured the steaming tea from the silver pot into an exquisitely thin porcelain cup. She added milk for him and passed the cup. Then she offered him plates laden with sweets, slices of cake, fruit tarts, pastries, and delicious savories, like the tiny sandwiches of pressed tongue, chicken mayonnaise, and mustard that Princess Alix favored. Next she served the Reverend Barnes, then Sam, and, last, herself. She knew exactly how to behave in such circumstances; she had had the

Florence Taking Tea at Sandford Orleigh (ca. 1889). When Charles Gordon came to tea at Sandford Orleigh in 1884, Florence sweetly reminded Sam that he had promised never to return to Africa without her—and she was not going back to the Sudan.

Prince of Wales to tea. No man's presence, however exalted he might be, could ruffle her gracious demeanor. After settling the men into their meal, Florence turned to Sam calmly and spoke when there was a suitable pause in the chitchat.

"Sam," she said gently, "you promised me you would never go back to Africa without me. I do not go, so you do not go." And then she smiled radiantly.

Sam looked at the expression on Florence's face and saw her for a moment as a stranger might see her. Because she was still beautiful, he had not noticed that she had grown older, plumper, and more matronly, nor had he faced the fact that he was now stout, gray-bearded, and troubled by various aches and pains of age. He saw in an instant so clearly that she was right. Of course he would honor his promise to her, but more than that, he realized that he was no longer the man for the job. He once had been, it was true, but he had aged and matured. He turned to Gordon and said simply, "You see how I am placed, my dear Gordon—how could I leave all this?" Then he turned to Florence and returned her smile, patting her hand softly for a moment.

Gordon was dumbfounded. He thought at first he had not heard correctly, that Florence had said something quite different. But Sam's remark was plain and he could not comprehend it. Had Sam Baker—Baker Pasha—just refused to go to the Sudan on a glorious mission *because of a woman's wishes?* It was impossible, untrue, unthinkable. And yet it had happened.

Gordon had always taken Florence for a pretty woman, nothing more. Perhaps he had never considered that to survive the rigors of two African expeditions she must have possessed exceptional courage, strength, and mental fortitude. He had certainly never fathomed that she and Sam loved each other so deeply. Florence and Sam were widely spoken of as a "love match," but Gordon never knew what that meant. He was a man of limited empathy who neither liked nor understood women. He had never wished to marry and, just a year before visiting Sandford Orleigh, had written of himself, "I wished I was a eunuch at 14." Little wonder that Gordon could not understand the strength of the bond between Florence and Sam. He and Barnes stayed at Sandford Orleigh for a rather awkward evening and departed on the first train in the morning.

On January 18 Gordon left for Khartoum, taking Major Hamilton Stewart as his staff officer. Neither would ever see England again. Gordon's mission was ostensibly to survey and report on the situation. More than one high-placed government officer expected that, once in the Sudan, Gordon would carry out the evacuation. During the entire trip out to the Sudan, Gordon's brain was abuzz with ideas, often contradictory, sometimes "half-cracked," and always mercurial. He flooded the agent general in Cairo, Sir Evelyn Baring, with letters and telegrams, some suggesting actions directly opposed to those endorsed in the previous communiqué. Doubtless the British government began to wonder what sort of creature they had unleashed.

Gordon arrived in Cairo on January 25 like a whirlwind; he was welcomed to Khartoum on February 18, 1884. In his first public speech, he made the astonishing announcement that taxes would be halved for 1884 and that slave dealing was to be permitted in the Sudan "just as it used to be in former days." This was part of a scheme he had discussed with Sam by letter; his intent was first to get the slave trade highly regulated and controlled and then to abolish it. However, as he did not reveal his long-range plans in his speech, the antislavery sympathizers in Britain were completely aghast at his pronouncements.

From then on, events moved with lightning speed toward outright disaster. Gordon continued the confusing barrage of communications with Baring and others. In one five-day period he sent no fewer than

thirty telegrams; in a month he sent five lengthy and different proposals for resolving the problem. Finally, on February 26, Gordon telegraphed Baring telling him of his plans to "smash up the Mahdi," asking for additional funds and for British troops to supplement the Egyptian forces. The cabinet was stunned; Gordon had been sent to evacuate the garrisons, not embark on open warfare. They sent neither money nor troops.

Irate that the government would not accede to his demands, Gordon gave a lengthy and appallingly indiscreet interview to Frank Power, a correspondent for *The Times* of London. On March 10, the day the inflammatory interview appeared, the telegraph line linking Khartoum to Berber and the outside world was cut. In a postscript to one of his last communications to reach Baring, Stewart added: "A considerable body of Arabs has appeared within sight of Khartoum on the right bank of the Blue Nile. We are throwing up a fort [named Omdurman] on the right bank." Khartoum was under siege.

Though for many months letters could be smuggled into Khartoum with some ease, getting them out was more difficult. During the siege, Gordon received letters from his sister Augusta, from Sam, from various government officials including Prime Minister Gladstone. Some of the letters from the government were maddeningly enciphered using a codebook that Gordon no longer possessed, for he had sent it out by boat, apparently for fear it would be captured. Among the letters Gordon managed to get smuggled out was one to Sam dated April 8, in which he made the extraordinary request that Sam raise three hundred thousand pounds from "British and American millionaires . . . to engage some Turkish troops from Sultan and send them here. This would settle the Sudan and Mahdi forever. . . . I do not see the force of being caught here [by the Mahdi] to walk about the streets for years as a dervish, with sandaled feet; not that, *D.V.* I will ever be taken alive."

Now that Khartoum was besieged, there was enormous public sentiment in England that an expedition must be sent to rescue Gordon. Even the queen sent a telegram to Lord Hartington, secretary of war: "Gordon is in danger, you are bound to try to save him." Still, the British government hemmed and hawed indecisively. They had sought to avoid costly and dangerous involvement in the Sudan by sending Gordon to extricate British interests. Now they were being pressed to rescue the rescuer.

After six months of siege, convinced that a relief expedition of British troops was on the way, Gordon ordered Stewart to leave Khartoum carrying with him a pathetic letter to Baring, reminding him how often Gordon had begged for reinforcements. In addition to carrying messages, Stewart and the men who went with him were charged by Gordon with retaking the garrison at Berber, though Gordon had been expressly and repeatedly ordered not to do this. This instruction so infuriated the prime minister that he demoted Gordon from governor-general of the Sudan to governor of Khartoum. The demotion was of little importance, as Gordon knew nothing of it.

There was no controlling Gordon from near or far, as many had predicted. The stress, the loneliness, and the anxiety of the situation brought Gordon very close to a complete mental breakdown. In his journals, he ranted and raved against everyone: the Sudanese, the British government, the Mahdists, and not least of all himself. On November 3 Gordon sent Sam and Florence a cordial note of farewell, saying, "We are about to be hemmed in here . . . all roads are cut off and we must eventually fall, and with Khartoum fall all other places. . . . I have not time for more and doubt if you will get this, for we may expect the roads cut today or tomorrow. If the Nile was high it would be easier."

The next day he sent word to the government that he could hold out for another forty days. Less than two weeks later the Mahdists attacked the fort at Omdurman across the river with tremendous force and determination. The result was that communications between Khartoum and Omdurman were cut off. Now Gordon was completely isolated.

December 13 was the 276th day of the siege, the day beyond which Gordon had told the British government he could not hold out. He was in despair. He sent out one last set of messages, begging for a relief expedition, and a final letter to his sister. On December 31 he sent out a native soldier who managed to get through the Mahdi lines. The messenger committed Gordon's words to memory so that he would not be carrying any papers that would condemn him if he were captured: "We are besieged on all three sides. Fighting goes on day and night. Our troops are suffering through want of provisions. The food we have is little, some grain and biscuits. We want you to come quickly. You should come by Mehetma and Berber."

On January 26 Khartoum fell. The Mahdists swarmed into the town, and Gordon, in his dress uniform, marched out of the palace and stood a moment at the head of the stairs. He was shot by the invaders, then speared. His dying body was dragged down to the bottom of the stairs, where he was slashed and stabbed repeatedly. Then he was beheaded and the trophy taken to the Mahdi's camp. His head was mounted in the fork of a tree on the east side of the Nile, where the Mahdi's followers stoned it. As they approached by steamer two days later, the relief expedition could see Gordon's head plainly. The steamer never bothered to land at Khartoum. Even if they had been in doubt as to whose head was displayed by the Nile, no British flag flew above the ramparts of the city.

General Charles Gordon (1885). Charles Gordon took on the task of evacuating the British citizens and troops from Khartoum, a nearly suicidal job that Florence persuaded Sam not to accept. This full-page portrait appeared days after Gordon died in the fall of Khartoum.

Like much of the British public, Sam and Florence were outraged by the government's indecision and timidity, which had doomed Gordon. Sam started referring to the prime minister as M.O.G., Murderer of Gordon, a phrase also used in the music halls. He was furious that his brave friend had died while the politicians smoked cigars and slowly pondered the safest and cheapest course of action. Sam fumed to a friend, "I shall never publish another remark concerning Egypt. Now that poor Gordon is sacrificed, I unstring my bow; and remain a passive spectator of the misery and shame that have been the result of British interference."

Sam had known Gordon and admired him in many respects. Florence shuddered at the terrible death that had befallen their colleague, though Gordon would have sent Sam in his stead had she not managed to stop it. Gordon was one of the few who knew what they had been through in the

Sudan and who could appreciate what they had accomplished. Gordon had followed in their footsteps in the Sudan, and he had gone courageously to fight one last time for the cause of the Sudan. Now the vision they had shared with him of a united, prosperous, and peaceful Egypt and Sudan was dead.

Sudan, and who could appreciate what they had accomplished. Gordon
had followed in their footsteps in the Sudan, and he had gone south
actually to fight one tribe, in order to free the slaves of the Sudan. Now the vision
they had failed to dream of a united prosperous civilized Sudan and Egypt and
Khartoum died.

HOW CAN I LIVE?

*I*n recent years, Florence and Sam had faced too many
deaths. Sam's sister Min Cawston had been the first to
die, in 1882, followed by his brother John and his daughter
Constance in 1883. In 1885, a few days before the fall of Khar-
toum and Gordon's death, Valentine's daughter Hermione
died of a long-standing illness. Within a month, Valentine's
wife, Fanny, was dead too. The Baker family was bereaved.
Travel seemed a good way to soften the blow and escape
the bitter winter cold of Devon. They spent the winter of
1885 in India, and the next winter visited Valentine and his
daughter Sybil in Egypt. Sam's daughters Agnes and Ethel
were in their early thirties but became close friends with
their cousin Sybil, who was just eighteen. It was lovely to
see them enjoying themselves and life in Cairo, but Flor-
ence and Sam were feeling a little old and useless.

In 1887 Valentine and Sybil came to spend his prolonged
leave, April to October, at Sandford Orleigh. On the day
set for the massive celebration of the queen's jubilee, June
20, they all traveled down to London to admire the grand
parade, in which all the finest regiments of Her Majesty's
armies, colonial and domestic, marched in procession

through London. The display looked like the height of the British Empire, though it was more nearly the beginning of its end. The Tenth Hussars, the regiment that Valentine had led so long and so well, were splendidly smart and their horses superbly turned out and handled. Valentine longed to be among them.

Unfortunately, Valentine did not know that the queen had finally relented in her condemnation of him. As recently as 1884 she had refused requests to reinstate him. In early June there was enigmatic correspondence from the queen to the Prince of Wales saying that any inquiry into Valentine's case was undesirable and could lead to the publication of surprising information. Then, on June 15, 1887, the queen wrote to the prince that she had consulted her advisers and Valentine would be reinstated in the army—but not, of course, in the very brief interval before the jubilee. Nothing had yet been announced by the time Valentine returned to Cairo in October, accompanied by Sybil, Ethel, and Agnes.

Sadly, on November 16 Valentine died of a heart attack on a *diahbiah* on the Nile, still ignorant of his forthcoming reinstatement. He was vindicated only after death. Valentine was buried with full military honors and dignity. Lavish praise for his brilliant career filled newspapers from Cairo to London. The Prince of Wales, Sir Evelyn Baring, and many other notables sent their condolences to the family, and a brass tablet in his memory was placed in the cathedral in Cairo.

Though Florence and Sam never returned to the Sudan, their legends lingered. Between 1878 and 1884 a German physician known as Emin Pasha—he had been born Eduard Schnitzer—was the ruler of the southern provinces of the Sudan. Not surprisingly, communication from Emin Pasha had been cut off by the Mahdist revolution and he was presumed dead. But in December 1886 the outside world learned that, incredibly, Emin Pasha was still holding out in the southern Sudan. Henry Morton Stanley, the man who had "found" Livingstone, was dispatched to Africa in 1887 to rescue Emin Pasha—who was somewhat ambivalent about being rescued at all. One of Stanley's colleagues was a young Englishman, A. Mounteney Jephson, whose diary revealed that there were still many Banyoro who remembered Florence and Sam vividly. They spoke to him of Florence, whom they called Myadue, with great fondness, and they remembered her kindness. But it was their admiration for Sam that was

Walker & Boutall. Ph. Sc.

Sam^l W. Baker

the most striking: "We don't care for Gordon or Emin, Baker is our man. When he fought, he was always to the front; when he fired, he never missed; he was indeed a man! If we did not obey orders, he shook us: then our teeth dropped out."

In April 1888 Stanley's expedition finally reached Emin Pasha, who reluctantly agreed to return to civilization late in 1889. One of the first letters Emin Pasha wrote in 1890, when he had recovered his health, was to Sam:

> As I always had the greatest admiration for the splendid work you did in our provinces, and as I had the privilege of following your tracks through comparatively remote countries—Latooka, for instance—I was most naturally delighted to have some lines first from you. You were not forgotten amongst my men, who never wearied of telling their young comrades the story of Sir Samuel (as they call you) and his daring feats. In Bunyoro, also, you are remembered: and many times old Rionga, whose country has been annexed by Kabba Réga, and even the latter, have spoken to me about you. . . .
>
> May I ask you to pay my deepest respects, and to give my kindest regards, to Lady Baker. The natives of Bunyoro have very often spoke to me of "the Morning Star," as they call her up to this day; and my men were delighted in sounding her praises as a kind intermediary between yourself and their duty. At M'tesa's, I saw a picture of Lady Baker and yourself, taken from The Albert N'yanza—and M'tesa said you had sent it to him.

The letter from Emin Pasha cheered Sam up greatly: all he and Florence had done was not in vain. Something persisted, if only the memory of an honest and true white couple who had penetrated the Sudan.

Sam's daughter Agnes married Antony Crawley Bovey, the superintendent of the Ceylonese estate that Sam and his brother John had founded so many years before. It seemed somehow right that she should return to the family plantation. But in 1890 at almost forty years old, she died giving birth to what would have been her first child. Of all the children born to Sam,

Sam Baker (ca. 1888). In 1890 Emin Pasha reported that the natives of the southern Sudan remembered Baker Pasha and Myadue, the Morning Star or Daughter of the Moon, as Florence was known.

only Edith and Ethel now survived; Ethel lived with Florence and Sam at Sandford Orleigh. Of Sam's six siblings, only James, Ellen Hopkinson, and Ann Bourne still lived. It was a cruel realization for a man like Sam, who loved to be surrounded by his family.

In the autumn of 1893 Sam's health seemed to deteriorate and Florence fretted. Sam was troubled more and more by gout and by mild attacks of angina. His doctor suggested more physical activity and less rich food, advice that Sam ignored. As he always had, he ate large meals and drank plenty of good port. After Florence's doctor presumed to recommend the same to Florence, she told him tartly, "I am not a horse that I should be exercised."

They decided to spend the winter quietly at home. Sam wrote to the Countess of Stradbrooke, with a charming refusal of an invitation:

> I really *dare not* accept it. . . . I am thinking of others more than of myself. I will not bother other people, now that I am growing old. If I were once again at [your house] Henham, I fear I could not resist the same enjoyments which I had in olden times. This would most probably bring on an attack of gout; in which case I should be a burden to my friends and an encumbrance to myself. . . . We have, in fact, made up our minds not to go beyond the limits of our own country this winter. . . . I shall try "prudence" this year—a drug I have not always recognized through life.
>
> I cannot tell you how my heart sinks when I acknowledge, that "the spirit is willing; but the flesh is weak." Those who were born in 1821 cannot be like those born at a later and more reasonable date. I have no fear of hot countries; but the cold keeps me indoors.

Sam hated to admit that he was no longer young, and he still loved to have younger people around him. Numerous nephews, nieces, and grandchildren found visits to Sandford Orleigh great fun; one immortalized Sam in her diary as a "dear fat old fellow and so affectionate" who kept them up late by telling fascinating tales of Africa. Florence persuaded Julian to come to Sandford Orleigh for Christmas of 1893, so the three might reminisce about their adventures in Equatoria while they sat warm and cozy by the fire. When Julian arrived, Sam had been sent to his bed

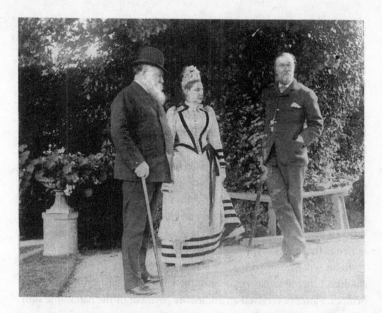

by the doctor, as for some days he had been feeling poorly with gout and chest pains. On December 29, alarmed by Sam's continued pain, Julian, without telling anyone, quietly left the house to seek a doctor.

Sam, Florence, and James Baker at Sandford Orleigh (ca. 1891). Though almost 30 years older than when the portrait of this threesome was taken in Paris, Florence retained the beauty and flair she showed in 1865. (From left: Sam Baker, Florence Baker, and James Baker.)

He need not have tried to fool Florence. She knew perfectly well how ill Sam was. She had lived with him and loved him for thirty-four years.

On the night of December 30, 1893, Florence sat with Sam, tenderly seeing to his every need, as she had in their direst moments of sickness and starvation in Africa. Near midnight, he opened his eyes to look at her and said, "Oh, Flooey, Flooey, how can I leave you?" Cradled in Florence's loving arms, Sam died.

It seemed to Florence that her heart stopped beating in her chest. In times of danger she had more than once sworn to shoot herself rather than live without Sam. Now, in the safety and comfort of Sandford Orleigh, she felt the same impulse. She wrote a friend in anguish, "How can I live, now that my all is taken from me?" The Baker family feared to leave her alone,

lest she attempt suicide, and went into their defensive formation. Julian returned for as long a visit as he could manage to help Ethel, who assumed all the responsibility for the household. Edith came to visit, along with her children—Cyril, Ellen, Ida, Violet, and Bernard—some of them now grown. At twenty-three, Ida was one of Florence's favorite grandchildren, and she stayed on for a few months. She was specifically instructed to sleep in Florence's room. However deep her despair in the dark hours of the night, Florence would never cause Ida to suffer finding her dead in the morning.

Florence went into deepest mourning, wearing only unrelieved black. She kept everything at Sandford Orleigh just as it was in Sam's day. According to his wishes, Sam was cremated. Many in the family were shocked; cremation was not common. Florence did not care. She had shocked people before, and this was what Sam wanted. His ashes were buried in the family crypt at Grimley, near Worcester.

In his will Sam provided handsomely for Florence and his remaining children, Ethel and Edith, so none of them need ever face any financial difficulties. Florence received an immediate payment of the handsome sum of two thousand pounds as well as

all my watches, jewels, gems, ornaments of the person and wearing apparel, and all my plate, furniture, linen, china, glass, pictures, musical instruments, books, articles of vertu and other articles of household use or ornament including objects of Natural History, guns, carriages, horses, harness, and stable furniture, live and dead stock, tools, implements and utensils, and wines, liquors, and household stores and provisions, and also all my manuscripts, copyrights, and interest in publications including any moneys due at the time of my death in respect of any copyrights or interest in publications and the full benefit of any contract or contracts. . . .

I devise my mansion house and estate called "Sandford Orleigh" . . . unto and to the use of my said wife Florence Barbara Mary Baker . . . to permit my said wife and her assigns to occupy the said mansion and estate or to receive the rents thereof so long as she shall live and continue my widow. . . .

And I appoint give and devise all the rest and residue of my real and personal estate and all leasehold and copyhold estate respectively belonging to me at my decease . . . unto and to the use of my said wife . . .

Florence also received an annual income from Sam's stocks and other investments. He had, as he promised, taken care of her. He even specified that, should Florence marry again, she would continue to receive an annual annuity of two hundred pounds, so that she might never be financially dependent upon another man.

Florence's courage was resurrected and she found some peace in life, but it took time. A year after Sam's death, she wrote to her niece Ruth Baily, daughter of Sam's sister Ann Bourne: "It will be a year since my all was taken from me; and I have been trying hard to struggle on without him; but I feel very lonely and forsaken until it will please God to take me to my darling."

Even in her sorrow, Florence's kindness and love of children persisted. Not long after this letter was written, she received a visit from Ruth and her son Robin. It was the child's first visit, and he was initially intimidated by his great-aunt Florence and the opulence of Sandford Orleigh. He remembered his first sight of Florence vividly:

> She was in black. Her countenance was colorless and grave, her figure below medium height and dumpy, her [once-blond hair had darkened to] auburn . . . perfectly combed and plaited, and parted down the middle in a straight white line. She soon put me at my ease. Tea was on the table, and she piled my plate with good things, and afterwards handed me over to her stepdaughter, Ethel, and some other female cousin, and these two kind women played hide-and-seek with me in the grounds until we all got very hot. It was the beginning of a great friendship.
>
> Breakfast and teas were a schoolboy's delight. Thick Devonshire cream and strawberry jam were piled in bowls as large as basins. There was a profusion of good dishes and [at dinner] a confidential butler dispensed good wine.

There was much of Sam in this boy, Robin, and his youthful spirits and joy awakened the sense of fun that had lain dormant in Florence since Sam's death. They soon developed an especially close and affectionate relationship.

Robin became an annual visitor. The boy aged into a young man, while Sandford Orleigh stood still. "It was one of those perfected ordered

homes where elements of change seem nonexistent," Robin remembered. "It was a benevolent autocracy. Aunt Florence was Grand Dame and Hausfrau. There was a Roman gravitas about her. She never raised her voice and she never gesticulated."

Robin attended Cambridge University, where he made a reputation as an outstanding wicket keeper in cricket. In 1909, to Florence's tremendous pleasure, he was selected for the elite Sudan Political Service. She laughed with him to hear of his enormous starting salary: £420.

Before Robin left for the Sudan, both his grandmother and his mother took him aside and told him some of the stories about Florence's early life and the slave market in Viddin. When he arrived in the Sudan, Robin found, to his astonishment, that Florence and Sam were both well remembered. Some of the old hands even asked him if it was true that she had been in a pasha's harem and had been given or sold to Sam in return for some kindness. He had thought of these stories as vague family legends,

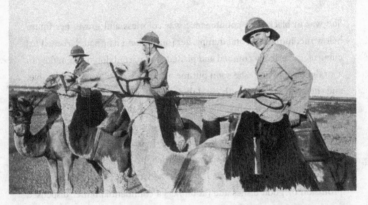

Robin Baily in the Sudan (1909). Sam's grandnephew Robin Baily joined the Sudan Political Service. He delighted Florence with stories of the sons and grandsons of the sheiks she had known. Robin is shown here with G. Hall (left) and C.G. Dupuis (right) in Karari, Sudan.

kept secret from the children until they were old enough to understand, so he had paid little attention to them. The fact that the story of Florence's harem origin was known surprised him. He stoutly defended Florence's honor by telling of her deep devotion and long, happy marriage to Sam—though of

course those in no way negated her unusual early life. But he would not have her thought of as a concubine or a trollop.

Robin always visited Florence when he was back in England. The more he came to know the Sudan and Arabic, the more fun he and Florence had trading stories. She would reminisce about the Hamran elephant hunters, and he would tell her that they still remembered her long blond hair and Sam's great gun, "the Baby." She would tell him her memories of some nomadic chief, and Robin would tell her of his friendship with the chief's son or grandson. She always spoke with great fondness of the trip to Abyssinia in 1861, and with bitter condemnation of the slave traders and their cruelty.

Having Robin visit was for Florence a little like having Sam back, and she loved to joke with him. He remembered:

> She loved to have parties and she looked charming in her black velvet with snow white arms and neck. She was not at all intellectual and took little part in the conversation but she made everyone else feel at ease and she smiled and laughed at anything that tickled her. Sometimes she would exchange a little Arabic with me. For instance, she allotted me a pretty girl to take into dinner and asked me across the table in Arabic what I thought of her and I answered "Allah will reward you oh my Aunt; the girl is lovely" and she shook with interior laughter.

No one else at the table had the faintest idea what had been said, for no one else spoke Arabic—and that was half the fun.

Naturally, it was to Robin that Florence recounted the occasion when a nervous young man, assigned a seat next to the famous Lady Baker at another dinner, had difficulty making conversation. Finally he stammeringly asked if she had ever been to Africa. "I just stared at him," Florence told Robin.

After Sam's death, Florence rarely heard from those involved in Uganda or the Sudan, except of course Robin and a few personal friends. Sam, not she, had always been the publicly acknowledged Sudan expert. Doubtless most thought her long dead, but she lived on for many years with the indomitable courage that had always marked her personality.

At the very end of Florence's life, her niece Lady Beatrice Wood came to live at Sandford Orleigh to help Ethel look after the old lady. Now that no one cared anymore, Florence began to tell more stories of her early childhood, of the terrible fires and bloodshed in Transylvania, of traveling with the army and enduring the dreadful conditions in the refugee camp, and of escaping from the slave auction in Viddin with Sam. These were the events she had hidden all her life. She had never spoken freely of them to anyone but Sam, though of course Sam's brothers and sisters, and their spouses, all learned something of Florence's past when she first appeared in England. As Florence reminisced about her youth to Beatrice, the details were vague and sometimes changed, but the emotions were still very strong: young Florence had been terrified, orphaned, stolen, sold, and stolen again. Sam's rescue of her was providential, their love story magical.

Some had wondered why Florence had never tried to find her family in central Europe, but the memories of Transylvania and the war explained everything. For whom would she look? She had seen her mother and brothers killed in front of her, and her father, the soldier, was certainly dead. Her nursemaid, if she had not died in the camp at Viddin, had abandoned her to a sordid fate. The Finjanjians, who took her in, raised her as a daughter, and put her up for sale as a harem slave, held no fond spot in Florence's memory. She remembered Ali and his kindness, but he was long dead and her memories of him were confused with those of Africans she had met along the Nile. She remembered the smallness of the ambitions she was allowed to hold in the harem and the claustrophobic restrictions of her life. Most of all, she remembered the terrible humiliation and fear when she realized she was a slave. There was no one in Hungary or Bulgaria she could have found that she cared for.

On May 8, 1899, Florence wrote out her last will and testament. She left most of her possessions—the best furniture, silver, ornaments, pictures, linen, and so on, carefully enumerated room by room—to Ethel, Edith Marshall, and Julian. The rest of the furnishings of the house and outbuildings were to be sold by the executors and set up as a separate endowment fund for the Cottage Hospital at Newton Abbot "in the memory of Sir Samuel and Lady Baker." The house itself did not belong to Florence but had been left to her for her use during her lifetime; it was

sold after her death and the proceeds were divided between Edith and Ethel. Ethel was left four hundred pounds for her many years of caring for Florence; various grandchildren, nephews and nieces, godchildren, and friends, including Robin Baily, were left smaller amounts. Even the servants received modest bequests. At the end of her will, Florence carefully listed her jewelry and its disposition:

I bequeath my diamond necklace with pendant, my diamond (bangle) bracelet (all by Garrard) and my small diamond ring, also all my lace and furs to . . . Ethel Lindsay Baker. I bequeath my dressing bag and all its fittings bearing initials, my watch and my large (French) diamond star to my goddaughter Mary Florence Baker. I bequeath one of my diamond stars and my diamond and sapphire ring to . . . Edith Marshall. I bequeath my other diamond star and my diamond (bangle) bracelet to . . . Ida Marshall. I bequeath my gold and amethyst bracelet and my gold ring with one ruby in it to Geraldine Baker, wife of . . . Julian Alleyn Baker. I bequeath my diamond brooch with a sapphire to my sister-in-law Ellen Hopkinson. I bequeath my large diamond ring with pearl and my ruby ring to my sister-in-law Louisa Baker.

Florence lived peacefully and quietly in Sandford Orleigh, tended by her faithful stepdaughter Ethel, for many years. But in 1914 an official came to the house inquiring as to Florence's place of birth, nationality, and parents' names. The First World War—the Great War as it was known—had just started. Germans living in England were under suspicion as enemy aliens, and many were being interned for the duration of the war. Florence still had a strong German accent; perhaps someone had noticed it and reported her to the police. The old lady was terrified. *Why would the government want to know about me?* she worried. *What have I ever done?*

She no longer saw herself as Hungarian or German. She had no nationality but Sam's. Ever since meeting him, she had clung to his very Englishness: his fundamental decency and courage, his enjoyment of life, his gentleness, and even his imperial British arrogance. Now that he was gone, she lived with his memory drawn close about her. These officers were asking for the sort of information she had never revealed except to family and, in truth, perhaps no longer knew. Florence was alarmed that

she would be interned or, worse yet, sent out of the country. *Will they deport me? To where?*

Ethel could not calm Florence, nor could she imagine what to do. Fortunately, Robin's father, Edward Baily, learned of the situation. He contacted someone in a position of power in the government and told the story. After all, an old lady of seventy years, the wife of a man knighted for his services to the empire, was a most unlikely spy, and it was wicked to frighten her. No more was ever heard of the matter.

23

MARCH 11, 1916

*W*hen she awoke this early morning, she was laboring to breathe. It seemed a terrible effort to move her chest to make the air go in and out. The air was close and hot. *Ah*, she thought, not bothering to open her eyes. *I know where I am. We are on the White Nile, and we must be mired in the sudd. It is always so hard to breathe there.*

It was reassuring to remember where she was, for sometimes she was very confused when she woke up. She did not feel very well. *Not quite the thing today*, she mused. *I must have fever again.*

Tock-tock-tock. She heard the noise and recognized it. *No, it is not fever*, she thought. *I have sunstroke again, that's it. The men are digging my grave, with pickaxes, just like the last time. That is what they do when you have sunstroke. Poor Sam; he must be very worried that I shall die. In a minute he will waken and come to me. I shall open my eyes and look into his dear face, and we shall both be so very happy to be alive and together in Africa.*

Her face smoothed with the serenity of this thought. *I shall be with Sam in a moment. Tock-tock-tock.* Her breath stopped, her heart stopped, and she went to join Sam and find the source of the Nile.

The hands on the grandfather clock in the hall pointed to a few minutes before six.

✻

FLORENCE'S PASSING WAS ANNOUNCED IN *The Times* with a simple death notice on March 15, 1916. Perhaps fittingly, her name was garbled:

BAKER—On the 11th March, at Sandford Orleigh, Newton Abbott, FLORENCE MARY BARBARA, wife of the late SIR SAMUEL WHITE BAKER, aged 74.

The world took little notice. The Bakers' remarkable deeds had been eclipsed by war news, for on the day that Florence's death was announced, eight hundred men were killed in the battle at Verdun. The loss of one old lady, even an extraordinary one who had escaped from a harem and explored Africa with her lover, seemed a small thing by comparison.

In their worst moments in Africa, Florence and Sam had been uncertain that all their efforts had produced any lasting changes for the better. They had even despaired of having any effect at all, fearing that Africa would swallow the order and decency they had tried to establish and return to unrestrained chaos and brutality. In this they were mistaken.

Long after the Bakers' journeys, travelers in Uganda and the Sudan continued to hear of memories of Florence and Sam. In 1894 Albert Lloyd, a missionary, spoke with a man living near Lake Albert who had been a personal servant of Sam's. The man said, "I am an old man, I have seen a great many Europeans in the Ganya country, but the greatest of them all called himself Baker Pasha. He had with him his wife and they built a house on the hill . . . and there he lived for many months. I went to him as a young man. . . . He used to tell me many things, and we loved him because he talked to us; he was kind and helped us in our sorrows and fought against our enemies. He tried to teach us. . . . We loved him and his wife, and we love their memory still, because they were kind to us."

Five years later, Charles Delmé-Radcliffe took charge of the Nile Province and found memories of the Bakers were still vivid. He wrote: "Our best recommendation to the natives we found to be that we belonged to the same nation as Baker, and that our government would be like his."

Whatever resentments the Africans had felt at the time concerning the Bakers' imperialist attitudes or high-handed ways, they faded with time until only the fondness remained.

In 1960—ninety-nine years after Florence and Sam had set out from Cairo on their first trip to Africa—an anthropologist working near Lake Albert heard stories of Baker Pasha and his beautiful Myadue. Sam's commanding presence and Florence's beauty and kindness were woven into local folklore about "the roseate days when Europeans freed the people from the slavers."

NOTES

1. I AM NOT A SLAVE

PAGE

2 "January was the usual time" Harvey, *Turkish Harems*, p. 245.

2 "had an uncanny ability" Some well-to-do, married women of the Ottoman Empire made a practice of buying young girls and training them for the harem: see Garnett, *Turkish Life*, pp. 79–80; Malik-Hanim, *Thirty Years*, pp. 125–40; Davis, *Ottoman Lady*, pp. 99–107; Toledano, *Slavery and Abolition*, pp. 40, 68–70.

2 "She took lessons" On the education of girls in the harem, see Davis, *Ottoman Lady*, pp. 45–60; Malik-Hanim, *Thirty Years*, pp. 125–26.

2 "Finjanjian Hanim" *Hanim* was an honorific used for married women in the Ottoman Empire. *Finjan* is the name for a tall porcelain beaker set into an openwork metal holder that is still used in central and eastern Europe. Finjanjian was a common surname in the Ottoman Empire for Armenian porcelain sellers: C. Fleischer, comment to author; White, *Three Years*.

2 "Knowing European languages" Davis, *Ottoman Lady*, p. 54.

2 "Florenz had reached puberty" In the Ottoman Empire in the nineteenth century, girls were usually married as virgins between the ages of twelve and fourteen, since the girls' puberty was required before consummation occurred: Croutier, *Harem*, p. 109; Davis, *Ottoman Lady*, p. 61. Slave girls sold into the harem were either sold early for further training (the age of six is cited by Davis, *Ottoman Lady*, p. 104, and Malik-Hanim, *Thirty Years*, pp. 125–26), or at puberty to be concubines or odalisques (Toledano, *Slavery and Abolition*, p. 68, cites "early teens" as the age of such sales). These early marriages and sales reflect a social view that a girl was adult at puberty, when she was required to wear the veil in public. Females were generally categorized as *umm-ül-velet*,

girls who had reached adulthood, at twelve years according to Sertoglu; see "Beçce," *Resimli osmanli tarihi ansiklopedisi*, cited in Davis, *Ottoman Lady*, p. 117.

2 "A new immigration law" For this law and its effect on the white slave trade, see Karpat, *Ottoman Population*, pp. 63–68; and Toledano, *Slavery and Abolition*, pp. 12, 32, 83–85. Some sense of the scale of the trade can be gleaned from a report in the *Morning Star* (London) on July 15, 1865, stating that upward of 10,000 Circassian children of Christian parents were exported annually from Constantinople and other Turkish ports in Egypt: quoted in Beachey, *Slave Trade*, p. 166.

2 "Sometimes they were kidnapped" A few firsthand accounts from those taken into the harem survive: Toledano, *Ottoman Slave Trade*, quotes the following story: "One day, however, my mother came to us with joy in her face and said to me: 'My children, your [late] father must be having in his favor the ear of the Prophet. Here comes to us a miraculous help. A rich *Hanoum* wishes to buy six or seven little girl slaves. I am going to sell you three little girls, and with the money go back to the mountains to bring up your brothers as True Roumeliotes, not like mice in the city.' We were very happy" (p. 18). Davis, *Ottoman Lady*, provides another valuable insight into the process by repeating a firsthand abduction story: "One Circassian used to recall how she had been playing with other children when a horseman appeared and asked her whether she would like a ride. Captivated by the idea as any child might be, she was easily captured by the man and then taken to a slave dealer in a costal town" (p. 101).

For additional information on the selling of Circassian and Georgian girls by their parents, see: Wylde, Minute, 27 March 1873, PRO, FO 84/1370/33–34; letter, H. Elliot to Earl of Granville, 3 March 1873, PRO, FO 84/1370/28–31; Toledano, *Slavery and Abolition*, p. 34; Harvey, *Turkish Harems*, p. 245; Pardoe, *City of the Sultans*, p. 312; Shami, "Prehistories of Globalization:" pp. 177–204; Toledano, "Şemsigül."

2 "She was one of Viddin's" Viddin, alternately spelled Vidin and Widdin, is a Bulgarian city on the Danube. In the nineteenth century Viddin was a provincial capital in the Ottoman Empire.

3 " 'A man has but one' " Croutier, *Harem*, pp. 20–21.

3 "*paşmalik*, or 'slipper money' " Every female in the *haremlik* was entitled to a regular allowance, known as slipper money because it was often spent on baubles and clothing. Goodwin, *Private World*, p. 100.

3 "a visit from a *goruçu*" Croutier, *Harem*, pp. 32–33; Davis, *Ottoman Lady*, pp. 61–64.

3 "As soon as the date" Decor and architecture of harem rooms, and food, from author's visit to the Topkapi Harem in Istanbul; contemporary paintings by John Frederick Lewis, Frederick Goodall, Jan Baptist Huysmans, Jean-Auguste Ingres, and others; Penzer, *The Harem*, pp. 115–17; Davis, *Ottoman Lady*, pp. 207–44; Croutier, *Harem*, pp. 93–103, 162–67; Montagu, *Complete Letters* (London, especially "Dining with the Sultana, 1718" and letter, Wortley Montagu to Lady Mary, 1 Apr. 1717; *Fraser's Magazine*, "Visit to the Harem," pp. 679–86, 682–83; M.A.P.B., "Reception of a Lady"; White, *Three Years*; Melman, *Women's Orients*.

6 "The main reception room" Ibid.

6 "The scribe prepared" The slave trade was licensed, highly regulated, and taxed; receipts as late as 1893 describe the details of such transactions and the characteristics of the slave in question: Toledano, *Slavery and Abolition*, pp. 31–35; Davis, *Ottoman Lady*, p. 103.

6 "The black eunuch Ali" For the role of black eunuchs in the Ottoman slave trade, see Toledano, *Slavery and Abolition*, pp. 41–53; Penzer, *The Harem*, pp. 125–51; Croutier, *Harem*, pp. 125–41.

7 "Finjanjian Hanim was much in evidence" Clothing taken from contemporary paintings by John Frederick Lewis, Frederick Goodall, Jan Baptist Huysmans, Jean-Auguste Ingres, and others; Croutier, *Harem*, pp. 71–80; Anonymous, "Visit," pp. 683–86; M.A.P.B., "Reception of a Lady," pp. 234–35; Montagu, *Letters*; Stanley, "People of Turkey"; Penzer, *The Harem*, pp. 163–73; Lott, *English Governess*; Goodwin, *Private World*.

7 "A male slave trader" Accuracy in description of a slave had legal consequences; a slave trader who misrepresented slaves could be prosecuted, fined, and/or imprisoned: Davis, *Ottoman Lady*, p. 103.

7 "Virgins . . . were never" Toledano, *Slavery and Abolition*, p. 70.

7 "Certificates of virginity" Davis, *Ottoman Lady*, p. 104.

8 "Ali had been assigned" Ibid., p. 30; Pierce, *Imperial Harem*, p. 113. Goodwin, *Private World*, p. 109, emphasizes the strong emotional bond between a *lala* and his charge, especially if the charge was female.

8 "A high-ranking eunuch" Penzer, *The Harem*, pp. 144–51; Toledano, *Slavery and Abolition*, pp. 43–53; Croutier, *Harem*, pp. 125–41.

11 " 'your ugly old *lala*' " Ugliness was a desirable trait in eunuchs, presumably to prevent romances between eunuchs and women of the harem: Davis, *Ottoman Lady*, p. 30.

11 " 'a certified virgin from Hungary' " Not being Turkish or Turkish-speaking was considered an asset: Toledano, *Slavery and Abolition*, pp. 36–37; Malik-Hanim, *Thirty Years*, pp. 125–26.

12 *"She would not be a slave"* I thank Anne Baker for this insight into Florence's probable reaction to being sold as a slave.

12 "He was a square-shouldered" These descriptions of Sam and Duleep Singh are taken from Sam's 1857 daguerreotype portrait and Duleep Singh's 1858 photo.

13 "There had already been reports" *Fremden-Blatt*, 16 Jan. 1859; *Frankfurter Journal*, 20, 22 Jan. 1859; *Morning Post* and *Field*, cited in Hall, *Lovers*, p. 240. See also Campbell, *Maharajah's Box*, pp. 63-ff.; Hall, *Lovers*, pp. 23-ff.

13 "His bid was promptly countered" Family story says that it was the pasha of Viddin who bid against Sam, but different versions disagree about whose bid was higher: Anne Baker, comment to author; Anne Baker, *Morning Star*, pp. 22-ff.; Hall, *Lovers*, pp. 27–29.

13 "Soon the pasha's man" Prices based on information in White, *Three Years*, pp. 279–84; Lewis, *Race and Slavery*, p. 8; Lane, *Manners and Customs*; Malik-Hanim, *Thirty Years*, pp. 125-ff.; Pischon, "Das Sklavenwesen"; Pardoe, *City of the Sultans*, p. 312; Cox, *Diversions*, p. 54. Exchange rates among currencies in the nineteenth century are calculated per McCarthy, *Arab World*, pp. 153–55. In the year 2001 approximately £21,339.40 or $47,890.60 had buying power equivalent to £460 in 1860, according to McCusker, "Comparing," and Officer, "Exchange Rate."

14 "Duleep Singh smiled" Information on Duleep Singh from Campbell, *Maharajah's Box*; Alexander and Anand, *Queen Victoria's Maharajah*; Login, *Lady Login's Recollections*.

15 "boat . . . used to carry corn" Corn, in British usage, usually refers to the grain known in the U.S. as wheat.

15 "Sam . . . stuffed a wad of currency into Ali's sash" One version of the Baker family stories about the auction is that Sam was outbid by the pasha of Viddin and bribed someone to let him make off with Florence. I consider this a more credible story than the alternative, that Sam outbid the pasha, on two grounds: first, it is unlikely Sam could outbid a pasha, and second, there would be no reason for the subsequent flight across Wallachia if Sam had simply bought Florence, yet the flight is documented in a letter: Sam to the Duchess of Atholl, 18 Apr. 1860.

2. SHOTS, KNIVES, YELLS, CORPSES, AND FIRE

20 "When they arrived in Calafat" This description of the customs official at Calafat is based on Barkley, *Between the Danube*, p. 4.

21 "They included passports" This imaginative use of a British gun license as a substitute for a lady's passport in the Ottoman Empire is described by Barkley, *Bulgaria Before the War*, p. 154. Since Barkley knew Sam and Florence in Bulgaria, it is possible that he used an incident from their lives for his book.

22 "He managed to find three drivers" Letter, Sam to Baker family, no date given, cited in Anne Baker, *Morning Star*, p. 22.

22 "The road was in appalling condition" Letter, Sam to Duchess of Atholl, 18 Apr. 1859, quoted in Hall, *Lovers*, p. 30.

22 "It was a thatched-roof" Description of the rustic inn and clothing after Lancelot, "Paris à Bucharest," pp. 177–224, 425–39; Paget, *Hungary and Transylvania*; Pulszky, *Memoirs*; Winifred Gordon, *Woman in the Balkans*; Barkley, *Between the Danube*.

23 "she had been there" All versions of Florence's escape from Transylvania involve her nursemaid, or *dadus*, according to the Baker family. Letter, Anne Baker, to author 24 Feb. 2001.

24 " 'The elephants of Ceylon' " Samuel Baker, *Nile Tributaries*, pp. 274–80; Samuel Baker, *Wild Beasts*, pp. 17–86.

25 " 'One time in Ceylon' " Middleton, *Baker of the Nile*, pp. 61–62; Samuel Baker, *Rifle and Hound*.

26 " 'I lived in the *haremlik*' " All women and children of Ottoman households lived in the *haremlik*: Penzer, *The Harem*, pp. 15–18.

27 " 'Handkerchief?' " Ibid., pp. 180–81.

28 " 'His name was Mathias Szász' " Mathias Szász was a signatory to letter, Majors Niuny and Dr. Gaal, Captains Frans Zinse and Dr. Regelsberg, Lieutenant Colonels Osvald Kadar and Vilmos Csokay, Lieutenants Mathias Szász, Carl Mandl, Istvan Zoka, F. Schlesinger; along with the entire officer staff of the Fifty-fifth and the larger portion of the Eighty-eighth and Twenty-seventh Battalions, to Louis Kossuth, 11 Sept. 1849. Reproduced in Hajnal, *Emigráció*, pp. 470–72, translated from the German. The letter was written in the refugee camp at Viddin. Matthew, the English spelling of Mathias, was the forename given for Florence's father in family legends and on her marriage license dated 3 Nov. 1865, available from the Lambeth Palace Library, Church of England, London. Szász is an alternative spelling of von Sass or Sass, both of which are frequently given as Florence's maiden name. The Szász family of Nagy-Enyed (see next note), of which Mathias was probably a member, was entitled to use the prefix "von" because they were aristocrats.

28 " 'in my grandfather's house' " I believe Florence's grandfather was Karoly Szász, a well-known professor at the Colegiul Bethlen Gábor and a representative to the Hungarian Diet, or parliament (Paget, *Hungary and Transylvania*; and letter, Dionisie Gyorgy [current librarian of the Colegiul Bethlen Gábor] to author). A letter in the possession of Anne Baker (Anne Baker to author, 24 Feb. 2001; Emil Bihari to Anne Baker, 7 Nov. 1972) recounts a story from a Hungarian grandmother, who recalled playing with Florence when they were children in Buda-Pesth, an unlikely event if Florence was an ordinary Transylvanian child. However, if she was the granddaughter living for the duration of the war in the household of a member of the Diet, Florence's

presence in Buda-Pesth is explained. So too is the impression of the grandmother described in the letter that Florence's father was a professor, assuming that a father and grandfather might be easily conflated by a child. The primary fact mitigating against this identification of Mathias Szász as a son of Karoly Szász is Mathias's absence from a Szász family tree constructed in 1912 (Görzsönyi, *Szmerjai*). I hypothesize that Mathias was omitted—effectively removed from the family—because, in the refugee camp in Viddin, he had converted to Islam, which was considered disgraceful. See notes below for more explanation about the conversion.

28 " 'shots, knives, yells, corpses, and fire' " These were Florence's own words, according to Baily, "Reminiscences of Florence Baker," in possession of Anne Baker. Additional details on the destruction of Nagy-Enyed on 8 Jan. 1849 by Vlach soldiers were given to me in a letter, Gyorgy to author 15 April 2002. See also Declaration of Independence by Hungary, 25 Mar. 1849, reprinted in Stiles, *Austria in 1848–49*, p. 416. General information on the Hungarian Revolution of 1848–49, its chief causes, and descriptions of massacres from Frost, *Kossuth;* Pulszky, *Memoirs;* "Letter from the Bishops of the Hungarian Church to Ferdinand, in Olmutz, on Oct. 28, 1848," in Headley, *Louis Kossuth*, pp. 136–40; Roberts, *Nicholas I;* Bona, *Hungarian Revolution;* Déak, *Lawful Revolution;* Hitchins, *Rumanian National Movement.*

29 " 'General Bem' " Appearance and character of Bem taken from Kozlowski, "General Josef Bem," pp. 135–54.

29 " 'We walked to Orsova' " General Bem and the remnants of his army were one of the last groups of refugees to set out for Orsova, where they could cross the Danube into Viddin; they left Temesvar on 17 Aug. 1849: Frost, *Kossuth;* Hermann, "Summer Campaign," pp. 432–33; "Letters of Hungarian Ministers on the Abdication of Kossuth," in Stiles, *Austria*, pp. 421–41.

30 " 'The camp . . . was on the plain' " Descriptions of the camp and the fates of refugees in Viddin from Pulszky, *Memoirs*, pp. 352–64; Kurat, "European Powers," Appendix 1; Report, M. Hory to Poujade, 31 Oct. 1849, enclosed in Sturmer to Schwartzenberg, 28 Nov. 1849, No. 55-B, Weisungeun-Varia-Turkei, P.A. 40, WienerStaats Archiv; *Tsarigradskii vestnik* 78, 17 Dec. 1849.

31 " 'to evil-doers' " Article 18 of the Belgrade Treaty, reprinted in Komlos, *Kossuth in America*, p. 35.

31 "The Austrians offered amnesty" Déak, *Lawful Revolution*, pp. 329–30.

32 " 'voluntarily subjected to' " " 'So long as our homeland' " Letter, Majors Niuny and Dr. Gaal, Captains Frans Zinse and Dr. Regelsberg, Lieutenant Colonels Osvald Kadar and Vilmos Csokay, Lieutenants Mathias Szász, Carl Mandl, Istvan Zoka, F. Schlesinger; along with the entire officer staff of the Fifty-fifth and the larger portion of the Eighty-eighth and Twenty-seventh Battalions, to Louis Kossuth, 11 Sept. 1849, reproduced in Hajnal, *Emigráció*, pp. 470–72.

32 "nearly five hundred men" Kurat, "European Powers," p. 315, gives numbers and the fates of the men in camp; Hajnal, *Emigráció*, pp. 529–39, 679–83.

32 "On September 18" Kurat, "European Powers," pp. 311, 312; also Hajnal, *Emigráció*, p. 467; Letter, Frederic Pisani to Stratford Canning, 1 Oct. 1849, enclosed in Stratford Canning to Palmerston, 5 Oct. 1849, no. 289, PRO, FO 78/780; Letter, Kossuth to Murad Pasha (General Bem), 19 Oct. 1849, reproduced in Hajnal, *Emigráció*, pp. 510–13.

32 " 'Rather the Russians than the Austrians' " Letter, Frederic Pisani to Stratford Canning, 1 Oct. 1849, enclosed in Stratford Canning to Palmerston, 5 Oct. 1849, no. 289, PRO, FO 78/780.

33 " '[A] fresh letter' " Letter, Kossuth to Palmerston, 20 Sept. 1849, reproduced in Hajnal, *Emigrácio*, pp. 482–86.

33 "Nearly 500 soldiers" Kurat, "European Powers," pp. 311–12.

33 "Mathias was . . . among them" There is no direct evidence that Mathias Szász converted, but many of the converts were Bem's men and Mathias was Bem's adjutant. After Mathias Szász signed the September 11 letter, his name does not appear in any further documents I have been able to locate, including a list of refugees who were alive in Shumla in January 1850, reproduced in Hajnal, *Emigrácio*, pp. 680–83, so he apparently disappeared between mid-September 1849 and January 1850.

34 "3,360 men" Kurat, "European Powers," pp. 311–12.

34 " 'Then the bundle woman' " Description of practices and clothing of Armenian vendors and bundle women from Napier, *Excursions*, vol. 2, p. 281; Croutier, *Harem*, pp. 167-ff.

35 " 'Finjanjian Hanim thought' " On the practice of renaming girls when they entered the harem, see Davis, *Ottoman Lady*, p. 105; Croutier, *Harem*, p. 30. I assume Florence was renamed because it was a standard practice upon entering a harem and because neither Florenz nor Florence is a Hungarian name (Z. Behrend, comment to author), unlike Barbara and Maria.

3. LIKE A HAWK AFTER A MOUSE

37 "The girls learned to recite" Davis, *Ottoman Lady*, pp. 45–60; Malik-Hanim, *Thirty Years*, pp. 125–26.

38 " 'A girl's future' " Croutier, *Harem*, pp. 97–98, 145–47; Davis, *Ottoman Lady*, pp. 61–63.

38 " 'removing body hair' " All body hair, including pubic hair, was removed: Croutier, *Harem*, pp. 85–86; Penzer, *The Harem*, pp. 217–21.

38 " 'A woman has only to please' " Reichart, *Girl-Life*, pp. 111-ff.; Croutier, *Harem*, p. 150.

39 "He was born the first son" Information about Sam's life from Brander, *Perfect Victorian Hero*; Murray and White, *Sir Samuel Baker*; Anne Baker, *Morning Star*; Middleton, *Baker of the Nile*.

41 " 'I could not face England' " Minor paraphrase from letter, Sam to John Baker, 3 Mar. 1856.

41 " 'Anything for a constant change' " Letter, Sam to unidentified family member, quoted in Hall, *Lovers*, p. 16; no further information given.

41 " 'I sent inquiries' " and " 'lacked a useful occupation' " Letter, Sam to Wharncliffe, 1857, cited in Brander, *Perfect Victorian Hero*, p. 50; Hall, *Lovers*, p. 8, citing Livingstone papers in the Bodleian Library, Oxford, Dep. C 80.14; letters, Sam to Murchison, 19 Jan. 1858, 5 Feb. 1858, 10 Feb. 1858, 5 Mar. 1858.

42 " 'Women have long hair' " Davis, *Ottoman Lady*, p. 25.

43 " 'we hired a covered boat' " Most of this dialogue is taken from letter, Sam to John Baker, quoted in Anne Baker, *Morning Star*, p. 19; no further information given.

43 " 'I wrote to my sister' " Letter, Sam to Min Baker, 4 Feb. 1859.

44 " 'I must say, striking that ice floe' " Paraphrased from letter, Sam to Wharncliffe, 30 Mar. 1859, Sheffield Archives WhM 418 (MF: 276), 1859.

44 " 'The road does rather jar' " Letter, Sam to Duchess of Atholl, n.d., cited in Hall, *Lovers*, p. 30.

45 "After the death of his father" Campbell, *Maharajah's Box*, pp. 38–62, and citing let-
ter, Queen Victoria to Governor General of India, Oct. 1854; Alexander and Anand,
Queen.

45 "spurned a possible match" Campbell, *Maharajah's Box*, pp. 63–64.

45 "In 1864 he married Bamba Müller" Ibid., pp. 90–95.

45 " 'rather a fiasco' " and " 'an old habitué' " Login, *Lady Login's*, p. 76.

4. A GIRL FROM THE HAREM

PAGE

49 " 'a mass of filth' " and " 'fleas as big' " Letter, Sam to Min Baker, 1859, quoted in
Brander, *Perfect Victorian Hero*, p. 33.

50 "One of the few Englishmen" Hall, *Lovers*, pp. 33-ff.

50 " 'I had a great struggle' " Letter, Sam to Edith Baker, 11 Mar. 1859.

50 "He wrote again to Min" Letter, Sam to Min Baker, early Apr. 1859.

50 "He wrote to Wharncliffe" Letter, Sam to Wharncliffe, 30 Mar. 1859, Sheffield Archives
WhM 418 (MF: 276), 1859.

51 "Mixed marriages" Sam made precisely this case much later: letter, Sam to Wharn-
cliffe, 4 Mar. 1867, Sheffield Archives WhM 418/11.

51 "other Hungarian refugees" Hajnal, *Emigráció*, p. 448, reports that Kossuth himself
had a false English passport in 1849.

53 " 'That is how all Turkish ladies' " Reichert, *Girl-Life*, p. 211.

54 "Florence's dressing" Florence wore men's clothing on the march in Africa: Samuel
Baker, *Albert N'yanza*, vol. 1, pp. 161–62. I speculate here that she began this habit in
Constanza.

54 " 'Mr. Baker, the great' " Letter, Henry Barkley to parents, 1859, quoted in Middleton,
Baker of the Nile, p. 35.

54 "However, they disapproved" and "Henry's wife" Letter, Henry Barkley to parents, 4
May 1859; Panayotova, "Labour, Time and Money."

54 "the age of consent" Terrot, *Maiden Tribute*, p. 21.

55 " 'Accordingly,' he wrote" Quoted in Hall, *Lovers*, p. 37; no reference given.

56 "In 1856 Richard Burton" Information on Burton and Speke and their joint expedition
can be found in Richard Burton, *Lake Regions* and *First Footsteps*; Burton and M'Queen,
Nile Basin; Moorehead, *White Nile*; Rice, *Captain Sir*; Speke, *Journal* and *What Led*; Bro-
die, *Devil Drives*; Johnston, *Nile Quest*, pp. 115–60.

56 " 'splendid fellow' " Letter, Sam to T. Douglas Murray, 22 Aug. 1893.

57 "It was Burton who" Richard Burton, *Footsteps* and *Personal Narrative*.

57 " 'He has mastered' " Rice, *Captain Sir*, p. 1, gives the total number of languages Bur-
ton learned as twenty-nine, plus many dialects.

57 " 'White Nigger' " and " 'that Devil Burton' " Ibid., p. 2.

57 " 'Not Speke' " In fact, Speke did once disguise himself as an Arab and was convinced
his mission failed because he was so unconvincing: ibid., p. 255.

57 "The association between Burton and Speke" Ibid., pp. 231–64; Brodie, *Devil Drives*, pp.
122–25.

59 " 'Don't step back' " Brodie, *Devil Drives*, p. 123; Young, *Search for the Source*, p. 53.

59 "Speke had lost so much money" and "five hundred pounds" Johnston, *Nile Quest*, pp.
117–18. Five hundred pounds in 1855, the year of the Burton-Speke Somali expedition,

had the purchasing power of £23,912.37 or about $50,583.38 in 2001, according to Mc-Cusker, "Comparing," and Officer, "Exchange Rate."

59 "The persistent illnesses" Brodie, *Devil Drives*, pp. 141–66.

59 " 'Goodbye old fellow' " Ibid., p. 166, citing Isabel Burton, *Captain Sir Richard F. Burton*, vol. 1, p. 327; Rice, *Captain Sir*, pp. 314–15.

60 " 'Speke went to see Murchison' " Speke, *Journal*, p. 31; Rice, *Captain* Sir, pp. 313–15; Richard Burton, *Lake Regions*, p. 526.

60 " 'Speke, we must send you there' " Speke, *Journal*, p. 31.

60 "The RGS gave him" Brodie, *Devil Drives*, p. 168.

61 " 'you know I was taught to read and write Arabic' " On Arabic as the lingua franca of the harem and a part of a girl's curriculum, see Davis, *Ottoman Lady*, p. 107.

62 "In a letter" Letter, Burton to Editor, *Times*, 8 Oct. 1859.

62 "He accused Burton" The correspondence on this matter is reprinted in Richard Burton, *Lake Regions*, Appendix 1; see also Brodie, *Devil Drives*, pp. 170–71.

63 "At their committee meeting" RGS, Committee Minutes, 20 June 1859 and 21 June 1859.

63 "Speke enlisted Captain James Augustus Grant" For information about Grant, see Grant, *Walk Across Africa*; Speke, *Journal*, p. 33 and throughout; Bridges, "Sir John Hanning Speke," pp. 23–44.

63 "The strict injunction" RGS Letter Book, Shaw to Speke, quoted in Bridges, "Sir John Hanning Speke," p. 33.

64 "John Petherick, the newly appointed" Hall, *Lovers*, p. 41.

64 "Using twelve hundred pounds raised" Petherick and Petherick, *Travels*, vol. 2, p. 91; RGS, Committee Minutes, 4 Feb. 1861; Proc. R.G.S. IV, pp. 233–36; Proc. R.G.S. V, pp. 40–14, 96–97, 108; Speke, *Journal*, p. 33.

64 "Because Petherick's salary" Bridges, "Sir John Hanning Speke," p. 33; RGS Correspondence F, letter, Petherick to Murchison, 19 Jan. 1860; Speke, *Journal*, p. 4.

64 "Confident that they had" Speke, *Journal*, p. 34.

65 " 'what point that will be' " RGS Archives I, Corr. Block 1851–1860 (7 letters), item no. 7, letter, Sam to Murchison, 20 Nov. 1859.

65 " 'Mr. Baker . . . is not' " RGS Archives I, Corr. Block 1851–1860.

65 " 'fully appreciate the value' " and " 'which had not yet been' " Ibid.

66 " 'I intend to be' " Letter, Sam to John Baker, 3 Dec. 1860.

67 " 'I cannot tell you' " Letter, Sam to Wharncliffe, early 1861, Sheffield Archives, WhM 418 (MF: A277), 1861. The original is now nearly illegible, but it is quoted in Brander, *Perfect Victorian Hero*, p. 63, who presumably examined the letter before it deteriorated.

67 " 'A wandering spirit' " Letter, Sam to Min Baker, 26 Jan. 1861.

5. SO ABSURD AN ERRAND

PAGE

69 "Florence and Sam arrived" Samuel Baker, *Nile Tributaries*, p. 1.

70 " 'Florence is determined' " Paraphrased slightly from ibid., p. 3.

71 " 'You must regularize' " Colquhoun's scolding is mentioned in letter, Grant to John Blackwood, 22 Oct. 1866, National Library of Scotland, MS 4209, pp. 188–95.

71 " 'I had not the presumption' " Samuel Baker, *Albert N'yanza*, vol. 1, p. 1.

71 "They set sail" and " 'spanking breeze' " Baker journal, 15 Apr. 1861.

71 "At night the cabin" Ibid., 3 May 1861.

72 "He had one custom-made" Ibid., 29 Apr. 1861.

72 " 'I do not think this cooking' " Florence habitually referred to food as "cooking": David Baker, comment to author.

73 " 'My impedimenta' " Samuel Baker, *Nile Tributaries*, pp. 3–4.

74 " 'Down one of the worst rapids' " Baker journal, 2 May 1861.

75 "After twenty-six days" and "May 12" Samuel Baker, *Nile Tributaries*, p. 3.

75 " 'His leaving is just' " Paraphrased from Baker journal, 12 May 1861.

76 "They set off" Baker journal, 16 May 1861.

76 "*Girbas* did not" Samuel Baker, *Nile Tributaries*, p. 8.

76 "The desolate landscape" Ibid.

77 "Moonlight transformed" Ibid., p. 7.

77 "She perspired uncomfortably" Ibid., illustration facing p. 67.

78 "It was the worst place" Ibid., pp. 7–8.

78 " 'El hambd el Allah!' " Ibid., p. 9.

79 "Sam counted an average" Ibid., p. 11.

79 "Taking pity on them" Ibid., p. 11.

79 "He reckoned that" Ibid.

79 "After a few days Florence" Baker journal, 27 May 1861.

79 "The dryness attacked" Ibid., 29 May 1861.

80 "The town had dusty" Ibid., 31 May 1861.

80 "Fortunately, the dignitaries" Ibid., 1 June 1861.

80 " 'The head of the Nile' " and " 'Don't go upon so' " Samuel Baker, *Nile Tributaries*, pp. 14–15.

81 "Their heavy baggage" Ibid., p. 15.

81 "they arrived in a flutter" Ibid., p. 16.

82 "June 8 Sunday" Baker journal, 8 June 1861. This was but one of many ailments the Bakers experienced on their journeys. It is impossible to determine which diseases (by modern diagnoses) they suffered from at any particular time. Along with malnutrition and dehydration, likely ailments include malaria, blackwater fever, typhoid, typhus, cholera, septicemia, yellow fever, tropical ulcers, food poisoning, dysentery, various parasites, and bites or stings of different insects or reptiles.

82 "notorious thief" and "he ordered the man" Samuel Baker, *Nile Tributaries*, p. 18.

83 "Mahomet became intermittently 'deaf' " Ibid., p. 22.

83 " 'a green umbrella' " Samuel Baker, *Albert N'yanza*, vol. 1, p. 253.

83 " 'I dress' " Baker journal, 10 June 1861.

83 " 'wretched bushes dignified' " Ibid.

85 "The prophylactic use" The quinine doses mentioned in Sam's journals (and generally taken in the mid–nineteenth century) were often less than half the dose recommended now to cure malaria and probably only suppressed the fevers: Brodie, *Devil Drives*, p. 146; Medicines Commission, *British Pharmacopoeia*, vol. 1.

85 "The local Arabs prized" Sameul Baker, *Nile Tributaries*, p. 24.

86 " 'At the report of a rifle' " Ibid., p. 29.

86 "Sam gave his permission" Drawing by Sam Baker, RGS.

86 " 'El Bahr! El Bahr!' " Samuel Baker, *Nile Tributaries*, pp. 36–37.

87 " 'That is the key . . . the sources of the Nile.' " Ibid., p. 38; Baker journal, 24 June 1861. Tense changed in quote for continuity. Italics in original.

88 " 'The river is as thick . . . fever lies in both' " Baker journal, 3 July 1861.

89 "After a few days the Turks" Samuel Baker, *Nile Tributaries*, p. 41.

89 "Here children were literally" Baker journal, 13 July 1861.

89 "local conditions of enslavement" Toledano, *Slavery and Abolition*, p. 17.

90 "Then an old woman took out" Baker journal, 9 July 1861.

91 " 'The operation upon the females' " Ibid., 3 Nov. 1862. This description is an elaboration of the one written 9 July 1861, when Florence and Sam first became aware of this practice. For simplicity's sake, I do not distinguish between infibulation (the excision of the labia and the sewing closed of the vagina) and female circumcision (the removal of the clitoris), since both were done at once.

During his travels in Arabia and Africa, Richard Burton made an extensive study of the practices of male and female circumcision and female infibulation. He wrote: "Circumcision of both sexes is a very ancient custom among the Arabs. . . . [I]n a young woman, it seems to be a preventative for unchastity. . . . (They cut off the clitoris because . . . that organ is the seat and spring of sexual desire.)" Rice, *Captain Sir*, p. 202, quoting Burton, *Personal Narrative*, original Appendix I (removed from many printings).

This observation raises the question of whether Florence was circumcised as a child in the harem. I believe she was not, because Florence and Sam were apparently unfamiliar with this custom until they encountered it among the Nile tribes.

92 "If they married" According to Blackstone, *Commentaries*: "By marriage, the husband and wife are one person in law: that is, the very being or legal existence of the woman is suspended during her marriage, or at least is incorporated or consolidated into that of her husband, under whose wing, protection and cover, she performs everything." In England, until the late 1800s, a married woman's body, her property, and her children legally belonged to her husband.

93 "Mahomet the dragoman begged"; "A corporal"; and " 'wild young Arabs' " Samuel Baker, *Nile Tributaries*, pp. 57–59.

93 " 'Bacheet, being caught wild' " Baker journal, 20 July 1861.

94 " 'I never saw such an exhibition!' " Samuel Baker, *Nile Tributaries*, pp. 68–69.

95 "She later found that her camel" and "Sam's camel" Ibid., pp. 69–71.

95 "The camels, so well adapted" and "Some of the baby camels" Ibid., p. 74.

96 "At Sofi, Florence and Sam" Ibid., pp. 98–100.

96 " 'the right of shooting' " Ibid., pp. 103–105.

97 "Florence carefully lined" Ibid.

97 "Horseflies, tsetse flies" Ibid., p. 107.

97 "a terrible attack of gastric fever" and "an outbreak of boils" Ibid.

98 "The Arabs, Sam learned" Ibid., pp. 108–14 passim.

98 "He made new shoes" Baker journal, 10 Aug. 1861.

98 "He also decided they should have a canoe" Ibid., 14 Aug. 1861.

98 "To Sam's immense delight" Samuel Baker, *Nile Tributaries*, pp. 114–19.

99 " 'Nothing can exceed' " Baker journal, 19 Aug. 1861.

100 "He calculated the number" Ibid., 25 Aug. 1861.

100 "On September 12 and 13" Baker journal, 12–13 Sept. 1861. In *Nile Tributaries*, pp. 140–43, Sam describes this same incident as occurring on 15 Sept. 1861.

101 "he composed a formal letter" Though Sam records that he wrote such a note to Peth-

erick (Baker journal, 23 Sept. 1861), he does not document the specific contents of the missive, which has not been preserved. However, the general purpose of the letter is clear.

102 "Florence awaited Sam's arrival" Baker journal, 23 Sept. 1861.

102 "he purchased a rogue of a horse" Samuel Baker, *Nile Tributaries*, pp. 194–95.

102 " 'The curse of Africa' " Baker journal, 15 Oct. 1861.

102 "Sam bought three new horses" Ibid., 25 Oct. 1861.

102 "Sheik Achmet of Wat el Négur" Samuel Baker, *Nile Tributaries*, pp. 178–80. Similar conversation recorded in Baker journal, 19 Jan. 1862.

103 " 'How . . . could you possibly' " Ibid.

7. SITT, I BE YOUR BOY

105 " 'What for master and the missus' " Samuel Baker, *Nile Tributaries*, pp. 214–15.

106 "One of the few loyal men" Ibid., pp. 233–36.

106 "They offered Sam transparent" and " 'Now, my good fellows' " Ibid., pp. 236–38.

107 "Sam railed against their perfidy" Baker journal, 11 Jan. 1862.

107 "Sam managed to kill a magnificent" Samuel Baker, *Nile Tributaries*, pp. 284–87.

108 "Sometime later, Sam's eyes" Baker journal, 17–18 Feb. 1862.

108 "The slave woman, Barraké" Ibid.

108 "Mahomet badly damaged" Ibid., 26 Feb. 1862.

108 "they toasted the birthday" Ibid., 9 Apr. 1862.

108 "Two days later Sam" Most of this incident, save the dialogue between Sam and Florence, ibid., 11 Apr. 1862.

110 "On May 19" Ibid., 19 May 1862.

111 " 'May 31' " Ibid., 31 May 1862.

111 "On June 8, 1862, they arrived" Ibid., 8–12 June 1862.

111 "a city of some thirty thousand" Stiansen, "Overture," pp. xi, 1.

111 "the British Consulate" Samuel Baker, *Nile Tributaries*, pp. 375–77.

112 "the Pethericks had not left Khartoum" Brownell diary, 20 Mar. 1862.

112 "abundant areas of papyrus" Ibid., 17 Apr. 1862.

113 "total European population" Stiansen, "Overture," pp. xi–1; Samuel Baker, *Nile Tributaries*, p. 380.

113 "Petherick's attractive housekeeper" Hall, *Lovers*, p. 65.

113 "consuls from France, Austria, America, and England" Stiansen, "Overture," p. xi; Sameul Baker, *Albert N'yanza*, vol. 1, p. 12.

113 " 'Dutch ladies' " Samuel Baker to John Baker, 16 June 1862, quoted in Middleton, *Baker of the Nile*, p. 107.

113 "the steamer they rented for one thousand pounds" £1,000 in 1862 is the equivalent of approximately £47,240.33 or $97,328.31 in 2001: McCusker, "Comparing"; and Officer, "Exchange Rate."

113 " 'A famous English couple' " Hall, *Lovers*, pp. 71–72, citing Harriet Tinné's diary; also quoted in Gladstone, *Travels of Alexine*, p. 106.

114 " 'the worst of Oriental failings' " Samuel Baker, *Albert N'yanza*, vol. 1, p. 13.

114 " 'Went to see Halil el Shami' " Baker journal, 10 June 1862.

115 "less than three hundred pounds" Bridges, "Sir John Hanning Speke," p. 33. £300 in 1863 had the purchasing power of £14,172.10 or $29,660 in 2002: McCusker, "Comparing"; and Officer, "Exchange Rate."

115 " 'August 17. . . . There is no doubt' " Baker journal, 17 Aug. 1862.

118 "The viceroy in Alexandria" Samuel Baker, *Albert N'yanza*, vol. 1, p. 26.

118 " 'August 24—I do not believe' " Baker journal, 24 Aug. 1862.

118 " 'This [betrayal] was a return' " Ibid., 28 Aug. 1862.

119 "By October 20" Ibid., 2 Oct. 1862.

119 " 'Your letter of 17th August' " Letter, Sam to Ellen Baker Hopkinson, 20 Oct. 1862.

120 "The Khartoumers drank" Baker journal, 5 Nov. 1862.

120 " 'hatred, malice, and uncharitableness' " Ibid., 24 Oct. 1862.

120 "signed by almost every other European" Letter, Sam to Petherick, 9 Feb. 1863, Museum Drawer 516, RGS.

121 "On November 19" Baker journal, 19 Nov. 1862.

121 "the American doctor . . . Clarence Brownell" Petherick and Petherick, *Travels*, vol. 1, pp. 139–40.

121 "Sam again wrote out his will" Baker journal, 2 Dec. 1862.

121 "a small black boy named Saat" Samuel Baker, *Albert N'yanza*, vol. 1, pp. 117–22.

123 " 'I shall be off tomorrow' " and " 'a physical explanation' " Baker journal, 18 Dec. 1862.

123 "The carpenter, Johann Schmidt" Ibid., 21 Dec. 1862.

123 "the Dutch ladies' steamer" Samuel Baker, *Albert N'yanza*, vol. 1, pp. 31–32.

124 "On the last day of 1862" and " 'At 4.15 p.m. Johann died' " Baker journal, 31 Dec. 1862.

8. A PERFECT HELL

125 " 'What on earth' " Baker journal, 2 Jan. 1863.

125 "Miss Tinné conceived of this journey" Johnston, *Nile Quest*, p. 194.

126 " 'Nothing can be more laborious' " Baker journal, 7 Jan. 1863.

127 " 'It is grand in African travel' " Ibid., 6 Jan. 1863.

127 " 'The misery of these unfortunate blacks' " Samuel Baker, *Albert N'yanza*, vol. 1, p. 69.

127 " 'Most of the men are tall' " Ibid., p. 71.

128 " 'The whole day we are beset' " Ibid., pp. 72–73.

128 " 'So miserable are the natives' " Ibid., pp. 73–74.

128 " 'malaria, marshes, mosquitoes' " Ibid., p. 75.

129 "Fifteen of the seventeen" Speke, *Journal*, p. 544.

129 "Moorlong had sold the entire place . . . thermometer" Baker journal, 24 Jan. 1863.

129 "Petherick had surely been" Petherick, *Egypt, the Soudan.*

129 " 'Where the truth lies' " Baker journal, 24 Jan. 1863.

129 "he admitted that the mission" and "Well done, Jesuits!" and " 'In vino veritas!' " Paraphrased slightly from Baker journal, 30 Jan. 1863.

129 "an improvement upon the dreadful swamps" Paraphrased from Samuel Baker, *Albert N'yanza*, vol. 1, p. 86.

130 "Bullets regularly buzzed" Ibid., pp. 94–95.

130 "he and Florence were regarded with deep suspicion" Ibid., p. 88.

130 "no sign of Petherick" Buckland, "Reported Death of Mr. Petherick," quoted in Petherick and Petherick, *Travels*, vol. 1, pp. 205–7.

130 " 'wonderful *fireworks*' " Samuel Baker, *Albert N'yanza*, vol. 1, p. 88.

131 " 'The closest trading station' " Ibid.

131 "'They had thick lips" Ibid., p. 90.

131 "They were excellent bowmen" Ibid., p. 91.

131 "The traders' solution" Ibid., pp. 92–93.

132 " 'Gondokoro is a perfect hell' " Ibid., p. 93.

132 "If not, they would desert" Paraphrased from ibid., pp. 95–97, and Baker journal, 13 Feb. 1863.

134 " 'Guns firing in the distance' " Samuel Baker, *Albert N'yanza*, vol. 1, pp. 99–100. Punctuation as in original.

134 "They had had a sleepless"; "they met Koorshid Aga"; and "When they saw" Speke, *Journal*, pp. 542–43.

134 "Sam was shocked" Sameul Baker, *Albert N'yanza*, vol. 1, p. 101.

135 "There was a beautiful young white woman" Victorian illustration, questionably attributed to the *Illustrated London News*.

135 "Sam, I thought your wife was dead" and *"chère amie"* Letter, Grant to Blackwood, 22 Oct. 1866, National Library of Scotland, MS 4209, pp. 188–93.

136 "tents to be erected" Baker journal, 15 Feb. 1863.

136 "Their first thoughts were for Petherick" Speke, *Journal*, p. 541.

136 " 'So Petherick, with twelve hundred' " Ibid., pp. 542–43.

137 "the *vakeel* would not release them" Ibid., p. 545.

138 " 'Does not one leaf?' " Samuel Baker, *Albert N'yanza*, vol. 1, p. 103.

138 "the purported position" Speke, *Journal*, p. 543.

139 " 'Have you any idea of the dangers' " Letter, Grant to Blackwood, 22 Oct. 1866, National Library of Scotland, MS 4209, pp. 188–93.

139 "the beautiful women of King M'tesa's tribe" Speke, *Journal*, pp. 339–40, 345–46, 359–61, 369–72; Rice, *Captain Sir*, pp. 343–47; Hall, *Lovers*, p. 129.

140 "the use of surveying instruments" Samuel Baker, *Albert N'yanza*, vol. 1, pp. 104–7.

140 " 'With their true devotion' " Ibid., p. 108.

140 "On February 20 Petherick" Petherick and Petherick, *Travels*, vol. 1, p. 310; Samuel Baker, *Albert N'yanza*, vol. 1, p. 108.

141 "Kate wearing a ragged red dress" Petherick and Petherick, *Travels*, vol. 1, p. 312.

141 "all the articles enumerated" Letter, Kathleen Petherick to sister Mona, 2 Oct. 1863, ibid., vol. 2, p. 20.

141 "a large ham" Ibid.

141 " 'It is no use' " Ibid., pp. 127, 132–33, 171.

141 " 'God bless you!' " Samuel Baker, *Albert N'yanza*, p. 110.

142 " 'The Nile is settled' " Murchison, "Speke and Party."

142 "that Petherick was involved in the slave trade" Speke, Christmas speech at Taunton, 1863, cited in Bridges, "Sir John Hanning Speke," p. 38, and printed in the *Overland Mail*, date unknown, but cited in Petherick and Petherick, *Travels*, vol. 2, p. 139.

142 " 'Acting under the advice' " M'Quie, "Captain Speke."

142 "Speke replied sharply" Letter, Speke to Editor, *Times*, 28 Dec. 1863.

143 "Desperate to clear his name" Petherick and Petherick, *Travels*, vol. 2, pp. 139–40; Proc. RGS 8, p. 131.

143 "Petherick had been unjustly accused" Proc. RGS 8, pp. 122, 149, cited in Bridges, "Sir John Hanning Speke," p. 38; letter, Petherick to Murchison, 16 Jan. 1864, correspondence F; letter, H. W. Bates, Asst. Secy. RGS, to Petherick, 24 June 1865, and enclosed minute in council, reprinted in Petherick and Petherick, *Travels*, vol. 2, app. A, pp. 168–73.

143 "The consulate at Khartoum was shut down" Letter, Earl Russell to Petherick, 31 Oct. 1863, quoted in Petherick and Petherick, *Travels*, vol. 2, app. A, p. 152.

9. ARE THE MEN WILLING TO MARCH?

PAGE

144 "Obtaining porters" Baker journal, 28 Feb. 1863.

145 "fifty-four hundred pounds of goods" Samuel Baker, *Albert N'yanza*, vol. 1, p. 114.

145 "struck for a pay raise" Baker journal, 1 Mar. 1863.

145 " 'Everything appeared to be' " Samuel Baker, *Albert N'yanza*, vol. 1, p. 115.

146 " 'I am again threatened' " Paraphrased from Baker journal, 16 Mar. 1863.

146 " 'Are the men willing to march?' " Incident and dialogue paraphrased from Samuel Baker, *Albert N'yanza*, vol. 1, pp. 122–26.

147 "With manful bravery" Ibid., pp. 122–24.

148 "for sale as scientific specimens"; " 'This is the British consul' "; and " 'How can I expect any man' " Paraphrased from Baker journal, 22 Mar. 1863.

148 " 'Verily, . . . these are dangerous' " Ibid.

148 "they would fire upon Sam" Samuel Baker, *Albert N'yanza*, vol. 1, pp. 126–27.

149 "He had organized" and " 'I worry that this expedition' " Paraphrased from ibid., pp. 129–30.

150 " 'Ah, Baker Effendi . . . with only a man and a boy' " Ibid., pp. 131–32.

150 " 'That night I was asleep' " Ibid., pp. 135–36.

152 "They agreed to serve as guides" Ibid., p. 148.

152 "This exhausting and disheartening" Ibid., pp. 152–53.

153 " 'Who are you?' " and following dialogue Ibid., pp. 161–62.

155 "140 armed men" Ibid., p. 170.

155 " 'Sam, you must call to him' " Ibid., p. 171.

155 " 'Ibrahim, why should we' " and "Florence loosed a torrent of words" Ibid., pp. 172–73.

156 " 'the greatest rascal' " Ibid., p. 176.

156 " '*Inshallah*, the vultures' " Ibid., p. 203.

157 " 'the finest savages' " Ibid., p. 204.

157 " 'A prettier pair of savages' " Ibid., p. 216.

157 "Bokké asked how many other wives. . . . Bokké thought" Ibid., p. 217.

158 " 'Are they all dead?' " Ibid., p. 223.

159 " 'We shall be dragged into fighting . . . if fighting breaks out' " Ibid., pp. 228–30.

159 "The night was deathly still" Baker journal, 20 Apr. 1863; Samuel Baker, *Albert N'yanza*, vol. 1, pp. 231–33.

160 "Their new camp was soon" Samuel Baker, *Albert N'yanza*, vol. 1, pp. 235–36.

161 "small game and wildfowl" Ibid., pp. 237–38.

161 " 'I wish the black philanthropists' " Baker journal, 10 Apr. 1863.

10. A GORILLA IN LONDON

PAGE

162 " 'I have no fear' " and " 'Savages will seldom deceive' " Samuel Baker, *Albert N'yanza*, vol. 1, p. 304.

163 "The natives looked different" Ibid., pp. 309–10, 315–16.

163 "Their chief, Katchiba, . . . 116 children" Ibid., pp. 317–19.

164 " 'I will not be alone' " Ibid., pp. 322–23.

165 " '*Dulce domum*' " Ibid., pp. 330–31.

166 " 'wait until you hear what I have found out!' " Baker journal, 25 May 1863.

166 " 'It is remarkably pleasant' " Ibid., 16 June 1863.

167 "Florence was dangerously ill again" Ibid., 24 June 1863.

167 "Sam put out arsenic" Samuel Baker, *Albert N'yanza*, vol. 1, p. 375.

168 " 'Had he fulfilled his contract' " Baker journal, 29–30 June 1863.

168 "series of seventy-four questions" Ibid.

169 " 'a white sheet' " and " 'a great roar' " Samuel Baker, *Albert N'yanza*, vol. 1, pp. 383–84.

169 " 'For some days. . . . *the relief of this treatment*' " Baker journal, 17 Oct. 1863, emphasis in original.

169 " 'The Obbo kills everything' " Ibid., 9 Dec. 1863.

170 "Ibrahim kindly agreed to exchange" Samuel Baker, *Albert N'yanza*, vol. 2, p. 13.

171 "Gentlemanly as ever" Baker journal, 12 Jan. 1864; Samuel Baker, *Albert N'yanza*, vol. 2, pp. 20–23.

172 "Kamrasi's people, the Banyoro" In Bantu languages the prefix of a word changes with the subject while the root remains the same. Thus, Kamrasi's country was Bunyoro and his people were Banyoro. Confusingly, some authors have called the country Uny-oro or even Nyoro. Beattie, *Bunyoro*, p. 1.

172 "Speke's brother" Samuel Baker, *Albert N'yanza*, vol. 2, p. 35.

172 " 'We cannot wait here' " The account of meeting with Kamrasi's people and much of the dialogue is from Samuel Baker, *Albert N'yanza*, vol. 2, pp. 34–44; and Baker journal, 25–26 Jan. 1864.

174 " 'Did Speke or Grant' " Samuel Baker, *Albert N'yanza*, vol. 2, p. 43.

175 " 'A gorilla would not' " Baker journal, 26 Jan. 1864.

177 " 'Dust!' " Samuel Baker, *Albert N'yanza*, vol. 2, pp. 51–53.

11. TOCK-TOCK-TOCK

PAGE

179 "Florence fell seriously ill" Baker journal, 31 Jan. 1864.

179 " 'Heaven help us' " Ibid., 5 Feb. 1864.

180 " 'Fools!' " Samuel Baker, *Albert N'yanza*, vol. 2, p. 62.

181 " 'I have no king' " Ibid., p. 64.

181 "the medicine chest" and " 'a most feverish country' " Ibid., p. 66.

181 "If Kamrasi did not supply them" Baker journal, 16–17 Feb. 1864.

182 "man carrying a heavy load of salt" Ibid.

182 " 'Every day, I must *give*' " Ibid., 21 Feb. 1864.

182 "a pretty yellow muslin handkerchief" Samuel Baker, *Albert N'yanza*, vol. 2, p. 75.

183 "he must leave Florence behind" and " 'Don't be angry! . . . never mention it again' " Incident and dialogue described ibid., pp. 77–79.

184 " 'Kamrasi's satanic escort' " Ibid., pp. 80–81.

185 "Sam decided to lead Florence" Florence's illness described ibid., pp. 85–89.

186 " 'Thank God!' " Ibid., p. 89.

186 *tock-tock-tock*" Baily, "Baker Reminiscences." Florence told Robin Baily she heard the sound of the pickaxes digging her grave.

187 "a sea of quicksilver" Samuel Baker, *Albert N'yanza*, vol. 2, p. 95.

188 " 'It is impossible to describe' " Ibid.

PAGE

190 "the natives' ingenious method" Samuel Baker, *Albert N'yanza*, vol. 2, p. 99.

190 "discuss matters with the chief . . . great storms" Ibid., pp. 100–101.

191 "Women never dared enter" Ibid., p. 105.

191 "fitted it with an arched framework" Ibid., pp. 107–8.

192 "the paddlers had gone" and "The canoes waltzed and pirouetted" Ibid., pp. 111–13.

193 "Sam fitted the lead canoe" Ibid., pp. 114–15.

193 "a heavy swell" Storm described ibid., pp. 116–19.

195 "no current at all" Ibid., p. 129.

196 " 'we should not abandon the Nile' " and " 'Seeing is believing' " Ibid., p. 137.

197 " 'Laid down with bad fever' " Baker journal, 6 Apr. 1864.

197 " 'The water cabbages are moving' " and "huge waterfall just ahead" Samuel Baker, *Albert N'yanza*, vol. 2, pp. 139–45.

199 "Murchison Falls" Ibid.

PAGE

200 "delirious with fever" Samuel Baker, *Albert N'yanza*, vol. 2, p. 149.

201 "the river fell" Ibid., p. 151.

201 " 'I am in a great fix' " Baker journal, 14 Apr. 1864.

202 "they dreamed of food" Samuel Baker, *Albert N'yanza*, vol. 2, pp. 160–62.

202 " 'Oh my legs' " Baker journal, 21 May 1864.

202 " 'he has treated me badly' " Samuel Baker, *Albert N'yanza*, vol. 2, pp. 163–64.

203 " 'Never mind . . . his kingdom' " Ibid., pp. 168–69; punctuation as in original.

203 " 'Who am I? . . . *he is the king*' " Ibid.

204 "The true Kamrasi"; " 'a mere beggar' "; and " 'imposter' " Ibid., pp. 176–77.

205 " 'I know a high cliff' " Ibid., p. 189.

205 "a short blue kilt" Ibid., pp. 192–98.

206 "magical flag" Ibid.

206 "a beautiful little boy" Ibid., p. 203.

206 "a huge army of the Baganda" The Banyoro called the Baganda the M'was for some reason. The Baganda were the people ruled by M'tesa in a country somewhat larger than what is now Uganda: ibid., p. 213.

207 "Florence, Sam, and their men" Ibid., pp. 218–19.

207 "a pool of blood" Ibid., p. 225.

207 "Florence suggested that they should abandon" Ibid., p. 227.

208 " 'I can go no farther' " Ibid., p. 233.

208 "Richarn walked into camp" Ibid., pp. 237–38.

209 "the second miracle" Ibid., p. 242, gives the date as 20 Sept. 1864, while the incident is recorded in Baker journal on 22 Sept. 1864.

210 " 'Xmas day!' " Baker journal, 25 Dec. 1864.

211 "The motherless child, Abbai" Samuel Baker, *Albert N'yanza*, vol. 2, p. 270.

211 " 'Take me with you, *Sitti!*' " Ibid., p. 281.

212 " 'I see the masts' "; " 'El hambd' "; and " 'Three cheers' " Ibid., pp. 295–96.

212 "No boats, no letters" Ibid., pp. 297–98.

213 " 'wasted these years' " Ibid.

14. LIFE SO UNCERTAIN HERE

PAGE

214 "enforce the anti-slavery laws" Samuel Baker, *Albert N'yanza*, vol. 2, pp. 299–300.

214 "the plague had come" Ibid.

215 "forty pounds" Ibid., p. 301. £40 in 1865 is the equivalent of £1,969.85 or $3,324.15 in 2001: McCusker, "Comparing"; and Officer, "Exchange Rate."

215 "Next Saat, by then a strong" Baker journal, 14 Apr. 1865.

216 " 'The fever is so dangerous' " Ibid., 16 Apr. 1865. £500 in 1865 is the equivalent of approximately £24,623.14 or $41,551.82 in 2001 currency: McCusker, "Comparing"; and Officer, "Exchange Rate."

216 "in a formal style" Hall, *Lovers*, p. 149, interprets the stiffness of the language in this passage as an indication that Sam was considering abandoning Florence rather than taking her home. I disagree most strongly with this interpretation and suggest that the formal language reflects Sam's awareness that Florence might need to show the passage to others. Also, Hall erred in stating that passages in Sam's diary had been excised or blacked out after his death (p. 150) to conceal Florence's existence or role in Sam's life. The journals as a whole contain all of the missing pieces except a single very small section less than 1 inch by 2 inches from the 1861–62 journal. During rebinding, several of the pages were placed out of chronological order, which gives the superficial impression that sections are missing. There is only a single instance where something is illegibly blacked out in Sam's journals and a set of quotation marks, set close together as if to enclose a single word, are still visible. This was Sam's habit when recording words in African languages, and probably a word or two are blacked out.

217 "Saat died" Samuel Baker, *Albert N'yanza*, vol. 2, pp. 336–37.

218 "pathetic compared with" Letter Book, RGS, Spottiswoode to Speke, 14 May 1864; RGS Committee Minutes, 17 Apr. 1864, in Bridges, "Sir John Hanning Speke," p. 40.

218 "energy and venom" Bridges, "Sir John Hanning Speke," pp. 36–37.

218 " 'Captain Speke was at the time' " Burton and M'Queen, *Nile Basin.*

218 "M'Queen drew attention to every questionable passage" Burton and M'Queen, *Nile Basin,* part 2, pp. 71–95; Moorehead, *White Nile,* pp. 71–74; Brodie, *Devil Drives,* p. 222.

219 "while he carried on . . . a 'flirtation' " Speke, *Journal,* p. 229.

219 "Speke's two Ugandan wives" Rice, *Captain Sir,* p. 373.

219 " 'in "central Europe" ' " This is in fact the story given in "Sir Samuel and Lady Baker," *Illustrated London News.*

221 " 'we must say you are twenty-three' " "Twenty-one upward" (meaning an adult) is Florence's age as given on the special marriage license Sam obtained from the Vicar-General's Office on 3 Nov. 1865, Lambeth Palace Library, Church of England, London.

222 "On May 22, 1865" Middleton, *Baker of the Nile,* p. 151.

222 "Shocking news awaited them in Khartoum" Samuel Baker, *Albert N'yanza,* p. 338.

222 "A public debate between Speke and Burton" Brodie, *Devil Drives,* pp. 223–27; Moorehead, *White Nile,* pp. 75–81.

223 " 'By God, he's killed himself' " Burton, *Captain Sir Richard F. Burton,* vol. 2, p. 426.

223 " 'a gallant soldier' " "Sad Death," *Times*, 19 Sept. 1864.

224 "What Florence and Sam found incredible" Sam expressed his surprise at Speke's death in a letter to Admiral Murray, 21 June 1865; letter, Sam to Colquhoun, 21 June 1865.

224 " 'I cannot tell you' " Letter, Sam to Speke, quoted in Murray and White, *Sir Samuel Baker*, p. 97; Baker journal, n.d. but after 5 May 1865.

224 " 'I have great fears' " Letter, Tinné to Editor, *Times*, 5 Oct. 1864.

225 " 'sheets and pillowcases' " and " 'Allsop's Pale Ale' " Samuel Baker, *Albert N'yanza*, vol. 2, pp. 356–57; italics in original.

225 "pleased with his job" Ibid., pp. 348–49.

227 "a fashionable photography studio" This is the earliest known portrait of Florence. It may have been taken by the renowned French photographer Disderi, but the original has been mislaid, and it is impossible to verify the photographer.

227 "13 Arlington Street" and "St. James's Parish" Hall, *Lovers*, p. 156.

230 " 'What a happiness' " Letter, Min Baker to Ann Baker Bourne, 4 Nov. 1865.

231 "Sam and Florence were wed circumspectly" Marriage Registry of the Church of St. James's, 4 Nov. 1865. Hall, *Lovers*, p. 158, implies that Florence's difficulties in signing this document indicate that she was barely or newly literate. However, she signed her name as "Florenz," confirming that she had been taught to read and write while she was in training for the harem and still known as Florenz. Sam called her "Florence," and if he had taught her to write, there would be no reason for him to teach her to sign her name "Florenz."

15. A COURAGEOUS LADY

PAGE

233 "dined that night with the Murchisons" Letter, Sam to Edith Baker, 30 Oct. 1865.

233 "founder of the RGS" Stafford, *Scientist of Empire*, p. 21.

234 " 'little blue-eyed Hungarian wife' " Hall, *Lovers*, p. 160; no reference given.

235 " 'Let me call your attention' " *Times*, 14 Nov. 1865.

236 " 'And there is one other' " Letter, Robin Baily to Anne Baker, 19 July 1972, including remarks in parentheses.

236 "Florence, blushing prettily" Hall, *Lovers*, p. 168.

236 "tenderly giving it to her" *Tour du Monde*, Dec. 1867.

236 "The *Illustrated London News*" "Mr. S. W. Baker," *Illustrated London News*.

237 " 'I arrived a few weeks ago' " Letter, Sam to Wharncliffe, [Nov. 1865?], Sheffield Archives WhM 418 (MF: 278), 1865.

237 " 'The fact of being remembered' " Letter, Sam to Wharncliffe, 21 Nov. 1865, ibid., (MF: A278), 1865.

237 " 'Baker married his mistress' " Letter, Livingstone to Cotton Oswell, 1 Jan. 1866.

237 " 'trump' " and " 'beauty' " Letter, Cotton Oswell to Livingstone, n.d., cited in Hall, *Lovers*; p. 167.

237 " 'It would have done' " Letter, Murchison to Grant, 2 Jan. 1866, National Library of Scotland, MS 17910, pp. 17–18, 52–3, 58–9. There is some confusion about whether Florence's putative age was twenty-three or twenty-four in the autumn of 1865; she was probably only eighteen or nineteen in reality.

238 "Colquhoun had mentioned her" Letter, Colquhoun to Rigby, 20 July 1861, cited in Hall, *Lovers*; no source given.

238 " 'I was at the meeting' " Letter, Rigby to Grant, 12 Feb. 1866, National Library of
Scotland, MS 17910, pp. 17–18, 52–53.

239 " 'Baker has certainly' " Letter, Rigby to Grant, 1 Dec. 1866, National Library of Scot-
land, MS 17910, pp. 17–18, 58–59.

240 "a pair of matching oval engravings" Samuel Baker, *Albert N'yanza*, vol. 1, frontis-
piece.

240 " 'I have written "HE!" ' " Ibid., p. ix.

240 " 'Could we not have' " Letter, Gladstone to Murchison, 23 July 1866, quoted in
Brander, *Perfect Victorian Hero*, pp. 108–9.

241 " 'I am commanded' " Letter, Lord Stanley to Sam, 15 Aug. 1866, quoted ibid., p. 109.

242 " 'it shows much more effrontery' " Letter, Grant to Blackwood, 22 Oct. 1866, National
Library of Scotland, MS 4209, pp. 188–93.

242 " 'I have watched pretty closely' " Letter, Blackwood to Grant, 1 Dec. 1866, National
Library of Scotland, MS 30362, pp. 141–43.

243 " 'vulgar-minded' " and " 'not a lady' " Letter, Min Baker to Ann Bourne, n.d.

243 " 'I was very miserable' " Letter, Sam to Wharncliffe, 4 Mar. 1867, Sheffield Archives
WhM 418/11.

244 " 'perhaps more intense' " Letter, Sam to Wharncliffe, 5 Mar. 1867, Sheffield Archives
WhM 418/12.

244 " 'a necklace of lion's teeth' " Richards and Elliott, *Julia Ward Howe*, vol. 1, chap. 12. See
also Samuel Baker, *Nile Tributaries*, p. 287.

245 " 'I feel towards you' " Letter, Florence to Edith Baker Marshall, Sept. 1868, quoted in
Brander, *Perfect Victorian Hero*, p. 113.

245 "a friend of Sam's brother Valentine" Anne Baker, *Question of Honour*, pp. 47–52.

246 " 'My dear Mama' " Letter, Prince of Wales to Queen Victoria, 27 Sept. 1868, quoted in
Brander, *Perfect Victorian Hero*, pp. 113–14.

246 "He once dared flirt" Weintraub, *Edward the Caressor*, p. 166, 247, 253, 277.

16. SUPREME AND ABSOLUTE POWER

PAGE

247 "she believed she might be pregnant" Florence's pregnancy is not documented. It is the
best hypothesis I can construct to account for her staying home from the Nile trip with
the Prince and Princess of Wales. The queen's disapproval was an insufficient reason,
since the queen's letters to the prince did not keep Sam from going (Anne Baker, *Morn-
ing Star*, p. 40; Hall, *Lovers*, p. 180). The only direct reference to Florence's absence is in
a letter from Sam to Wharncliffe, in which he remarks that the trip was "quite impos-
sible" for Florence, which might very well refer to the perceived danger of her miscar-
rying. The interpretation that she had become pregnant and lost the child would also
explain Florence's surprising grief and unhappiness (Anne Baker, *Morning Star*, p. 42)
when Sam returned from Egypt with his commission from the khedive.

248 " 'quite impossible for Lady Baker' " Letter, Sam to Wharncliffe, 29 Oct. 1868, Sheffield
Archives WhM 418/13.

248 "The final party" Samuel Baker, "List of the Royal Party written by Sir Samuel Baker,
Cairo, Feb. 4, 1869." In the possession of the Reverend Ian Graham-Orlebar.

248 "Queen Victoria protested" Letters between Queen Victoria and Albert, Prince of
Wales, cited in Hall, *Lovers*, p. 180; and Brander, *Perfect Victorian Hero*, p. 114.

248 "a floating bawdy house" Hall, *Lovers*, p. 181.

250 "ten thousand pounds per annum" Anonymous, "Sir Samuel Baker: The Khedive Employs." £10,000 in 1869 is the equivalent of £489,862.72 or $836,914.13 in 2001: McCusker, "Comparing"; and Officer, "Exchange Rate."

250 "Florence was in poor health and low spirits" Anne Baker, *Morning Star*, p. 42. There is no direct evidence as to why Florence never bore a child. If she miscarried, as I hypothesize, then she may have damaged her womb during premature labor or contracted a postpartum infection that scarred her Fallopian tubes or ovaries.

252 " 'We, Ismail, Khedive of Egypt' " Samuel Baker, *Ismailïa*, pp. 3–4.

253 " 'was to possess supreme and absolute power' " Baker journal, 15 May 1869.

253 " 'It was obvious' " Samuel Baker, *Ismailïa*, p. xi.

253 " 'The magnitude of the operation' " Ibid., p. xiii.

254 "Sam would rely most heavily" Personnel and description of objectives of enterprise and equipment from letter, Sam to Wharncliffe, 22 Oct. 1869, Sheffield Archives WhM 418/14.

255 "Florence insisted that they read" Florence journal, 25 May 1870.

255 "they hired four Egyptians" Baker journal, 10 June 1869.

255 "Sam ordered nine thousand pounds' worth" Samuel Baker, *Ismailïa*, pp. 481–83. In 1869, £9,000 had the purchasing power of £440,876.45 or $765,131.37 in 2001: McCusker, "Comparing"; and Officer, "Exchange Rate."

255 "Sam would command" Letter, Sam to Wharncliffe, 22 Oct. 1869, Sheffield Archives WhM 418/14.

255 " 'We came here on the 17' " Letter, Florence to Edith Baker Marshall, 29 Oct. 1869, quoted in Anne Baker, *Morning Star*, pp. 45–47.

258 " 'terrible desolation' " Samuel Baker, *Ismailïa*, p. 11.

258 "an extremely tough" Ibid.

259 "not a single ship" Letter, Sam to Cherif Pasha, 12 Jan. 1870, draft in Baker journal.

259 "notorious slave trader, Kutchuk Ali" Samuel Baker, *Ismailïa*, p. 12.

259 " 'Delay is one of the' " Ibid.

259 " 'peculiar light-fingered' " Ibid., p. 15.

260 "February 8, 1870" Florence journal, 8 Feb. 1870.

260 "Julian was fascinated" Julian Baker journal, Feb. 8, 14, 17, Mar. 8, 1870.

260 " 'miserable place' " Florence journal, 14 Feb. 1870.

261 " 'full of fever' "; " 'a good many people' "; " 'horrid village' " Ibid.

261 " 'the most miserable place' " Julian Baker journal, 14 Feb. 1870, Bodleian Library, G. B. 0161 Mss. Eng. Misc. c. 869, ea 1391–2, g. 353–4.

261 " 'We now came upon a region' " Samuel Baker, *Ismailïa*, pp. 17–18.

262 "Sam ordered fifty swords" Ibid., p. 20.

263 " 'It was in vain' " Florence journal, 1 Mar. 1870.

264 "a pile of eighteen bodies" Baker journal, 4 Mar. 1870.

264 "a hippo attacked" Florence journal, 5 Mar. 1870.

265 " 'beautifully mended' " Ibid., 6 Mar. 1870.

265 " 'Who could believe the change?' " Sam journal, 9 Apr. 1870.

266 " 'Sam and I went out' " Florence journal, 14 Apr. 1870.

267 " 'The banks of the river' " Samuel Baker, *Ismailïa*, p. 42.

267 " 'our arrival is quite' " Ibid., p. 43.

268 "Allahu akbar!" Ibid.

268 " 'I ordered the ropes, irons' " Episode described ibid., pp. 44–47.

269 "his first station . . . Tewfikeeyah" Ibid., pp. 49–53.

270 "an 'awkward smell' " Ibid., pp. 62-ff.

270 " 'Poor things' " Florence journal, 10 May 1870.

271 " 'I never heard such dreadful' " Ibid., 24 May 1870.

272 " 'I am very much afraid' " Ibid., 25 May 1870.

272 "She never got used" Ibid., 4 June 1870.

273 " 'The Englishmen are a little better' " Ibid., 1 Sept. 1870.

273 " 'a perfectly mad man' " Ibid., 9 Sept. 1870.

17. MY LADY AND I SHALL PROCEED ALONE

PAGE

275 "three thousand Turkish lira" In 1870, 3,000 Turkish lira was the equivalent of £2,459 or, in 2002, £120,840.05. In 1870, 3,000 Turkish lira was worth $13,745.81 or $188,379.23 in 2002. Currency-exchange rates calculated per McCarthy, *Arab World*, pp. 153–55; Mc-Cusker, "Comparing"; and Officer, "Exchange Rate."

276 " 'The curtain began to rise' " Samuel Baker, *Ismailïa*, pp. 72–73.

276 "the entire White Nile . . . were already leased" Ibid., pp. 74–75.

277 "Gedge looked past any . . . recovery" Ibid., p. 82.

277 "Margaret and Lewis, and little Mistoora" Florence journal, 8 Dec. 1870.

278 " 'It is dreadful to lose' " Ibid., 16 Dec. 1870.

278 "Quat Kare, king of the Shillook" Samuel Baker, *Ismailïa*, pp. 86–89.

278 " 'It was quite glorious' " Florence journal, 27 Dec. 1870.

279 " 'It would be quite impossible' " Letter, Florence to Edith Baker Marshall, 19 May 1871.

280 " '6 pairs of the best brown' " Ibid.

280 " 'wildest anarchy' " Ibid.

281 " 'You had better' " Dialogue, with minor addition and changes for clarity, from Samuel Baker, *Ismailïa*, pp. 114–15.

281 " 'On May 26' " Letter, Sam to Wharncliffe, 26 Aug. 1871, Sheffield Archives WhM 418/16.

282 " 'irrepressible vermin' " Samuel Baker, *Ismailïa*, p. 148.

282 "He took 450 men" Ibid., p. 156.

282 "After less than a month" Letter, Sam to Prince of Wales, 19 Oct. 1871, published in *Times*, 8 Feb. 1872.

283 " 'On November 3, thirty vessels had left" Samuel Baker, *Ismailïa*, p. 193.

283 " 'I should have clapped Abou Saood' " Ibid., p. 138.

283 " 'I wrote the khedive,' " Gray, "Ismail Pasha."

284 " 'We may not hear from the khedive' " Indeed, the khedive did not write such a letter until sometime in February 1872, and it was never received by Sam, nor did he become aware of its content. Gray, in "Ismail Pasha," discusses this letter, which extended Sam's *firman* but also instructed him not to move south of Gondokoro until such time as he had firmly established peace in that region because of potential danger of proceeding into Bunyoro. There is no evidence that the letter was sent. Thus, its text might have been written or altered later than its vague date of "February 1872" in order to shift the blame for the extreme hostilities in Bunyoro from the khedive's shoulders to Sam's. If it was sent, it may have been delayed or stolen by someone who wished the expedition to fail and who hoped to cause dissent between the khedive and Sam. Gray argues convincingly that, if the letter was written as it is dated, the khedive failed

to make its contents known to Sam at any time, which was possibly to the khedive's benefit.

284 " 'And I shall write to' " Samuel Baker, *Ismailïa*, p. 193.

284 "Sam decided to leave 340 men" Ibid., pp. 217–19.

284 "the 'domestic staff' " and "of 'strong passions' " Ibid., pp. 220–21.

286 " 'African diplomacy' " Ibid., pp. 227–28.

286 " 'sad and heartbreaking' " Florence journal, 31 Jan. 1872.

287 " 'Are we camels' " Samuel Baker, *Ismailïa*, p. 233; punctuation as in original.

287 " 'I recalled to their recollection' "; " 'no good Negroes' "; and "You *shall* do all" Ibid.

288 " 'My work has been' " Florence journal, 8 Feb. 1872.

288 " 'It is really horrible' " Ibid., 2 Mar. 1872.

288 "On March 6" Samuel Baker, *Ismailïa*, pp. 257–60.

289 "their old dragoman, Mahomet" Ibid., pp. 259–60.

289 "replaced by his son, Kabba Réga" Ibid., p. 264.

289 "the hospitality of his settlement" Ibid., p. 260.

289 "The music was an irresistible temptation" Ibid., p. 261.

290 "a detachment of one hundred men" Ibid., p. 277.

290 " 'No. 46 with all sorts' " Florence journal, 18 Mar. 1870.

290 " 'nasty muddy river' " Ibid., 19 Mar. 1870.

291 "the traditional manner of settling succession" Gray, "Diaries of Emin Pasha," pp. 149–50; Beattie, *Bunyoro*, p. 27.

291 " 'to advise Kabba Réga' " Samuel Baker, *Ismailïa*, p. 287.

291 " 'Negroes are great deceivers' " Ibid.

291 " 'I am sorry to say' " Florence journal, 23 Mar. 1872.

292 " 'What a horrible, horrible country' " Ibid., 10 Apr. 1872.

292 "On April 11" and "a miserable dirty village" Ibid., 11 Apr. 1872.

293 " 'It all shews' " Ibid., 21 Apr. 1872.

293 " 'a miserable dirty place' " Ibid., 25 Apr. 1872.

293 "322 miles since" Samuel Baker, *Ismailïa*, p. 306.

294 "Sam found a lovely banyan tree" Florence journal, 25 Apr. 1872.

18. NOT A GENTLEMAN IN THE WHOLE OF AFRICA

PAGE

296 " 'unmannerly cub!' " and "When the bugler blew" Incident and some dialogue from Samuel Baker, *Ismailïa*, p. 308.

296 " 'In about ten minutes' " Florence journal, 27 Apr. 1872.

297 " 'gauche, awkward, undignified' " and " 'He was cowardly, cruel' " Samuel Baker, *Ismailïa*, p. 309.

297 " 'The Pasha is not like' " Ibid., pp. 313–14.

299 " 'with my scarlet blankets' " Florence journal, 6 May 1872.

299 " 'I hate this place' " Ibid., 11 May 1872.

299 "as if the grass were an asset" Samuel Baker, *Ismailïa*, p. 324.

300 "On May 31" and " 'I immediately sent for the cattle' " Florence journal, 31 May 1872.

301 " 'Well done, Kadji-Barri!' " Samuel Baker, *Ismailïa*, p. 349.

301 "so 'disgustingly drunk' " and "could not say a word" Florence journal, 31 May 1872.

302 "Sam set about designing" Samuel Baker, *Ismailïa*, pp. 354–56.

302 "especially the large colored print" Florence journal, 4 June 1872.

302 " 'Wah! Wah! Speekēē!' " Samuel Baker, Ismailïa, p. 358.

302 " 'There is not a gentleman' " Florence journal, 4 June 1872.

303 "the men had been poisoned"; " 'wonderful effect' "; and " 'I was rather afraid' " Letter, Florence to Agnes Baker, n.d., quoted in Anne Baker, Morning Star, pp. 154–62. Beattie, in Bunyoro, pp. 19–20, notes that Banyoro oral tradition insists that the beer was not poisoned, just particularly strong, and that Sam misinterpreted events substantially. Banyoro oral tradition also claims that "Baker mowed down large numbers of [Ba]nyoro with a Maxim gun" (Beattie, Bunyoro, p. 20) at the battle of Masindi. Since the battle occurred in 1872, and the Maxim gun was not invented until 1885 and not adopted by the Royal Army until 1889, a conflation of different times and events has apparently occurred.

304 "near hysteria" Samuel Baker, Ismailïa, p. 365.

304 " 'The disgusting ingratitude' " and " 'What is to become' " Baker journal, 8 June 1872.

304 "The vultures collected" Samuel Baker, Ismailïa, p. 370.

304 "Florence returned to her pretty house" Letter, Florence to Agnes Baker, n.d., quoted in Anne Baker, Morning Star, pp. 154–62.

305 " 'six large iron boxes' " Samuel Baker, Ismailïa, p. 377.

306 " 'It was very easy to pack up' " Letter, Florence to Agnes Baker, n.d., quoted in Anne Baker, Morning Star, pp. 154–62.

307 " 'I will not give you an account' " Letter, Florence to Agnes Baker, n.d., quoted ibid.

308 "Sam has brought me" and "There is no point in living" Florence expressed these sentiments many times in many ways: e.g., letter, Florence to Agnes Baker, n.d., quoted in Anne Baker, Morning Star, pp. 154–62; letter, Florence to Erica Bourne Graham, quoted in Baily, "Reminiscences"; letter, Florence to unknown correspondent, shortly after Sam's death, quoted in Anne Baker, Morning Star, p. 226.

309 "like a grotesque chicken" Samuel Baker, Ismailïa, p. 394.

309 "Julian stopped and burned" Letter, Florence to Agnes Baker, n.d., quoted in Anne Baker, Morning Star, pp. 154–62.

309 " 'barbarous ceremony' " Samuel Baker, Ismailïa, p. 393.

310 "at Rionga's request" Julian Baker was twenty-four years old at the time of this ceremony. His son, John R. Baker, went to Uganda in 1957 on the eighty-fifth anniversary of this ritual alliance and repeated it with the grandson of Rionga, Omubito Kosiya K. Labwoni. John Baker, "Baker and Ruyonga." See also Samuel Baker, Ismailïa, pp. 402–4. Peter Baker accompanied his grandfather, John R. Baker, on this trip. (Peter Baker, comment to author 2003.)

310 "leave sixty-five soldiers under Abd-el-Kadr" Samuel Baker, Ismailïa, p. 405.

311 "hip-deep marshes, high grass, forest, and swampland" and "they met some messengers" Ibid., pp. 408–9.

312 "Florence began to smell treachery" Description of the battle from ibid., pp. 412–14; letter, Florence to Agnes Baker, n.d., quoted in Anne Baker, Morning Star, pp. 154–62.

312 " 'Men must eat' " Baily, "Reminiscences."

312 " 'The rumor of a lamentable tragedy' " "Reported Murder," Times. See also Proc. RGS 17 (1872–73), p. 161; Saunders, "On the Case"; Pall Mall Gazette, 10 May 1873.

313 "Daily Telegraph said" Letter, Arthur Baker to Eliza Baker, 24 Apr. 1873, quoted in Anne Baker, Morning Star, p. 204.

313 "an enormous granite plateau" Samuel Baker, Ismailïa, p. 258.

314 "The other three walls" Ibid., pp. 432–34.

314 "used by the Bakers" Thomas, "Baker's Fort at Patiko."

314 "Florence passed the autumn months" Florence journal, 23, 28 Sept.; 2, 14, 31 Oct.; and 15 Nov. 1872.

314 "the sizeable collection" Ibid., 3 Oct. 1872.

314 " 'I think the natives are very bad' " and " 'Only about six weeks ago' " Ibid., 13 Nov. 1872.

315 "the rats were eating" Ibid., 6 Nov. 1872.

315 " 'I am dreadfully afraid' " Ibid., 15 Nov. 1872.

316 " 'nothing to do' " and "longing to go home" Florence journal, 20 Dec. 1872. See also 25, 28 Dec. 1872; 23 Jan. 1873; 4, 8, 26 Feb. 1873; and 8, 15 Mar. 1873.

316 "an extensive set of orders" and "about 600 copies" Samuel Baker, Ismailïa, pp. 451–52.

316 "death of Roderick Murchison" and "illness of Mary" Florence journal, 8 Mar. 1873.

316 " 'She did not like the ox' " Ibid., 13 Mar. 1873.

317 " 'Nobody ever obeys' " Ibid., 15 Mar. 1873.

317 " 'kick rider after rider' " Ibid., 21 Mar. 1873.

19. THE LEGENDARY REPUTATION FOR AMAZONIAN QUALITIES

PAGE

318 "Higginbotham . . . had died" Samuel Baker, Ismailïa, pp. 457–58.

318 "it had been allowed to fall in" Ibid., p. 454.

319 " 'My heart has often ached' " Letter, Sam to Ellen Baker Hopkinson, 20 May 1873, quoted in Anne Baker, Morning Star, pp. 217–18.

320 " 'May God give you' " and "brush tears from his eyes" Samuel Baker, Ismailïa, p. 455.

321 " 'We hear that five boats' " Florence journal, 5 June 1873.

321 "Abou Saood had left Khartoum" Samuel Baker, Ismailïa, p. 421.

322 "the odor of filth, disease" and "the new governor" Ibid., p. 458.

323 the message to Ismail Ayoub Pasha" Ibid., pp. 459–61.

323 " 'At 8.30 a.m.' " Florence journal, 29 June 1873.

324 "Sam sent a cable" Gray, "Ismail Pasha," p. 208, citing Annual Register of the Foreign Office, 1873, part 2, p. 58.

324 " 'My labor expended' " Letter, Sam to Prince of Wales, 1 July 1873, reprinted in Anne Baker, Morning Star, p. 209.

325 " 'We both heartily' " Telegram, Prince of Wales to Sam, July 1873, quoted in Hall, Lovers, p. 204.

325 " 'The Ladies at the harem' " Florence journal, 8 July 1873.

326 "two of her 'boys' " Ibid.

326 " 'I am quite heartbroken' " Ibid.

327 "The khedive never revealed" See Gray, "Ismail Pasha," for a discussion of this matter.

327 " 'Sir Samuel Baker' " Daily News, 6 Oct. 1873, quoted in Middleton, Baker of the Nile, p. 244.

327 " 'this courageous and skillful' " Illustrated London News, supp. 11 Oct. 1873, pp. 345–46.

328 " 'my friend Sir Samuel' " Times, 9 Dec. 1873.

328 " 'welcomed back' " Ibid.

329 "The honors and acclaim" Brander, Perfect Victorian Hero, pp. 144–45; Anne Baker, Morning Star, pp. 210–15; Murray and White, Sir Samuel Baker, pp. 210–14.

329 " 'almost as good a book' " Moorehead, *White Nile*, p. 375.

329 "Charles Gordon" For background information and character of Gordon, see, e.g., Thompson, *Imperial Vanities*; Churchill, *River War*; Trench, *Road to Khartoum*; Elton, *Gordon of Khartoum*; MacGregor-Hastie, *Never to Be Taken Alive*; Waller, *Gordon of Khartoum*; Strachey, *Eminent Victorians*; Moorehead, *White Nile*.

330 "Gordon refused the same immense salary" Moorehead, *White Nile*, p. 171. £2,000 in 1874 had the same purchasing power as £85,669.44 or $170,243.70 in 2002: McCusker, "Comparing"; and Officer, "Exchange Rate."

330 " 'Now as I am one of the unfortunate' " M'Williams, "Baker's Expedition."

331 " 'If Sir Samuel Baker wishes' " Ibid.

331 " 'Sir Samuel always wished' " Julian Baker, "S. Baker's Expedition."

331 "Abou Saood's treacherous ways" Letter, Gordon to Abou Saood, 3 Sept. 1874, reproduced in Murray and White, *Sir Samuel Baker*, pp. 217–18.

332 " 'You ask me why' " Letter, Gordon to Sam, 18 Nov. 1874, reproduced ibid., pp. 221–22.

332 " 'Do not let us speak' " Letter, Sam to Gordon, 14 Jan. 1875, reproduced ibid., pp. 222–23.

332 " 'I have gone through' " Letter, Gordon to Baker, 1 Oct. 1874, quoted in Brander, *Perfect Victorian Hero*, p. 148.

333 " 'It certainly is' " Letter, Gordon to unknown correspondent, n.d., quoted in Murray and White, *Sir Samuel Baker*, p. 218.

333 "The billiard room" Baily, "Reminiscences."

334 "the Prince of Wales's sons Edward . . . and George" Ibid. It is perhaps relevant that Edward was very hard of hearing even as a child.

334 " 'Oh, we have but one' " Lomax, *Sir Samuel Baker*, p. 131.

20. THAT DISGRACEFUL OUTRAGE

PAGE

335 "Sam's younger brother, Valentine" General information on the character and career of Valentine Baker from Anne Baker, *Question of Honour*.

336 "a telegram from Valentine" Ibid., p. 78; see also "Extraordinary Charge," *Times*; "Criminal Assault," *Times*.

336 "That afternoon he had boarded" Description of the journey taken from Miss Dickinson's testimony as reported in "Criminal Assault," *Times*; and Anne Baker, *Question of Honour*, pp. 77–82.

336 " 'his body was on me' " "Criminal Assault," *Times*.

337 " 'When shall we' "; " 'I pray you' "; " 'This man' "; and "his trouser buttons were undone" "Criminal Assault," *Times*; and Anne Baker, *Question of Honour*, p. 81.

338 "yet they all defended Valentine" and "too amorous" See, e.g., letter, Sam to Wharncliffe, 25 June 1875, Sheffield Archives WhM 418/20; letter, Edith Baker Marshall to Robert Marshall, 2 Aug. 1875, reprinted in Anne Baker, *Question of Honour*, p. 85.

339 " 'is an officer of distinction' " and " 'I am placed here' " "Criminal Assault," *Times*.

340 " 'If a man kisses' " and " 'Now, it is not correct to say' " Ibid.

341 "a fine of five hundred pounds" £500 in 1875 is the equivalent of £23,264.79 or $44,849.50 in 2001. McCusker, "Comparing"; and Officer, "Exchange Rate."

341 " 'I always knew' " Letter, Sam to Wharncliffe, 25 June 1875, Sheffield Archives WhM 418/20.

341 " 'that disgraceful outrage' " Anne Baker, *Question of Honour,* p. 91, quoting Queen Victoria's diary, 3 Aug. 1875.

341 "The Duke of Cambridge . . . wrote the Queen" Anne Baker, *Question of Honour,* pp. 92–93.

341 " 'Lieutenant Colonel' " *London Gazette,* quoted ibid., p. 93.

342 "In yet another action" and "He was restored to membership" Hall, *Lovers,* p. 221.

21. YOU PROMISED YOU WOULD NEVER RETURN WITHOUT ME

PAGE

343 "where Amarn grew to manhood" Sadly, there is no further information about Amarn that I have been able to locate.

343 "the tiaras, brooches" Florence Baker, Last Will and Testament, 1 May 1899.

344 " 'If it were not' " Letter, Sam to Gordon, 18 Sept. 1875, quoted in Murray and White, *Sir Samuel Baker,* p. 236.

344 " 'Still they keep on' "; " 'unless the offender' "; and " 'If you could come' " Letter, Gordon to Sam, 1 Sept. 1878, quoted in ibid., pp. 243–44.

344 " 'I should have much liked' " Letter, Sam to Gordon, 16 Dec. 1877, quoted in Murray and White, *Sir Samuel Baker,* p. 258.

345 "If on his rambles" Baily, "Reminiscences."

345 "his appointment blocked" Hall, *Lovers,* p. 222.

346 "the Mahdi, or Expected One" General information about the Mahdi and Mahdism can be found in Thompson, *Imperial Vanities;* Churchill, *River War;* Trench, *Road to Khartoum;* Elton, *Gordon of Khartoum;* MacGregor-Hastie, *Never to Be Taken;* Waller, *Gordon;* Strachey, *Eminent Victorians;* Moorehead, *White Nile.* A valuable Victorian view is given in letter, Giegler Pasha to Sam, 18 Nov. 1882, in Murray and White, *Sir Samuel Baker,* pp. 293–305.

346 " 'Whosoever doubts my mission' " Trench, *Road to Khartoum,* pp. 187–88.

347 " 'harmless idiot, such as' " Letter, Giegler Pasha to Sam, 18 Nov. 1882, quoted in Murray and White, *Sir Samuel Baker,* p. 294.

347 "a force of 240 soldiers" Trench, *Road to Khartoum,* p. 190.

347 " 'a small nest of sleeping devils' " Letter, Gordon to Sam, 8 Feb. 1883, quoted in Murray and White, *Sir Samuel Baker,* p. 292.

347 "God was working out" Trench, *Road to Khartoum,* p. 190, quoting letter, Gordon to Augusta Gordon, 15 Oct. 1883.

347 " 'I believe an army of old' " Trench, *Road to Khartoum,* p. 192, quoting Hamilton Stewart, *Report on the Sudan.*

350 " 'perhaps the worst army' " Churchill, *River War,* p. 41.

351 " 'If the Mahdi is a prophet' " Trench, *Road to Khartoum,* p. 195.

351 " 'If you want some out-of-the-way' " Ibid., p. 162, citing Wilson, *My Official Life,* pp. 199–200.

351 "Gordon kept urging Sam" Wingate, "Baker's Papers," quoting letter, Gordon to Baker, 4 Jan. 1884.

351 "an interview . . . *Pall Mall Gazette*" "Chinese Gordon" reprinted in *Times;* "General Gordon and Sir S. Baker Oppose," *Times.*

352 " 'The Mahdi has no backbone' " Wingate, "Baker's Papers."

352 " 'Why should not' " Letter, Sam to Editor, *Times,* 16 Jan. 1884.

352 "a very nervous colonel" Trench, *Road to Khartoum,* p. 194.

352 " 'utterly worthless' " Fanny Wormald, diary, 6 Feb. 1884, quoted in Anne Baker, *Question of Honour*, p. 141. Wormald was a friend staying with Fanny Baker, Valentine's wife, in Cairo.

353 "Gordon decided to visit Sam" Incident described in Baily, "Reminiscences"; Elton, *Gordon of Khartoum*, pp. 279–80.

353 "Gordon talked with his eyes alight" Apparently Gordon was ashamed of his eagerness to go to the Sudan, for late that night he asked Barnes if he had seen the expression on his, Gordon's, face. Upon being told Barnes had, Gordon replied enigmatically, "You saw *me*; that was *myself*; the self I want to get rid of" (Elton, *Gordon of Khartoum*, p. 280). Interestingly, Barnes made little impression upon the Bakers because his presence is not noted in Baily's unpublished reminiscences or family stories.

353 *"a way of offering his death to God"* In letter, Gordon to the Reverend R. H. Barnes, Gordon admitted he had gone to the Crimea hoping to be killed without committing the sin of suicide, and he may have viewed going to the Sudan similarly.

353 "pressed tongue, chicken mayonnaise" Paterson and Wright, in *Two Fat Ladies*, p. 131, assert that this was a favorite sandwich of Princess Alix (Alexandra).

354 " 'Sam . . . you promised me' " and " 'You see how I am placed' " Baily, "Reminiscences."

355 "I wished I was a eunuch" Letter, Gordon to the Reverend R. H. Barnes, 26 Sept. 1883. Biographers of Gordon have speculated intensely on what prompted Gordon to say this extraordinary thing; he may have been sexually abused.

355 " 'half-cracked' " Trench, *Road to Khartoum*, p. 215, quoting letter, Baring to Granville.

355 " 'just as it used to be' " Trench, *Road to Khartoum*, p. 225.

356 " 'smash up the Mahdi' " Ibid., p. 235, citing letter, Gordon to Baring.

356 "Frank Power, a correspondent" Trench, *Road to Khartoum*, pp. 235–36.

356 " 'A considerable body' " Ibid., p. 239, quoting letter, Hamilton-Stewart to Baring.

356 " 'British and American millionaires' " Letter, Gordon to Baker, 8 Apr. 1884; Thompson, *Imperial Vanities*, p. 239; Charles Gordon, "General Gordon's Telegram."

356 " 'Gordon is in danger' " Trench, *Road to Khartoum*, p. 244.

357 "Gordon had been expressly" Ibid., p. 260, quoting letter, Gladstone to Hartington, 25 Sept. 1884.

357 " 'We are about to be hemmed in' " Letter, Gordon to Baker, 3 Nov. 1884, quoted in Anne Baker, *Question of Honour*, p. 160.

357 " 'We are besieged' " Anne Baker, *Question of Honour*, p. 160.

358 "Gordon, in his dress uniform" Elton, *Gordon of Khartoum*, pp. 368–69. There is some debate about exactly how Gordon was killed.

358 "His head was mounted" Thompson, *Imperial Vanities*, p. 253.

358 "Murderer of Gordon" Anne Baker, *Question of Honour*, p. 162; Weintraub, *Edward the Caressor*, p. 281.

358 " 'I shall never publish' " Murray and White, *Sir Samuel Baker*, p. 342.

22. HOW CAN I LIVE?

PAGE

360 "too many deaths" Anne Baker, *Question of Honour*, pp. 167–68.

361 "As recently as 1884" Ibid., pp. 150–51.

361 "Then, on June 15, 1887" Ibid., pp. 167–68. The nature of the surprising information is not specified.

361 "Valentine died of a heart attack" Ibid., pp. 169–75.

361 "Emin Pasha was still holding out" Jones, *Rescue*.

361 "Myadue" Jephson diary, quoted by Hill, *Lovers*, p. 229.

362 " 'We don't care for' " Ibid.

363 " 'As I always had' " Letter, Emin Pasha to Sam, 1 Apr. 1890, quoted in Murray and White, *Sir Samuel Baker*, pp. 369–70.

364 " 'I am not a horse' " Baily, "Reminiscences."

364 " 'I really *dare not* accept it' " Letter, Sam to Countess of Stradbrooke, 5 Oct. 1893, quoted in Murray and White, *Sir Samuel Baker*, pp. 415–16.

364 " 'dear fat old fellow' " Bourne diary.

365 " 'Oh Flooey, Flooey' " Anne Baker, *Morning Star*, p. 226.

365 "Sam died" Not surprisingly, obituary notices appeared in newspapers such as the *Daily Telegraph*, the *London Illustrated News*, and *The Times* in early January 1894.

365 " 'How can I live?' " Letter, Florence to unknown correspondent, shortly after Sam's death, quoted in Anne Baker, *Morning Star*, p. 226.

366 "She was specifically instructed" Anne Baker, *Morning Star*, p. 226.

366 "Sam was cremated" Hall, *Lovers*, p. 230.

366 "two thousand pounds" and " 'all my watches' " Samuel Baker, Last Will and Testament. The modern (2001) equivalent of £2,000 in 1893 is roughly £133,305 or $190,630.

367 " 'It will be a year' " Letter, Florence to Erica Bourne Graham, quoted in Baily, "Reminiscences."

367 " 'She was in black' " and " 'It was one of those' " Baily, "Reminiscences."

368 "£420" Allen, *Tales from the Dark Continent*, citing an interview with Angus Gillan of the Sudan Political Service.

368 "Florence and Sam were both well remembered" Letter, Robin Baily to Anne Baker, 19 July 1971, citing his diary.

369 "She always spoke" Ibid.

369 " 'She loved to have parties' " and " 'I just stared' " Baily, "Reminiscences."

370 " 'in the memory of' " Florence Baker, Last Will and Testament.

370 "On May 8, 1899" and "Ethel was left four hundred pound" £400 in 1916 had the buying power of about £14,657 or $31,674 in 2001.

371 " 'I bequeath' " Florence Baker, Last Will and Testament. The total gross value of the estate is marked on the front of this document as £11,448.19.1; the equivalent in 2001 was roughly £415,298 or $1,178,477.

371 "an official came to the house" Letter, Baily to Anne Baker, 19 July 1971.

23. MARCH 11, 1916

PAGE

374 " 'BAKER—On the 11th March' " *Times*, 15 March 1916, p. 1a.

374 " 'I am an old man' " Lloyd, "Acholi Country."

374 " 'Our best recommendation' " Delmé-Radcliffe, "Surveys and Studies."

375 "the roseate days" Girling, "Acholi," p. 132, quoted in Gray, "Ismail Pasha," p. 213.

BIBLIOGRAPHY

PUBLISHED

Alexander, Michael, and Sushila Anand. *Queen Victoria's Maharajah*. New York: Taplinger, 1980.

Allen, Charles, ed. *Tales from the Dark Continent*. London: BBC, 1979.

Baker, Anne. *A Question of Honour: The Life of Lieutenant General Valentine Baker Pasha*. London: Leo Cooper, 1996.

———. *Morning Star: Florence Baker's Diary of the Expedition to Put Down the Slave Trade on the Nile—1870–73*. London: William Kimber, 1972.

Baker, John. "Baker and Ruyonga." *Uganda Journal* 28 (1963), pp. 213–16.

Baker, Julian. "On Sir S. Baker's Expedition." *The Times* (London), 5 Aug. 1874, p. 8b.

Baker, Samuel. *Wild Beasts and Their Ways: Reminiscences of Europe, Asia, Africa and America*. London: Macmillan, 1890.

———. Letter to Editor, *Times* (London), 16 Jan. 1884.

———. *Ismailïa: A Narrative of the Expedition to Central Africa for the Suppression of the Slave Trade*. London: Macmillan, 1874.

———. Letter to Prince of Wales, *Times* (London), 8 Feb. 1872.

———. *The Nile Tributaries of Abyssinia and the Sword Hunters of the Hamran Arabs*. London: Macmillan, 1867.

———. *The Albert N'yanza, Great Basin of the Nile and Explorations of the Nile Sources*. London: Macmillan, 1866.

———. *Rifle and Hound in Ceylon: Stories from the Field 1845–1853*. London: Longman's, 1855.

Barkley, Henry C. *Between the Danube and Black Sea or, Five Years in Bulgaria*. 2d ed. London: John Murray, 1877.

———. *Bulgaria Before the War*. London: John Murray, 1877.

Beachey, R. W. *The Slave Trade of Eastern Africa*. London: Rex Collings, 1976.

Beattie, John. *Bunyoro: An African Kingdom*. New York: Holt, Rinehart and Winston, 1960.

Blackstone, William. *Commentaries on the Laws of England*. Oxford: Clarendon, 1765–69.

Bona, Gábor, ed. *The Hungarian Revolution and the War of Independence*. Highland Lakes, N.J.: Social Science Monographs, 1979.

Brander, Michael. *A Perfect Victorian Hero*. Edinburgh: Mainstream, 1982.

Bridges, R. C. "Sir John Hanning Speke and the Royal Geographical Society." *Uganda Journal* 26, no. 1 (1962), pp. 23–44.

Brodie, Fawn. *The Devil Drives: A Life of Sir Richard Burton*. New York: W. W. Norton, 1967.

Buckland, Frank T. "Reported Death of Mr. Petherick." *Field*, 30 Jan. 1863, p. 527.

Burton, Isabel. *Life of Captain Sir Richard F. Burton*. London: Chapman and Hall, 1893.

Burton, Richard. *Lake Regions of Central Africa, a Picture of Exploration*. New York: Harper & Brothers, 1860.

———. *Personal Narrative of a Pilgrimage to Al-Madinah and Meccah*. London: Long, Green, and Longman's, 1855, 1857.

———. *First Footsteps in Africa, or An Exploration of Harar*. London: Longman, Brown, Green, and Longman's, 1856.

———, and James M'Queen. *The Nile Basin*. London: Tinsley Brothers, 1864.

Campbell, Christy. *The Maharajah's Box*. London: HarperCollins, 2001.

Churchill, Winston. *The River War, An Account of the Reconquest of the Soudan*. New York: Award, 1964.

Cox, Samuel. *Diversions of a Diplomat in Turkey*. New York: Webster, 1893.

Croutier, Alex Lytle. *Harem: The World Behind the Veil*. New York: Abbeville, 1989.

Davis, Fanny. *The Ottoman Lady: A Social History from 1718 to 1918*. London: Greenwood, 1986.

Déak, István. *The Lawful Revolution: Louis Kossuth and the Hungarians, 1848–1849*. New York: Columbia University, 1979.

Delmé-Radcliffe, C. "Surveys and Studies in Uganda." *Geographical Journal* 26 (1905), pp. 482–83.

Elton, Lord Godfrey. *Gordon of Khartoum: The Life of General Charles George Gordon*. New York: Alfred A. Knopf, 1955.

Fraser's Magazine. "A Visit to the Harem of the Pasha of Viddin," 18, pp. 679–86.

Frost, John. *Kossuth and the Hungarian War*. Philadelphia: H. C. Peck & Theo. Bliss, 1851.

Garnett, Lucy. *Turkish Life in Town and Country*. New York: Dodd, Mead, 1904.

Girling, F. K. "The Acholi of Uganda." Khartoum: His Majesty's Sudan Office, 1960.

Gladstone, Penelope. *Travels of Alexine: Alexine Tinné 1835–1869*. London: John Murray, 1970.

Goodwin, Godfrey. *The Private World of Ottoman Women*. London: Saqi, 1997.

Gordon, Charles. "General Gordon's Telegram to Sir S. Baker Appealing to the Millionaires of England and America for Money to Pay Soldiers on His Own Account to Aid Him." *Times* (London), 30 Apr. 1884, p. 6d.

Gordon, Winifred. *A Woman in the Balkans*. London: T. Nelson & Sons, 1918.

Görzsönyi, Vargha Zoltan. *A Szmerjai Szász Család*. Koloszvár: Steif Jenö És Társa Könyvnyomdája, 1912.

Grant, J. A. *A Walk Across Africa: Or, Domestic Scenes from My Nile Journal*. Edinburgh: William Blackwood & Sons, 1864.

Gray, Sir John. "The Diaries of Emin Pasha—Extracts II." *Uganda Journal* 25 (1961a), pp. 149–70.

———. "Ismail Pasha and Sir Samuel Baker." *Uganda Journal* 25 (1961b), pp. 199–213.

Hajnal, István. *A Kossuth-Emigráció Törökországban.* Budapest: Nyamatott a Királyi Magyer Egyetemi Nyomdában, 1927.

Hall, Richard. *Lovers on the Nile: The Incredible African Journeys of Sam and Florence Baker.* New York: Random House, 1980.

Halsband, Robert, ed. *The Complete Letters of Lady Mary Wortley Montagu (1708–1720).* Oxford: Clarendon, 1966.

Harvey, Annie Jane (Tennant). *Turkish Harems and Circassian Homes.* 2d ed. London: Hurst & Blackett, 1871.

Headley, P. C. *The Life of Louis Kossuth.* Auburn, N.Y.: Derby & Miller, 1852.

Hermann, Róbert. "The Summer Campaign," in Gábor Bona, ed., *The Hungarian Revolution and the War of Independence.* Highland Lakes, N.J.: Social Science Monographs, 1979, pp. 432–33.

Hitchins, Keith. *The Rumanian National Movement in Transylvania 1780–1849.* Cambridge: Harvard University Press, 1969.

Illustrated London News. "Mr. S. W. Baker, the African Traveller," 5 Dec. 1865, pp. 544–45.

———. "Sir Samuel and Lady Baker," Supp., 11 Oct. 1873, p. 346.

Johnston, Harry. *The Nile Quest: A Record of the Exploration of the Nile and Its Basin.* New York: Frederick A. Stokes, 1903.

Jones, Roger. *The Rescue of Emin Pasha: The Story of Henry M. Stanley and the Emin Pasha Relief Expedition 1887–1889.* London: History Book Club, 1972.

Karpat, Kemal. *Ottoman Population 1830–1915; Demographic and Social Characteristics.* Madison: University of Wisconsin, 1985.

Komlos, John. *Kossuth in America 1851–1852.* Buffalo, N.Y.: East European Institute, State University of New York at Buffalo, 1973.

Kozlowski, Eligiusz. "The Embodiment of the East Central European Revolutionary Warrior: General Joseph Bem." In Béla Kiraly, ed., *War and Society in East Central Europe.* Vol. 4 of *East Central European Society and War in the Era of Revolutions.* New York: Brooklyn College, 1984.

Lancelot, M. "De Paris à Bucharest." *Tour du Monde* 3 (1861), pp. 177–224, 425–39.

Lane, Edward G. *An Account of the Manners and Customs of the Modern Egyptians: Written in Egypt During the Years 1833–1835.* London: Alexander Gardner, 1860.

Lewis, Bernard. *Race and Slavery in the Middle East: An Historical Enquiry.* Oxford: Oxford University, 1994.

Lloyd, A. B. "Acholi Country: Part 2." *Uganda Notes* 5 (1904).

Login, Dalhousie E., ed. *Lady Login's Recollections: Court Life and Camp Life 1820–1904.* New York: Dutton, 1916.

Lomax, Alfred E. *Sir Samuel Baker, His Life and Adventures.* London: Sunday School Union, 1900.

Lott, Emmeline. *The English Governess in Egypt.* Philadelphia: T. B. Peterson & Bros., 1867.

McCarthy, Justin. *The Arab World, Turkey & the Balkans (1878–1924): A Handbook of Historical Statistics.* Boston: G. K. Hall, 1982.

McCusker, John J. "Comparing the Purchasing Power of Money in Great Britain from 1264 to Any Other Year Including the Present." Economic History Services, 2001, URL: http://www.eh.net/hmit/ppowerbp/.

MacGregor-Hastie, Roy. *Never to Be Taken Alive: A Biography of General Gordon.* New York: St. Martin's, 1985.

Malik-Hanim. *Thirty Years in the Harem: or, the Autobiography of Melik-Hanim, Wife of H. H. Kibrizli-Mehemet-Pasha.* New York: Harper Bros., 1872.

M.A.P.B. "Reception of a Lady of Rank in a Turkish Harem." *Lady's Book* (Philadelphia), 30 (May 1845), pp. 234–35.

Medicines Commission. *British Pharmacopoeia.* Cambridge: University Press, 1980a.

Melman, Billie. *Women's Orients.* Ann Arbor: University of Michigan, 1992.

Middleton, Dorothy. *Baker of the Nile.* London: Flacon, 1949.

Moorehead, Alan. *The White Nile.* Bungay, Suffolk: Richard Clay, 1960.

M'Quie, P. B. "Captain Speke and Consul Petherick." *Times* (London), 24 Dec. 1863, p. 6f.

Murchison, Sir Roderick. "Speke and Party on the Nile." *Times* (London), 7 May 1863, p. 9f.

Murray, T. Douglas, and A. Silva White. *Sir Samuel Baker: A Memoir.* London: Macmillan, 1895.

M'Williams, John. "On Sir S. Baker's Expedition." *Times* (London), 1 Aug. 1874, p. 12d.

Napier, Edward. *Excursions Along the Shores of the Mediterranean.* London: Collins, 1842.

Officer, Lawrence H. "Exchange Rate Between the United States Dollar and the British Pound, 1791–2000." Economic History Services, 2001 EH.Net, 2001. URL: http://www.eh.net/hmit/exchangerates/pound.php.

Paget, John. *Hungary and Transylvania: With Remarks on Their Condition, Social, Political and Economical.* London: John Murray, 1850. Reprint, New York: Arno Press and New York Times, 1971.

Pardoe, Julia. *The City of the Sultans and Domestic Manners of the Turks in 1836.* London: Henry Colum, 1837.

Paterson, Jennifer, and Clarissa Dickson Wright. *Two Fat Ladies Ride Again.* London: Ebury, 1997.

Penzer, N. M. *The Harem, An Account of the Institution as It Existed in the Palace of the Turkish Sultans with a History of the Grand Seraglio from Its Foundation to Modern Times.* London: Spring, 1963.

Petherick, John. *Egypt, the Soudan, and Central Africa with Explorations from Khartoum on the White Nile to the Regions of the Equator, Being Sketches from Sixteen Years' Travel.* London: Tinsley Brothers, 1861.

————, and Katherine Petherick. *Travels in Central Africa and Explorations of the Western Nile Tributaries.* London: Tinsley Brothers, 1869.

Pierce, Leslie. *The Imperial Harem.* Oxford: Oxford University, 1993.

Pischon, C. N. "Das Sklavenwesen in der Turkei. Eine Skizze, entworfen im Jahre 1858." *Zeitschrift der Deutsche Morgenlandischen Gesellschaft* 14 (1860).

Poole, Stanley Lane, ed. "'The People of Turkey: Twenty Years' Residence Among the Bulgarians, Greeks, Albanians, Turks, and Armenians. By a Consul's Wife and Daughter." *Quarterly Review* 146 (1878), pp. 256–88.

Pulszky, Theresa. *Memoirs of a Hungarian Lady.* Philadelphia: Lea & Blanchard, 1850.

Reichart, Anne. *Girl-Life in the Harem.* London: J. Ouseley, 1908.

Rice, Edward. *Captain Sir Richard Francis Burton: The Secret Agent Who Made the Pilgrimage to Mecca, Discovered the Kama Sutra, & Brought the Arabian Nights to the West.* New York: Charles Scribner's Sons, 1990.

Richards, Laura E., and Maud Howe Elliott. *Julia Ward Howe 1819–1910.* Boston: Houghton Mifflin, 1916.

Roberts, Ian. *Nicholas I and the Russian Intervention in Hungary.* New York: St. Martin's, 1991.

Saunders, Edward. "On the Case of Sir Samuel Baker." *Times* (London), 19 Apr. 1873.

Shami, Seteney. "Prehistories of Globalization; Circassian Identity in Motion." *Public Culture* 12, no. 1 (2000), pp. 177–204.

Speke, John. Letter to Editor, *Times* (London), 28 Dec. 1863, p. 9d.

————. *Journal of the Discovery of the Source of the Nile.* London: William Blackwood & Sons, 1863.

————. *What Led to the Discovery of the Source of the Nile.* London: William Blackwood & Sons, 1864.

Stafford, Robert A. *Scientist of Empire: Sir Roderick Murchison, Scientific Exploration and Victorian Imperialism.* Cambridge: Cambridge University, 1989.

Stewart, John Hamilton. Letter to Baring, 10 Mar. 1884. *Cairo Intelligence Report* 171.

Stiles, William. *Austria in 1848–49.* New York: Harper & Bros., 1852. Reprint, New York: Arno Press and New York Times, 1971.

Strachey, G. Lytton. *Eminent Victorians.* London: G. P. Putnam's Sons, 1920.

Terrot, Charles. *The Maiden Tribute: A Study of the White Slave Traffic in the Nineteenth Century.* London: Frederick Muller, 1959.

Thomas, I. F. "Baker's Fort at Patiko." *Uganda Journal* 2 (1963), pp. 195–204.

Thompson, Brian. *Imperial Vanities: The Adventures of the Baker Brothers and Gordon of Khartoum.* London: HarperCollins, 2001.

Times (London). "BAKER," 15 March 1916, p. 1a.

————. "Colonel Baker for Criminal Assault," 21 June 1875, p. 9c.

————. "Col. Valentine Baker for Criminal Assault," 3 Aug. 1875, p. 10b.

————. "Chinese Gordon for the Sudan," 11 Jan. 1884; originally in *Pall Mall Gazette*, 9 Jan. 1884.

————. "Extraordinary Charge of Assault," 19 June 1875, p. 7c.

————. "General Gordon and Sir S. Baker Oppose the Cession of Khartoum," 11 Jan. 1884, p. 5a.

————. "Reported Murder of Sir Samuel Baker and His Lady," 17 Apr. 1873, p. 9a.

————. "Sad Death of Captain Speke, the African Traveller," 19 Sept. 1864, p. 6d.

————. "Sir Samuel Baker: The Khedive Employs at a Large Salary to Suppress the Slave Trade," 16 Aug. 1873, p. 7e.

Tinné, John. Letter to the Editor, *Times* (London), 5 Oct. 1864.

Toledano, Ehud. *The Ottoman Slave Trade and Its Suppression, 1840–1890.* Princeton, N.J.: Princeton University, 1982.

————. "Şemsigül: A Circassian Slave in Mid-Nineteenth-Century Cairo." In E. Burke III, ed., *Struggle and Survival in the Modern Middle East.* Berkeley: University of California, 1993.

————. *Slavery and Abolition in the Ottoman Middle East.* Seattle: University of Washington, 1998.

Trench, Charles Chenevix. *The Road to Khartoum: A Life of General Charles Gordon.* New York: Dorset, 1978.

Waller, John H. *Gordon of Khartoum: The Saga of a Victorian Hero.* New York: Atheneum, 1988.

Weintraub, Stanley. *Edward the Caresser; The Playboy Prince Who Became Edward VII.* New York: Free Press, 2001.

White, Charles. *Three Years in Constantinople: Or, Domestic Manners of the Turks in 1844.* London: H. Colburn, 1845.

Wilson, Sir Charles Rivers. *Chapters from My Official Life.* London: Edward Arnold, 1916.

Wingate, Ronald. "Sir Samuel Baker's Papers 1875–93." *Quarterly Review,* July 1967, pp. 295–308.

Young, D., ed. *The Search for the Source of the Nile: Correspondence Between Captain Richard Burton, Captain James Speke and Others from Burton's Unpublished East African Letter Book.* London: Roxburghe Club, 1999.

UNPUBLISHED

Baily, Robin. Letter to Anne Baker, 19 July 1971. In possession of Anne Baker.

————. "Baker Reminiscences." In possession of Anne Baker.

Baker, Florence. Journals, 1870–1874. In possession of Anne Baker.

————. Last Will and Testament, on file in the District Probate Registry of the County of Devon, dated 1 May 1899.

Baker, Julian. Journal, 1870–1874. Bodleian Library, Oxford.

Baker, Samuel. Last Will and Testament, on file in the District Probate Registry of the County of Devon, dated 18 October 1890.

————. "List of the Royal Party Written by Sir Samuel Baker, Cairo, Feb. 4, 1869." In possession of the Reverend Ian Graham-Orlebar.

————. Journal, 1861–1865. Royal Geographical Society.

————. Journal, 1869–1874. Royal Geographical Society.

————, and Florence Finnian, special marriage license obtained 3 Nov. 1865. Lambeth Palace Library, Church of England, London.

Brownell, Clarence. Diary. Copy at Sudan Archives, Durham University Library, U.K.

Bourne, Erica. Diary, 21 Jan. 1882. In possession of the Reverend Ian Graham-Orlebar.

Gordon, Charles. Letter to the Reverend R. H. Barnes, 26 Sept. 1883. Barnes MSS, Boston Public Library.

Jephson, A. J. Mountenoy. Diary, 1888. School of Oriental and African Studies, University of London.

Kurat, Y. T. "The European Powers and the Question of Hungarian Refugees of 1849." Unpublished Ph.D. dissertation. University College London, 1958.

Panayotova, Dora. "Labour, Time and Money in Henry C. Barkley's Accounts of Bulgaria." M.A. thesis, University of Ruhr, Germany, retrieved from http://www.victorianweb.org.

Stewart, John Hamilton. *Report on the Sudan.* 1882. Available from the Sudan Archives, Durham University Library.

Stiansen, Endre. "Overture to Imperialism: Trade & Economic Change in the Sudan in the 19th Century." Ph.D. dissertation, University of Bergen, Norway.

A NOTE ON ARCHIVES

1. **BAKER FAMILY:** Anne Baker holds the diaries of Florence Baker, Robin Baily's "Baker Reminiscences," many letters, photographs, and other possessions of Sam and Florence Baker; the Reverend Ian Graham-Orlebar holds additional letters and photographs, and the diary of Erica Bourne Graham. I presume some member of the family has Fanny Wormald's diary, but I have not seen it. Items or letters used here are reproduced with the kind permission of Mrs. Anne I. Baker, David Baker, and the Reverend Ian Graham-Orlebar.

2. **THE BODLEIAN LIBRARY** holds Julian Baker's journal of the Nile journey and Sam Baker's letters to Douglas Murray.

3. **THE NATIONAL LIBRARY OF SCOTLAND, MANUSCRIPTS DIVISION,** has many letters to and from James A. Grant. Letters quoted here are reproduced with the kind permission of the Trustees of the National Library of Scotland. This permission is granted by the Library as owner of the original letters and does not extend to any copyright permissions that may be required.

4. **THE PUBLIC RECORD OFFICE,** London, holds a voluminous correspondence pertaining to the Sudan, Egypt, the Ottoman Empire, the Hungarian Revolution, and many of the people discussed in this book.

5. **THE ROYAL ARCHIVES** at Windsor Castle holds diaries of Queen Victoria and Albert, Prince of Wales (later King Edward VII), as well as their correspondence on many matters pertaining to the people discussed in this book. Material from the Royal Archives is quoted by gracious permission of Her Majesty the Queen Elizabeth II.

6. **THE ROYAL GEOGRAPHICAL SOCIETY** has Sam Baker's journals from the African expeditions, a number of letters, an account book, many photographs, maps, watercolors, and drawings. The society also has notes from committee meetings pertaining to the people discussed in this book and their explorations. Quotations from material in this archive is quoted with kind permission of the Royal Geographical Society.

7. **THE SHEFFIELD ARCHIVES** contains correspondence to and from the Earl of Wharncliffe including many letters from Sam Baker. Letters quoted here are owned by the late Earl of Wharncliffe's Trustees and are in the custody of the Head of Leisure Services, Sheffield City Council; they are quoted by permission of Anne I. Baker and David Baker.

8. **THE SUDAN ARCHIVES, UNIVERSITY OF DURHAM,** holds a partial copy of the diary of Clarence Brownell, documents from Robin Baily and photographs of him, material on Gordon and Stewart, and much official and unofficial correspondence pertaining to the Sudan and Egypt.

9. **THE WELLCOME LIBRARY FOR THE HISTORY AND UNDERSTANDING OF MEDICINE** holds a small number of letters from Sam and Florence and a photograph of Sam Baker.

ILLUSTRATION CREDITS

p. 73 From author's private collection and Samuel Baker, *Ismailïa*. London: Macmillan, 1874, p. 142.

p. 77 From the author's private collection and Samuel Baker, *The Nile Tributaries of Abyssinia*. London: Macmillan, 1874, p. 67.

p. 84 Reprinted by permission of Mansell/TimePix.

p. 112 From the author's private collection and John and Katherine Petherick, *Travels in Central Africa*. London: Tinsley Brothers, 1869, frontispiece.

p. 116 Reprinted by permission of the Mary Evans Picture Library from David Livingstone, *Life and Explorations of David Livingstone*. London: Adam & Co, 1880.

p. 126 From the author's private collection and Samuel Baker, *Ismailïa*, London: Macmillan, 1874, p. 91.

p. 128 From the author's private collection and Samuel Baker, *The Albert N'yanza*. Vol. 1. London: Macmillan, 1866, p. 72.

p. 135 Unknown Victorian source, possibly the *London Illustrated News;* copy in the possession of Anne I. Baker.

p. 184 From the author's private collection and Samuel Baker, *The Albert N'yanza*. Vol. 2. London: Macmillan, 1866, facing p. 80.

p. 187 From the author's private collection and Samuel Baker, *The Albert N'yanza*. Vol. 2. London: Macmillan, 1866, frontispiece.

p. 194 From the author's private collection and Samuel Baker, *The Albert N'yanza*. Vol. 2. London: Macmillan, 1866, p. 117.

p. 198 From the author's private collection and Samuel Baker, *The Albert N'yanza*. Vol. 2. London: Macmillan, 1866, facing p. 143.

p. 209 Reprinted by permission of the Illustrated London News Picture Library from the *Illustrated London News*, July 4, 1863.

p. 228 Reprinted by permission of Anne I. Baker and David Baker.

p. 231 Reprinted by permission of the Westminster City Council Archives.

p. 234 Reprinted by permission of the Mary Evans Picture Library.

p. 235 Reprinted by permission of Anne I. Baker and David Baker.

p. 239 From the author's private collection and Samuel Baker, *The Albert N'yanza*. Vol. 1. London: Macmillan, 1866, frontispiece.

p. 245 Reprinted by permission of the National Portrait Gallery, London.

p. 248 Reprinted by permission of Anne I. Baker and David Baker.

p. 249 Reprinted by permission of the Mary Evans Picture Library from W. H. Russell, *Diary in the East during the Tour of the Prince and Princess of Wales*. London: Routledge and Sons, 1869.

p. 250 Reprinted by permission of the Mary Evans Picture Library.

p. 253 From the author's private collection and Douglas Murray and A. Silva White, *Sir Samuel Baker*. London: Macmillan, 1895, p. 147.

p. 254 From the author's private collection and Samuel Baker, *Ismailïa*. London: Macmillan, 1874, facing p. 6.

p. 256 Reprinted by permission of Anne I. Baker and David Baker.

p. 257 Reprinted by permission of the Mary Evans Picture Library from the *Illustrated London News*, Dec. 11, 1869.

p. 258 From the author's private collection and Samuel Baker, *Ismailïa*. London: Macmillan, 1874, p. 13.

p. 260 From the author's private collection and Samuel Baker, *Ismailïa*. London: Macmillan, 1874, facing p. 14.

p. 261 From the author's private collection and Samuel Baker, *Ismailïa*. London: MacMillan, 1874, facing p. 15.

p. 263 From the author's private collection and Samuel Baker, *Ismailïa*. London: Macmillan, 1874, facing p. 38.

p. 264 From the author's private collection and Samuel Baker, *Ismailïa*. London: Macmillan, 1874, facing p. 102.

p. 269 From the author's private collection and Samuel Baker, *Ismailïa*. London: Macmillan, 1874, p. 63.

p. 282 From the author's private collection and Samuel Baker, *Ismailïa*. London: Macmillan, 1874, facing p. 149.

p. 285 From the author's private collection and Samuel Baker, *Ismailïa*. London: Macmillan, 1874, p. 238.

p. 297 From the author's private collection and Samuel Baker, *Ismailïa*. London: Macmillan, 1874, p. 308.

p. 300 From the author's private collection and Samuel Baker, *Ismailïa*. London: Macmillan, 1874, p. 340.

p. 306 From the author's private collection and Samuel Baker, *Ismailïa*. London: Macmillan, 1874, p. 387.

p. 311 From the author's private collection and Samuel Baker, *Ismailïa*. London: Macmillan, 1874, p. 437.

p. 319 From the author's private collection and Samuel Baker, *Ismailïa*. London: Macmillan, 1874, facing p. 455.

p. 328 Reprinted by permission of the Illustrated London News Picture Library from the *Illustrated London News*, Oct. 11, 1873.

p. 333 Reprinted by permission of Anne I. Baker and David Baker.

p. 346 Reprinted by permission of the Illustrated London News Picture Library from the *Illustrated London News*.

p. 348 Reprinted by permission of the Mary Evans Picture Library from Illustreret Tidende, Feb. 3, 1884.

p. 354 Reprinted by permission of the Reverend Ian Graham-Orlebar.

p. 358 From the author's private collection and the *Illustrated London News*, Feb. 11, 1885.

p. 363 From the author's private collection and Douglas Murray and A. Silva White, *Sir Samuel Baker*. London: Macmillan, 1895, frontispiece.

p. 365 Reprinted by permission of the Reverend Ian Graham-Orlebar, Anne I. Baker, and David Baker.

p. 368 Reprinted by permission of the Sudan Archives, University of Durham; photo by Angus Gillan, SAD/A79/38.

Front endplate: Map by Jeff Mathison.

Back endplate: Map by Jeff Mathison.

INDEX

Abbai (child), 211

Abd-el-Kadr, Lieutenant Colonel, 268, 270, 293, 303, 307, 310–11

Abderachman "El Jamoos," 106, 107

abduction of Florence: and flight from Viddin to Budapest, 18–36, 37–47; from slave market, 15–17

Abdullah, Mahommed Ahmed ibn. *See* Mahdi

Abdullah, Major, 290, 291, 311, 312, 316, 317

Abou Hammed: desert trip to, 75–79

Abyssinia, 71, 96, 111, 139, 369. *See also* Nile expedition (Baker); *specific town or village*

Achmet (relation of Mahomet's), 93, 101

Achmet, Sheik, 102–3

Aga, Koorshid, 127, 129, 130, 133, 134, 148, 149, 151, 166

Agad, Ahmet Sheik, 275–76

Airey, Richard, 339, 340

The Albert N'yanza (Baker), 239–41, 255, 329, 363

Albert N'yanza. *See* Lake Albert

Aldershot, 336

Alexandria, Egypt, 66, 114, 118, 248, 256, 324

Ali (eunuch), 6–11, 15–17, 23–24, 26, 42, 46, 60, 113, 127, 128, 327, 370

Ali, Kutchuk, 259, 265–66, 267, 270

Ali, Mehemet, 341

Allorron, Sheik, 281

aLuta N'zigé: return from, 191–99, 200–213, 214–15

Amarn (Abyssinian boy), 285, 315, 320, 327, 333, 343

America: Sam and Florence visit, 343

Angarep River, 110

Anti-Slavery Society, British, 330

Arabic: Gordon's command of, 331; Sam and Florence's knowledge of, 60–61, 71, 73, 82, 83, 108, 139, 149, 182, 369

Asua River, 163, 164, 181, 288

Atbara River: fishing rights on, 96; Sam and Florence plan for investigation of, 81; Sam and Florence reach junction of White Nile and, 85; Sam and Florence's boat trips on, 85–89, 94–110

Atholl, Duke and Duchess of, 42, 157, 237

Austria: and Transylvania army in Viddin, 30–35

Austrian missions, 122, 129, 258, 280, 318

aWat-el-Kareem (servant), 285, 317, 327

Bacheet (young Arab), 93–94, 97, 105

Bacheeta (slave woman), 169, 172, 182, 192, 201

Baganda (Mwa people), 206–7

Bahr el Ghazal, 123, 126, 136, 259

Bahr Giraffe, 261–63, 266, 324, 330

Baily, Edward, 372
Baily, Robin, 367–69, 371
Baily, Ruth (niece), 367
Baker, Agnes (daughter), 40, 50, 70, 99–100, 252, 303–4, 306–8, 360, 361, 363
Baker, Ann (sister), 39, 69, 70, 229, 230, 231, 243, 364, 367, 368
Baker, Arthur (nephew), 40
Baker, Charles Martin (son), 100
Baker, Constance (daughter), 40, 50, 70, 99–100, 252, 316, 360
Baker, Edith (daughter), 40, 50, 99–100, 220, 239, 244–45, 251, 252, 255–56, 279–80, 364, 366, 370, 371
Baker, Eliza Martin (sister-in-law), 39, 40, 324
Baker, Ellen (sister), 39, 69, 70, 119–20, 229, 319–20, 364, 371
Baker, Ethel (daughter), 40, 99–100, 252, 360, 361, 364, 366, 367, 370, 371, 372
Baker, Fanny (sister-in-law), 335, 338, 342, 360
Baker, Florence: age of, 220–21, 234; awards and honors for, 329; birthday for, 225–26; Bunyoro entranced by, 175–76, 288, 361, 375; death of, 373–74; depression of, 325–27; desire for children of, 99–100; early childhood of, 22, 25–36, 208, 304, 370; English suspicions of German origins of, 371–72; fears of, 291–92; fondness for children of, 122–23, 211, 245, 251, 271, 272–73, 285, 314, 315, 326, 367; as godmother to Cyril, 245; and heart of lion, 104, 133, 236; life after Sam's death of, 369–70; lion's teeth necklace of, 107–8, 244; names/nicknames of, 18, 19–20, 50, 51; passport for, 21, 51, 232; pregnancy of, 247, 250–51; reputation/fame of, 236–37, 242, 243, 288, 314, 327, 328, 361, 364–65, 375; riding and shooting of, 139; Speke and Grant's views about, 113–14; Tinné's views about, 113–14; as Victorian wife, 221–22, 236, 240; wedding of, 230–32; will of, 370–71
Baker, Geraldine, 371
Baker, Henrietta Martin (first wife), 39–40, 41, 54, 99, 100, 135–36, 250
Baker, Hermione (niece), 335, 342, 360
Baker, James (brother), 39, 40, 41, 225, 226–27, 231, 240, 243, 364
Baker, Jane (daughter), 100
Baker, John (brother), 23, 24, 39, 66, 113, 222, 243, 360, 363

Baker, John Lindsay Sloan (son), 100
Baker, Julian (nephew), 40, 321, 331, 370; awards and honors for, 327; and firman expedition, 254, 260, 261, 268, 277, 278, 283–88, 290, 291, 292, 296, 299–300, 303, 307–11, 316, 320; and flight from Masindi, 307, 308, 309; illness of, 292; and Mary's death, 323–24; and Sam's death, 364–65, 366
Baker, Louisa (sister-in-law), 226, 227, 229, 231, 243, 371
Baker, Mary Florence (goddaughter), 371
Baker, Mary "Min" (sister), 39, 43, 49, 69, 70; as caretaker of Sam's daughters, 40, 50, 67, 71, 226, 229, 243; death of, 360; Florence's views about, 71; marriage of, 252; and Sam and Florence's marriage, 226–27, 229–31; Sam and Florence's relationship with, 239, 243; and Sam's expedition as success, 217; and Sam's firman trip, 252; and Sam's plans, 50, 67; and Sam's return to England, 229
Baker, Mary (niece), 40, 316, 323–24
Baker, Sam: assessment of journey by, 210–11; awards and honors for, 222, 235, 236, 238, 241–42, 243, 253, 327, 328–29; birth of, 39; criticisms of, 330–31; death of, 364–66; life story of, 39–44; motivation for finding source of Nile of, 213; reputation/fame of, 236–37, 242, 243, 288, 290, 310, 361, 374–75; Saood's description of, 297–98; silver and china of, 52; at slave market, 12–13, 14, 15–17; thrown from horse, 108–10; wedding to Florence of, 230–32; will of, 121, 216–17, 366–67; writings of, 55, 140, 239–41, 245, 255, 329, 343, 363
Baker, Sybil (niece), 335, 342, 360, 361
Baker, Valentine (brother), 25, 39, 40, 41, 245; death of, 361; "disgraceful outrage" of, 335–42; in Egypt, 345, 350, 352, 360; and Sam's expedition as success, 217; and stories about firman expedition, 313; and Sudanese civil war, 350, 351, 352; in Turkey, 341–42
Baker's daughters. See Baker, Mary "Min": as caretaker of Sam's daughters; specific daughter
baksheesh, 74
Bari tribe, 131–32, 134, 149, 150, 166, 280, 281–83, 288, 290, 298
Baring, Evelyn, 355, 356, 361
Barkley family, 54

Barnes, R. H., 353, 355
Basé tribe, 100, 106
Batthyanyi, Casimir, 33
Bedawi, Captain, 263
Belgrade Treaty (1739), 30–32
Belignan (town), 151–52, 282
Bem, General, 28, 29, 30, 31, 32–33
Berber, 75–83, 225, 257, 344, 356, 357
Bey, Ali, 261, 267–69
Bey, Ismail (aka Ismail Ayoub Pasha), 323–24
Bey, Raouf, 260, 265, 277, 278, 283, 284, 347
bin Saed, Seyed, 336
Binder, Herr, 127
Bishareen Arabs, 88–89
Blackwood, John, 218, 242–43
Blue Nile: origin of, 114
Bokké (Latooka woman), 157–58
Bovey, Antony Crawley, 363
Brighton, England, 329
Britain. *See* England; Victorian society; *specific person*
British Foreign Office, 324
British square, 301
British troops: and Sudanese civil war, 356, 357
Brownell, Clarence, 112, 121
Bucharest, Romania, 39, 45, 47, 48–54, 82
Buganda country, 291
Bullinaria, Margaret, 255, 265, 271–72, 277
bundle woman, 34–35
Bunyoro tribe/country: annexation of, 295; and *firman* expedition, 284, 285, 286–310; and Luta N'zigé journey, 169, 170, 172–79, 206–7; Rionga as ruler of, 311; Sam and Florence as legends among, 361, 363; Sam and Florence's views about, 176–77; and source of Nile River, 180–81. *See also* Kabba Réga; Kamrasi; Masindi
Burton, Richard: books of, 218; and *firman* expedition, 329; legacy of, 224; personal and professional background of, 56–57; and RGS, 234; Rigby's disagreement with, 62–63; Sam's study of notes from, 121; and Speke, 56–57, 59–60, 62–63, 64, 217, 218, 222–23; and Speke and Grant expedition, 138; and Speke's death, 223; and White Nile expedition, 64, 65

Cairo, Egypt: and beginning of *firman* expedition, 255–57; British Consulate in, 280; and *firman* expedition, 280, 321–22,
323, 325; and Gordon, 355; memorial to Valentine Baker in, 361; Sam and Florence in, 225, 344, 360; and Sam's plans for Nile expedition, 64, 69–71; and Saood, 312, 321–22; slave trade in, 121; and Speke-Grant expedition, 63; Wales's trip to, 247–50
Calafat, Romania, 20–21, 22
Cambridge, Duke of, 336, 341
Cambridge University: Sam's lecture at, 329
camels: baby, 95; baggage, 94, 95; bargaining for, 75–76; buying of, in Cassala, 93; for desert trip of Sam and Florence, 75–76, 78, 79; donkeys compared with, 83; and *firman* expedition, 257; and Luta N'zigé journey, 149, 151, 152, 154, 165, 169; riding, 94–95; and White Nile expedition, 75–76, 78, 79, 83, 94–95, 119
cannibalism, 309
Canterbury, Archbishop of, 226
Capellan, Adriana van, 113–14, 121, 123, 125, 136
Carrington, Lord, 248
Cassala (Sudan), 89–93
Ceylon: Bovey family in, 363; death of Sam sons in, 100; Sam in, 23, 24–25, 29, 39–40, 41, 42, 65, 237, 250; Sam's writings about, 55
Chasseloup-Laubat, Marquis de, 236
Cheriff Pasha, 253, 283, 350
children: and *firman* expedition, 271, 272–73; Florence's fondness for, 211, 245, 251, 271, 272–73, 285, 314, 315, 326, 367; Florence's views about, 99–100; in Masindi, 299. *See also specific child*
circumcision of women, 90–91, 99
clothes: for children, 211; for desert trip, 77; Florence's first English- style, 48–49; for hunting, 101; and Luta N'zigé journey, 153, 209, 211; riding, 52–54; and White Nile expedition, 82, 83, 119; and women in harem of Halleem Effendi, 82
Colquhoun, Robert, 50, 51, 69–70, 71, 238, 242
commercial expansion, 248–50, 252, 298
Congo, 353
Constanza (Black Sea village), 50, 52, 54–60, 64
Cottage Hospital (Newton Abbot, England), 370

Cotton Oswell, William, 64, 237–38
cowry shells, 166
crocodiles, 72, 98, 191–92, 199, 262, 265, 333
Cyprus, 343, 344

Danube River, 43, 44, 50
Darfur province, 259, 350
de Bono family, 120, 131, 134, 205–6
death: Sam and Florence's discussion about, 201
Delmé-Radcliffe, Charles, 374
Denby, Earl of, 241
desert trip: from Korosoko to Berber, 75–80
Dickinson, Kate, 336–40, 341
Dinder River, 110
Dinka tribe/language, 60, 113, 127–28
displaced people, 271
Djaffer Pasha, 259, 274, 275, 276, 277, 284, 286
donkeys, 83, 119, 152, 162, 165, 167, 169, 293, 305, 312
Dufferin, Lord and Lady, 238
Dutch ladies' party, 113–14, 121, 123, 125, 136

East India Company, 57
"Eastern Question," 343
Edinburgh, Duke of, 233, 336
Edward VIII (king), 333
Eesur (servant/porter), 132, 133
Egypt: Agad granted firman by, 276; and firman expedition, 253, 316; and Gordon in Sudan, 350; and khedive's offer to Sam, 248–50; military and commercial expansion of, 248–50; police in, 345, 350, 352; Sam and Florence visit, 343; slavery in, 214, 254, 266; and Sudan, 276, 345–59; Valentine Baker in, 345, 351, 352, 360; Wales's trip to, 247–50. See also Alexandria, Egypt; Cairo, Egypt
Egyptian army, 255, 259, 266, 345, 347, 350–51, 356
El Baggar "The Cow," 93, 94–95
El Obeid (Kordofan capital), 347
elephants, 23–25, 66, 98–99, 100, 110, 114, 163, 164, 206
Ellis, Captain A., 248
Ellyria Valley, 154–55

Emin Pasha (aka Eduard Schnitzer), 361, 363
England: and fame of Sam and Florence, 236–37; Florence's refusal to live in, 70–71; and Gordon in Sudan, 350, 358; and marriage of Sam and Florence, 219–20; Masindi stories in, 312–13; military and commercial expansion of, 248–50; Sam and Florence plan for return to, 215, 217, 219–22; Sam and Florence return to, 225–32, 327–28; Sam and Florence's early days in, 233–46; Sam's trip to (1860), 64; Sam's views about domestic arrangements in, 103; science in, 233–34; slavery views in, 130, 132, 254, 355; Speke and Grant's reception in, 209; and Sudanese civil war, 352–59; and Transylvania army in Viddin, 31, 33. See also Victorian society; specific person
Eppigoya (town), 195
Equatoria, 249, 250, 327, 364
equipment. See supplies/equipment
Ethiopia, 114. See also specific location
Eugénie, Empress, 277, 329, 336
eunuchs, 24, 26. See also Ali

Fadeela (slave woman), 151, 179
Faky (holy man), 98
Faloro station, 144–46, 163–65
Fanko area, 288–89
Farajoke (village), 164
Fashoda (town), 216, 260–61, 267–69, 273–74, 277, 321–22
Fatiko (town), 290, 291, 311–12, 313–15, 316, 317, 320, 333
Ferdinand (emperor), 29
Finjanjian Effendi, 7, 13, 14, 26
Finjanjian Hanim. See Sultana Vilidé
Finjanjian family, 1, 26, 34, 35, 370
Finnian, Florence Barbara Maria, 51. See also Baker, Florence
firman expedition: beginning of, 255–57; criticisms of Sam on, 330–31; and expiration of Sam's term as pasha, 317; extension of Sam's contract for, 283–84, 327; and flight from Masindi, 305–8; Florence's depression at end of, 325–27; members of, 254–55; offer and charge of, 250–53; planning for, 251–52, 253–55, 256–57, 258–59; and rumored deaths of Bakers, 312–13; Saood's stories about,

312–13; size of, 255, 260, 277; as success, 324–25

Forty Thieves, 259, 282, 287, 303, 309, 320, 327

Foweera (chief), 200, 202, 203, 205, 206, 207–8; camp of, 207–10, 211, 222

Foweera (garrison), 291, 311

Galla tribe/country, 65, 89–92

Gash River, 89

Gedge, Joseph, 254, 273, 277

George VI (king), 333

Gibbe River, 65

Giegler Pashar, 347

gifts: and firman expedition, 286, 291, 296, 299, 301, 302, 304; and Kabba Réga, 291, 296, 299, 304; and Kamrasi, 181, 182, 204, 205, 210; and Luta N'zigé journey, 156, 173, 174, 175, 181, 182, 204, 205, 207, 210; for M'tesa, 302

Gladstone, W. E., 240–41, 351, 356, 357, 358

Gojeb River, 65

Gondokoro (town): and Agad's firman, 276; description of, 130, 145, 280–81; and firman expedition, 252, 257, 263, 276, 277–81, 283, 286, 287–88, 316, 317; Ibrahim's trips to and from, 158–59, 182, 209; and Luta N'zigé journey, 192, 196, 200–213; and Petherick, 129, 136, 140–41, 224–25; plague in, 214; porters/servants in, 132–33, 144–49; Sam and Florence in, 130–41, 144–51, 153, 212–13, 214–15; slavery in, 130, 131, 132, 214, 276, 281–82; and Speke and Grant expedition, 63, 64, 114, 134–41, 219, 238; and White Nile expedition, 127, 130–41. See also Ismailïa station

Gordon, Charles: Bunyoro views about, 363; in Cairo, 355; death of, 358; in Khartoum, 331, 355, 356–58; and khedive, 327, 330, 344, 345; and Sam, 331–33, 351–55, 356, 357, 358–59; and Sam and Florence's relationship, 344–45; as Sam's successor, 329–30; and Saood, 331–32; and slave trade, 330, 344, 355; and Sudan, 331–33, 344, 347, 351–59

Görgei, Artur, 30

Gouramma, Victoria, 45

governor-general: Sam as, 250

Gozerajup (Bishareen village), 88–92

Grant, James Augustus, 218, 222, 234, 235, 238–39, 241–43. See also Speke and Grant expedition

grave: for Florence, 186

guns/weapons: and Atbara River trip, 86; and "The Baby," 72, 369; and beginning of Nile expedition, 72; on desert trip, 80; and desertion/mutiny of servants/porters, 147, 157, 158, 160; and firman expedition, 262, 300, 307, 308, 312; Florence's aim with, 25, 72, 149; and Kamrasi, 174, 180, 181, 182, 202, 204, 205; and Luta N'Zigé journey, 174, 180, 181, 182, 202, 204, 205, 208–9; of Richarn, 208–9; for Saat, 123; and swords of Hamran Arabs, 98–99

Hadendowa tribe, 89–92

Halifax, Viscount, 339

Halleem Effendi, 80–82, 83

Hamran Arabs, 98–99

Hansall, Mr., 121

harem/harems: as brothels, 26; characteristics of, 26, 27–28; English views about, 68; Florence first taken into, 34–35; Florence's life in, 1–17, 25–28, 35, 37–38, 42, 61, 92, 99, 325–26, 368–69, 370; of Halleem Effendi, 81–82; of khedive, 325–26; Sam's views about, 26, 27–28; of Sheik Achmet, 102; slaves in, 254

Harness, Hadji, 255

Hartington, Lord, 356

Hauslab, General, 33–34

heads: as scientific specimens, 148

heart of lion, 104, 133, 236

Hedenham, England: home of Sam and Florence in, 239

Her, Mohammed, 156–57, 158

Hicks, William, 345, 350–51

Higginbotham, Edward, 254, 257, 266, 268, 273, 275, 277, 278, 284, 318

hippopotamus, 85–86, 199, 262, 265–66

Hitchman, William, 254

homesickness, 108, 202, 272, 316

horses: and firman expedition, 277, 290, 293, 305; and journey to Khartoum, 102; and Luta N'zigé journey, 144, 149, 151, 152, 165, 167; and Sam thrown from horse, 109–10

Howe, Julia Ward, 244

"human nature": Sam's study of, 74–75

Hungarian Revolution, 28–35, 308
hunting: in Abyssinia, 96; and Atbara River
 journey, 85–86, 101; bear, 42; boar, 42;
 clothes for, 101; crocodiles, 72, 199, 333;
 and early hunting trips of Sam, 15, 23–25,
 42, 43, 66; of elephants, 23–25, 66, 98–99,
 100, 110, 114, 163, 164; and firman expedi-
 tion, 290; by Florence, 25, 114, 139; harte-
 beest, 164; hippopatamus, 85–86; lions,
 105, 107–8; and Luta N'zigé journey, 163,
 164, 199; Sam lost while, 108–10; Sam's
 writings about, 55; along Settite River,
 105, 107–9, 110; in Sudan, 96; with swords,
 98–99; at Tarrangollé, 161; and Wales's
 trip to Egypt, 247. See also guns/weapons

Ibrahim (vakeel): and journey to Luta
 N'zigé, 150, 151, 155–56, 158–59, 162,
 167–68, 170, 174, 175, 180, 181, 182; and
 return from Luta N'zigé, 200, 203, 205,
 206, 209, 210
illness: on Atbara River journey, 101; in
 Bunyoro country, 140; on desert trip, 77,
 79; of Dutch ladies, 136; and Faloro trip,
 145; feigned, 106; and firman expedition,
 250–51, 266, 273, 277, 278, 292, 293, 318;
 and Florence's pregnancy, 250–51; and
 Luta N'zigé journey, 165, 166, 167, 168,
 169–70, 171, 179, 180, 181, 185–86, 187, 191,
 195, 196–97, 200, 201, 202, 205, 207–8,
 211–12, 216–17; of Mouche, 102; of Peth-
 erick, 142, 146; and Sam and Florence's
 evaluation of progress, 110; of servants/
 porters, 101, 102, 106, 108, 145, 179, 191;
 and Settite River journey, 102; of sol-
 diers, 266; and Speke and Burton expe-
 dition, 59; of Turks, 165; and White Nile
 expedition, 82, 83, 85, 92, 97–98, 100, 101,
 102, 106, 108, 110, 123–24, 132–33
Illustrated London News, 209, 210, 236, 327
Illustrated London Times, 224
India, 56, 343, 360
Ismail Ayoub Pasha, 323–24
Ismail Pasha, 247, 280
Ismailia (Baker), 329, 330
Ismailia station, 280–85, 315, 316, 317, 318–20
ivory, 89, 130, 131, 132, 136, 144, 145–46, 156,
 166, 181, 182, 206, 210, 276

Jarvis, Charles Robert, 254
Jephson, A. Mounteney, 361

Journal of the Discovery of the Source of the
 Nile (Speke), 137, 218, 239, 241
Jusef Effendi, 320, 321, 323

Kabba Réga (Bunyoro chief): and firman
 expedition, 292–94, 295–308, 310; and
 gifts, 291, 296, 299, 304; hostilities of,
 303–8; peace offering and apology from,
 301–2; and Rionga, 292, 296, 298, 299,
 310, 311, 363; and Saood, 291, 294, 297–98;
 as successor to Kamrasi, 289, 291
Kaffa tribe, 65
Kalloé (chief), 210
Kamrasi (Bunyoro chief): asks for Florence
 to be his wife, 182–83; death of, 289, 291;
 enemies of, 171, 172, 181, 200, 201, 202,
 203, 205, 207–8, 210; fear of, 170; flight
 of, 207–8; Florence chastises, 182–83;
 Florence's teasing about, 220; and gifts,
 181, 182, 204, 205, 210; and guns/weap-
 ons, 180, 181, 182, 202, 204, 205; Illustrated
 London News picture of Speke given
 to, 210, 224; and Luta N'zigé journey,
 172–78, 180–83, 200, 201–8, 294; M'Gambi
 impersonates, 203–4; and negotiations
 with de Bono's men, 205–6; and Sam
 and Florence at M'rooli, 180–83; Sam
 and Florence follow flight of, 207–8;
 Sam and Florence's meetings with,
 180–83, 204–5; "Satanic Escort" provided
 by, 183–85; and servants/porters for
 Sam and Florence, 182, 183–85, 201–2;
 and Speke, 140, 169, 172, 173, 174–75, 177,
 178, 180, 181, 202–3, 204, 205, 224, 235; and
 supplies/equipment, 173, 175, 176, 178,
 181, 201–2, 204–5, 207; and Turks, 203
Kanyamaizi Island, 310
Karagwé (village), 190
Karka (servant woman), 285, 315, 327
Karuma Falls, 172, 191–92, 195, 196, 290,
 292–93
Katariff (village), 106
Katchiba (Obbo chief), 163, 164, 165, 167,
 170
Khartoum, Sudan: Austrian mission in,
 122; British government in, 111–12, 114,
 142, 143, 201, 277; fall of, 358; and firman
 expedition, 257–60, 266, 273, 274, 275–77,
 283, 320–24; Gordon in, 331, 355–58; gov-
 ernment corruption in, 114; and joining
 of Blue and White Nile, 114; money
 in, 212; population of, 113; return of

mutineers to, 147; rumors of Sam and
Florence's death reach, 212; Sam and
Florence in, 111–23, 215–17, 222, 225, 275–
77; Sam and Florence send luggage by
boat from Berber to, 81; Sam and Flor-
ence's views about, 120, 258; and Sam's
plans for Nile expedition, 66; Saood in,
312, 321–22; Saood to bring Mahdi to,
347; servants/porters in, 145, 168; slaves/
slave trade in, 115, 118, 120, 214; social life
in, 113; and Speke- Grant expedition, 63,
141–42; and Sudanese civil war, 350, 352,
353, 355– 58; trip to, from Berber, 83–87.
See also specific person
khedive: and Agad's *firman*, 276; and
awards for Sam, 327; and *firman* expedi-
tion, 251, 253, 256–57, 261, 266, 268, 271,
276, 281, 283–84, 290, 295, 312–13, 316, 321–
22, 325; and Gordon, 327, 330, 344, 345;
harem of, 325–26; offers Sam position,
248–50; resignation of, 345; and slavery,
266, 268; and Sudanese civil war, 352
Khedive (steamer), 318, 320–21, 322
Kisoona (camp/village), 204–6, 207, 292,
310
Knollys, W., 246
Kordofan province, 347, 350
Korosoko (town), 75–80, 256, 257
Koshi (town), 195–96
Kossuth, Louis, 29, 30, 31, 33, 34
Kutchuk Ali, station of, 265–66, 267
Kytch (Dinka village), 127–28

Lado (town), 344
Lake Albert: and *firman* expedition, 285,
286; fish at, 189–90; and memories of
Sam and Florence, 375; Sam encouraged
by Speke and Grant to find, 139–40, 235;
Sam and Florence on, 189–96; Sam and
Florence reach, 187–88; and Sam's plans
to return to England with Florence, 220;
steamer service on, 286, 294, 344; storm
on, 193–95; verification of, as source of
White Nile, 199, 215. *See also* Murchison
Falls
Lake Sapanga, 66
Lake Tsana, 114
Lake Victoria. *See* Victoria N'yanza
Latome (village), 158
Latooka tribe/country, 152, 153, 154, 155,
157–61, 162–63, 165–66, 177, 363
Leggé (chief), 156

Livingstone, David, 41–42, 237, 302, 361
Lloyd, Albert, 374
Lobbo, sheik of, 315
Loboré (town), 286–88
Login family, 42, 43, 44, 45
Lombrosio, Monsieur, 217
Lucan, Lord, 339
Luta N'zigé: journey to, 144–61, 162–78,
179–88, 224–25; return from, 189–99,
200–213, 214–15; Sam and Florence at,
189–95; Sam's first exploration of, 138–
39; Speke and Grant suggest, 138– 39,
172, 235

Magungo (town), 166, 190, 191–92, 195
Mahdi, 346–47, 350–52, 356, 357, 358, 361
Mahomet (Baker dragoman), 73, 78, 83, 93,
101, 105, 108, 289
Mahommed (de Bono *vakeel*), 144, 146, 147,
148, 150, 151, 168
Mahommed Tewfik Pasha, 269
mail service, 285, 294
Mallegé (aka Sam Baker), 288, 310
"mansion," Sofi: as Sam and Florence's
first home, 96–100
maps, 42, 61, 65, 210
Marcopolo, Michael, 254, 270
Marlborough Club, 245, 342
marriage/relationship, Sam and Flor-
ence's: Colquhoun's views about, 69–70;
and commitment to each other, 110, 111,
220; and Florence with heart of lion,
104, 133; and Florence as personification
of ideal wife, 221–22; and Florence's age,
220–21; and Florence's trust of Sam, 46;
Florence's views about, 92–93; Gordon's
views about, 344–45, 355; and lion claw/
teeth necklace for Florence, 107–8; and
other women, 335; and physical attrac-
tion, 49; and Queen Victoria, 243, 244,
245, 246; and religion, 51; and return to
England, 215, 217, 219–22, 226; and return
to Sudan, 344; rumors about, 237–39,
245– 46; and Sam falls in love with
Florence, 39; and Sam and Florence's
evaluation of progress, 111; and Sam as
lost while hunting, 109, 110; and Sam's
return to Sudan, 354; Sam's views about,
101, 139, 243–44; Speke and Grant's views
about, 135–36, 137, 138–40; telling friends
and family about, 50–51, 67–68, 215, 217,
219–22, 237; and wedding, 230–32

Marshall, Bernard (grandson), 366
Marshall, Cyril (grandson), 245, 251, 366
Marshall, Ellen (granddaughter), 366
Marshall, Ethel. *See* Baker, Ethel
Marshall, Ida (granddaughter), 366, 371
Marshall, Robert, 244–45
Marshall, Violet (granddaughter), 366
Martin, Charlotte (sister-in-law), 40
Masindi: attacks at, 303–5, 306, 311, 313; and *firman* expedition, 302–4; flight from, 305–10; fort at, 302, 303; hostilities at, 299–301, 303–4; Sam and Florence in, 293–94, 295–305
Mehetma (town), 357
Mehjid, Abdul, 120
M'Gambi (Kamrasi's brother), 203–4, 205, 206
Mistoora (orphan girl), 271, 273, 277
Moir tribes, 149
Montague, Honorable Captain, 248
Moorlong, Franz, 129
Moosa Pasha, 114, 123
Mouche, Florian, 96, 97, 100, 102, 119, 122
M'Queen, James, 218–19, 220
M'Quie, P. B., 142
M'rooli (Bunyoro capital), 173, 177, 179–82, 189, 297
M'tesa (Baganda king), 139, 206–7, 218, 291, 302, 363
Müller, Bamba, 45
Murchison, Roderick: and awards and honors for Sam, 222, 238; death of, 316; and Gladstone's suggestion of honors for Florence, 240–41; and Petherick, 142, 143; Sam names falls after, 199; and Sam's desire to join Livingstone's expedition, 41; and Sam's lecture before the RGS, 236; and Sams' return to England, 227; and Sam's return to Khartoum, 222; scientific activities of, 233–34; and Speke, 218, 223; and Speke and Burton expedition, 60; and Speke and Grant expedition, 142, 143; and success of Sam's expedition, 217; as supporter of Bakers, 234–35; and White Nile expedition, 65
Murchison Falls, 197, 199, 201, 233
Murie, James, 112, 140–41, 146, 148
Murray, Admiral, 64
M'Williams, James, 254, 330–31
M'wootan N'zigé. *See* Luta N'zigé
Myadue (aka Florence Baker), 288, 361, 375

natives, African: Florence's views about, 314–15, 317, 327; nakedness of, 75, 163, 289; Sam's views about, 118–19, 127–28, 161, 281, 291, 304
Newera Eliya (Baker settlement in Ceylon), 39–40
Niambara village, 129, 136
Nile River: damming of, 280; slave trade along, 89; source of, 55–57, 59–61, 66, 71, 80–81, 87, 114, 120, 136, 138, 140, 149–50, 180–81, 188, 213. *See also* Somerset Nile; White Nile; *specific expedition*
The Nile Tributaries of Abyssinia (Baker), 245
Nubia, 88. *See also specific village or tribe*
Nuer tribe, 127

Oakes, Colonel, 339
Obbo country, 162–65, 167–70, 210
Omdurman fort, 356, 357
Oriental and Egyptian Trading Company, 217
Ottoman Empire, 30–32, 89, 92, 253, 343. *See also* Viddin
Owine (chief), 206

Palliser, Eddie, 25
Palmerston, Lord, 33
Paris, France, 225–27, 236, 240, 327
Parkani (village), 187
Parry, Serjeant, 339
pasha: Sam awarded rank of, 253; of Viddin, 13, 14, 16, 19, 24, 39, 44. *See also specific person*
Patooan Island, 200–203
Peck, Lewis, 255, 265, 272, 277
Petherick, John: allegations about, 120, 129, 141, 143; as British consul, 111–12, 114, 120; difficulties with, 126; and Dutch ladies' party, 121; funding for, 137, 142; and Gondokoro, 136, 140–41, 224–25; illness of, 142, 146; and ivory, 145–46; and Luta N'zigé journey, 212, 224–25; murder of *vakeel* (headman) of, 130; news about, 129, 130; in Niambara village, 129; reputation of, 147, 148; and Royal Geographical Society, 130, 142–43; salary of, 64, 114–15; Sam asks permission to accompany, 65; and Sam and Florence in Khartoum, 111–12; Sam sends letter to, 114; and Sam's concerns about Florence if he should die, 101; Sam's views about,

148; servants/porters for, 145–46, 148; and slavery, 120, 129, 142, 148; and Speke and Grant expedition, 64, 65, 111, 112, 134, 136, 137, 141–43, 148, 213, 219, 224–25; and supplies/equipment, 137; wants to join Sam and Florence's party, 145–46; and White Nile expedition, 66

Petherick, Katherine "Kate," 66, 111–12, 141, 142, 146, 148, 238

plague, 214, 215–16

poison arrows, 131–32

porters/servants: dependence upon, 165, 286; and desert trip, 76; and Faloro trip, 144, 145–47; and firman expedition, 263, 278, 284, 286, 287, 288, 289, 290, 292, 293, 294, 301, 304, 310, 311, 315–16; Florence's management of, 133, 139, 146–47, 301, 312; former employees as, 289; in Gondo-koro, 132–33, 144–49; and guns/weapons, 147, 157, 158, 160; illness of, 101, 102, 106, 108, 145, 179, 191; and journey to Luta N'zigé, 150–52, 156–57, 160, 167, 168, 169, 170–71, 179, 181, 182; and Kamrasi, 182, 183–85, 201–2; in Khartoum, 115, 119, 145, 168; mutiny/desertion by, 106–7, 108, 110–11, 118–19, 132–33, 145, 146–47, 148, 150–51, 156–57, 158, 168, 171, 181, 192, 194–95, 203, 287, 292, 293; payment in slaves and cattle for, 148; for Pether-ick, 145–46, 148; and return from Luta N'zigé, 190, 191, 192, 193–95, 201–2, 203, 210; and Rumanika tribe, 191; and Sam and Florence's evaluation of progress, 110–11; Sam's views about, 106–7, 133, 145–46, 147, 151, 168; along Settite River, 105–6, 108; slaves as payment for, 115, 119, 132, 168; for Speke and Grant expedition, 145; for White Nile expedition, 71, 73, 83, 93–94, 101, 102, 106–7, 108, 110–11, 115, 118–19, 122, 132–33, 139

Power, Frank, 356

prostitutes, 68, 115, 220

Punch, 209, 329

Quat Kare (Shillook king), 270, 278

Rahad River, 110

Rahonka (Bunyoro commander-in-chief), 292

railroad: Sam as managing director for, 50, 64

Ramsell, James Thomas, 254

Rawlinson, Henry, 312–13

religion, 51, 129

Richarn (servant): devotion to Bakers of, 145, 150; Florence's fondness for, 327; and Luta N'zigé journey, 145, 147, 149, 150, 174, 175, 180, 190, 192, 207, 208–9, 210, 225; personality of, 119; rifle of, 208–9; and Saat, 122; schooling of, 122; and White Nile expedition, 119, 122

riding: and Florence as rider, 25, 52–54, 139, 149

Rigby, Colonel, 62–63, 238–39

Rionga: as Bunyoro ruler, 311; and firman expedition, 293, 296, 298, 299, 305, 306, 310; and Kabba Réga, 292, 296, 298, 299, 310, 311, 363; as Kamrasi rival, 171, 172, 181, 200, 201, 202, 205, 206; memories of Sam and Florence of, 363; Sam's alliance with, 310–11

Rivers, C. Wilson, 351

Rot Jarma (Shooli chief), 290

Royal Geographical Society (RGS): and Burton, 234; and firman expedition in danger, 312–13; and Grant, 234; Murchi-son as founder of, 233; and M'Williams' criticisms of Sam, 331; and Petherick expedition, 112, 130, 142–43; Sam's addresses before, 222, 234–36, 239, 328–29; and Speke, 217–18, 234; and Speke and Burton expedition, 57, 59, 60, 62, 63; and Speke and Grant expedition, 63–64, 65, 142–43, 209; and White Nile expedi-tion, 65–66, 71, 234

Royal Society, 329

Royal Statistical Society, 329

Royan River, 110

Rumanika tribe, 190, 219

Russia, 29, 30–32, 341–42

Saat (servant): biography of, 121–22; devo-tion to Bakers of, 145, 211; Florence's fondness for, 122–23, 327; gun for, 123; illness/death of, 215, 216, 217, 315; and Luta N'zigé journey, 145, 146, 147, 149, 164, 174, 175, 180, 190, 192, 193, 197, 211, 212; and Richarn, 122; and White Nile expedition, 121–23, 133, 136

Said Pasha, 114

St. James's Church (London, England), 226, 227, 231

Salaam River, 110

Salisbury, Lord, 351
salt, 189, 190
Sampson, David, 254
Sandford Orleigh (Baker home), 333–34, 336, 343, 352–55, 360, 364, 365–66, 367–68, 370, 371
Saood, Abou: arrest of, 322–23; and Bari tribe, 282–83; and Bey, 283; and Cairo, 312, 321–22; description of Sam by, 297–98; and devastation of Gondokoro, 280, 281; and Djaffer Pasha, 275; expiration of *firman* of, 289–90; and *firman* expedition, 282–83, 288–90, 293, 294, 295, 297–98, 311, 312, 321–23; and Gordon, 331–32; and Kabba Réga, 291, 294, 297–98; in Khartoum, 312, 321–22; and Mahdi, 347; M'Williams' comments about, 330–31; released from jail, 331; as Sam's enemy, 282–83, 284
"Satanic Escort," 183–85
Schmidt, Johann, 119, 121, 123–24
Schnitzer, Eduard (aka Emin Pasha), 361, 363
Sennar region, 350
Settite River, 102, 105–6, 110
Shami, Halil el, 114, 121
Shepheard's Hotel (Cairo), 225
Shillook country/tribe, 122, 127, 261, 267–69, 270–71, 278
Shooa (town), 170–71, 201, 206, 210, 211
Shooli tribe, 289–90
Shute, Colonel, 339
Singh, Maharajah Duleep: and abduction and flight of Florence, 18, 19, 20, 21, 22, 23, 37, 38, 39, 43–45, 47; personal life of, 14–15, 45; Sam's tour with, 13, 14–15, 42, 43–44, 47; at slave market, 13, 14–15
slave auction, Viddin, 1–15, 368, 370
Slave Traders Guild, 1, 2
slaves/slave trade: and Agad's *firman*, 276; in Cairo, 121; cartoon about Sam and, 329; in Cassala, 89; comparison of African and Ottoman, 89; and Egyptian government, 214; English as opponents of, 130, 132, 254, 355; as essential to Egyptian society, 254; and *firman* expedition, 250, 252, 253, 254, 256, 258, 261, 266–69, 270–71, 273–74, 279, 281, 284, 288, 289, 293, 295, 298, 299, 312, 321–22, 325, 326, 329; Florence's views about, 89–91, 266–67, 369; in Gondokoro, 130, 131, 132, 214, 276, 281–82; and Gordon, 330, 344, 355; in Hadendowa country, 89–92; in Khar-

toum, 115, 118, 120, 214; and khedive, 249, 266; and Luta N'zigé journey, 150, 158, 170, 206, 211; and Mahdi, 347; along Nile, 89; as payment for servants/porters, 115, 119, 132, 168; and Petherick, 120, 142, 148; as prostitutes, 115; Sam's views about, 115, 118–19, 145, 266–67, 279, 281–82; and Turks, 89, 118, 169
smallpox, 165, 167, 322
Sobat River, 65, 71, 261–62
Sofi (village), 94–100
soldiers: and *firman* expedition, 255, 259, 266, 267, 287, 288, 293, 299–301, 303, 304, 306, 311, 312, 316, 317, 325; Florence designs uniforms for, 119; illness/death of, 266; Sam asks viceroy in Alexandria for, 118; Sam hires own, 118, 119, 133; slaves purchased by, 267; viceroy of Alexandria turns down Sam's request for, 118
Somali/Somalia, 57, 59, 163
Somerset Nile, 171–72, 191–92, 195–96, 197–98. *See also* Lake Albert; White Nile
Souakim (town), 257
Speke, John Hanning: awards and honors for, 241; and Baganda people, 206–7; books of, 218, 239, 241; Burton's comments about, 217, 218, 222–23; Burton's expedition with, 56, 57, 59–60, 62, 63; as celebrity, 217–18; corroboration of information provided by, 191; death of, 222–24, 302; Florence's views about, 219; and Kamrasi, 140, 169, 172, 173, 174–75, 177, 178, 180, 181, 202–3, 204, 205, 224, 235; Lake Victoria discovered by, 56, 59, 188, 220; Luta N'zigé map of, 166, 171; M'Queen's criticisms of, 218–19, 220; and M'tesa, 218; personal and professional background of, 56; reputation of, 219; and RGS, 218, 234; and Sam and Florence's relationship, 242; and Sam's plans for White Nile expedition, 66, 71; Sam's relationship with, 56, 142, 209, 215, 224–25, 235; and Sam's return to Khartoum, 222; and women, 139–40, 218–19, 220, 239. *See also* Speke and Grant expedition
Speke and Grant expedition: and Burton, 138; and Dutch ladies' party, 114, 121; funding for, 63, 64, 136, 137; and Gondokoro, 114, 134–41; leave Gondokoro for Khartoum, 141–42; London reception for, 209; and Murchison Falls, 199; and

Petherick, 64, 65, 111, 112, 134, 136, 137, 141–43, 148, 213, 219, 224–25; and Royal Geographical Society, 63–64, 65, 142–43, 209; Sam and Florence meet up with, 134–41; and Sam and Florence's relationship, 135–36, 137, 138–40; and Sam's exploration of Luta N'zigé, 138–39, 235; Sam's views about, 224; separation of Speke and Grant during, 164; and Somerset Nile, 171–72; supplies/equipment for, 64, 137, 141; and White Nile expedition, 66, 71, 118, 130–31, 134–41

Stanley, Henry Morton, 361, 363

starvation, 127–28, 167

Steele, Thomas, 339, 340

Stewart, John Hamilton, 347, 350, 355, 356, 357

still, whiskey, 210

Sudan: abandoned and burned areas in, 258; Bakers' contemplate return to, 344–45, 351–55; civil war in, 346–59, 361; criticisms of Sam in, 330–31; and Egypt, 249, 276, 345–59; and *firman* expedition, 249, 250, 254, 258, 266, 276, 324; and Gordon, 329–30, 331–33, 344, 347, 351–55, 358–59; Gordon's visit with Sam about, 352–55; hunting rights in, 96; memories of Sam and Florence in, 361–62, 374–75; Robin Baily in, 368; Sam's views about natives in, 118; as slave society, 266. *See also* Khartoum

Sudanese soldiers, 115, 255, 259, 266

sudd (swamp), 112, 126, 137, 195, 196, 257, 261–63, 266, 267, 268, 279, 284, 320, 325, 330

Suez Canal: opening of, 255–56, 257

Suleiman (Abou Saood *vakeel*), 290, 292–93

Suleiman (Latooka man), 159–61

Suleiman (soldier), 255

Sultana Vilidé (aka Finjanjian Hanim), 1, 2–3, 7, 11, 13, 27, 28, 35, 37, 38, 42, 70

supplies/equipment: and *firman* expedition, 250–53, 255, 257, 273, 275, 277, 278, 280, 287, 290, 291, 292, 293, 294, 301–3, 304, 305, 306, 309, 310, 312; and Gordon in Khartoum, 357; and journey to Luta N'zigé, 172, 173, 176, 178, 179, 181, 186–87; and Kamrasi, 140, 173, 175, 176, 178, 181, 201–2, 204–5, 207; and Petherick expedition, 137; and return from Luta N'zigé, 193, 194, 195, 201–2, 204–5, 207, 209–10, 216; for Speke and Grant, 64, 137, 140, 141; and White Nile expedition, 66, 72, 85, 119, 121, 127, 130, 140

Sutherland, Duke and Duchess of, 245

swamps: crossing, 171. *See also* sudd

swords, 182, 262

Szász, Florenz Barbara Maria. *See* Baker, Florence

Szász, Mathias (Florence's father), 28, 29, 30, 31, 32, 33, 34, 35, 51, 231–32, 308, 370

Taka country, 81

Tarrangollé (Latooka town), 157–61, 162, 163, 165–67

Tavistock, Marquis, 339

Teesdale, Colonel, 248

Tewfikeeyah station, 269–74, 276, 277, 278, 284

Thibault, Georges, 113, 120

The Times of London, 62, 142, 223–25, 234–35, 313, 316, 329, 330, 338, 351, 352, 356, 374

Tinné, Alexine, 113–14, 121, 123, 125, 136

Tinné, Harriet, 113–14, 121, 123, 125, 136

Tinné, John, 224

Tokrooni tribe, 106, 123

Tollogo Valley, 152–54

Transylvania: bear hunting in, 42; Florence's early childhood in, 22, 28, 36, 208, 304, 370

Transylvania army: Florence as child with, 28, 29–35, 208; in Viddin, 30–35, 370

Travels in Central Africa (Petherick), 129

tribes: differences among, along Upper Nile, 74–75; along White Nile, 115, 118. *See also specific tribe*

Tuareg tribe, 123

Turks/Turkey, 88–89, 93; and Bunyoro, 172, 174, 203, 204, 205, 212; in Latooka country, 166; and Luta N'zigé journey, 155–56, 160, 165, 170, 203, 204, 205, 212; and Mahdi, 346; and Russia, 341–42; and slaves, 118, 169; and Sudanese civil war, 352, 356; Valentine Baker in, 341

Turner's Company, 329

Twefik (khedive), 345

Uganda, 219, 374

United Service Institution, 329

Utumbi tribe, 191

Vacovia (village), 188, 189–90, 191–92, 195

Victoria N'yanza, 56, 59, 60, 63, 136, 138, 172, 188, 218, 220

Victoria (queen of Great Britain): and awards and honors for Sam, 241; and Duleep Singh, 14–15; and *firman* expedition, 324; and Gordon, 356; jubilee of, 360–61; and military and commercial expansion, 249; Sam dedicates book to, 240; and Sam and Florence's marriage, 243, 244, 245, 246; Sam invokes name of, as threat, 181; and Speke's honors, 217–18; and Sudanese civil war, 352; and Valentine Baker, 341, 342, 345, 361; and Wales's trip to Egypt, 248

Victorian society, 74–75, 103, 221–22, 231, 236, 240, 328, 353–54

Viddin (Ottoman Empire): Florence first arrives in, 30, 208; Florence's homesick thoughts of, 202; pasha of, 13, 14, 16, 19, 24, 39, 44; Sam's and Singh's travels to, 43–44, 45; slave market in, 1–15, 368, 370; Transylvania army in, 29–35, 370. *See also* harem/harems: Florence's life in

Vivian, H. C., 324

Wales, Prince of, 233, 245–46, 247–50, 324, 325, 329, 333, 336, 341, 354, 361

Wales, Princess of, 247–50, 299, 302, 324, 325, 329, 336, 353

Wallachia, 22–24, 55, 238

war: Florence's views about, 308

Wat-el-Mek, Mahommed, 205, 206, 211, 220, 315, 316

wedding: of Sam and Florence, 230–32

Wharncliffe, Lord, 25, 41, 50–51, 67, 217, 237, 243–44, 248, 281, 329, 338, 341

White Nile: characteristics of region around, 81, 125–26; slavery along, 115,

118; source of, 114; and Speke-Grant expedition, 63. *See also* Khartoum; Luta N'zigé journey; Murchison Falls; Somerset Nile; sudd; White Nile expedition

White Nile expedition (Baker): along Atbara River, 85–87, 88–93, 94–100; and Berber to Khartoum trip, 83–87; and Cairo to Korosoko trip, 71–75; to Cassala, 89–93; and desert trip from Korosoko to Berber, 75–83; early days of, 69–75; from Berber to Atbara River, 83–85; funding for, 65, 66, 121, 149; and Gozerajup, 88–92; at junction of Atbara River and, 85; Petherick meets, 140–41; plans for, 61–62, 64–67, 80, 81, 234; Sam and Florence's evaluation of progress on, 110–11; size of, 119; and Speke and Grant expedition, 118, 134–41. *See also* Luta N'zigé

Whitfield, George Robert, 254

"womanly arts," 37–38, 39

women: in Arab culture, 73, 99; Bunyoro, 176; capture of, 166; circumcision of, 90–91, 99; flogging of, 151; Latooka, 157–58, 161; in Ottoman society, 92; Sam's views about, 99, 103–4, 139–40; Sheik Achmet's views about, 103–4; and Speke, 139–40, 218–19, 220, 239. *See also* Victorian society; *specific woman*

Wood, Beatrice (niece), 370

World War I, 371–72, 374

Zanzibar, 56, 59, 62–63, 64, 166, 238, 313, 336

zebra (Persian miniature), 52

Zeneb (Dinka woman), 225